DEAD
artists
LIVE
theories

WITHDRAWN

DEAD
artists
LIVE
theories

and Other Cultural Problems

Stanley Aronowitz

ROUTLEDGE

New York • London

Published in 1994 by

Routledge
29 West 35 Street
New York, NY 10001

Published in Great Britain by

Routledge
11 New Fetter Lane
London EC4P 4EE

Library of Congress Cataloging-in-Publication Data

Aronowitz, Stanley.
Dead artists, live theories, and other cultural problems / Stanley Aronowitz.
p. cm.
Includes bibliographical references and index.
ISBN 0-415-90737-3 (HB) — ISBN 0-415-90738-1 (PB)
1. Criticism. 2. Literature and society. 3. Politics and culture. I. Title.
PN85.A73 1994
306.4'7—dc20 93-26973
 CIP

British Library Cataloguing-in-Publication Data also available.

CONTENTS

PREFACE

The idea of a purely literary criticism is fairly new. Until 1950, many cultural critics explored the social world through fiction or poetry. It was not only the intellectuals huddled around little magazines, notably *Partisan Review,* who valued art as a truer register of life than traditional historical writing, political tracts, or scholarship. Even academics such as F. O. Matthiessen were interested in illuminating, through literature, what they understood to be American culture. The literati commented on history and politics. Edmund Wilson published one of the best reflections on the Russian revolution and its aftermath, *To the Finland Station,* in 1940, when he effectively dominated literary criticism. The upstarts of the interwar period, radicals and ex-radicals who counterposed James to Whitman, Joyce to Dreiser and Pound and Eliot to William Carlos Williams, were engaged in more than a turf fight. Philip Rahv, Lionel Trilling, and Clement Greenberg praised modernism against naturalisms of all sorts, and believed the fight for the canon had high political purpose. They were waging ideological war on a peculiar marriage of Stalinism and mass culture; this constituted a powerful cultural politics in the 1930s' antifascist struggle. The later notion of studying the "poem itself" (John Ciardi) as a purely aesthetic object was out of the question for the literary avant-garde of this period.

The subsequent defense of art against politics led, egregiously, to the militant statement that art had nothing to do with politics or culture, but was simply an expression of the pure imagination. First the "new" criticism and then critical theory set the tone for a tendency to

focus exclusively on the languages of art. Where once the essay resembled a work of literature, in the sixties it rapidly became another academic discipline. Writing was considered different from painting; movies, once a major repository of mass culture, became "film," its language subject to the same analytic rigor as the narrative or a symphony. As Russell Jacoby has noted, the academicization of criticism marked the end of the public intellectual. The academy also attempted to make of criticism a natural science. The key moves were structuralism and poststructuralism, which, among other things, made formal analysis the name of the game.

The French turn in American literary criticism of the 1970s displays the dangers of imports of all sorts. For just as French wine loses some of its zing after a three-thousand-mile journey, so French theory, torn out of its context and placed in English and comparative literature departments of elite universities, ceased to resemble the original in all except jargon. In France, deconstruction was a method of disenchantment. It showed that theory, both Marxist and existentialist, had exchanged one kind of God for another and, therefore, failed to escape the thrall of essentialism. The critique of essentialism was a profoundly political intervention within the left; but, in the early eighties, it became apparent in France as well as the United States that poststructuralism and its offshoot, deconstruction, had run their course.

In his widely disseminated book, *Literary Theory,* Terry Eagleton sounded the retreat from the farthest outposts of Theory about Theory. He called on the left to return to the artistic text, to make criticism speak to vital historical issues. Of course, he wanted to retain some of his Marxist bite; he was not about to give up the study of ideology either for a sanitized notion of discourse analysis, as some of the deconstructionists had done, or for old-fashioned Anglo-American canon-building through historical studies.

The future of criticism is to recover the space of the public intellectual, a job that entails speaking about culture—economic, political, and literary. Perhaps because they are marginalized in the academy, only feminist, gay, and Black critics retain a sense of urgency about capturing public space. Which doesn't mean that we shouldn't learn from the French invasion. For the real teaching of Lévi-Strauss, Foucault, and Co. is that politics is embedded in form. The language (pronounced discourse) of sexuality, of social exclusion, of marginality may provide more accurate clues to the quality of social life than foreign

policy, mainstream economic analysis, or direct political commentary. Our mode of life is embedded in art, as well as in the documents from which historians reconstruct the past. Literary criticism must, therefore, become social theory and social criticism. Otherwise, criticism is doomed to occupy a respectable but not very interesting space in the academic division of labor.

It also must discover its mission(s). This does not mean simply reproducing the nationalisms, Marxisms, and aestheticisms of the past. Nor can criticism sustain itself by the worship of method, as it has done in the last twenty years. I would choose a new democratic ideology that seeks to uncover the gaggle of voices in cultural texts, that adopts the postmodern stance toward canon (good stuff is good stuff regardless of its pedigree), and recognizes that the energy is going to remain at the margins for a long time. Genre fiction may be the best place to find the snapshots of the social world; critics should focus on the bad new things rather than the good old things. And, as long as most of us remain in the universities, we must avoid at all costs, taking honored places in our disciplines. Some critics are nonacademic writers, but their numbers dwindle with every failure of magazines and newspapers that accommodate serious criticism rather than consumer guides. Maybe a Walter Benjamin is out there, waiting to take the temperature of the times. Chances are he's a woman.

ACKNOWLEDGMENTS

All of the essays in this book concern contemporary cultural politics and political culture. The earliest of them, on the transformation of the critic into a star, points to one of the themes explicated throughout: the ubiquity of popular culture, even in academic precincts, which is perhaps most visible in the explosion of the performative principle as a relatively recent mode of intellectual life. In the 1970s Roland Barthes was the pioneer figure who brought criticism from the academy to the Sunday papers. "Critic as Star" first appeared in the *Minnesota Review* (Fall, 1977). The later piece on Barthes and one of his American interlocutors, Susan Sontag, who may best exemplify the emergence of criticism as public activity, was published as a review essay in *The Voice Literary Supplement* (VLS) (November, 1982).

"So What's New? The Postmodern Paradox," the second chapter of this book and which, together with the Introduction, frames one of its key themes, was first published in *VLS* (October, 1983). "The Tensions of Critical Theory" is an essay on the contradictions of the methodology of the Frankfurt School. It first appeared in Seidman and Wagner, eds., *Postmodernism and Social Theory* (Blackwell, 1992).

The essays on Raymond Williams and on Mikhail Bakhtin published here for the first time extend perhaps the major thesis of the book: literature and other art forms do not represent an external reality; nor is art self-referential. Works of fiction and other art forms are signatures that indicate domains without representing them. Bakhtin reads Rabelais as the signature of a specific domain, village, and French

peasant life in the sixteenth century. Dostoyevski's novels are, at their pinnacle, reports of lived experience which are situated in the lives of the Russian middle classes in a time of ferment. And Williams traces through poetry the awful, exhilarating moment of the Great Migration from country to city. I take these readings as ways in which literature provides ways of seeing not available to other ways of reading history. The work of art and its critical appropriation must, of necessity, refer to its own domain the formal apparatus of its production. But this apparatus is not logically separated from its motifs. Like the *corpus delicti* in the detective narrative, its motifs are derived, initially, from the outside but find their way to the inside. It is the way in which "the form of expression is no longer really distinct from form of content" (Deleuze and Guattari, *Thousand Plateaus,* p. 142).

Education increasingly occupies more space in contemporary culture. The essay on Paulo Freire first published in Peter McLaren, ed., *Paulo Freire a Critical Encounter* (Routledge, 1993) addresses, in different ways, some of the central issues of educational politics. In this essay, I try to counter the tendency to view his work as *methodology,* and replace it in the historical-political context within which it was developed. Freire's appropriation in North American is mediated by the depoliticizing tendencies of educational discourse which, for the most part, reduces ideas to their operational aspects. The two review essays on ecological politics were written for the *VLS* in the 1980s. "The Power of Positive Thinking" appeared in *VLS,* Sept. 1984.

My four attempts to come to terms with shifting political identities, "The Decline of American Liberalism," "Birthrights," "Reflections On Identity," and "Is Democracy Possible?" were written as occasional pieces, the first for the inaugural issue of a new series of an old journal, *New Politics* (vol. 1 No. 1, 1986), the second as a review essay of Orlando Patterson's *Slavery and Social Death* (*VLS,* December, 1982), the identity reflections for a special issue of *October* (No. 61, Summer 1992), and my democracy essay was published in Bruce Robbins, ed., *The Phantom Public Sphere* (University of Minnesota Press, 1993).

I want to thank M. Mark, Editor of *VLS,* for insisting that complex ideas can be expressed with wit and clarity.

1

INTRODUCTION: THE DEATH OF "ART"

–I–

Periodizing cultural change has become tricky when cultural theory regards the concept of historical causality with considerable skepticism. For the categories of "period," "stage," "era," "epoch," or any other terms that demarcate and classify constellations of events or trends under labels (romanticism, modernism, postmodernism, for instance) are all implicated in the idea of temporal order, even if not so recognized by those who invoke them. But for much of contemporary cultural theory, following some perspectives in physics, time is spatialized and order is viewed as a construct, a logos that may be deconstructed to show the exclusions as well as the inclusions in discourse. Under these circumstances, it may be foolhardy to suggest, as I do, the historicity of the summary judgment that there is little, if any, value in the distinction

between high and low art except socially and, at a deeper level, high art is a domain linked to historically situated conventions that arose with the emergence of a large European middle class. Nevertheless, the *generalized* challenge to the very idea of Great Art opposed to mass culture can be located in the turbulent 1960s, in the wake of the coming of age of rock 'n roll as the characteristic cultural expression of the generation born around 1940.

That the three generations since 1940 have, for example, turned their backs on classical music can be observed in the half-full halls for chamber and symphony concerts in recent years, and the preponderant gray heads seated in the audience.[1] Even performance stars have a hard time filling many auditoriums in small and medium-sized cities, where classical music rather than painting occupies elite public cultural space. The chronic depression in classical music, manifested in frequent budget crises due to diminishing patron contributions, as well as income losses at the box office, has sent managers and performers into a searching reexamination of their branch of the culture industry. Following the lead of Leonard Bernstein, an indefatigable pedagogue, the most energetic of them have embarked, furiously, on public education programs, hoping to attract a new generation of consumers, through an aggressive sell to music schools and music appreciation programs, especially in young people's concerts and in high schools. And, although famous (dead) painters often bring huge tourist crowds into museums to view mammoth retrospectives of their work, there is little sign since the 1960s, when Andy Warhol and Robert Rauschenberg, among others, brought pop art into mainstream art world venues, that a new voice in traditional painting can elicit much excitement beyond collectors, curators, and professional critics. With the development of video cassettes, even the film industry, once the preeminent pop cultural form, has undergone a fundamental restructuring. The old lions, major studios who were the arbiters of taste as much as the source of movie production, have been reorganized, when they have not gone out of business. Mergers and acquisitions, the major US economic event of the 1980s, hit the studios somewhat earlier; today most of the major production companies are merely one business in the vast portfolios of communications empires. At the same time as film, like jazz, comprehends its future as a high art form, during the last thirty years academic and independent theorists and critics have tried to transform the image of film from entertainment into an art form, with

its own canon, bibliography, and central creative figures (in the auteur theory, the director).

We may explain the turn away from classical music and other high art forms by calling this a signifier of postmodern culture. It remains open to debate whether, following Fredric Jameson's highly influential formulation, this disdain was part of a new "cultural logic of late capitalism," or a sign that we have witnessed the end of Art and the definitive victory of degraded mass culture.[2] Jameson himself is somewhat ambivalent on this point. By linking postmodernism's emergence to a definite *stage* in the history of capitalism, he appears to vindicate the judgment, first enunciated by the Frankfurt School half a century ago, that art has lost most of its autonomy and technological domination in the late twentieth-century has all but swept away the last vestige of resistance. For "late" capitalism seems to bring to the extreme the tendency first enunciated by Lukács after World War I, that the commodity form penetrates all corners of the social world, including art. The crisis consists not in the truism that almost all art forms are subject to the same rules as any other commodity. The issue is the *commodification* of the work of art itself, the imperative that art subject itself to the rule that it find a definite mass audience or risk marginality. In turn, late capitalist culture problematizes the formulation of center/ periphery or margin. The space for an oppositional avant-garde has narrowed for two principal reasons: the voracious appetite of the culture industry—its ability to incorporate the opposition into the mainstream— and the end of the long era of cheap rent in the city slums where artists create an autonomous public sphere, in part in opposition to the homogeneous culture that surrounds it.[3]

But there are two late capitalisms. The first came into existence during the Great Depression and its aftermath, and was marked by the integration of the state with the private sector of the economy. Under pressure from workers' movements and social reformers, the New Deal and its European counterparts constructed a huge welfare state, and made labor a stable production cost (and an economic stimulus through relatively high wages) by recognizing the legitimate role of unions in a tripartite alliance. This era of capitalist regulation is marked by the universalization of Fordist production and consumption (consumer society) and a tripartite system of power where organized labor becomes a partner of the state and agrees to negotiate with capital within the regulative framework.[4] The second late capitalism, which may be lo-

cated in the early 1970s, signals a new era of sharpened international economic competition, resulting from the entrance of revived economies of Western Europe and Japan into the world market. It has been called the era of post-Fordism, disorganized capitalism, or global capitalism; each designation signifies some difference, but the consequences of the end of national capitalist regulation have had, at different rates, similar effects.[5]

"Post"-Fordism signifies a certain "disorganization" in world capitalism. In the mad race for markets in goods and capital, none of the arrangements of the earlier period remain sacred. Once believed to be a particularly US aberration, the progressive deterioration of the welfare state and labor's rights is now a routine feature of state policies in an increasingly economically integrated Europe. Deregulation and privatization of state-sector enterprises complete the crucial policy reversals initiated by nearly all governments ostensibly to assist "their" corporations to meet the intensifying foreign competition. Living standards have been forced sharply downward into the bargain, and the working class is decomposed and recomposed according to a different regime of smaller-scale, highly decentralized production and consumption.

One of the more dramatic illustrations of the coming of the new post-Fordist regime is the ubiquity of the global car. The old vertically integrated factory, such as Ford's River Rouge, Michigan plant where steel, parts, and assembly operations are produced under a single roof or in the same region, is today the exception rather than the rule. Now an "American" car may use US, Japanese, or Korean steel, parts made in Malaysia, or Mexico, and be assembled in Germany, Japan, or Mexico. Under this new regime, unemployment slowly rises in all countries, but especially the "advanced" industrial areas. Technological innovation combines with wage erosion to increase productivity, but the whole job culture has become an endangered species at a time when the left as much as the right are more reluctant to defend the social safety net.

Under these conditions we can observe two contrary tendencies in the relation between the state and culture. On the one hand, lacking even the fig leaf of effective economic planning, or indeed, interventions that can thwart the effects of galloping globalization, high art, for centuries a vital component of state culture, occupies an even more central place in the symbolic pantheon of government and other state institutions. While few governments were as overt in their opposition to new movements for cultural diversity as the Bush administration,

the incorporation of art in proportion as other props to state legitimacy were removed is a crucial feature of the last two decades. Government-run arts councils became militant champions of tradition and in some cases, notably France, poured substantial financial resources into these activities in the name of *national* pride.

Under the redoubtable Jack Lang, the French Ministry of Culture, in collaboration with some of the country's leading corporations, produced the greatest outpouring of state culture since Louis the Fourteenth held the nobility at bay with style. Where the United States government spends less than two dollars per capita on culture, the French government under Francois Mitterand allocated forty-one dollars. France spends more for culture, in absolute terms, than any other country. While Lang put some money in popular cultural forms such as rock 'n roll, the "great" projects were architectural: additions to the Louvre, the construction of a new national library; the Grand Arche de la Defense, the Bastille Opera, a refurbished National Music Conservatory, and some three hundred museums which have been built or rebuilt.

State culture is, typically, spectacular and nationalist. In contemporary democratic societies where the aristocracy is to be found in corporate boardrooms and, except in the United States, exercises its control over government and cultural institutions only indirectly, the state (government, foundations, patrons) builds palaces of culture, including the arts and sport, to dazzle the underlying population and, most of all, to establish the credentials of the regime which, in most other respects, is completely addled. We recall a similarly dramatic increase in state culture by the Bolsheviks during the Soviet Union's long ascent to industrial and military power, a climb which—given its compressed speed—necessarily entailed mass suffering. When rendering an account of the survival of this often-brutal regime, especially to its opponents, the capacity of official culture to maintain the appearance of coherence in an otherwise-turbulent political situation should not be underestimated. In the midst of famine and bare subsistence for the majority, the Soviet government spent millions on acquiring magisterial collections of rare art in refurbished museums, subsidizing world-class orchestras which could be heard by a considerable fraction of the population at cheap concerts, providing a flourishing theatre and creating, almost from scratch, a large film industry. Workers' resorts and palaces of culture were built in literally hundreds of cities and towns; for a

considerable section of the industrial working class these were the wages of devotion. These achievements, rivalled in liberal democracies only by Lang's parallel efforts, attested to the resolve of Lenin and his successors to compensate for the mean conditions of everyday life with a glittering display of cultural resources. And judging by the extraordinary efforts of the Socialists in the field of mass ornamentation, perhaps the survival, over nearly thirteen years, of an otherwise-failed government may be attributed in part to President Mitterrand's canny ability to draw at least one page from Stalin's book. For state culture is no mere ornament of power. Or, in Kracauer's terms, the mass ornament is intrinsic to the constitution of modern power.[6]

On the other hand, the disarticulation of high art as official state culture with emerging popular discourses has not abated. In all Western industrial countries and in Eastern Europe, the arrival of new refugee populations from Africa and the Middle East and, in the United States, from Asia and Latin America comes at a time of economic stagnation and cultural despair at the highest levels of power. Political leaders and their ideologues are unable to evoke reverence for Western traditions as an intellectual argument for loyalty, leaving only the most xenophobic appeals to justify military preparedness and intervention. Whereas earlier generations of immigrants more or less rapidly assimilated into the American patriotic version of the Greco-Roman ideal of Western Culture, this ideal is today in ruins and with it, most of its treasures. The audience for traditional art has declined so precipitously that even the classically trained musicians and visual artists who continue to work within its precincts are constrained to come to terms with the popular. The time when American composers, for example, in the interest of preserving the independence of art, could safely emulate Schönberg's *formal* rejection of tonality, seems definitively over.

Today composition, even if retaining some of the dissonance characteristic of high musical modernism, is prone to cross over between "classical" and popular genres—jazz, "folk" idiom and, more recently, Latin and rock 'n roll. For example, the line between the "serious" music of Phillip Glass and Steve Reich and the neo-rock minimalism of Brian Eno, Robert Fripp, and John Cale is effectively blurred, and is reasserted only by the different audiences they usually attract, although "avant-garde" rock shares with jazz a taste for the "legitimate" concert hall. And since the 1930s, film and the musical theatre continue to attract musicians working in virtually all genres. Leonard Bernstein's

symphonies have, for the most part, been indifferently received, but he succeeded with three Broadway musicals. Several bombed, mainly because they could not cross over from their highbrow premises, upon which Bernstein lavished earnest devotion despite his own stature as one of the leading postmodern musicians of his time. Aaron Copland, perhaps this century's leading American classical music composer, wrote for the movies and the dance theatre; Igor Stravinsky and Maurice Ravel wrote for the ballet and incorporated popular, even jazz themes and rhythms into their compositions while retaining their status as "serious" composers. And Shostakovich and Prokofiev composed many film and dance scores, patriotic cantatas, and marching songs. The subsumption of some of the works by these composers under Soviet state culture became, during the Cold War, the occasion for vituperative criticism among the art-for-art's-sakers and anti-Communist critics, especially in the United States, a criticism not applied to American composers who were engaged for similar purposes. That Shostakovich suffered from the Cold-War hysteria is revealed by the differential treatment he received in the post-Stalin era, especially with the publication of the memoirs published under his name that purportedly showed he had been a dissident. From that moment, works that had been labeled propaganda became instant masterpieces, and Shostakovich was heralded as the greatest symphonist of the twentieth-century, the legatee of Bruckner and Mahler.

The very idea of a cultural logic parallel to the economic logic implied by the phrase "late capitalism" suggests the determination by the economic, at least in the last instance.[7] One might say, for example, that in the postmodern condition, capital no longer mainly accumulates in the form of "things"—mines and mills, large machinery, or even in the guise of labor, termed human capital by neoclassical economists. Capital accumulates as signs: information, financial services, and knowledge. Art is subsumed under the sign of information/entertainment, which in the late twentieth-century became perhaps the most important investment option. Avant-garde art becomes a kind of "futures" investment in the hope that today's margin is tomorrow's center. For example, marginal filmmakers such as Barbara Kopple and Michael Moore, whose documentary films on the decline of labor elicited much critical acclaim including winning Academy Awards, are now making feature films which one day may follow Spike Lee into Hollywood's mainstream. Others, such as independent filmmakers Dee Dee Halleck

and Yvonne Rainer, are able to stay on the margins if, and only if, their work is subsidized by government agencies, foundations, and other wealthy patrons. Although there is always a politics of art and culture, to the degree that traditional high art is the defining official culture, and commercial success perhaps the only legitimate equivalent, the state's capacity to accommodate the work of its opposition may, from time to time, constitute an important element of its legitimacy.

Yet those four years of the Bush presidency gave us a glimpse of the limits of tolerance. The denial of funds to some performance artists by the chair of the National Endowment for the Arts raised the question of whether art could exempt itself from politics. The Bush administration's cultural policy, informed by its political alliance with the fundamentalist Christian right as well as cultural conservatives—many of whom were leftist intellectuals *manqué*—exposed as a pretense the doctrine that government support for the arts was nonpolitical. The controversy surrounding federal arts policy brought a relatively new element into the debate: in a free society, should federal funds support the arts, or do "taxpayers" have a right to support only those works that conform to their morality?

Now, the commodification of culture is by no means new. But what distinguishes the commodification of art in recent years from earlier times is the ubiquity of cultural consumption and its integration, by means of technological innovations, into production. Now the consumer is also a producer, and not merely insofar as the text is also interpreted even as it is received. Thanks to technologies such as popularly priced hand-held camcorders, every person can be a filmmaker, just as desktop publishing may one day encourage a new generation of writers to produce, at every level, their own texts. And the mass production of modems makes possible a profligate intellectual culture: we are already witnessing the revival of an eighteenth-century art form, the epistolary. And e-mail, still frequented by a small, but growing, minority of businesspeople, scholars, and journalists, may lead to a new burst of electronic letter writing, only a few decades after telecommunications threatened to condemn all but business mail to extinction. Moreover, television programming which in its infancy merely reproduced the traditional patterns of passive cultural consumption, has turned, at least in some genres, to overtly participatory shows. In contrast to the sham audience participation of earlier talk shows, hosts such as Phil Donahue, Oprah Winfrey, and Arsenio Hall actively solicit the

audience's involvement.[8] While the distinction between producer and audience has not been abolished, the authority of the professional producer has markedly eroded in recent years.

The new genre of "trash," mostly daytime, TV responds to restlessness and discontent among significant fractions of the TV viewers, many of whom have grown weary of processed information. Recall Benjamin's rueful remark that in advanced capitalist societies experience is transformed into information. There seems no room left for unrationalized, unprocessed feeling. As information, experience is subject to the same rules that govern the distribution of any product in the marketplace. Of course, Benjamin hesitated to join the chorus of criticism against the emergence of objectified experience; after much rumination, he condemned efforts to preserve the private sphere, regarding it as a thinly disguised cover for maintaining the cultural basis of economic and social privilege. Jameson is right to detect nostalgia as much as celebration in Benjamin's account of the triumph of mechanical reproduction and a yearning for the recurrence of the time when an artistic avant-garde, in addition to its protest against the commercialization of art, was able to carve out an alternative public sphere.[9]

However, in the age of mechanical reproducibility, the self is dissolved into so many bytes of emphemeral messages. And of course, in a period where any unified identity is regarded with scepticism, especially for those who practice art, the self appears hopelessly, but creatively, fragmented. The problematization of the self, the subject of modernist narrative, raises the question of whether the novel is possible if it depends crucially on the existence, even in the imagination, of an autonomous individual and the nuclear family. For while novels of the family romance are still written and read (demonstrating Nietzsche's antiprogressivist dictum that nothing goes away and that everything that goes around, comes around) it may be seriously doubted that any of them can be compared in significance to the classical incarnations. For one thing, before radio and television novels commanded the attention of virtually the entire literate, middle-class public. The writers were in daily contact with audiences. The novels of Dickens, Thackeray, Dostoyevski and many other nineteenth-century writers were produced for daily newspapers and weekly magazines before finding their way between cloth covers. A new work by a leading poet or novelist was an event to be marked by critical commentary on street corners as much as in the press and journals.

Today the novelist works in relative isolation, except in East European countries and the "Third World," where fiction is still taken as a form of political intervention. Since the 1960s the best narratives in the US are produced in genre fiction, principally adventure and mystery stories, and science fiction. "Regular novels"—those that emulate the intention of the classical forms—rarely, if ever, attract more than a remnant of the novel-reading audience, except for the work of a handful of writers such as Norman Mailer, Joseph Heller, Saul Bellow, E. L. Doctorow, and Phillip Roth who, as often as not, work on the genre borders. Thus, Doctorow writes for the most part in the once-popular genre of the historical novel; Mailer's recent fiction has a distinct documentary character, and is a development and continuation of his 1960s series of narratives derived from contemporary political events; Roth's leading characters are uniquely and uncomfortably situated in the postwar, postmodern era, and concern the fate of first- and second-generation Jewish intellectuals from petit bourgeois backgrounds who have difficulty finding themselves at a time when Jewish identity is buffeted by the assimilation imperative, on the one hand, and the persistence of Jewishness as a form of cultural capital, on the other.

But most novels that work with traditional motifs and forms, even those that receive favorable critical attention, are read by tiny audiences, mostly critics, academics, and other writers. The postmodern novels of Hawkes, Donald Barthelme, Pynchon and DeLillo have their fans, and in the recent past, their work occupied the space of the avant-garde, even as they earned their living from academic gigs, foundations grants, and modest advances. They have a relatively large audience among the hip, big-city intellectuals but of these authors only DeLillo has produced anything approaching a best-seller. While it must be admitted that this state of affairs cannot be laid at the door of the writers themselves, there is no doubt that with the end of the tragic hero, all that remains is the cynic. And cynicism doesn't sell well in the suburbs.

Perhaps one of the more impressive developments in narrative fiction in the 1960s was the emergence of the considerable, but segmented, audiences for women's, African-American, and Latino writing. Some writers, notably Toni Morrison, Alice Walker, Gloria Naylor, and Paule Marshall, have attracted a crossover audience, not only between Blacks and women, but also with a more broadly based fiction audience from the avant-garde to those who devour works on the *Times*'s best-seller

lists. But Walker's popularity was assisted by the hit movie version of her novel *The Color Purple,* and Naylor's worked is squarely situated in the popular family romance/drama.

In general, African-American women writers have fared better than African-American men. James Baldwin and Richard Wright achieved great critical and even commercial success, and Chester Himes's Harlem crime series, featuring two street cops, are some of the most commercially successful exemplars of the detective genre. But his three "race" novels of the 1940s, *If He Hollers Let Him Go, Cast the First Stone,* and *Lonely Crusade* were too politically controversial for the critics and too angry to attract large audiences. Although, like Wright's more famous *Native Son,* their view of whites was sharply critical, they were more unrelenting than Wright's works. For one thing, Himes does not present an ambiguous view of Blacks, as does Wright. There is no figure like Wright's Bigger Thomas to soften the critique: in Himes's work Black rage is unmediated by psychological angst. For another, in *Lonely Crusade* Himes's literary weapons of criticism are trained on the white left as well as mainstream whites. Himes does not forgive the left's racism, despite its good intentions. The fiercely nationalist tone of his work was dissonant with the integrationist "line" of the 1940s' popular front and its civil rights coalition aftermath.

Reprinted in the African-American cultural revival of the late 1980s, these works retain their bite because the issues they raise remain unresolved. Similarly, Langston Hughes, perhaps the bard of the 1930s New Deal-oriented civil rights movement, was marginalized in the 1950s when, in his "Simple" novellas, he dealt with African-American working-class everyday life, and consequently found himself out of fashion in the wake of the triumph of literary modernism exemplified by the near-canonical status of Ralph Ellison's Dostoyevskian *The Invisible Man.*

Until the 1950s the novels which received most critical attention were also best-sellers. Their authors were important public figures who were celebrated in their own lifetime by the popular press as well as by critics. Faulkner, Hemingway, Fitzgerald, Steinbeck, and Farrell, and the fairly substantial coterie of Southern writers of the 1930s and 1940s such as Eudora Welty, Robert Penn Warren, and Carson McCullers, were critically received as serious writers, and their books sold well and were made into films. Penn Warren's *All the King's Men* became something of a film classic, and McCullers *Member of the Wedding*

was also highly successful in its film adaptation. In the theatre, Tennessee Williams and Arthur Miller produced hit after hit, and many of their plays were made into widely praised and commercially successful movies. Miller's quintessential little man, Willy Loman, and Williams' characters, Blanche DuBois and Stanley Kowalski, were incorporated into the popular culture in ways no contemporary playwright, after the triumph of television, can hope for. And after World War II the songs of Rodgers and Hammerstein, many of which reached the Top 40 charts, like those of Gershwin, Cole Porter, and Jerome Kern, or had universal appeal. Many Broadway ballads of the 1930s and 1940s have managed to survive rock 'n roll's domination of popular music, although it is inconceivable that the genre itself can ever return to its former preeminence. And, rock 'n roll often appropriates canonical ballads.

Although rock music was a truly generational art form, especially for the 50's and 60's youth generations, its emergence signals the fragmentation of the popular audience. By the early 1970s, country and western, rock, and ballads claimed listeners whose class, geographic, and age characteristics were as diverse as the country, had become divided into segmented "markets." Of course, the 1960s generation, especially middle-class kids who earlier would have formed the base for high cultural products, did not confine their rejection of art to the hitherto accepted view that universal aesthetic value is situated in classical rather than popular music, museum and gallery art rather than poster or commercial graphics, "literature" (the narratives of the conflict of individual against society or, in another version, formal modernism) rather than genre fiction, or, of course, poetry as opposed to rock lyrics. Enraged by their sense of betrayal by what many young people considered to be a dying class and its dying culture, a substantial portion of the whole generation, not merely its political and cultural activists, became deeply sceptical of most precepts of liberal democracy in favor of participatory democracy; fervently identified with the civil rights movement's challenge to the Democratic Party's hesitation before the vision of complete racial and social equality; broke decisively, in their opposition to the Vietnam War, with the consensus view of the propriety of US hegemony in international politics; and questioned, if not entirely overturned, conventional sexual morality. A smaller group, by no means tiny, embraced one aspect or another of a counterculture,

the core ethic of which was to make the shibboleth of personal—especially sexual—freedom applicable to everyday life.

What was remarkable, and for many of earlier generations, disturbing, about this rupture was that many of its features cut across traditional class, gender, and racial divisions. Although it would be excessive to claim anything like equivalence in the degree to which the break was made in each of these groups, and the assertion of a *generational* mode of thought and feeling is always subject to modification by those who insist on the persistence of specific differences within a given generation, it would be difficult to deny that something like a generation gap in thought and feeling emerged at this historical moment, despite the prevalence of conservatism, whose representatives regularly issue hortatory statements urging us toward High Culture in order to save civilization.

One of the leaders of the countercharge, Irving Kristol, has gone so far as to evaluate efforts such as those of Allan Bloom, Hilton Kramer, and himself to reassert the hegemony of Western tradition, as a failure. If, indeed, the struggle between high and low may be characterized as a last-ditch effort by a defensive cultural order against something that may be called a postmodern "logic," conservative efforts to resuscitate awe and wonder for the "High" appear to have been foredoomed. As their minions diminish, one can see the palpable hysteria that has overcome some of the most articulate spokespersons of the new fogeyism. Cultural radicals in the universities are accused of perpetrating a new McCarthyism because, among other things, they insist that the curriculum as well as the canon must be altered, if not completely changed, to accommodate emerging discourses of ethnicity, gender, and sexuality. After an initial flurry, charges that a new reign of "left" terror has sunk deep roots on college campuses and even secondary schools abated with the election of a new Democratic administration.

Some observers, notably Paul Lauter, suspected that the counter-radicalism of the Kristols and Blooms was a huge smoke screen behind which lurked the almost invisible hand of the budget cutters who, in the face of the explosion of college enrollments over the past thirty years, were eager to find a rationale for downsizing what they perceived to be overbloated and politically troublesome student bodies. Of course, the idea that enrollments are too large is a relative judgment. As long as the economy suffered shortages of technically trained labor and state

budgets were growing, post-secondary school expansion made sense. But if America and the rest of the industrialized world now faces a glut of professional and technical workers, what is the point of maintaining relatively open enrollments that result in the entrance of large numbers of African-Americans, Latinos, and women? And if they remain intent on making trouble for the standard curriculum, better to undermine their strength by getting rid of several layers of the least qualified students.

This strategy cannot account for the fact that some of the best-qualified young people, at least in terms of traditional academic criteria, are similarly disaffected. Consequently, the cultural shift is most apparent in elite institutions. Women's Studies, Cultural Studies, African-American and other "ethnic" studies programs, stalled in the late 1980s, have resumed their popularity and growth, often at the expense of traditional humanities (read: Western, white, male, and dead culture) departments. College campuses, the remaining site for all forms of elite culture, seems to have followed the trend away from tradition and joined the postmodern popular.

–II–

In the late 1960s, one of the preeminent philosophers and critics of the century, Theodor Adorno, wrote the epitaph to the long wave of high cultural dominance:

> The Hegelian notion of a possible withering away of art is consistent with the historical essence of art as a product of becoming. This seemingly paradoxical fact, that Hegel conceived of art as something mortal while at the same time treating it as a moment of absolute spirit, is fully in line with the dual character of his system. His view however implies a conclusion he would never have drawn himself, namely that the content of art—its absolute aspect, according to Hegel—is identical with the dimension of life and death. It is conceivable that content might precisely be art's mortality. Music is a case in point. A latecomer among the arts, great music may well turn out to be an art form that was possible only during a limited period of human history. The revolt of art which programmatically defined itself in terms of a new stance towards the objective historical world has become a revolt against art. Whether art will survive these developments is anybody's guess. Nobody however should ignore the fact that for once reactionary cultural pessimism and critical theory of culture see eye to eye on the following proposition: art may as Hegel speculated it would, soon

enter the age of its demise. A century ago Rimbaud's dictum intuitively anticipated the history of modern art; later his silence and his being co-opted on becoming an employee anticipated the decline of art.[10]

Of course the notion of the historicity and the consequent decline, let alone the mortality, of authentic high art remains controversial, no matter how much critical theory and its mirror image, reactionary "cultural pessimism" are persuaded that the epoch of "great" art has finally ended. Authentic art is commonly taken as a signifier of some inherent aesthetic sense which is, precisely, not subject to the vicissitudes of history, whether in its political and economic dimensions or, indeed, in the context of the wider definition of culture. For critics and philosophers, as much as the general public, art is a special type of human activity which, unlike science, technology, and commerce, and especially craft, with which it is often compared, reminds us of the distance we have traveled since our collective childhood. We like to think that, even if there is reason for despair about nearly every other aspect of human endeavor, art is the last viable gatekeeper against barbarism.

"What has already died are not only aesthetic forms but also many substantive motifs," among them "the literature of adultery" which depended upon the rebellion against Victorian morality.[11] However, says Adorno, the "dissolution of the bourgeois nuclear family and the loosening up of monogamy" has deprived literature of one of its characteristic themes. Here, Adorno echoes Marcuse's more famous paradoxical phrase, "repressive desublimation," a category that signifies the coming of age of sex, owing to the advent of material plenty.[12] But even if capitalism can deliver the material conditions for abandoning some features of conventional morality, it can only tolerate sex without happiness. In Marcuse's conception, advanced industrial societies, armed with technology, not the least of which are contraceptives, can offer a version of sexual pleasure in the image of the surfeit of commodities that litter the human landscape to soothe the bruised human soul. But material plenty, easily available contraception, and relief from psychic guilt are not sufficient conditions for romantic love, nor indeed, the formation and maintenance of a community of autonomous individuals.

The end of art parallels the death of the Subject and, even more precisely, the eclipse of the individual in societies of technological domination. For subjects are formed and can exist only on condition of the separation of the private sphere from the public sphere. The

realm of the private, in its classical formulation, consists in relationships found in the family and friendships that are, relatively speaking, autonomous and beyond the control of state authority. It is here that genuine individuality is cultivated, chiefly through the rebellion of the child against parental authority, and the development of alternative relationships of equality that may be found only among peers. These peer relationships provide support to the individual for the rebellion which, at least among sections of the middle class, may also foment a nonconformist intellectual community. The public sphere is constituted by individuals who congregate, either face-to-face or by writing, to discuss and decide upon their common concerns. But the existence of civil society depends, crucially, on the vitality of the private sphere. And in the bourgeois epoch, the "motifs" of great art were those that exemplified the conflict between "private" desire and public constraint. However, in a totally administered society, where public and private have been collapsed, normative surveillance institutionalized, and the individual otherwise subsumed under a "democratic" state which nevertheless possesses strong authoritarian features, technology (or technoscience), including organization and bureaucracy, becomes the sole authority.[13] Advanced, computer-based technologies can even simulate experience, including sex, and permeate every nook and cranny of social life. Social interaction is unthinkable without technological mediation. In these processes, the individual withers in proportion as she is unable to distance herself from the givens of the social world. Every act of independence from approved norms is labelled pathology. At the same time as the pace of life quickens, memory is obliterated, so that the past is recalled only in the form of nostalgia.

Perhaps the significance of a work of art may be measured by whether or not it is worthy of censorship by established authorities. The recent effort of a US prosecutor to ban Robert Mapplethorpe's sexually charged photographs from being shown in a Cincinnati museum revealed the limits of tolerance in democratic society. Although a jury found for the defendant, what is important is that the government could bring a suit with some expectation of success. Similarly, under the Bush presidency, the National Endowment for the Arts (NEH) refused grants to dissident performance artists, notably Karen Finley, despite favorable peer reviews. And despite the apparent end of the political ascendancy of the most conservative, national, political regime

in recent memory, there is no sign (yet) that its ideological force has lost momentum.

We can observe what one can hope is only an aftershock of the much-heralded "end" of the Cold War in the treatment of the sharp disputes that disrupted Russian politics after the breakup of the Soviet Union in 1991. The mainstream and the "alternative" electronic media and the daily press have taken the collapse of the Soviet Union and Communist governments in Eastern Europe to mean that since presumably the Cold War has ended, there is no reason to give voice to dissent from the ideological pillars of capitalism. There is virtually no public challenge to the concept of the free market in labor and goods, the notion that liberal democratic government is the best of all possible worlds, or the view that the austerity policies which have forced living standards down for at least twenty years are absolutely necessary for achieving economic well-being.

For example, in reporting on the power struggle that surfaced a few months after Boris Yeltsin deposed the last Soviet president, Mikhail Gorbachev, the US and British press and television have chosen to frame the issues as a battle between "reformers" and "conservatives" or "hardliners." In turn, the strong suggestion is that the conservatives are nearly identical with the remnant of communist functionaries who, it is intimated, dominate the Parliament, and were last elected during the waning years of Soviet rule. Of course, even in the mainstream news media, some reporters and commentators mention the fact that opposition to Yeltsin spans a much broader spectrum of opinion and ideological positions than the Communists. But news photographs of anti-Yeltsin demonstrations are almost invariably of older people carrying pictures of Stalin and Lenin. The key issues—whether state enterprises will be sold off to private investors and subsidies and price controls entirely removed—seem to override all other considerations. So in March 1993, when President Yeltsin declared Parliament suspended, and aggressively asserted his office as the only legitimate political power pending a plebiscite to vote confidence in his presidency, there was no whisper either in the media or by the American president that this could have possibly been a violation of democratic process. Neither institution missed a beat in their wholehearted support of his act. Nor did the treatment of the Russian crisis alter when, in the face of considerable internal opposition, Yeltsin reversed himself by issuing the

text of his declaration *without the key provision* about the imposition of presidential rule.

And it is surely no surprise that, in the perspective of the coming to power of a Democratic administration which has promised to carry out the spirit of conservative economic policies more faithfully than its Republican predecessors, the *political* culture has become flat. Surely, absent even faint murmurings of dissent, the press has no warrant to pose itself as an outpost of a nonexistent opposition. This is especially true in a period where the press and television have become, perhaps, the pillars of state culture. While there may be room for a small alternative, if not oppositional, press, there is much less room within the dominant media for a genuine clash of views when the spokespersons for conservative to right-wing organizations, such as the American Enterprise Institute and the Heritage Foundation, maintain their status as mainstream sages.

This somewhat depressing state of affairs may be attributable to what used to be called a "cultural lag" by early twentieth-century sociology. A backlash against open-throated free-market ideology, austerity, and other hallmarks of conservatism may indeed develop. Surely the cultural policies of the Clinton administration, especially his support of abortion rights, seem to prefigure a resumption of some of the social conditions necessary for freedom and diversity. In fact, away from the corridors of power—in universities and colleges, on the streets, and in a plurality of cultural forms, especially music and genre fiction—the culture war rages, and so far the results are not so bad.

But if experience is transformed into information, it is not democratically distributed. As is well known, the clientele for the vast quantity of information that is still available is as segmented as the larger social structure. News media are hierarchically organized according to the requirements of its clientele. While all news is subject to an intellectual labor process—in Mark Fishman's felicitous phrase, is "manufactured"—the extent of its processing depends crucially on how the news is constructed and what readers and viewers "need to know." Fishman's *Manufacturing News,* a study of the manufacture of a New York crime wave in the early 1970s by news organizations is a powerful demonstration of the thesis that the media make the news, even as they present themselves as its vessels.

And of course the discursive style of news reports manifests the character of the intended audience. The majority of US adults receive

nearly all of their world, national, and local news from television. From the less than fifty percent who read some kind of newspaper or news-magazine, the tabloids have the largest readership. In these publications murder and mayhem, still the stuff of the urban and suburban imagination, dominate the first dozen pages, and, besides reports on official corruption and local political news, international and national affairs are relegated to the deep recesses of the inside pages.

The combined daily circulation of the three leading national news-papers of record (excluding *USA Today,* which is a national tabloid)—the *New York Times,* the *Wall Street Journal,* the *Washington Post*—is about three and half million. But the relatively small readership belies the enormous influence wielded by these publications on the state, including culture. Politicians, and top corporate executives, as well as the preponderance of "opinion leaders" in virtually every walk of life, including all sectors of the arts, are counted among regular readers. Equally important, radio and television producers, news writers, and cultural critics ritually consult these newspapers to determine their lead *political stories,* to acquire the discourse and vocabulary of breaking news, and to decide what's hot and what's not in the arts. Journalists employed by these newspapers provide commentary for television and radio news and talk shows; to work for one of these papers is enough to certify a reporter as a reliable "expert," and some of them, especially in the domain of electoral politics, are equivalent in stature to most academics who are similarly recruited by the electronic media.

Consistent with the advent of the consumer society, art is transformed into electronically mediated entertainment, and for Adorno, loses its capacity to illuminate the fundamental conflicts, not to say contradictions, between individual freedom and domination. In the light of these judgments, modernism may be understood as the protest against the social forces that undermine individuality. For Adorno's generation of critics, Kafka and then Beckett were the key figures who, formally and substantively, embodied the essential features of the new forms of the alienated human condition. In contrast to the great nine-teenth-century narratives of suppressed desire, in the "new" novel the individual's ability to realize desire is at bay:

Surely a writer like Kafka does anything but appeal to our faculty of desire. Prose writings such as *Metamorphosis* and *Penal Colony* on the contrary, seem to call forth in us responses like real anxiety, a violent drawing back

and an almost complete revulsion. They seem to be the opposite of desire. Yet these phenomena of psychic defence and rejection have more in common with desire than the old Kantian disinterestedness. Kafka and the literature that followed his example have swept away the notion of disinterestedness.[14]

From which follows Adorno's sharp rebuke to the concept of "aesthetic enjoyment" as a:

bad compromise between the social essence of art and the critical tendencies inherent in it. Underlying this compromise is a bourgeois mentality which, after sternly noting how useless art is for the business of self-preservation, grudgingly concedes to art a place in society, provided it offers a kind of use value modelled on the phenomenon of sensuous pleasure.[15]

Yet Adorno is not quite prepared to ditch the idea of beauty, chiefly because of its relation to *form*. For Adorno, form is art's way of pointing to a praxis beyond labor. At its best art displays, through the objectification of subjectivity, the possibility of work that does not crucially depend on the commodity-form. Of course, since, as Lukács tells us, the commodity-form sweeps all opposition before its ineluctable dissemination, art cannot, intentions notwithstanding, remain exempt from the market. Nor can cultural production escape commodification; even if unintended, the work embodies something of its exchange value. Nonetheless, according to Adorno, true art is distinguished by a "plus." The plus consists in art's capacity, through mimesis, to transcend its conditions of production to point toward nature. Of course, art is not a mere copy of nature; but neither is the imagination a purely spontaneous invention of mind. Rather, in the face of the utter triumph of postmodernity, Adorno's last best hope for art's subversion of the prevailing order is the idea of beauty as humankind's reconciliation with its own (natural) history, of which, at least in the nineteenth-century, sexuality was the signifier.[16]

Adorno, together with Ernst Bloch, is among the last of the philosophers for whom art and literature, as quintessential *aesthetic* forms, are also supremely political to the extent they challenge the givens of the social world. Thus the family romance, deeply embedded in culture, becomes, for Kafka, a nightmare. Kafka's horrific narrative uncovers the grisly side of everyday life, explodes the categories of bourgeois

complacency, and remains, despite its inevitable commodification, the embodiment of hope that beyond the tangled lattices of bureaucratic power over the individual there is something else. Despite, or rather because of, their marginalization, writers such as Kafka, Proust, and Musil provide the "something missing" from a social world in which the technological imperative seems to overwhelm the imagination.[17] Art provides, in Bloch's words, the possibilities without which "reality . . . is not complete." True art counters the "technological coldness" of which the lifeless products of the machine and the bleak new housing districts are visible examples.[18] In his essay, "Art and Utopia," Bloch takes the argument a step further: while critical theory counterposes art to technology, and thereby cedes to the latter an irreversible, even if problematic, existence, Bloch demands not the aestheticization of technology, for example, the development of a warm machine in which technology fuses with art, but a technology that serves purely functional ends in the service of humankind. According to Bloch, there can be no confusion of art and technology, but neither should technology remain cold. Drawing a distinction between the present, capitalist, economic framework and the realm of freedom toward which art and socialist politics strives, he envisions "A totally different technology, not for profit but humanistic" which "would have to come, and a completely different technology for purely functional purposes without any of the junk of commodity production and mechanical substitutes of the earlier artistic goods would have to be invented."[19]

Among the most interesting and contemporarily relevant aspects of Bloch's theory of art is the notion of the utopian function of art, music, and literature. Utopian thought, which is, in Bloch's philosophy, an anticipation of things to come rather than a series of ethical statements about what ought to be, gained a bad name in the twentieth-century because it is identified with the tragic history of really existing socialism. Communism presented itself on the one side as the inevitable outcome of capitalist contradictions; but it was also inculcated with a heavy dose of voluntarism, most saliently in its notorious doctrine that socialism would create the "new man." This project of human psychological and pedagogical reconstruction inevitably had a dark side: Marxism was transformed into a system of religious belief; Soviet ideology after Lenin contained a substantial millenarian but also paranoid dimension that was employed to justify stifling dissent, but perhaps equally egregiously, helped isolate the state from the rest of the world.

And despite its Western European successes in achieving a massive welfare state, and more impressively governmental power, "democratic" socialism appears to have entered permanent crises.

Bloch, whose complex relationship with Communism finally led him to reject the neo-Stalinism of the East German government without simultaneously abandoning Marxism, argues for retaining the utopian as a necessary function of any possible social and historical transformation. Bloch's crucial contention is that, without a conscious idea of the "not-yet," we inevitably become mired in, even committed to, existing conditions. But the not-yet is no geographically isolated space like Thomas More's Island Utopia. Neither is it merely unfulfilled, generalized desire. Nor is it confined to a *determinate* negation of the present state of affairs, as Adorno, following Hegel and Marx, would have it. Utopia is concealed in the "not-yet conscious," objective tendencies of a given era, and is present in both art and science. Bloch insists on the adjective "objective" in order to combat the tendency to make hope a category of feeling, thereby relegating hope to the realm of arbitrariness.

To address the popular confusion between utopia and idle wish, Bloch is at pains to situate his conception in the "paradox of the 'concrete' utopia."[20] The anticipation by science and Art of the "something missing" in the fact-mired present is not to be conflated with fantasy; instead, it can be found, for example, in Hegel's imaginative category of *quality* in nature.[21] Whereas Cartesian and Kantian philosophy, following seventeenth-century science's mechanization and quantification of the world picture, situated quality in Mind, Hegel insists that quality as well as quantity are properties of nature. Similarly, Bloch wants to situate the concrete utopia in the conditions of the present, which, however, must be uncovered by philosophical investigation, even of art forms. Facticity parallels the reified object in Simmel's and Lukács's formulation; the given situation appears eternal. The task of theory and criticism is to read discourses and artworks for concealed tendencies that point toward a different future. Bloch and Adorno part ways from Lukács on the burning question of cultural theory of their time: whether modernism, even if it fails to *typify* the sociohistorical situation, nonetheless signifies the contradictions of social space/time. For if the European landscape following World War I witnessed, definitively, the death of the subject, any attempt to reproduce the great family drama that animated the era of what Benjamin called "high" capitalism, was

anachronistic. Rather, in Kafka's allegories, the horror of everyday existence, especially the sense of exile that pervades this work, animates the imagination. Adorno ascribes the power of Kafka's writing to his "negative sense of reality" and his ability to obliterate the boundaries between fiction, fantasy, and reality so that representation itself perishes.[22] For Bloch, Kafka joins other modernists such as Joyce and Musil in exploding the unified sense of time. While, in Benjamin's terms, Kafka "postpones the future" it is the nonsynchrony in Kafka's work which, for Bloch, constitutes its radical content:

> Surrealism had popular sources in the silent film, which was in fact itself often the stuff of dreams; but the echo is esoteric which is thrown back to its Freudianisms, from today's hollow space, and in which it principally finds its objects. Most definitely esoteric are symbols which no longer cross over into an overworld, but which incorporate archaic-utopian presentiments merged together into the porosities of the upper middle-class world. Quite close to this symbolic probation, also this-worldliness stands the silent, great phenomenon of *Kafka,* here a submerged or other world up until now found in the life of this world its uncanny return. A submerged world: it reflects old prohibitions, laws and order-demons in the ground water of pro-Israelite sins and dreams, as this water advances again in the decay. An other world up till now: it orbits in Kafka's novels. . . . Seldom have anxiety and matters of piety been drawn closer together, seldom has house security been more ransacked, more complicated. . . .[23]

Thus, in contrast to virtually all previous utopian thought, in which the future is anticipated in the form of an alternative *system* separated in space from the here and now, Bloch rummages literature, art, music, and the daily newspapers to uncover their utopian content. Kafka's invocation of the underground dreamworld, with its anxieties of desire, contrasts sharply with the overworld of hollow urban space, in which technology and its companion bureaucracy dominate everyday life. As for anarchist and libertarian thinkers, Bloch clearly names *piety,* here identified with "house security," that is, the absolute necessity in this hollow space to control the population, even dam up the dreamworld, as the enemy of the future. Although Benjamin is right that Kafka postpones the future, it reappears in the archaic recesses of the dream work and, as with the Marranos of Spinoza's time, because the individual is forced to live a perpetual double life, the utopian dimension

takes the underground form of fantasy. In this double life, body and mind must be segregated. But unlike the bourgeois account of alienation, according to which the *mind* may retain its autonomy in the wake of the brutalization and industrialization of the body, in Kafka the body "slips away" (Benjamin), returns to its archaic, natural incarnation, while the mind gives itself over to the routines of labor and leisure.[24] Contrary to common sense and philosophical idealism, the beautiful soul finds refuge in its underground beastly existence, in the despised body.

Whereas modernist critics such as Michael Fried revile the tendencies in contemporary art toward theatricality, Bloch praises the theatre from Shakespeare to the present as the "paradigmatic" space for the presentation of the "sensual reality of experience"—the body—in the face of the indirect speech and feeling offered by other, technologically mediated, art forms. Here, the utopian function of drama is to offer a window to "experience" in the face of the triumph of information in virtually all other aspects of everyday life. And herein lies the break between Bloch and his friend, Adorno. At the end of the day, Adorno must make the specifically aesthetic judgment that an artist's work corresponds to a series of criteria that, *a priori,* exclude so-called degraded mass cultural forms such as genre fiction, movies, television, and popular music. For example, in the course of his critique of Benjamin's theory of the aura, Adorno argues that the commercial film, without an exception that is anywhere exemplified, does not qualify as an art form capable of pointing to the determinate negation of the existing order because:

[it] is a creation that, in its production and reproduction, contradicts the here and now, aiming straightaway at an illusory reality. This tendency is also harmful to individually produced art as soon as the latter tries to preserve aura by concocting "something special" and by coming to the aid of an ideology that relishes the best products of individuation as though there were still such products in a bureaucratized world.[25]

Although he discerns "discrepancies" between the mass cultural aspects of film and its "craft-like" traditions, there is no place where Adorno accords to any body of film art the attention he devotes to Kafka, Schönberg, and Beethoven, or even "minor" composers such as

Offenbach (Perhaps with the partial exception of Poe, a popular writer whom Adorno rightfully credits as a powerful influence on Baudelaire and a precursor of modernism, but makes no effort to assess the nature of this influence.) Likewise, there is in Adorno's writing no recognition of Poe's centrality to the development of the detective novel. Plainly, critical theory sees almost no point in a close reading of genre fiction, since it is unable to overcome the burden of recognizing that all of them are sources of vast quantities of trash.

But from Bloch and Benjamin to Jacques Lacan, Fredric Jameson, and Gilles Deleuze there are strong, but different, reasons in these writers, for paying attention to genre fiction, but especially detective and science fiction narratives. In none of these readings is the point to determine whether they meet an aesthetic criterion to be called "art." Instead, as in Bloch's essay "A Philosophical View of the Detective Novel,"[26] the reading is undertaken to illuminate the crisis of modernity. Although he situates the development of the genre in Poe's *Murder in Rue Morgue,* Bloch does not engage in reproducing a myth of origin; rather he shows the homology between the fundamental premises of the detective novel and many of the central preoccupations of modern philosophy, psychoanalysis, and social thought: good and evil, the uncanny, oedipal relationships, alienation, the impossibility of representation, appearance and essence, and "bourgeois pandemonium"—the anxiety pervading the upper reaches of society that everything is out of control. From a not-so-different point of view, Deleuze and Guattari point to the detective novel as a literary genre where temporality structures the entire narrative.

Lacan finds in Poe's story of the purloined letter the "agency" of language and the unconscious in everyday life.[27] This interpretation confirms and extends Freud's own practice of taking myths and other literary texts as *case studies* of the working of the unconscious, "fiction" that illuminates and extends psychoanalytic theory. Lacan's use of Poe's story belies the commonsense distinction between fact and fiction in two ways: literature is taken as knowledge, not representation; and has empirical, historical status. Jameson reads Raymond Chandler's work, and its cinematographic transmutation by Hitchcock, as disassemblage of everyday life by indirection ("out of the corner of his eye").[28] Although he shifts the scene to the problems associated with urbanism— both Chandler and Hammett situate their narratives in newly emergent

West Coast cities—Jameson's reading parallels that of Bloch and Lacan: we read detective stories to *detect* what other forms ellide. Bloch finds that as ordinary a writer as Agatha Christie creates Hercule Poirot, who is able to provide knowledge of the *micrological dimension* and, as opposed to Sherlock Holmes's late-nineteenth-century scientistic methods of detection, recalls Bergsonian intuition that is able to see what induction can never reveal, the microreality in the midst of macroscopy.

These extra-aesthetic readings do not constitute a rejection of literature and other discourses that have the conventional tag of art form. The theoretical significance of the critical work on detective stories addresses not merely time-honored debates within criticism—high/low, the political in art—but also questions about knowledge: does literature qualify as social knowledge? Are narratives case studies in the ways of the unconscious? "it" (Groddeck's phrase; for Lacan, windows to the mysteries, the Freudian "thing").[29]

Adorno's extended lament for the death of Great Art should not obfuscate his own conviction that all art is politically implicated, even if, like Engels, he wasted little time with political art. Clearly, like Marcuse, in the context of technological domination, Adorno understood aesthetics as a kind of resistance to the barbarians, art is a protest against the velvet chains around our souls.

—III—

A quarter of a century after Adorno's magisterial oration at the funeral of Great Art, a very substantial group of cultural critics remains tied to the view that virtually all art is a commodified product of the culture industry. It is enough to utter the phrase "postmodernism," and there appears a spate of works which simultaneously decry, denounce, and otherwise expose the extent to which what is taken as authentic, popular culture can be shown to be hopelessly commodified. While only reactionary pessimists and perhaps the small core of authentic critical theorists would go so far as to dismiss the entire domain of popular cultural forms, such as jazz, rock 'n roll and genre fiction, as nothing more than mass-produced commodities of the culture industry, the theme of commodification suffuses a good deal of cultural criticism.

This is particularly evident in the celebrated debate about the work of Madonna, who has almost single-handedly elevated music video into a major cultural form. And there can be no doubt that her celebrity

occupies considerable cultural space, despite the fact that as a singer, ostensibly her métier, her work leaves much to be criticized. To begin with, it is not difficult to demonstrate that on every level except that of *style*, Madonna's music is unexciting. Her voice is ordinary, and the songs, with some exceptions, are uninspired. But her singing is quite beside the point; what elicits so much controversy is her theatricality, particularly her performance, which drips with provocative sexuality.

While many rock video performers work with explicit sexual signifiers, their representation of sexuality is more or less conventional for our time. That is, their identity is clearly hetero and, with the exception of Boy George, REM, kd lang, Michael Jackson and Madonna, and some others, unambiguously gendered. Moreover, the sexual images of MTV performers are fairly "clean," if by that term we mean they follow the rule that sexuality be suggestive but not explicit, and that the kinky be avoided at all costs.

Madonna is a performance artist who deploys pop music as a prop equivalent to that of the white rooms and long, cavernous corridors through which she runs, slinks, and crawls. Her singing is a vehicle for something else going on; for it is the plus or the surplus in her performance that elicits the excitement about Madonna. What is perhaps most outrageous about her performances is their invocation of at least three sexual prohibitions: autoeroticism, sadomasochism, and bisexuality. Unlike Jackson, she does not affect androgyny, but neither is her femininity completely gendered or without contradictions. In a single video she mocks the sex kitten and, in her flaunted tits and ass, the stereotypical face of sex work. Yet she exudes male and feminist power over her sexual partners and, as Lynn Chancer has argued,[30] is empowering to her women viewers by appearing to totally possess her image. To the degree that her presentation invites the voyeur, she cannot entirely elude the male gaze, even when proffered by women. Yet to point this out completely elides her flagrant irony in the modes of display by which she invites the female gaze. She is attractive to both "men" and to "women" because she produces a crisis of conventionally gendered sexual identity. Here her control over the presentation of the body makes plain that she is not inviting male possession, but is inviting the women in her audience to take possession of their own sexuality.

The core of Madonna's performance style is to engage the politics of the body. She explores her own orifices as well as those of her sexual partners; where *touch* is clearly occluded from traditional video per-

formance, except in the acceptable convention of kissing, Madonna's strategic deployment of touch explodes the code, and invokes sexual pandemonium. This unpredictability engenders considerable viewer anxiety. It is not that she extracts desire, metaphysical or sensual, from her audience. Rather, she "uncovers" desire to display its embarrassments to a public which, despite the "loosening of monogamy" and other desublimated displacements, is capable of squirming because trapped in conventional sexual morality. If she gets us to squirm, whether this maneuver is a manipulation in the service of "money" (and I have no doubt that some of it is), what remains to be explained is why it succeeds in achieving discomfit.

I want to argue that the controversy surrounding Madonna's music videos, just like the violent response to some of Mapplethorpe's photographs, is a barometer of the extent to which the public sphere remains deeply influenced by American pietism. For if Foucault is right to point out that sexual anxiety is not the result of its public repression, but on the contrary it seems most intense in moments when sex is everywhere, at the same time its profligate public face lacks a certain material intensity. In fact, the condition of its wide dissemination is that sex remain merely suggestive. Hollywood may have relaxed its moral code in the 1960s to accommodate the double bed, allowed glimpses, in the seventies and eighties, of nudity, and even permitted filmmakers to simulate, suggest, and otherwise connote copulation. But Hollywood sex is almost invariably heterosexual, gendered, and sanitized; with almost no exceptions homoerotic and autoerotic love remain outside acceptable representation.[31] On the other hand, the heat generated by some of Madonna's videos indicates that the pietism James Joyce encountered more than seventy years ago is alive and well: the rule remains: do what you will in specially designated spaces for 'that kind of thing' but at all costs, do not bring the multiplicity of sexual expression out into the open.[32]

In sum, the decline of great literature may have accompanied the erosion of the most virulent forms of sexual repression and the declining significance of the oedipal triangle as a formative trope. Yet at least in the United States, the thesis of repressive desublimation may have been overstated. To paraphrase Adorno, critical theory's observation concerning sexuality "may have applied only in a limited time in human history." Concomitant with the reintroduction of scarcity in Western

economy and culture, we have seen the reimposition of pillars of conventional sexual morality, such as monogamy and a fierce and *ideologically* resuscitated, bourgeois, nuclear family continuance. Runaway divorce rates, adultery, sex work of all sorts have shown no signs of abating, and, contrary to Foucault's generally well-conceived insight that treatment of homosexuality has passed from a legal problem to a question of pathology, we are witnessing the return of homosexuality to the legal domain.

Perhaps it is a case of a certain discourse signifying in its death throes, the inevitable counterrevolution. We might interpret political betrayals such as a Democratic president retreating on a pledge to reverse the military's ban on gays and lesbians as a temporary blind sight of a frightened politician; and everything else forges ahead. Or we have been lulled by the return of the ideology of progress, in which case, art may return to its old stand at the subversive margin. Maybe so, but it won't be "great" art.

NOTES

1. It may be objected that this formulation of the death of classical music could have applied in the 1920s, when a National Bureau was created to promote classical music in the face of the rise of radio, film, and records that had a major impact on the fate of high art. What distinguishes the present from the post-World War I period is that today large sections of the middle class, the traditional constituency for classical performances, have turned away from consuming such musical commodities as the symphony orchestra concert, much less the recital. We observe a new effort to revive the classical music audience in the 1980s and 1990s. This time, in the interest of novelty, the effort takes various odd forms: the reversion to playing the seventeenth- and eighteenth-century classics on "original" instruments; organizations such as the Kronos Quartet devoted to crossing over between classical and popular forms; the emergence of hip classical music stations, such as New York's WNYC-FM and WNCN-FM, that focus on "difference" as a crucial strategy to build their respective audiences.

2. Fredric Jameson, "Postmodernism or the Cultural Logic of Late Capitalism," *New Left Review* No. 146 (1984).

3. Max Horkheimer and Theodor Adorno, *Dialectic of the Enlightenment* (New York: Seabury Press, 1972).

4. For his conception of late capitalism, Jameson relies on Ernest Mandel, *Late Capitalism* (London: New Left Books, 1982).

5. John Urry and Scott Lash, *The End of Organized Capitalism* (Madison: University of Wisconsin Press, 1987).

6. Siegfried Kracauer, "The Mass Ornament," *New German Critique* No. 5 (Spring 1975); David Frisby, "Siegfried Kracauer: Exemplary Instances of Modernity," in *Fragments of Modernity* (Cambridge: MIT Press, 1986).

7. The term is Louis Althusser's. See, especially, Louis Althusser and Etienne Balibar, *Reading Capital* (London: New Left Books, 1970).

8. Paolo Carpanignano, Robin Andersen, Stanley Aronowitz, and William DiFazio, "Chatter in the Age of Electronic Reproduction," *Social Text* No. 25-26 (1990).

9. Fredric Jameson, "Walter Benjamin, or Nostalgia," in Fredric Jameson *Marxism and Form* (Princeton: Princeton University Press, 1972).

10. Theodor Adorno, *Aesthetic Theory* trans. C. Leonardt (London: Routledge and Kegan Paul, 1984), pp. 4–5.

11. Adorno, *Aesthetic Theory*, p. 5.

12. Herbert Marcuse, *Eros and Civilization: An Inquiry into Freud* (Boston: Beacon Press, 1955).

13. Horkheimer and Adorno, *Dialectic of the Enlightenment;* Herbert Marcuse, *One Dimensional Man* (Boston: Beacon Press, 1964).

14. Adorno, *Aesthetic Theory*, p. 18.

15. Ibid., p. 20.

16. For Adorno's discussion of this point, see Theodor Adorno, *Negative Dialectics* (New York: Seabury Press, 1974).

17. Ernst Bloch, "Something's Missing," in *The Utopian Function of Art and Literature* trans. Jack Zipes and Frank Mecklenberg (Cambridge: MIT Press, 1988).

18. Ernst Bloch, *The Utopian Function*, p..79.

19. Ibid., p. 80.

20. Ibid., p. 69.

21. Ibid., p. 14.

22. Adorno, *Aesthetic Theory*, p. 28.

23. Ernst Bloch, *Heritage of Our Times* trans. Neville and Stephen Plaice (Berkeley and Los Angeles: University of California Press, 1991), pp. 221–222.

24. Walter Benjamin, "Kafka," in *Illuminations* ed. Hannah Arendt (New York: Schocken Books, 1967).

25. Adorno, *Aesthetic Theory*, p. 66.

26. In Ernst Bloch, *The Utopian Function*.

27. Jacques Lacan, "The Agency of the Letter in the Unconscious," in *Ecrits* (New York: W. W. Norton, 1977).

28. Fredric Jameson, *Signatures of the Visible* (New York: Routledge, 1990) pp. 104–105.

29. Georg Groddeck, *The Book of the "IT";* (New York: New American Library 1962); Jacques Lacan, "The Freudian Thing," in *Ecrits*. Trans. by Alan Sheridan (New York: W.W. Norton, 1977).

30. Lynn Chancer, *Sadomasochism and Everyday Life* (New Brunswick: Rutgers University Press, 1992).

31. Michel Foucault, *History of Sexuality An Introduction* vol. 1 (New York: Vintage Books, 1980) chap. 1.

32. The film "The Crying Game" is only a partial exception to this rule. Here, the theme of gay love is promulgated, but a heterosexual woman became the enemy.

I

AGAINST MODERNIST CULTURAL THEORY

2

SO WHAT'S NEW?
THE POSTMODERN PARADOX

Modernism is dominant but dead. Its corpse inhabits the canon of establishment literature, adorns the walls of museums, the warehouses of art, and fills the concert halls of our major cities with increasingly familiar sounds. Jazz, once adopted by twentieth-century high-brow composers as America's authentic folk music, is now proclaimed its only real "classical" music. Society has taken its polyphonic improvisations in stride. Even the harmolodics of Ornette Coleman and the angularity of Eric Dolphy are nibbling at the mainstream's heels.

In the early twentieth-century, art defended itself against the incursions of business society by declaring that it represented nothing but itself. Modernism's interiority and marginality were its salvation: the avant-garde acted as society's conscience, reminding us that com-

merce did not exhaust all of life. Finally, society caught up with art, and the avant-garde became one of the myths of which historical memory is made. In the abyss between modernism's victory over its Victorian realist detractors and the search for a new cultural paradigm that subverts the rationalization of practically everything in contemporary life, the critic rather than the artist has taken center stage. More to the point, the distinction between these former antagonists has virtually disappeared. We no longer speak of culture as the work of specialists; performance no longer looks up to writing or composing as the real creative work; visual artists are no longer silent. Laurie Anderson, Martha Rosler, David and Eleanor Antin speak their art as well as show it.

The Anti-Aesthetic[1] is a pioneering attempt to establish a "postmodernism of resistance" as the new cutting edge. In his preface, editor Hal Foster defines this type of postmodernism as "a counter-practice not only to the official culture of modernism," but also to the strain in postmodernism that defines anything new as inherently good. Oppositional postmodernism "seeks to question rather than exploit cultural codes," Foster says, "to explore rather than conceal social and political affiliations." The book contains essays written from a common ground that refuses distinctions between art and politics, high culture and pop culture, philosophy and criticism. Yet the writers Foster has chosen are by no means united; unintentionally, he has structured the book as a debate.

Although everyone agrees that modernism is in deep trouble after its "pyrrhic victory" in the cultural struggle, Fredric Jameson and Jean Baudrillard are not convinced that postmodernism has succeeded in providing more than parody and pastiche. Both argue that postmodernist practices are symptoms of our schizophrenic culture. Foster admits that, because these practices have not broken completely with the modernist tradition, they stand somewhere between the radically different and the old crap; but he retains a sense of urgency in promoting postmodernism. Jameson and Baudrillard, on the other hand, recognize that postmodernism signals a crisis in culture, the loss of its sense of self as a subject, the loss of mastery in the world.

Jameson argues that postmodernism is a symptom of our "inability to locate ourselves historically," to escape the prison house of the mind and confront external reality. Like a schizophrenic, the postmodernist artist and critic grasp only bits and pieces of the world, and try to make

sense of its fragmentation. For Jameson, postmodernism corresponds to the "deeper logic" of a new social system—call it consumer society or late capitalism. Experience has been transformed into information, but its meaning remains obscure. Though most writers in the book find hope in postmodernism's boundary-smashing, Baudrillard mourns the "implosion of the private and the public," of the personal and the political. He finds no solace in the "ecstasy of communication" that places us, mesmerized, in front of the television screen, lost in its pleasures and deprived of critical distance. Baudrillard's essay is a parody of Marcuse's one-dimensional society: the modern world has abolished all "secrets, spaces, scenes" and replaced them with the screen, the smooth surface upon which the entrails of our internal lives have been spilled.

With the exception of philosopher Jürgen Habermas, who is still holding out for an oppositional modernism, the other essayists are committed to producing a critical theory of oppositional postmodernism. Craig Owens, Rosalind Krauss, Douglas Crimp, Gregory Ulmer, and Kenneth Frampton are joined by Edward Said in declaring the subversive possibilities of postmodernism. Said proclaims the end of professionalism, particularly the academic ghetto to which literary criticism has been assigned. In their classic examples of postmodern criticism, Crimp and Krauss forcefully demonstrate that prevailing visual art forms have become monuments rather than living practices. Crimp portrays the museum as a graveyard, its ruins signifying the past; Krauss says middle-brow critics have manipulated the visual arts to "diminish newness" because they can no longer find pristine objects to tuck safely into tradition. Painters, sculptors, architects, and landscapers are no longer content to stay in their conventional compartments. Krauss shows that the division between philosophy and art is tenuous, however much conservatives wish to preserve their separation.

For critics like Hilton Kramer, postmodernism is villainous precisely because it has torn down the barriers that modernism so carefully constructed. Of course, neoconservatism needs no forum here. Except for a temporary break, during the sixties, it has maintained a virtual monopoly in the various worlds art is forced to inhabit. Edward Said, himself a product of established literary criticism, attempts to dispose of right-wing objections to postmodernism and does a credible if uninspiring job (you can take the critic out of the mainstream but you have a harder time taking the mainstream out of the critic). Said's

argument—that criticism should break out of academic modernism—is strangely old-fashioned, but justified by the survival of Hilton Kramer and his entourage. There's been a revival of representational painting in the eighties, a turn toward nostalgia in filmmaking and fiction, and a counterrevolution in criticism, led by writers such as Denis Donoghue, for whom the poem is a manifestation of the human spirit's resistance to the prevailing degradations of cultivated taste.

Despite the different perspectives from which left and conservative critics approach postmodernism and its critical buddy, poststructuralism, there is more convergence than either likes to admit. The theory of one-dimensionality was advanced by Marcuse and the Frankfurt school as a response to the passing of traditional culture. Marcuse's last book, a passionate defense of modernism, argues that in a world increasingly dominated by administration, art is the last subversive activity. For Marcuse, as much as for Habermas and Baudrillard, the problem was finding a point of resistance to consumer society, to the passivity of the spectator and the transformation of art into entertainment. The more technology dominates culture, the more civilization is imperiled: since the 1930s, intellectuals have been overpowered by a metaphor of the future as apocalypse, driving both left and right to search for a past organic society which, though mythic, preserves a glimmer of hope.

Modernism broke with realism at the turn of the century by facing the tragedy of society's fragmentation, rather than pretending that art could typify reality with a narrative or picture. Yet modernism yearned for the synthesis of art and life. So it invented symbolic, mythic, and other formal devices which were not obviously representational but which referred to the alienated human condition. The allegories of literary modernism supplemented the sensible world, they did not controvert it. The surrealists tried to "represent" the unconscious. Abstract expressionists "represented" art as an internal discourse. These movements thought themselves free of the limitations imposed by representation, but succeeded only in substituting their kind of universalism for a discredited one. Crass civilization put them in a ghetto, which merely strengthened their claim to represent the beautiful, now mythically ensconced as the last refuge of the truly human.

Art is not produced by the solitary singer, but by the interaction between performer, writer, producer, and audience. The gulf between the artist's creativity and the consumer's passivity gives rise to the

tyranny of style. "Taste" was a mask used by the modernist critic-czars to maintain their mastery over the art world. Kramer's predecessors, Dwight MacDonald and Clement Greenberg, were self-appointed keepers of the high cultural faith. Their implied slogan—"democracy in politics, aristocracy in art"—guided the cultural lives of the intellectual generation that emerged from World War II. Style was the signifier for the new, which by definition was consigned to the margins of the art worlds. Describing art as entertainment was the ultimate insult.

Andy Warhol and other pop artists broke with traditions when they placed ads in high art frames, and Tom Wolfe elevated pop criticism to an art form. As early as the sixties pop music critics were trying to develop a postmodernist aesthetic without benefit or detriment of fancy French theory. Artists and critics were calling attention to the arbitrariness of the boundary between high and pop culture—between "production," which modernist criticism privileged, and consumption, emblem of the new postmodernism. Through pop (art, music, criticism), we came to understand that consumer society was not, as Marcuse taught us, an unmitigated disaster, but a route to liberation from the productivist prison. The early postmodernist revolt disparaged the efficacy of taste by paying critical attention to commercially successful entertainments. With irony, but also seriousness, Robert Christgau wrote consumer guides to rock music. His variation on *Consumer Reports* ratings of washing machines slammed the elitism of high cultural criticism at the same time that it offered practical advice. Greil Marcus's *Mystery Train* and Simon Frith's *Sound Effects* refused to trivialize rock and roll; they claimed that this music of a rebellious generation expressed its deepest critique of prevailing cultural and political values.

Henry Mancini never bothered to make his way into the ranks of the eminent. Unlike André Previn, who beat a path from the movie studio to the symphony, Mancini stayed with flicks, introducing jazz into film scores at a time when the modernist "Americana" style initiated by Aaron Copland, Morton Gould, and Elmer Bernstein had grown stale. When Mancini led the London Symphony in a concert of movie music, the critics ignored him. Mancini, Erich Korngold, Bernard Herrmann, Max Steiner, and others working primarily or entirely for film constitute an outsiders' group. Their music tends to the pastiche: it is always performed to accompany images; and, as Mancini says, it's obliged to absorb new materials from the pop, rock, jazz, and classical

genres. No major film critic has regularly discussed film music and its relation to the form, and most classical music critics still prowl the concert halls bouncing against the pillars of tradition.

The postmodernists eschew modernism's nostalgia. Critics of postmodernism say it surrenders artistic standards by celebrating punk, praises the new for its own sake, and destroys reason itself. These philistines confuse postmodernist art and kitsch. Kitsch is not a pastiche of exhausted forms; it takes these forms seriously and imitates them without irony. Postmodernism is nothing if not ironic; its entire enterprise is to deconstruct the solemnity of high modernism, to show the sutures in its wounds. Yet the irony does not degenerate into cynicism; postmodernism takes up the Enlightenment's dream that art, politics, and morality can be released from their separate worlds and once more become part of everyday life. But it challenges the idea of a single art, and presents its politics as molecular, the alliance of otherwise disparate groups for specific and perhaps temporary goals. It blasts rules, but makes a series of anti-rules, which are rules all the same.

Gregory Ulmer's essay in *The Anti-Aesthetic* calls for an end to the distinction between critics and creative writers. For Ulmer, the notion of the artist who occupies a special place in the world has become obsolete; he wants to bring the collage "revolution" to criticism, and abolish the elegant reflective essay. Criticism would consist of rediscovering both the materials and subject matters of art; in effect, critics would produce a new work. For Ulmer, postmodernist art is exactly what criticism ought to be: "a kind of research, an exploration into the logic of materials," a science which explodes the difference between nature and culture. Unfortunately, Ulmer skates dangerously close to proposing that criticism should become a work of art. Though many have written about the need to cross boundaries between art and criticism, it seems to me that much of the talk remains pretty arty. Ulmer, whose writing is admirably clunky, falls into the old trap of seeing criticism as art rather than getting us out of the whole poetic mess. (I call this the Brechtian paradox. No matter how hard he tried to expunge sentimentality and breathless narratives that pulled at the heartstrings, Brecht never succeeded in making a truly didactic theater; at bottom he was a master of theatricality. The more his characters stepped out of the action to drive home a political or moral message, the more we became immersed in the drama. Brecht may have instructed us, but we also enjoyed his irony, one of the hallmarks of postmodernism.)

Craig Owens and Kenneth Frampton want to break completely with the old ideology of art as truth. Frampton opposes his principle of critical regionalism to the older universal of the Bauhaus. That once revolutionary innovation now seems, to Frampton and others, a regrettable move toward homogeneity, partly responsible for the destruction of community which is antithetical to functionalism. Frampton's critique of the conformist tendencies inherent in the abstractions of modernist architecture is a powerful reminder that all traditions are not bad because they are old. He wants to find an architecture that blends design with physical context, an architecture sensitive to the specific history of its people. In opposing technological uniformity, he has invented a postmodernism that conserves rather than overturns.

Owens flatly declares that postmodernism has a solution for the crisis of representation which does not smuggle the old crap through the back door. His "Discourse of Others" is a manifesto for outsiders: women cannot be represented by men any more than Blacks can be represented by whites, or artists by critics. His essay is the most explicitly political and also the boldest. The crisis of representation is, for him, the crisis of cultural authority. Rather than lament the passing of cultural arbiters, Owens welcomes the breakdown. The void has created new space for the "others" of Western culture, those who have been excluded. Now they are demanding self-representation, challenging in one stroke both the universal claims of art and Western patrimony.

Where Marxism and other modernisms tried to heal cultural fissures by inventing a master discourse, Owens declares war on mastery; no single theory or paradigm can encompass the whole of human experience. It is not a question of passively accepting the current state of affairs, or of making a virtue out of separatism and marginality; Owens proffers the dialectic of difference as our only hope of eventually attaining synthesis. When we approach the universal again, somewhere down the line, the silent will be heard, the invisible will be seen. This argument goes overboard when he equates male power with the triumph of the visual in Western culture. According to Owens, women's oppression is culturally constituted by the male gaze that represents them as "narcissistic perfect specimens of male desire." Feminists have long attacked the male penchant for objectifying women; Owens argues, following French feminist Luce Irigaray, that "the body loses its materiality" by being transformed into images. Images, modes of rep-

resentation of and by the dominant group, are tools of oppression. Those who are *imagined* are thereby deprived of control over their destiny to the extent that they accept these images as reflections of themselves.

Owens's mistake is to equate picture-making with domination and subordination. For even if Western culture has wrongly privileged vision in the service of what Heidegger calls the "laying hold and grasping" of others, this rule does not obtain when oppressed groups reappropriate representations. When women and Blacks employ conventional art forms, the effect is different from those male white visions subjected to Owens's analysis. The excluded can use image-making as a weapon for laying hold and grasping cultural apparatuses. Owens has forgotten one of the cardinal features of his own postmodernist criticism: placing old forms in new frameworks changes their significance. When women write long narrative novels that reveal to other women the details of everyday relations, they appropriate a traditional form to reveal secrets obscured by modernism's passionate devotion to abstraction. When Blacks create images of themselves by means of realist painting, they violate the white rule of Black invisibility. On the surface, Charles White's heroic, almost mannerist representations of the Black Mother seem conventional. Yet, when received in the Black community, they signify an alternate vision of beauty, a weapon of solidarity.

Owens's lapse demonstrates the difficulty of forging a consistent postmodernist program. All discourses, including art, are battlegrounds. The "others," for whom Owens refuses to speak, cannot afford to turn their backs on tradition until they have squeezed all the benefits from it. Even the women artists Owens extols as exemplars of the postmodernist project of merging art with politics are obliged to live in the art world Martha Rosler, Sherrie Levine, Louise Lawler, and Dara Birnbaum engage in metacommentary on traditional representations (Levine and Lawler entitle one of their pieces "a picture is no substitute for anything"). They are busy deconstructing the dominant visions of women as well as superimposing their own violations on these images.

Owens substitutes the universal of otherness for the older mastery which enforces hierarchy and domination. He has not dealt a deathblow to authority: he is still caught in the history of insiders and outsiders. The Brechtian paradox remains. Postmodernism cannot be an affirmative culture. It is condemned to subvert traditions, to recast their forms, to decenter and recombine art, politics, and theory in ways that

defile their pristine expression. Any new movement that wishes to force a shift in ways of seeing, feeling, and perceiving begins by questioning established power. Its primary activity is to delegitimate the norms and values of the prevailing order by showing that they are the ideology of a particular group, rather than objective "truth." *The Anti-Aesthetic* maintains that modernism is a mask for illegitimate authority because it cannot represent the new ways that have already transgressed its strictures. Sometimes the theorists oppose all authority, sometimes they invent authoritative new categories such as collage/montage to merge art and politics.

That unflappable critic of Western logic, Jacques Derrida, once admitted there was no escape from logic as an organizing principle of thought, even though it weighs on us like a heavy dinner. There is no escape from art as a separate sphere, or from storytelling—which is perhaps our most ineluctable representational mode. We might tell different stories from those of the canon, but our desire for closure is lodged too deeply in the wounded psyche to be eradicated by even the most powerful weapons of criticism. I greatly admire *The Anti-Aesthetic*'s feisty refusal to compromise: if postmodernism, in its new critical phase, has not wholly succeeded, part of the fault lies with the immensity of its aspirations. It wants nothing less than to break decisively with the official art world, which has every artist and writer in its grip. This book takes a long stride in providing space for heretics—those groping for different audiences, and for a sort of autonomy art hasn't enjoyed since Beethoven found a way to take his show on the road between commissions from Russian aristocrats to write string quartets.

NOTES

1. Hal Foster, ed., *The Anti-Aesthetic* (Seattle: Seattle Bay Press, 1983).

3

CRITIC AS STAR

American literary and cultural criticism is currently engaged in a hard
struggle for its legitimacy. The mainstream, which for nearly all the
years since World War II assumed that the decontextualized exami-
nation of the literary text was not only the starting point of criticism,
but the totality of the critical project as well, suffered significant setbacks
in the 1960s and early 1970s when a new generation of students and
scholars became influenced by Marxism, structuralism, and phenome-
nology. For the newer critic, the problem was not only that the critical
project that flowed from the work of John Crowe Ransom and the
fugitives group, Cleanth Brooks, or even the group that developed
around Northrop Frye failed to come to grips with social and political
reality as it unfolded in the 1960s, but also that these critics were hostile

to any effort to evoke sociohistorical considerations in the analysis of literature and other forms of cultural production. The new criticism was shown to have adopted an antitheoretical stance with respect to literature, even though some of its earlier proponents, especially Ransom, were quite aware of theoretical issues, particularly the epistemologies that inhered in the text. The new criticism was the literary expression of empiricism, the dominant philosophical tendency of the mid-twentieth-century. Its attempt to grasp the text through the senses, rather than reducing it to its historicity, was emphasized by its insistence that "the business of the literary critic is exclusively with an aesthetic criticism" which may become "as definitive" as the "new physics or the new logic" of scientific empiricism.[1] It was the exclusive preoccupation with the literary text as aesthetic object, excluding ideological considerations as a matter of method since these required going outside the text, that posed the most serious issues for the new generation after the 1950s. But the New Criticism's rigid formalism may have proved compatible with the general desire of critics to find ways to perform their task in the discourse of science. Thus, even if the new criticism *appeared* to eschew questions of theory by its insistence that the text yielded a special knowledge that was, in principle, not reducible to any other level of analysis, its canon was by no means innocent. As John Fekete has shown,[2] the adaptation of the romantic irrationality of the agrarians and the fugitives to the apparent techniques of new critical analysis was facilitated by their common ground: the effort to transmute all experience from the social and historical to the aesthetic. The view of art as a higher form of knowledge preserves the romantic, ideological character of the New Criticism within its apparently self-enclosed scientific shell.

In historical retrospect, it is not difficult to appreciate the reasons for the militant defense of the poem or the novel itself. Critics believed the 1930s were marked by the vulgar ideological and sociological reductionism of the varieties of Marxist criticism associated with the Stalin era.[3] On the other side, liberal literary commentary suffered from a reliance upon the dubious category of taste for its strength and, in the midst of the world economic crisis, subjectivism was no match for the "science" of Marxism, which seemed to have uncovered the secrets of the social world by its deft reductions. Edmund Wilson may be taken as the epitome of the virtues as well as the shortcomings of liberal criticism. Lacking an apparatus that offered scientific precision, Wilson

substituted stylistics and rhetoric for criticism. These weapons were powerfully wielded by the eminent stylist and could yield valuable insights when accompanied by his impeccable literary sensibility.[4] However, it could not provide a rigorous set of approaches to the text that were capable of extracting its essential significance. The New Critics sought a standard that could distinguish the work of art from kitsch. This quest was closely related to the rise of the culture industry and its spurious claims to artistic status. The advent of mass culture, which proved somewhat compatible to Marxist cultural politics in the 1930s and 1940s, offered a challenge to liberal critics to abandon their arbitrary high cultural taste as a measure and to substitute procedures whose validity rested on definite foundations.

The positivism of the New Critics enabled them to fragment a text into its component parts through the analytic method, as a step towards endowing it with signification that was to be found almost exclusively in its aesthetic dimension. Their hostility to other theoretical tendencies had ideological and aesthetic presuppositions that were transcended by historical events, particularly the breakup of Stalinist hegemony and the rise of the New Left in Western capitalist countries. By the mid-1960s it was clear that the unchallenged reign of the New Critics was over and that New Criticism would be obliged to make an alliance with phenomenological, psychoanalytic, or structuralist schools that were important in Europe, or face eclipse.

The choice of the structuralist and poststructuralist tendencies is not surprising given the difficulties posed by the others. By 1960, the leading figure of phenomenological literary studies, Jean Paul Sartre, had declared marxism can be *the* critical theory of capitalism and that the dialectical method, interpreted in the light of phenomenology to be sure, was the only possible approach to art, politics, and history. Moreover, the epistemology of Sartre and his predecessor, Husserl, was opposed to the scientism of positivist philosophy.[5] Husserl's *Crisis of European Sciences* had already become an antipositivist manifesto for a whole generation of critical theorists moving toward an alliance and merger with Marxism.

Although some important critics of the past several decades who adhered to the new critical school's insistence on the autonomy of the text, if not its methods, were attracted to psychoanalytic ideas, Freud's theory proved inhospitable to most of them. In the first place, psychoanalytic thinking required a theory of knowledge that went beyond

appearances, one that valorized the concept of a substructure whose specification was not available to the senses, except via symptomology. Freud constituted a type of critique of surfaces to reveal an underlying psychic structure that is morphologically independent of the external world but is linked to it. Second, Freud refused the explanation of artistic activity as autonomous. His insistence that both the production and the contents of art are linked to sublimated sexuality went outside the text for its categories of explanation. Finally, his own critique of artistic works traced them to problems of unconscious everyday life. His work, therefore, was hardly compatible with efforts to give new vigor to the idea of a high culture whose discourse was self-justifying.[6]

The domestication of structuralism was based on its unintended affinities with the New Criticism. Both are equally hostile to the notion of history as a determinant of social and artistic structure. Instead, history is only one of the terms in the form, a manner of speech compared to the language of human relations that is, relatively speaking, invariant in time. Or, as Lévi-Strauss has expressed it, language is the structural theme of human social life, while history may help to account for the variants.[7] While structural presuppositions are valuable for isolating and giving coherence to phenomena that are buried in the historical stream, the notion of much of its theory, that structures are relatively autonomous from the influence of human praxis and social time and must be examined on their own terms, fits neatly into the American context.

In France, literary, anthropological, economic, and sociological studies have been deeply influenced by the structuralist school. Some Marxists, such as Louis Althusser, Etienne Babibar, and Pierre Macherey, engaged themselves in an interrogation of Marxism from the structuralist side.[8] But it cannot be claimed that the two are fully compatible, any more than Marx and Freud can be neatly united into a single new paradigm. Structuralist cultural criticism reached the zenith of its influence by 1968, after which Jacques Derrida, Roland Barthes, and other leading figures undertook a critique of some of their own arguments.

It is a common error of contemporary criticism to aggregate post-1968 French philosophy, and social and cultural theory under the sign of "post-structuralism." Accordingly, Derrida, Foucault, Deleuze and the later work of Barthes lose their distinctiveness. While each of these writers has put a particular spin on Nietzsche's relentless critique of

kantian and hegelian philosophy, their respective projects are dissimilar in other ways. For example, if one goes beyond the canonical *Anti-Oedipus* (or even bothers to read it closely) it can be easily shown that, basing his work on Spinoza, Deleuze wants to clear the idealist, metaphysical elements from materialism; he aims at nothing less than a final overturning of Cartesianism, of which he regards Kant and, more surprisingly, Hegel as an unwitting legatee.

Although superficially parallel to this project, Derrida is chiefly a decipherer, his work is that of disassemblage. He is sceptical as much of any attempt at a "positive" philosophy as he is of negative dialectics. And, as John Racjman has convincingly shown, with his last major work *The History of Sexuality* Foucault's major contribution may prove to be as an philosopher and critic of ethics. And, consistent with the academic culture industry which includes and excludes ideas and their bearers on the basis of the fashion process, important writers such as Serge Moscovici have barely been noticed; we read Emannuel Levinas *through* Derrida and, with the exception of a single work, distinction, only some social scientists read Pierre Bourdieu and Alain Touraine.

This is not the place to make a thorough examination of Derrida, Foucault[9] and others who have proposed a philosophical and literary project that attempts to recover history by suspending structure. The importance of this tendency consists in its renewed attack on any metaphysical center, such as structure or history itself, which encapsulates the object into a concept that leaves out more than it captures. The poststructuralist interrogation of orthodox Marxism (exclusively of those critical schools that rely on the work of Lukács), which posits continuity in history and establishes a new hypostastized center around which all knowledge devolves, or its critique of the Kantian presuppositions of Lévi-Strauss, constitute valuable correctives to the incipient metaphysics that lurk in all recent orthodoxies. At the same time, Derrida and Foucault have rejected a dialectical view of history and social life insofar as they focus upon the *positivities* of social phenomena. The absence of a negative dialectic combined with their radical nominalism ushers metaphysics through the back door. These are the philosophers of the end of the subject. In their haste to jettison the subject-object split from their discourse, they open the way to a new positivism. The curious relation of this tendency, with its reliance upon Nietzsche's attack on philosophy, to the English-American tradition of empiricism may not appear palpable at first sight. Indeed, the discourse is quite

dissimilar. Yet the conjuncture appears at the level of the result: both wish to abolish the vagaries of perception, to show consciousness as a category of the *a priori* rather than a constituent of social reality. And herein lies the attraction of this difficult European philosophical archaeology for Americans who wish to place cultural sciences on the "firm foundations" of the methodologies inherited from the natural sciences.

–I–

The fundamental thesis of this chapter is that the critic, rather than the artist, has become the subject of the cultural sphere in the past two decades. The development of both the new theory in this country and the structuralist and poststructuralist schools in Europe coincides with a series of tendencies in the modern world that have produced changes in the relation of high culture, mass culture, and popular culture. Among the most important of these is the changing status of high culture in the light of the hegemonic character of the culture industry in Western countries.[10] It may be argued that high culture, as a conceptual frame for evaluating artistic discourse, depends almost entirely upon the social composition of the audience. That is, the artifact itself does not contain the distinction between art and commodity. Thus, the penetration of mass audience culture into all corners of the social world has generated a crisis for critics, artists, and those culture consumers concerned with the preservation of high art. The power of the culture industry is to absorb even the most opposed art forms and force the artist to produce work in the context of the requirements of the industry. Or alternatively, the artist remains ostensibly outside of it, but is still connected by means of her or his increasing compulsion to comment upon it in the work of art. Mass audience art may be a degraded type of high art or a colonized version of those popular expressions that become vulnerable to incorporation into the commodity forms. But the curiosity of the past several years is that so much "high art" consists of the adoption of the ironic expressive mode of discourse for the purpose of commenting upon mass culture. It is as if Laurence Sterne lives: the author once more engages in a narrative that both tells a story and comments upon the relation of the story to himself as well as to its discourse, the materials of the production of the text, and its degradation by the strange connection of the audience with the culture industry. Narrative as metacommentary is no longer immanent in the text. Now it dominates the surfaces, so that the dialectic of code/

decoding which, in the cultural division of labor, has been the province of the critic, now becomes the preoccupation of the author. Thomas Pynchon constructs a "fiction" that consists, principally, in metacommentaries upon American culture and recent political and technological history which are often intertwined so that the notion of "character" is absent. Culture itself, rather than the individual, becomes the object of literary discourse. The game is the impenetrability of the object world without ideological mediations—mediations that may be taken for the object because differentiation between the two is increasingly difficult.[11]

Mass culture and high art have lost their dichotomous existence and, in the process of their merging, difference has become increasingly arbitrary, depending in the last instance upon the weight of the criticism industry of which the author has become a member. The literary text becomes the raw material for the critic who, by deconstructing it, reduces it to a rubble whose signification is only attained by critical reconstruction.[12] As the artist becomes more reflexively objective, that is, recognizes the commodity character of her or his work, the delineation of the narrative codes as well as the ideological problematic immanent in the text occur simultaneously in the writing, so that the author takes herself as her own object. This self-critical mode is expressed well in Norman Mailer's self-characterization, "Advertisements for Myself." Here the author sees himself as object, as commodity, and, from within, transforms the novel into criticism and back again. When Mailer comments on a mass demonstration or, indeed, upon a cultural controversy such as feminism, it is clear that the event conforms not to some social or historical process, but to the canon of literary discourse. It is Mailer, not the siege of the Pentagon, who constitutes the subject of discourse. The event is the raw material out of which meaning will be produced. It is a series of signifiers without necessary referentiality. And yet the author cannot be subject, since he sees himself as "goods" rather than as artist. Thus "high" art emerges only as the preoccupation of the philistine. Much of that which we might call high art depends on its audience and its context—museums, reviews in little but highly regarded magazines, chamber music halls, and of course, the university—in short, the haunts of critics and "artist"-critics whose work merges. The critic's appraisal of the work of art can certainly propel it to stardom or assign it to obscurity. But there is little in the work of art that reveals its aesthetic value that can be distinguished from its exchange value. The

business of judgment, whose legitimacy depends upon its bureaucratic parameters and its market location, has become the cornerstone of high culture itself. In the bargain, the critic has become a mass cultural figure. Indirectly, the critic is a central investment counselor who predicts the value of the work of art in order to insure its transformation into exchange value. But here prediction may be a misnomer, since the critical act produces exchange value or allows the work of art to remain merely a use value. The result of this is that the critical work *both* produces value and becomes a work of art. The conjuncture means that the critic-author has become a star.

The emergence of the critic as the central figure in artistic production is linked in diverse ways to several cultural developments. Coincident with one another in the early twentieth-century, and all linked in one way or another with the emergence of mass audience culture, were the loss of character complexity in the arts, the elimination of subjectivity (the character's or the author's), the emergence of an intense literalism, and, perhaps predictably, the loss of an audience for high art. Among the disintegrations that these developments have brought with them, it is perhaps understandable that the persons offering explanations of them, or those appearing to do so, should assume as much or greater importance than the creators themselves.

Among the ubiquitous features of mass audience culture is the merging of forms into each other. The adaptation of novels into film has been characteristic since the 1920s, when film became a mass form. It should be stressed that often the narrative of the novel is little more than a substratum that is so bent out of shape as to be beyond recognition. Indeed, as George Bluestone[13] has shown, the transformation of novels into film tends to produce an entirely new phenomenon since little is left of the original narrative beyond the plot outlines. Bluestone's argument that the richness of characterization is lost in the transition, and that subtleties of social relations that can only be expressed in words and not in dialogue or pictures are blunted or disappear altogether, is certainly well taken. For the novel is not merely the telling of a story. It also expresses the standpoint of the writer towards his characters, their interaction, and of course, the cultural and social milieu of their existence. And novels are types of literary history insofar as they comment upon other novels. None of these aspects is adequately represented in film. Film has its own ontology, that is, at the most elementary level,

the novel evokes the imagination to generate mental images while the filmmaker works with visual images and tends to transform the imagination by a system of representation in which meaning must be produced by the juxtaposition of camera shots.[14] The film produces meaning by its reliance on the ability of the audience to interpret signs whose significance is entirely cultural. If the filmmaker wishes to introduce a character in terms of his work relations, even though the workplace may never be shown, he or she will dress the character in a way that will signify either specific occupational or class position. Clothing becomes a sign of social class. Of course this cultural code may change, as in recent years, for example, where jeans are no necessary sign of social class. The signified disappeared as jeans were adopted by young people of all social classes to signify their opposition to middle-class modes of dress, and connotatively, to the entire middle class structure. A filmmaker wishing to *show* the worker must now find a new sign that particularizes the individual in this way. Probably he will focus upon speech, or place the character in a context such as a working-class bar or family. In these instances the decor may signify the class background of the character. In any case, film produces meaning with visual images that are almost always metonymic, that is, the part is taken as the sign for the whole. Dress, furniture, the type of house, the stereotypical restricted language codes attributed to working-class people, may all be employed to drive home the point. In contrast, the novelist is able to avoid these stereotypes insofar as individuation is permitted by the plasticity of words and the interplay between characterization and the requirement that the audience participate through its imaginative faculties in the production of the narrative.

Despite these differences, successful novels have become the stock-in-trade of a large proportion of films. The choice of novels such as *All Quiet on the Western Front* or *War and Peace* confirms the well known analytic statement that the film as narrative draws its overt content from the transformed novel. That is to say that, even though film and novel are "overtly compatible and secretly hostile" to each other, the choice of widely read novels for film treatment insures the core of an audience, even among those who have not read the book, but know it by reputation. Beyond this, novels may be the best story lines available. On the surface, the homology between traditional realistic novels and films relates entirely to their mutual reliance upon romance, adventure, and sharp characterizations that are compatible with specific film ontology.

Film is best when it presents types rather than individuals, because it is an object medium whose capacity to avoid metonymy is sharply restricted by the requirement that visual rather than mental images constitute its mode of production. On the other side, film and its successor, television, attract a mass audience rather than the middle-class audiences which most novels rely on. As opposed to the narrow, middle-class reader for whom the bourgeois concept of subjectivity is entirely within her or his range of experience, the film goer may be essentially a person for whom interiority as an idea is problematic. Which, of course, is not to deny that working-class people think. But the idea of the individual is by no means secure as either ideology or a mode of social praxis, since family, work, and other social ties in the working class tend to be more objective, even more collective.

The star system has emerged in film in terms of the ability of the actor to represent a social type so that, no matter what the role, the audience perceives the *actor,* not the character portrayed. The actor as a sign of a social type may help to explain the essentially marginal significance of the story, since the audience is actually experiencing the film as an enactment of familiar social relations, even when the plot takes place under entirely exotic circumstances. Contrary to the commonly held belief that film is a form of escape, the late nineteenth and early twentieth-centuries saw the formation of typologies of bourgeois character which are reproduced in film: the driven entrepreneur who sacrifices self and family on the altar of commerce; the bourgeois woman caught in the contradiction between her assigned sex role and her desire to enter the man's world and at least escape the household; the romantic fighter for social justice of aristocratic background; the oppressed petit bourgeois professional doctor, lawyer, or student who enters the world with a clear conception of work and self and leaves it disillusioned; the adventurer whose self-interest corresponds to society's needs for either conquest or social order. These figures or character types provided the basis for successful adaptations of Dickens, the Brontes, Dreiser, Dostoyevski, and Tolstoy. The tragedy of the conflict between the individual and society was congealed in the images of specific actors who represented these types. Erroll Flynn and Clark Gable were quintessential adventurers, Leslie Howard the sensitive-turned-cynical professional, Barbara Stanwyck and Jennifer Jones the restless housewife who yearns for liberation from the kitchen, Cagney, Bogart, and Edward G. Robinson the demented criminal, John Garfield the criminal pro-

duced not by dementia but by society's inequality. The action of the film was built around the assumption that the character was sufficient to propel the narrative so that other functions could be subsumed under the large umbrella of the star's aura. It was not that the star, *per se,* made the movie, but that the star embodied those social character traits that were recognized, albeit unconsciously, as typical of our epoch. The homologies between the nineteenth-century realistic novel and the film of the 1930s and 1940s consisted in the efforts of individual persons to grapple with social constraints within parameters dictated by their social character. On the surface it was easy to effect a transformation of the novel as a form and the film. The tendency of the film to depict the outer shell of social character, left the core unrepresented. Unlike the novel, which was free to explore the interior dimension as well as the action, the film settled for stereotypes defined as much by its mode of representation—the visual image—as by the ideological predisposi-tions of the producers faced with a mass audience for whom interiority as a psychic category was at least problematic.

Gone With the Wind may be taken as the archetypical novel that signals a reversal of the relationship between novels and film. The book was among the first that was composed with an eye on film production. It provides stage directions, terse dialogue, contains almost no reflexivity of the characters and, what is important, draws stereotypes rather than complex character types which facilitates the writing of film scripts. Margaret Mitchell's novelscript became the model for future writers who have become aware of the cinematic potential of their writing. Since the beginning of World War II, the film has come to dominate the novel rather than the other way around. Now the novel is marked by both the visual as well as the literal, and has increasingly abandoned imaginative evocation.

Literalness, perhaps the dominant aspect of film, has come to oc-cupy, largely because of film's popularity, a hegemonic place in all the arts. Its chief feature is the abandonment of subjectivity in the work. In place of interiority, which presupposed the individual who was dis-tinguished from the objects outside of her- or himself by consciousness, even if socially determined or conditioned, literalism dissolves the sub-ject-object split into object relations. This development is not confined to literature. Michael Fried[15] has shown that contemporary visual arts are dominated by the same tendency. Fried's attack against minimal art consists in his claim that, in this genre, the object and the artist's

sensibility have become indistinguishable. But the object is the audien for which the art is intended. Literalist art, according to Fried, is not art at all because it is the work of *effects*, of a presence whose power resides in a situational aesthetic. Since the art object itself possesses no critical distance because it has eschewed reflexivity or interpretation, Fried argues that it has become a form of theatre, which is the enemy of the visual arts. Fried charges that minimal art excludes the possibility of artistic value or quality since it provides nothing but the object itself. Object art, in his view, becomes a manipulation. In Fried's view, theatre stands between the arts and their proper object because it represents the end of subjectivity, the reduction of sensibility to the facts of experience. The specific stamp that humans impose upon their external world by artistic interpretation has been suppressed in literal art in favor of the mere representation of objects as hypostatized things. While Fried suggests a moral as well as aesthetic judgment in his criticism of trends in contemporary art, we may adopt a less evangelical point of view. The exhaustion of artistic form is signaled by the advent of minimal or literalist art. Artists order the world in a specific way that is different from other modes of imaginative ordering. An ordering consists in a set of hierarchical relations in which certain perspectives are imposed upon objects by artistic perception so that some emerge as more significant than others. In short, a system of hierarchy is the way in which artists produce signification. What literalist art signifies is the abandonment of signification, since it takes the reified object as the totality of representation. In Salvador Dali's famous painting, *Portrait of My Wife*, the artist places himself at the head of a long table which looks down upon the tiny figure of his wife. Dali makes clear the relation between himself and his wife, the place she occupies in his life, the significance of his own ego in his relationships. Dali's wife is the object, not the subject of the painting. By using the traditional concept of perspective he is able to portray his feelings and his priorities. At the same time, the concept of the painting, linguistically expressed, is relatively harmonious with its representation. Dali has ordered his world so that he masters it through his mastery of the canvas. The painting is made as irony. The crucial absence may be the reverse of what its presence would signify. His wife may dominate the relationship, or Dali may have painted the picture to express his desire for domination. For Dali, those in his life are subordinate to his own needs and wishes. He has organized the world around his personality and

work. In contrast, much recent painting and sculpture regards the world as alien, incapable of being controlled. The idea of domination, even if only by the symbolic means of art, has been divested from modern art. Contemporary art lacks a sense of hierarchy, an ability to restore order out of the chaos of modern existence. Therefore, all that can be done with the world is to represent it without comment or, alternatively, to reduce it to its object status. Gone is the concept of interpretation, because the artist has lost the right to undertake this activity. In a kind of democratic ethos, the artist expresses the dominant social theme of alienation from both artistic and ethical traditions that once allowed the world to be assimilated in a coherent albeit on undemocratic way.[16]

For Ernest Hemingway, often noted by critics to be among our earliest "cinematographic" writers, knowledge has been reduced to the activity of the senses. The traditional nineteenth-century notions of character that motivated action are abandoned in favor of a conception of human activity as a set of object relations. As with minimal art, Hemingway's characters are theatrical. The entire narrative is contained in a set of scenes in which actors play their parts according to the stage directions of the author. Hemingway's situationalism, his literal, terse descriptions, even his first-person narrations which lack the narrator as a distinguishing figure, mark the merging of "literature" with mass culture.

It is not that Hemingway is actually a pulp fiction writer who, for some reason, the critics have mistaken for a modern master of the novel. Hemingway is the novelist of the twentieth-century precisely because he has extirpated the "extraneous" category of subjectivity. In his narratives, persons are never named until they are called by another, so that the reader is not accorded privileged status along with the narrator as a kind of *deus ex machina*. The narrator cannot be called "Ishmael" because he has become part of the scene, possessing no more control over the action than any of the characters. In Hemingway's novel, *To Have and To Have Not,* this epistemological perspective is shown by the swift changes in the narrative voice from scene to scene. Just as we come to expect that the story will be told in terms of the perceptions and interests of Harry Morgan, the chief protagonist, the author switches voice so that Morgan becomes objectified. The effect of these permutations is to make the situation, rather than the persons, the

subject of the action. The persons function as appendages to circumstances.

Hence Hemingway introduces Fate into the story, as the critical absence in the text. Since emotion is never the leading thread of the tale, since men do not make their own circumstances but the circumstances make the men, even "thought" becomes problematic. What is cinematographic in Hemingway is the occlusion of all that happens by surfaces. Even death causes no more than a momentary pause in the swift progress of the story to its conclusion. Everybody dies, hero and villain alike. But violence has been divested of its horror, since all the characters are antiheroes and are not capable of gripping the reader's sympathy.

Unlike the French novelist Robbe-Grillet, for whom the inanimate social relations among objects constitute the limit of description, Hemingway allows for the category of time. But time becomes TIME, so that it encloses all objects as well as human contacts. Time, the absolute, effects a subtle transformation of everything into space, because whatever happens really does not matter since it appears to be inscribed in stone from the beginning. Yet the "playing out" of Fate remains exciting, because the reader becomes engrossed in the game of hide and seek (as in Hemingway's short story, The Killers) or wonders exactly how Harry Morgan, who has been shown to be a remorseless killer himself, will finally meet his own ignominious end. Hemingway writes in the ironic mode, showing little if any sympathy for his characters, even those who are innocent of wrongdoing. The social world as perceived is peopled by deformed beings who harbor the illusion that they are able to control their own destiny, but finally recognize they are marionettes in the hands of the grand puppeteer.

The reduction of everything to a series of functions in Hemingway parallels the tendencies of modern art towards objecthood. Here the concept of meaning loses its force and is replaced by the concept of the game. Like his mentor, Gertrude Stein, Hemingway has stripped language of its elegance because human consciousness has been stripped of its autonomy. Since complexity is the game and business of intellectuals, and Hemingway writes of those who are possessed of everything save intellect, there is no need to reproduce the discourse of subjectivity. When Gertrude Stein wrote of a simple servant woman in her 1909 short story, The Good Anna, she sought to make the nar-

rative style fit the perception and thought modes of her leading character. The distinction between the narrator and Anna was barely preserved and, as the narrative progresses, the reader is struck by the artlessness of its telling. But the loss of distance between narrator and character deprives literature of its particularity as an art form and makes it the handmaiden of the senses. Literature after Stein has to become more visual, its subject matter ever more literal. Increasingly, questions that had occupied the novelists of the past century became less relevant. Such issues as morality and justice, which were the subject matters of the Victorian novel, now gave way to art as facticity.

It was not that "naturalism" gripped the novel. The absence of moral perspective and of subjectivity did not return the work of fiction to "nature" unmediated by consciousness and historical reflection. Rather, modern fiction experienced increasing difficulty separating itself from modern "scientific" perception. That is, the philosophical antipathy of the bourgeois mind toward "metaphysical" reflection, which scientists called "poetry" rather than true empirical knowledge, was reflected in the work of twentieth-century novelists. The only way to make sense of the world was to present it "as it is" rather than making commentaries upon it. Hemingway and Stein believed that their job was chiefly descriptive. In consequence, their writing is spare, "economical," careful to exclude any reflexivity that does not emanate from the characters themselves, and confines itself to modes of thought that were believed appropriate to their social position, that is all thought was about the object, not the self.

Since scientific myth states that all knowledge emanates from the senses, the dominant tendency of the modern novel was towards the visual and the situational. Its positivist bent was heralded as a literary revolution in comparison to the rather old-fashioned nineteenth-century fiction, whose discourse was clearly intended for limited audiences of educated persons. The neat convergence of the broadening of the reading audience with the simplification of literary style corresponded to the evolution of the cinema as the characteristic art form of our century. It was not that the novel was directly "influenced" by film, but that their epistemological foundations were similar. Both proceeded from the concept of the object-as-seen as the true source of knowledge. Both saw action rather than "talk" as the significant forms of communication. To the extent that dialogue was necessary, it had no value

in itself. It became a function of seeing, acting, reacting. The novelist became a camera, just as the film became a novel.

−II−

The merger of the novel with the film signals the merger of mass culture and high culture. It now becomes possible to see that the distinction between the two consists almost exclusively in their different audiences. That is, the concept of high culture has been subverted, not so much by the degradation of culture as a whole, but by the emergence of universal premises for all culture, high or low. These consist mainly in the refusal of modern society to recognize artistic knowledge as a privileged or even autonomous mode of knowing and its insistence that the scientific paradigm is universal. The triumph of "common sense" both in the arts and in science and technology produces the convergence of the two. At the same time, neither the scientist nor the artist possesses confidence, if they ever did, in their capacity to make sense of the world. "Making sense" is an activity that is opposed to "common sense." The former assumes that the activity of reason may impose coherence upon a world which otherwise is not comprehensible. The notion of common sense assumes that the world-as-seen is all there is to see. Understanding appears as totally arbitrary, if at all possible. While the artist may reveal the "shape" of things, the things themselves remain a mystery. Since interpretation has become suspect, what other way is there to portray reality than literally? Theatre provides the "game" that sustains interest in the work of art, because no other meaning can be conjured.

TV audiences and most film audiences consume the products of these industries as if they were playing a game. The rules include the understanding that nothing on the screen is endowed with inherent meaning, although the audience is permitted understanding. What we *understand* is the action as a series of functions that are related to the outcome of the narrative. The absence in the text is the concept of meaning itself that overcomes the specificity of the action. Even television and film criticism in America implicitly accept the invocation that the significance of the artifact consists in its ability to sustain putative audience interest. Either the "tale" is successful as entertainment, or it has failed as art.

In the preponderance of American criticism we can observe the

triumph of the reified object that excludes interpretation since its significance cannot be discerned by reference to any other reality. In much the same way, literary critics are prone to evaluate the work of art according to canons that can be confined to the immanence of the text. Pierre Macherey's notion that the text contains *both* what is expressed and what is absent is strictly eschewed on grounds not unlike the literary precepts of Hemingway. To admit of silences opens the way to a referent that lies beyond the text. Although the ideological, social, and historical referents may not be imposed upon the work of art but must be found in the contradictions expressed within it, the sociohistorical context of the work, its cultural codes, which include not only linguistic codes but sociolinguistic dimensions as well, must become part of the critical project. The perception of the world of art objects as self-contained itself expresses an ideological problematic: the relation of the artist to modern capitalist society, the increasingly precarious notion of the artist's autonomy from the marketplace, or from corporate and institutional life.

The problem of the autonomy of art both from the marketplace and from the ideological constraints demanded by political commitment has been partially responsible for the emergence of the artist as critic in the postwar era. At least these are the issues that have preoccupied many writers. I have already remarked that the novel itself has bifurcated into two distinct modes: by far the most prevalent tendency is towards the cinematographic, in which interiority is dissolved in the narrative and replaced by stereotypical representation. The other tendency is equally literal, but expresses critical intention: to abolish the dependence of the work of art on any but linguistic and narrative codes, that is, to achieve its autonomy from politics and from bourgeois canons of subjectivity, if not from the marketplace, which, it must be remembered, remains the crucial silence in all texts. It may be said that writers such as Thomas Pynchon attempt to achieve distance from the marketplace (a euphemism for the sociohistorical context within which the work is produced) by incorporating reality into a paranoid vision of a world enclosed by conspiracy. By recapitulating world history, writing about writing, recalling that the structures of technological domination destroy even the traces of hallucination and myth so that the merging between fact and fantasy defies the imagination to reach beyond the bizarre present, Pynchon resembles Borges in his efforts to reconstruct history as myth in order to control it. Pynchon may be considered as

the latest example of a writer who attempts to prevent his own strangulation by immersion in the strangeness of the world. That is, he tries to make the grotesque familiar by naming it and by surrendering to the hallucination of total domination.

But Robbe-Grillet articulates the stance of most twentieth-century writers who try to eliminate referentiality from the text by asserting the separation of art from politics. His crucial work, *For a New Novel*,[17] appeared in the 1950s, when rigid thought control was imposed upon writers by both Soviet and some Western bureaucratic capitalist states. In France, the powerful Communist Party demanded a form of commitment from the artist that often implied the debasement of art in the service of a political line.

In the mid-twentieth-century, politics had a specific meaning in relation to the arts that differed from that in earlier times. In contrast to the period after the decline of court patronage of the arts, the bourgeois revolutions "freed" the artist from such patronage and put him in the marketplace. In the late eighteenth-century, free of the constraints imposed by the feudal aristocracy, but free also of a steady income, artists found themselves subject to the vicissitudes of the marketplace. Under such circumstances, the ideology of artistic autonomy and its concomitant, the idea that the sources of cultural creation lay exclusively with the individual imagination of the artist, became a shield against the brutal indifference of the fickle audience that came to regard the arts as just another fashion alongside clothing.

Eighteenth- and nineteenth-century artists found themselves becoming more and more entrepreneurial, and their self-conception as craftspersons passed away. Mozart may be taken as the most important transitional figure among composers. Beginning his career as a court favorite, he was forced to consider abandonment of the artisanal mode of his musical production as the feudal world disintegrated throughout Europe in the late eighteenth-century. Toward the end of his life, Mozart was vainly seeking an audience outside the courts and the Church. It was Beethoven who made the break with the older forms of musicianship. Disdaining as much as possible the patronage of the aristocracy (although he was often commissioned by some of them to write chamber works), he chose to offer his music to larger, middle-class concert audiences. Thus, we find most of his symphonies and piano music composed for performances scheduled in concert halls rather than in courts. Consequently, in contrast to his more introspective chamber

works, such as the late quartets and some of the piano sonatas, the concerti and the symphonies possess theatricality, in that they are composed for effects and are suffused with decorative and dramatic touches. Beethoven may have been a willing servant of the marketplace, but many of his spiritual sons and daughters have found such a course impossible in the twentieth-century.

With the exception of performers who work under contract to a producer, hiring their services in much the same manner as Beethoven, and a few writers and visual artists able to make their living as independent artisans, most artists are enclosed in the grip of the arts bureaucracies. Rare is the composer, painter, or poet who can afford to offer her- or himself to the marketplace unaided by a foundation grant, university appointment, or even an old-fashioned patron. Unless the writer produces mass-audience fiction in the manner of Harold Robbins, Jacqueline Suzanne, Lawrence Sanders, or Arthur Hailey, the support by institutions seems inevitable. For example, Donald Barthelme, whose work commands much critical acclaim, but has only a small but dedicated audience, was obliged to accept a series of honorary university posts in order to make a living. Although the direct pressure of institutions may not be as onerous as that exerted by political parties or the state, the influence of bureaucracies on the arts can hardly be denied. The autonomy of the artist is a demand, not a reality. When the actual audience for a work of art becomes a large corporation such as the Public Broadcasting System, the results may improve the quality of television programming, but they cannot insure artistic freedom.

"Art for art's sake" is the slogan of the protesting artist whose autonomous space becomes ever narrower. The slogan expresses the desire of the artist for some degree of freedom from the process of commodification. Desire is transformed magically into a new reality in which autonomous space is finally won, namely, interiority. The world of events, of everyday existence, is denied in favor of the separate reality of artistic creation, a process that takes place, so to speak, outside the artist as an unconscious act. For many writers the social world becomes "appearance," in contrast to the interior artistic reality that is essence, where the creator lives for her- or himself. Yet language, the discourse of the writer, embodies this new reality so that even the private intention, the personal expression, contains a contradiction within itself. Words may take on a life of their own when juxtaposed in a way that is outside ordinary speech or the familiar context in which commu-

nication takes place; but the notion that coded speech gives to the text an autonomy that is not available to those who choose to represent the world of affairs and everyday life in the manner of realistic convention remains illusory. The writer produces a new reality with words; the filmmaker's art is never really representational in the sense of an imitation of life. Rather, the external world sneaks in by the back door. Insofar as narratives are paradigmatic of ideological problematics that remain unresolved in ordinary existence, the artist constructs a reality out of materials that are, in themselves, social productions. For both language (the structure of human communication) and speech (its cultural expression) are inescapably public. The notion of the autonomy of private existence is produced as a sociohistoric problematic; it appears when community has dissolved into society, a *civil* society in which the individual presents her- or himself as a commodity. That is, the concept of the individual is itself a social and historical phenomenon. Its appearance presupposes a definite historical development where collective forms of the production of art are apparently replaced by the individual artist. Architecture becomes a handmaiden of the building industry, the great institutions of painting, particularly the church, give way to the collector and his showrooms, the galleries. Artists no longer work with walls and ceilings. That is, art is no longer embedded in the objects of ordinary perception but becomes an aspect of the division of labor; from a collective artisan, the artist now becomes a petit bourgeois professional. The class location of the artist changes with the transformation of society. Artistic consciousness then perceives the world of "appearances" as alien. The real artist dwells within.

Robbe-Grillet offers a critique of the separation of the public and the private, and proposes a theory of literature in which the artist becomes critic, since the discourse itself excludes interpretation. The artist's critique of art appears as a predigested choice of forms. He has remarked that he wishes to purge the object of its "romantic heart." As for many others, for Robbe-Grillet the signification of the work of art is the business of the reader, not the writer. He rejects Roland Barthes's phrase, "the romantic heart of the object" which implies investiture of meaning in the writing itself and the juxtaposition of words and things in the objects or relations it depicts, because he wishes to safeguard the autonomy of the writer and the object that is created in his work, preventing the appropriation of writing by those who would incorporate it into ideological, political, or any other context.

The creative process requires nothing outside itself for its own justi-
fication, either as art, or as a document of its times. Certainly, Robbe-
Grillet does not literally mean that his work, which may be said to
carry the project of the elimination of the subject from literature to
the extreme, is devoid of historical reference. In the first place, the
project itself contains its own opposite. The attempt to go beyond
bourgeois subjectivity to the things themselves is entirely consistent
with the tendency of modern thought to transform everything into a
measureable object in order to dominate it. Yet the activity of abolishing
the interiority is undertaken in the name of freedom from domination.

In his essays on fiction, Robbe-Grillet explicitly argues for an an-
tipolitical art, no doubt in reaction to the insistence of Sartre, the Com-
munists, and other "engaged" French intellectuals that the writer must
be conscious that he is a historical actor. Although Robbe-Grillet departs
from most writers in his admission that "patient labor, methodical con-
struction, the deliberate architecture of each sentence of the whole has
played its part" in constructing the literary works of the past, and that
"critical preoccupations, far from sterilizing creation, can on the con-
trary serve it as a driving force," he remains committed to the creative
process which justifies itself by its very undertaking.

One can see the connection between such rumination and the novels
of Robbe-Grillet. He calls upon the novelist to abandon the "search for
secrets" that lie beneath and behind objects. The new novel is about
the solidity of surfaces that require no metatheory to explain them.
Novels are not about uncovering truth; they are interrogations treating
human relations as object relations. The part played by the writer is
merely to present the object as an integrity rather than as a function
of such vague categories as the "human soul." According to Robbe-
Grillet, just as the critic must jettison the critical search for "depth,"
the writer seeks not to "excavate nature" by producing character which
transcends the limits of ordinary object relations. "The novel of Char-
acter belongs entirely to the past; it marks a period—that which marked
the apogee of the individual."[18]

And herein lies the crucial link between Robbe-Grillet and art as
objecthood in the twentieth-century. Novels are constructed out of
language, rigorous construction of sentences and choice of words. Lan-
guage then, is the fundamental mediation between the writer, his object
(the text), and his audience. For Robbe-Grillet the idea of a content
that is separated from the act of writing itself is absurd. What is im-

portant (if, indeed the word may be employed at all) is to remove all the romantic heart from the object by trying to proscribe adjectival writing from the text. There is nothing out there but the surfaces that exist for us insofar as they are useful. But their use is purely functional. They contain within themselves no significance or depth that goes beyond what is seen, or to be more exact, what is perceived. We may describe, but we may not import such dubious categories as "interiority" of persons, since these are conjectural rather than scientifically rigorous.

Robbe-Grillet articulates the conception of art as some sort of pres-cientific discourse that functions in accordance with the precept that all there is is that which is known through the senses. Therefore the notion of depth ("content" that is separate, even analytically, from form, or, put another way, thought or meaning that is somehow separate from the means by which discourse is conducted, namely language) is oc-cluded.

It is as if Robbe-Grillet, in paying meticulous attention to the detail of the object, intends to drain, consume, or use up the object, as Barthes rightly observes.[19] Although Barthes argues that the novel of surfaces seeks strictly to exclude substance, without the shield of an *idée fixe* for the writer who seeks to destroy "the classical concept of literary space" and replace it with the space of the new physics or cinema, it is not sufficient to ascribe such efforts to the effort to place the "object in the dialectic of space." I believe Robbe-Grillet's scientificity expresses some-thing that is not articulated. To "use up" the object, to consume it, exhaust its surfaces, constitutes a "reading" of reality. Like positivism, its metaphysic resides in what is silent rather than what is said. Robbe-Grillet is seeking to appropriate the object, to dominate it, to control the world by describing it extensively. If this is so, then the point is to achieve dominion by the act of writing. By renouncing the ability of the writer to speak of more than the senses yield and the craft allows, Robbe-Grillet has tried to exclude historical or social referentiality, and to restrict reference to the mental process that produces writing. "Art is nothing" corporeal, claims the author. It makes no commentary, if by commentary we mean a genre of writing that interprets something outside of the act of writing itself, the "real" world, for example. The attempt here is to make the writing an objective act, not one of rum-ination. But, of course, the writer cannot succeed in avoiding a "reading." A conception, a worldview, is produced despite the effort to refuse meaning. The effort to extirpate temporality is itself an in-

sertion of the primacy of presence. And the subject-object relations presuppose the epistemology of sense-perception in which all other categories—memory, for example—are assigned the status of the arbitrary. But it is not as if objects were free to interact with abandon. The writer remains the author by restricting relations to those that may be described as purely geometric, as if by mathematics the illusion is preserved of pure observation.

How much Robbe-Grillet situates himself within his own epoch may be demonstrated on almost any page of his text. Sentences from *Jealousy* such as "On the bare earth of the garden, the column's shadow now makes an angle of forty five degrees with the perforated shadow of the balustrade, the western side of the veranda, the gable-end of the house," strung together in endless series in which there is no transition between things and persons, are preceded by no literary convention. "A . . . is no longer at the window" exemplifies the way in which the person becomes an object to be located spatially. This sentence is followed by "Neither this window nor either of the two others reveals her presence in the room. And there is no longer any reason to suppose her in any one of the blank areas rather than in any other. . . . The bedroom again looks as if it were empty." Here we are not permitted inferences as if the room were a painting whose visible parts are determined by the arrangement of shadows and light. We may speak only of that which can be seen.

What makes the modern novel cinematographic may be expressed in its absences. Since the subject is gone, the notion of character is obsolete. One can only know the character as object through what may be reasonably inferred about seeing and doing through observation. And since the senses will not reveal what the character thinks or feels, emotion and intellect being invisible to object perception, the new novel transforms the human persons from a thinking, emotion-laden individual into an object that moves among other objects. Robbe-Grillet's descriptive method parallels that of early Wittgenstein. One transforms all sentences such as may indicate beliefs and vague unspecified feelings in what people say they feel or think, or, if feeling is to be admitted, it must be confined to feelings of physical pain or discomfort. Robbe-Grillet, like Wittgenstein of the *Tractatus,* seeks to reduce all statements to those about facts and things, which corresponds to the scientific attitude that every statement must contain a central element of sense, which of course excludes such "invisible" presuppositions as are con-

tained in psychoanalysis, Marxist conceptions of history and society, or, indeed, any type of speculation in favor of a behavior-grounded discourse.

The ontology of the film has triumphed over the meta-assumptions of the nineteenth-century novel or even the construction of reality that pervaded the expressionist novels of the early years of the twentieth-century, in which the effort of the writer to appropriate the world through its fictional transformation showed itself in the fragmentation of narrative. When Kafka presents bureaucratic domination, he makes no attempt to disguise the horror of the encounter with the world. Spaces are "carnivorous," the adjectival is preserved, the writing has a normative quality. However attenuated, subjectivity is made aware of its encapsulation by the swarm of corporate entities. Only by rendering itself invisible, or by its transformation into another species, can the subject regain autonomy.

In contrast to the mental images evoked in the novel of subjectivity, even of the problematic subject, the new novel, if the term "novel" be applicable at all, marks the triumph of visual imagery. Every novel may be made into a film, since their ontology has become identical. Hemingway, Stein, and Robbe-Grillet, each in her or his own way, have extirpated from the novel its critical character. Its scientist form in which, in the name of the attack against humanism, interiority and interpretation are overtly absent, expresses a historically rooted episteme in which the assumptions of empirical science, its logic of truth conditions, and the general attack against the subject, are dominant.

The term "episteme" is taken from Michel Foucault.[20] Although I use it somewhat differently, it agrees with his usage in that it designates discursive practices that are not the same as the "spirit" of the times or of a single epistemology that may be coextensive with a historical period. "Episteme" designates a way of seeing reality that not only forms a specific perception of the social world as well as ordinary objects, but also becomes a way of acting and inscribes itself in institutions such as law and education. Every age reveals an episteme specific to itself, and is inextricably bound with its activity particularly at the margins. History, then, is the outcome of this relationship. Of course we sometimes act in ways that are at variance with our consciously held schema for organizing reality. But the notion of episteme requires not only an examination of ideological stance; it demands an attempt to recognize and name that which, in activity, resists representation in

terms of ideological or scientific categories. That is, practical activity may reveal more than what may be made into concept. Foucault names that which goes beyond concept as the unconscious which leaves a trace that is discontinuous with contemporary scientific or ideologic statements. We may be able only to approach the unconscious element of the episteme through a complex symptomology of social institutions, literary texts, the system of laws, and, of course, documents of historical events or social life. History, then, becomes an interrogation which refuses to privilege political and economic events or perceptions over expressive forms, scientific results over speculation. From the perspective of history as a theory of discontinuity as well as continuity, it is the evidence of society which both does and does not know itself that constitutes the discourse.

The modern novelist, having abandoned the search for meaning, having lost the ability to order reality hierarchically and to organize perceptions coherently according to the recognized precepts of classical philosophy that requires a classificatory system, a causal nexus, and an explanatory model as well as one that is descriptive, takes refuge in object relations or types of metonymy in which parts are taken for the whole. The preconception that allows the hierarchical organization of the object of perception requires an imagination that is informed by what Hegel calls the "consummation of experience" considered historically. Since most artists in the twentieth-century believe or act as if history is a betrayal, and can be trusted no more than their agent or their patron, the notion of consummation which implies some desire to make sense of the world, to connect the past with the present, is discarded in favor of an immediacy that is inscribed as *concept.* The artist works synchronically, grasps the object as representation, and refuses to look back or to probe the something that may refuse the certainties of the sensible world. It is as if the discovery of something else would produce intolerable pain if it could not be integrated into the doctrine of surfaces which forms the artistic sensibility.

From the perspective of much contemporary art, the presence of the artist in the work is diminished, since both the idea of the individual and of subjectivity are regarded as some kind of nineteenth-century relic imposed upon writing or visual artists by critics, politicos, or unsophisticated audiences. The tendency of art to be enslaved by the objects of ordinary life, or technologically permeated by hyperrealism signaled the simultaneous loss and renunciation of the self as an on-

tological category. Instead, what has emerged is the unification ɑ called high culture with mass audience culture. The artist cannot n tain this distinction because she or he has refused to comment ι reality except by abolishing her or himself in the work. The abolition of art is in part a statement about the reduction in recent years of all art to investment, as well as a statement that many artists have lost their audiences, despite the fact that museums, theatres, and galleries appear to be teeming with sightseers on Sunday afternoons. In recent years, the critic has performed the role of preserving the concept of a high culture by acting as a traffic cop of art. The critic occupies a vital space for both investor and consumer who wish to know what to buy. But this activity contains within itself a contradiction. Although the critic confers exchange value upon the work of art, he must also attest to its use value. To some extent, the exchange value of the work of art, as for all commodities, presupposes a use value. But whereas Marx insisted that use values could not be the measure of value in exchange, nor could the marketplace determine the value of a commodity, but instead the commodity itself was determined by the amount of socially necessary labor-time required for its production, it seems to me that the work of art is a commodity whose value has more or less arbitrary determinants. The critic has become the arbiter of artistic and exchange value by virtue of his designated prerogative: to make an aesthetic judgment in which use is equated implicitly with exchange. Those critics on whom the art marketplace confers the function of determining the aesthetic worth of a work of art establish the preconditions for the entrance of the artist into the legitimate market, as well as influence the value of the work as investment or as an object of consumption. The function of criticism mediates the relationship between buyer and seller only if the ideology of high art can be maintained. That is, the category of high culture mystifies the character of art as commodity. Some artists who have abandoned traditional twentieth-century modernism in painting and sculpture have embraced concept art or literalism precisely because they refuse the function of art as commodity. They have attempted to remove the aura from art by the very techniques that Michael Fried abhors: the aesthetic of art is objecthood, the refusal of interpretative representation, the use of the materials of mass culture such as videotapes, the "artless" reproduction of advertising arranged so as to make political comment (while eschewing the comment as artistic reflection). For radical concept art, the subject disappears only

in forms of representation. In place of representation the artist chooses reproduction of the most degraded of commercial forms in order to hold up to the commercial art world its hypocrisy. From forms of eternal representation of the human soul, the concept artist declares the historicity of everything, that the fashion process in the art marketplace destroys the possibility of art except as commodity. Since artists have lost their audience—except for collectors, art bureaucrats, critics, and other artists—radical literalism has undertaken a form of guerrilla theatre as the only possible resistance.

–III–

What do I mean by the loss of audience for high culture? In the first place, the concept of audience must be defined. An audience is not a random collection of persons who happen to consume a concert or an exhibition of painting, sculpture, or other visual art forms. Nor does it consist of readers of the present or any other writing. More books are consumed in the United States than ever before and the galleries are full. Yet the audience for art has disappeared, if by audience we mean a group of people who are connected to the artists both intellectually and culturally. In the past two centuries the terms of communication have been defined by the act of consumption. When culture became a commodity in the early nineteenth-century, having left the royal courts and the private-public realm of patrons, it retained part of its audience because among those who heard music or read novels were members of definite strata of society who produced art themselves, whose lives were portrayed in painting and literature, and who had direct or close relations to the artist.

To be deadly simple: an audience talks back and participates in the production of signification. Substantial numbers, albeit a minority of members of the middle classes, artists and writers, and skilled workers in every capitalist country of the nineteenth-century, were involved in art insofar as they constituted an active, critical public which spoke directly with authors, engaged in the production of art itself, and expressed its criticism forcefully at public performances, in letters to publishers, and at exhibits.

Artists and writers were part of their own audiences. In a variety of literary clubs of the seventeenth- and eighteenth-centuries, writers read each others' work, supported each other in publishing, and constituted a community of constant exchange of ideas and sharing of

fortunes. Jonathan Swift, Alexander Pope, and other writers of the early eighteenth-century met regularly to discuss their work as well as their financial fortunes.[21] Similar groups have made their influence felt in every nation through the twentieth-century. Since the bourgeois revolutions of the eighteenth- and nineteenth-centuries, even the early growth of a mass audience that simply consumed culture as it ate in restaurants or attended circuses, failed to deter artists from working together. The notion of a movement in the arts was often synonymous with the idea of artistic politics. Those who discovered new modes of perception, and evolved new means of expression, were forced to band together with the sympathetic part of their audience to defend their discoveries both in the art marketplace as well as among general audiences. Without a community if not a political organization to defend its interests, a new movement would find itself barred from publication outlets, galleries, concert halls, and other places where its work could be seen, read, or heard. Often the movement was forced to open its own galleries, give its own concerts, and start its own presses because those who controlled the key outlets were committed to the old art.

The course of development of a new movement within the context of the capitalist marketplace had three possibilities: either the movement became absorbed within the dominant culture by gaining recognition from those who controlled the culture industry; it remained on the margins for some time, having succeeded in capturing a fragment of the audience, some investors and critics, and small promoters who catered to the "avant-garde" consumers; or it disappeared because it could neither find an audience nor a financial base for its art.

Historians and critics of art wish to believe that only the best gets absorbed into the dominant culture and receives outlets. Of course such conceptions are part of the mythological apparatus of any establishment. Often an art movement such as surrealism never arrives, but instead lives an underground existence for most of its life. Fragments of its vision are absorbed by mainstream art, or, to be more exact, its vision is never understood, but a series of techniques is extrapolated from its corpus and used by artists within an entirely different context. Cubism and its offshoot, abstract expressionism, became the central movements in painting and sculpture of the twentieth-century, but their success coincides with the loss of audience for high art. For the development of cubism must be seen within a framework of the emergence of film as the hegemonic form of visual art. The ontology of film is quintes-

sentially representational. With the development of photography as an art which not only ushers in the phenomenon of mass reproducibility to the visual arts, but takes from painting the vestiges of realism that were already in the process of decomposition in the late nineteenth-century, painting and sculpture were assigned a new role in the artistic division of labor: to make a metacommentary upon reality by abstracting form from content. Representation did not disappear from high art; it portrayed the hollowness of objects and allowed their formal side to become a partial totalization. The artist tried to preserve the objects of perception by eliminating those elements within them that may be taken as their transitory character. The art of geometric form, far from showing a kind of modernism, was a return to the visions of late Greek art and philosophy—the search for the eternal. The religiosity of modern art is belied by its scientific discourse, by its efforts to transform the world into forms. Buffeted by the degradation of the marketplace, the artist's secret is no longer to be found in the "stuff of life" but in the attempt to overcome the finitude of existence, to encounter the death of art by its redemption through form.

The transformation of the art world in the late nineteenth-century had several consequences: the world became fragmented, as film and photography captured the sphere of representationality and, more generally, of content, and simultaneously seemed to effect a degradation of art. The painter's eye had to rescue the language of art from its speech. Speech represented that which was ephemeral in the world, the contingent in both ordinary and artistic discourse. Language or the grammar that was declared the sphere of the new popular arts, the syntax and even the semantic field of discourse, was enduring. Thus did high art return to the Cartesian dichotomies of subjectivity and the object. On the one hand, the triumph of cinematographic culture raised the object to a supreme position in the social and perceptual world. On the other hand, subjectivity, having withdrawn into itself, proclaimed its supremacy. Subjectivity tried to assimilate the object as its own creation, while positivism tried to reduce the perceiving subject by declaring the immutable facticity of the world, declaring the concept as merely derivative of the factual. The crisis in high art, produced in part by the migration of the audience to the literal media of photography and film, led at first to the redefinition of high culture in purely polemical terms. The high arts were abstract, conceptual, and critical,

while mass audience culture was concrete, mindless (here defined in terms of its propensity for narrative which now became an art of a lower order), and spectacular. Implicit in these distinctions was a judgment of the audience. The audience that "consumed" mass culture consisted of the undifferentiated masses, an audience without character, intellect, or a grasp of traditional bourgeois culture. The idea of massification did not connote an image so much of large groups as of a "lonely crowd," an atomized collectivity of isolated individuals imprisoned by their private lives.

Art movements such as surrealism and cubism and literary modernism preserved in the early period of the rise of the cinema some degree of artistic autonomy. Their very distance from a mass audience and from the idioms of mass culture made possible the project of the subject-object split against the spurious totality of mass culture. But it was ultimately not possible for the artist to remain separated from either the mass audience or its culture. The power of the commodity form and the severely restricted audiences for high art produced an economic crisis for the majority of artists who wished to create a critical art of expressive forms. Advertising, which in the nineteenth- and early twentieth-centuries was still characterized by a functionalist representation of products in terms that were largely restricted to their uses, created forms of commercial art that were bursting with connotations and finally eliminated the referent entirely. That is, from verbal and pictorial representations that attempted to persuade potential buyers of the sturdiness of the product, its efficiency, and its economic advantages, ads now abstract the commodity from its concrete uses. Instead, pictures try to persuade on the basis of connotations of enhanced sexuality, prestige, and other desires that are far removed from the actual powers of the product. The product is sold on the basis of its status as a sign that could evoke desires that were suppressed in everyday life.[22]

This trend in advertising finally reached its apogee in the elimination of even this referent, however removed from the concrete uses of the product. The latest and most pervasive type of advertising simply presents the product as a sensuous object whose meaning is entirely contained by its presentation, or performance. One buys the product because it titillates our senses. The signifier no longer requires a signified that denotes utility or connotes values that are removed from the concrete object. The object itself is all that is required on TV, accompanied

ı voice-over that has resonance and can be considered itself an aes-
ʌʌʌetic object. Or the figure of a beautiful woman driving a car leaves
the interpretation entirely to the beholder.

Of course, the propensity of contemporary art to preoccupy itself
with forms did not protect it from the vacuum of commercialization.
The presentation of words or a figure ensconced in a design that derives
from the geometric or geodesic shapes of a Mondrian is sufficient to
convey the message. In these instances, the form of the sign becomes
the signifier, not the message itself. Viewers recognize the design and
recognize it by the product rather than its quality, price, or other as-
sociations. Signification appears to have been extirpated from the ad-
vertising industry. The transposition of the artifacts of high culture to
mass advertising took place both with and without the complicity of
the artists and their audiences. Modern technology, which allowed for
the mass reproducibility of all art, robbed art of its "aura," although,
as Adorno has pointed out, it did not prevent the artist from acquiring
this aura. The artist as star, rather than the artifacts that he or she
creates, has appropriated the aura.

The reaction of art to its incorporation into mass culture has taken
the form of an effort to adapt the techniques of mass culture to high
art. The development of pop art as a critical metacommentary upon
mass culture signalled the final surrender of high art to the marketplace.
Or, to be more exact, it proclaimed the identity of all art and the
elimination, at the level of the intrinsic representation of the work of
art, of the distinctions between high and mass culture. The bitter ad-
aptation of the co-opted forms of high art back to high culture con-
tained a dialectical reflexivity. What is transformed in the return of
the mass sign to high art is not the image, but the context.

High art in the late twentieth-century has become a question of
context. Its existence has no reality apart from its social reference be-
cause it has lost the space in which to develop an autonomous genre.
Now it is forced to copy mass culture, to submerge itself in the pho-
tographic image, or to reproduce the totality of representational forms
and try to distinguish itself by means of its design or commentary as
in concept art. Thus does subjectivity return to art, but not as a new,
objectified form. The intellect becomes a kind of voice-over, whose
content is often without significance, except insofar as words and pic-
tures are now joined in the design.

Of course, the artists who practice concept and pop art have developed private codes for designating their work as high cultural production. These codes are expressed as eccentricity rather than coherence, but they succeed in distinguishing an apparent montage of ordinary objects, either painted or arranged as a sort of sculpture, from the objects as mere use values. Recognition of the difference between their use and their value as artistic representations becomes itself the sufficient ritual for admission into the select audiences that have identified this as art.

There seems little debate about the formation of the mass audience in the twentieth-century. Critics and artists alike have agreed that the mass audience does not constitute more than a receptacle for the most degraded commodities of the culture industry. The mass audience is marked by the instrumental use of culture as escape rather than as a part of its life, enriching its sensibility and indeed its social existence. There is little argument that the reduction of art to consumption has also reduced the idea of the audience itself to a part of the apparatus rather than a critical participant in the process of artistic creation.

The problem arises when we examine the audience for so-called high art. Immediately one can observe that this audience does not overlap in class terms with much of the mass audience. For example, the audience for so-called classical music is typically recruited from middle and upper strata of American society. And, since neither ticket nor record sales are sufficient to meet operating expenses for a symphony orchestra, the real audience for this music consists almost entirely of those who are considered patrons, the large donors and season ticket holders in the most expensive seats. These groups control the programs of most symphony orchestras, and more often than not exclude from consideration those twentieth-century works that have adopted the more radical modes of expression developed by Arnold Schönberg and Edgar Varese and currently practiced by such composers as Karlheinz Stockhausen, John Cage, Pierre Boulez and others. When these composers' works are played, it is the price that vice pays to virtue. It is usually a token of the catholicity of the organization and may reflect the conductor's taste (which must be indulged upon occasion) or, more likely, adds to the luster and legitimacy of an orchestra otherwise constrained by the musical offerings of the baroque, classical, and romantic eras. In recent times, twentieth-century composers represented on or-

chestral programs are confined to those like Bartók, Rachmaninoff, the early and middle Stravinsky, and Hindemith, who are significantly influenced by previous periods of musical composition. The work of Bartók and Stravinsky that attempted to effect some reconciliation with serial music is given short shrift. Aaron Copland, perhaps the most popular American composer, is represented in the standard repertory not by his later dissonant and serial music, but by his programmatic compositions that were commissioned for ballet and films. The latter are excellent examples of the tendency of much contemporary music to imitate popular forms without comment in order to evoke imagic tonality.

Pierre Boulez, whose short tenure at the New York Philharmonic was highlighted by his continuing conflict with the patrons of the organization over questions of the repertory, finally left the orchestra and parted after the 1977 season. He was replaced by Zhuban Mehta of the Los Angeles Philharmonic, who mastered the politics of the classical music industry in a manner not matched by his other talents. Mehta is among the growing list of conductors who have chosen to play the politics of safe music. They know that the audience consists not of the dedicated music lover who cares about recent developments in the form, but instead of large corporate and individual donors who "know what they like" even if they do not understand it.

In contrast, the 1980s witnessed a revival of public art, but not in the usual middle class way. In New York, Los Angeles and other large cities, African-American and Latino young people produced vast quantities of graffiti and mural art whose venues were, at least at first, subways, public buildings and the brick walls of empty lots within the 'hoods and the barrios. Needless to say, these interventions met with hostility of city officials and many middle class residents for whom these artworks were understood as defacements.

As with many popular expressive forms, critics, museums and collectors discovered the "aesthetic" value of many of these works in the late 1980s and early 1990s, but not until the erstwhile New York Mayor, Ed Koch arranged to whitewash much, (but not all) of the graffiti from buildings, subway cars and station walls. Street artists were celebrated in some communities, particularly in Los Angeles where many housing projects were adorned with extraordinary murals that frequently became primary documents of the vast immigrant waves into that area.

Those excluded from programmatic decision-making should not be taken for the genuine article. On the contrary. There is every reason to assume that the modern audience has internalized all of the qualities of the mass audience that imbibes popular music. The classical music lover is distinguished only by the kind of music that he consumes, not by a disdain for cultural consumption itself. To a large extent, those who listen to classical music do not understand the conditions of its production, either the technical side or its aesthetics. Issues that are debated by composers and others, but by few critics—since criticism has become an integral part of the patron-dominated apparatus in music and is employed to maintain the status quo in taste—are never addressed by classical music audiences. For the most part, classical music performs an emotional, recreational, and social function for the "serious" music lover, when music is not being used as high grade Muzak to accompany eating, reading, or polite conversation.

To be sure, a minority of the music audience takes its interest beyond the obvious bounds of consumption. These are the collectors who have made a fetish of the performance rather than the composition. Discology rather than musicology characterizes their interest. To some extent, distinctions among performers are a sign of distinctions of musical comprehension. And it must be supposed that some portion of the collectors audience is involved in problems of performance as interpretation, and proceeds from a well-defined set of artistic precepts. On the whole, however, such distinctions are made on the same subjectivist basis that informs the decisions and influence of the patron audience for orchestral music. Questions of taste rather than musical ideas are evoked. And taste itself is a culmination of the social and artistic episteme of our time. It is largely permeated by a romantic, harmonically consonant, aural perception, where the tune has become the center of interest. In this instance, the rituals of consumption are rigorously enforced beneath the appearance of higher interest.

The stratification of the musical audience reaches its apogee with musicians and professional musicologists who constitute perhaps the only genuine audience for recent music that has departed from the mainstream. In this instance, once again, the return to objecthood has not escaped even the most innovative and interesting work.[23] The advent of electronic music is heralded as a "revolution in sound," but what has been lost is the expressionist modalities of serial composition, in

favor of a mimetic mode of musical expression. The music represents the sounds of the city, its sirens, the whirring of machines, its cacophony of metallic clashing. While consistent with the intentional efforts of serial composers such as Webern to abstract from musical speech its essential linguistic discourse, what has been lost is the notion of form. Without form, the ordering of experience, so vital to the fundamental character of all art, is abandoned. By presenting the abstracted object as entropic, the chaos of the world is not expressed through the mediation of artistic consciousness, but consciousness now becomes the absent term in the process of artistic creation, except by its omission. The identity of the audience with the creative process in the development of electronic music has deprived this genre of the element of *difference* that may provide for art its dialogic necessity. The new music becomes solipsistic. By that term I mean that it is involved in the problem of distorted communication where the Other can no longer be assumed and the requirement of intelligibility is somehow suspended.

When I employ the term "intelligibility" I do not mean to engage in that philistine debate about representational music or art. What I am referring to is the requirement that art show to the audience its concept or its structure. Even if these are hidden, or the artist refuses purpose or self-interpretation, the work must function as a totality of signs that provides the raw materials of interpretation that do not require some specialized intelligence or sociological reduction.

Much of what is considered new music has collapsed into the means of musical production—a dimension that may be called "aesthetic." The new music is not precisely an antiaesthetic in the sense that Webern meant when he presented fragments of sound and refused continuity. In Webern we hear the commentary upon conventional tonality and musical organization, and a new type of coherence is suggested, but never revealed. Having lost its sense of difference as much as its musical identity, the new musician disclaims any teleology save the reproduction of the aural actuality of the object world which has become identical with its technology. That is, the means contains the ends, not as a suppressed content but as a simple identity. The sounds of the world are mechanical. Music is not only capable of mechanical reproducibility, it is the machine. The new music has surrendered to the object, and it has become merely a reporter of the growing incapacity of artistic perception to assimilate reality within its existing forms.

The reversion by Stravinsky and others after World War I to neo-classical forms expressed the frustration of artists with the loss of an audience for new music, on the one hand, and their distance from social reality on the other. The music of Bocherini may not have addressed the "human condition" in postwar Europe, but it provided a tradition that could be used as a starting point for the reconstruction of art by the reconstruction of the audience. As Adorno has pointed out,[24] Stra-vinsky was eternally aware of the society around him, the preferences of musical audiences, and the wages of social isolation. The return to eighteenth-century roots was not only an attempt at the restoration of authenticity to music from its sojourn into the privatized spheres of the incomprehensible, but an effort to make music acceptable to a society not prepared to work at listening. Stravinsky chose to ignore the present rather than lose cultural currency. Adorno points out, rightly I think, that even before his neoclassical period Stravinsky was co-opting commercial art forms and spectacles such as the circus, in order to capture his audience.

Stravinsky's music became "music about music," either in cabaret, or other entertainment, or by the use of extensive quotations from earlier periods of musical history, particularly the classical compositions. The treatment of music as an internally autonomous and hermetically sealed literary text corresponds to tendencies in modern literature. Much of what is classified by critics as twentieth-century "modernism" consists of the commentary within the framework of novels or poetry, on prior literary history and its works. Novels are as much about novels or narrative paradigms as they are about a putative external reality. A major tendency of recent criticism has been directed towards showing that, far from making a commentary upon the conduct of everyday life, even "realistic" novels, albeit unconsciously, are nothing more than imaginative reproductions of classical structures of storytelling.

–IV–

This observation may be interpreted in different ways. One view would associate the apparent hermeneutic character of novels with an epis-temology that proclaims social reality, the object world as a whole, and, beyond the realm of perception, the category of history itself, as having no specific content. Literary texts have their own history, and a careful analysis of them, according to this point of view, reveals neither

ideologies that may express aspects of the objective social world, nor a correspondence with that world at all. In short, literature is an instance of the proposition that consciousness has its own development, lacking referentiality. The core of the argument hinges on explanations of texts that require only an analysis of forms of language, syntactical rules that obtain within it, and the *écriture* or style of the writer, which is presumed inexplicable except through an examination of literary conventions, and taken thereby as a difference or consonance with them. Roland Barthes, for example, makes an analysis of texts in terms of categories derived from the production of writing, rather than from an ideology or system of values that may originate outside the text. Consistent with the views of many semioticians and the so-called structuralist school of criticism, Barthes denies that the importance of criticism consists in the effort to discover meaning in the text:

> This text is a galaxy of signifiers, not a structure of signified. It has no beginning; it is reversible . . . the codes it mobilizes extend *as far as the eye can reach.* They are indeterminable (meaning here is never subject to a principle of determination, unless by throwing dice). The systems of meaning can take over this absolutely plural text, but their number is never closed, based as it is on the infinity of language.[25]

For Barthes, "nothing exists outside the text" that can have significance in terms of its understanding. Beyond those who would define the text in terms of the conflict among a finite number of narrative structures that may play within it and could constitute some kind of totality, Barthes asserts the infinite plurality of the text. We can see two tendencies inside modern literary criticism. The first and older position requires that the text be decomposed so that its mythic and symbolic content may be revealed, however much these are buried in language and in the narrative. Those critics who try to name such myths and symbols may still deny the sociohistorical context of the text, but they open the way to the discovery of immanent *meaning* as a property, not of the reader, but of the text itself. For others who are simply interested in reconstructing the narrative in such a way that the signification of the text may be discovered, there still lurks some adherence to the lawful character of literature and its production. Even as some tendencies in the formalist school are prepared to jettison the notion

of referentiality in favor of their morphological approach, there is no necessary contradiction between the discovery of forms that are principally internal to the text and an attempt to connect these with social and historical references.

Of course, even Barthes is unable to avoid the world of extratextual reality. The category of desire, which Barthes has extrapolated from as a generative emotion that propels the narrative of a Balzac story, is subject to a variety of philosophical and social meanings. At one point in his book, *S/Z,* Barthes employs the concept of desire as a sign of the recognition of one's desire for another by the other. It may be supposed that the reference to Hegelian conceptions of the centrality of desire in human relations is merely an intraliterary reference, if philosophy itself is regarded as a branch of literature whose writing involves the same processes. But Barthes cannot avoid saying anything about the text that does not employ categories that go beyond or are prior to it. The mere act of analysis does not imply the extraction of that which is immanent in the text (that is, it is not merely a "reading" that refers to nothing save the object), but brings an apparatus from the outside in order to make sense of what is written. Barthes employs the concept of *code* as a central mechanism to make sense of what is going on in the story. But codes such as the hermeneutic and the cultural are derived from rational categories which are prior to the text. The text may employ them as part of its unfolding, but they imply a social referent. Hermeneutics is a way of seeing that assumes a logical process that can disclose that which is repressed in the discourse of the text. In other words, it assumes a difference between that which is presented and that which is hidden inside word constructions, sequence, and cultural signifiers. Although the hermeneutic does not refer directly to the social, cultural, and historical that lies beyond the text as a code, it presupposes the rationalist tradition whereby knowledge may be obtained prior to any possible experience. This tradition is a significant part of the cultural code of which Barthes speaks. It not only possesses its own history in the plethora of biblical interpretations that depend upon their immediate social context as much as upon religious scholarship and its mythic and symbolic foundations, but constitutes a way of thinking that can be located in specific forms of human society, particularly the feudal order. Which does not mean that hermeneutics has remained constant in different historical periods. Its methods as

well as its significance change with social transformations, and at the same time retain an element of the past, insofar as a way of thinking remains relatively unaltered.

Barthes violates his own rule against referentiality by evoking the cultural codes which are "references to science or a body of knowledge," which may have medical, historical, or any other type of knowledge as their content. Yet he leaves this sphere devoid of specification in his own text, by design. He renounces any intention to reconstruct the cultural code to which the text refers, thereby occluding the social context from examination. Naturally, this omission is neither arbitrary nor innocent. For the cultural codes that may be discovered within the text are the mediations that may bring the text outside itself and locate it in society and history. Under such circumstances, the critic is obliged to make sense of history and of social structure in order to fulfill adequately the task of destructuration. By declaring that this task is beyond the purview of his literary studies, the critic has imposed a limit upon his own vision that leads, however unintentionally, to a vision of the literary world that generates a new partial totality. The text itself becomes the sufficient condition for its own existence, requiring nothing beyond itself. As long as culture is given no specification, the world of language and expression remains autonomous.

I am not claiming that Barthes offers nothing of value to those who wish to understand the richness of artistic creation. By focusing attention upon the production of the literature rather than its effects, the critical school of which Barthes is an important part illuminates an aspect of literature that has hitherto remained hidden to us. Equally important, by positing the text as an object whose signification may be found by its deconstruction into linguistic and semiotic elements, Barthes, and others who have taken this stance, provide a powerful corrective to the overhistoricized readings that emanate from both older bourgeois and traditional Marxist criticism.

The trouble lies not in what appears in the critical commentary, but in its silences. Barthes has taken a series of valuable procedures for identifying the internal composition of the work of art for the entire critical project. He has transformed literary theory into ideology by making his procedures into a totality of the critical project. This partial totalization has effected a marriage with the American tradition of the New Criticism which in the thirties and forties made the text an autonomous, sacred object. Since the 1960s, the New Critics have suffered

substantial eclipse in literary and artistic debates because their extreme empiricism, which valorized the senses to the exclusion of reason, was out of phase with the stream of historical events. Having jettisoned the anti-Marxism that informed the critic's retreat into the text, a new generation of American writers and critics sought to immerse itself in social and historical reality. The revival of Marxist and radical social ideas among university students in the late 1960s produced a challenge to those reared in the critical paradigms of the Cold War.

The function of French literary theory in the American university in the 1970s was to provide new legitimacy to the dominant academic criticism. For it could hardly be claimed that Barthes, Derrida, and others whose work stemmed from structuralism were devoid of theoretical premises, or that these were derivative of positivist thought. Moreover, nearly all French intellectuals of the recent past identify themselves with the emergent left in their country. Nevertheless, politics and art remain strictly separated within the French academy, just as they are regarded as irrelevant to each other in American critical thought. Critical theory has come to mean the interrogation of texts from linguistic and semiotic perspectives or, alternately, the analysis of texts from philosophic presuppositions.

While some, like Barthes, are prepared to admit that cultural codes which may include ideological issues are to be found in novels and stories, there remains a reluctance to investigate these issues. For while literature may not be regarded as simply another form of ideological discourse, since it also constitutes a form of knowledge not available in scientific areas, it would be equally mistaken to avoid the social context and preconditions that account, in part, for the production of the work of art. Surely, to observe, as Terry Eagleton does, that the writer does not portray Paris as it *really* is, but as he or she sees it, implies that perception is conditioned, if not determined, by a vision of the world that includes ideological elements. In turn, these elements are often congealed in cultural codes that can be identified as ideological problematics which are suppressed in types of narrative paradigms. Whether we are speaking of a typical American detective story or a so-called high cultural literary work, these paradigms seem to reappear, and are prior to the process of writing, but are imbedded in artistic unconsciousness.

Let me offer an example of this suppression from an important American film. *Network* concerns at least two separate ideological prob-

lems that mark our era. The first and most obvious is the fate of the individual in large bureaucratic organizations such as a television network. The film poses the question: can critical content emanating from an employee survive the requirement of the organization? The film answer: yes, as long as it becomes a sufficiently powerful spectacle to meet the criterion of profit, which in turn depends on audience viewing ratings. The more outrageous and nonconformist the individual, given the malaise of the post-Vietnam and post-Watergate audience, the larger the audience, and the more advertising income the network can command. As soon as the ratings slip, even if the slippage is the result of the corporation's own pressure on the individual to change his political and ideological stance, the individual must be taken off the air, if not the planet. Here is an important cultural code, the knowledge required to survive in a large corporation, which is, after all, the characteristic business organization of our epoch. The film shows this code of survival by conformity with another code—the ideology of individualism that is said to motivate both economic perception, and economic participation in a capitalist society.

Naturally, these codes, within which are contained both a type of "scientific knowledge," insofar as perceptions are transformed into concepts that insure economic and political survival, and the ideology which proclaims this concept of conformity, natural law, are not framed realistically. No television network, given our current political or social conditions, could or would go as far as to permit a commentator to be consistently, and openly, critical of both his employer and the entire corporate establishment on the air to millions of viewers, even if the promised economic benefit justified it. Large corporations have some constraints on their drive to profits, even moral and ideological limits. Their attitude towards a "nut" who called upon his viewers to take action against everything they believed in and owned would probably restrain their short-term avarice.

So *Network* is not a description of the executive suite in mass media. But it uses a variant of a narrative structure that is permeated by a central problematic of our cultural life, one that has been prominent in Western literature since the beginning of the twentieth-century, but has roots in the entire history of the bourgeois epoch, and especially in the novel tradition itself. The problem, identified by Georg Lukacs as the struggle of the individual to reconcile the idea of autonomy with the demands of social and cultural codes that demand discipline and

conformity but also hold out the promise of personal freedom, runs like a red thread throughout the history of English, American, and French literature. Ann Marie Feenberg has pointed out that, while in the English novel the conflict consists in the struggle between individual greed, or at least self-aggrandizement, and a society which insists on a strict moral code that places the interest of the community above those of the individual, the French novel constitutes a somewhat different historical structure. She notes that the heroes of Balzac's novels seemed little concerned by problems of conscience in their quest for worldly success.

The reasons for this difference, I think, hinge on the relative weakness of the feudal traditions in which the ideology of community holds sway from the English point of view. Nevertheless, while Marx may have been right in his remark in *The Communist Manifesto* that the bourgeoisie sweeps away all idyllic relations in its wake, including those of community, the same may not be said for continental Europe, where the concept of the social good takes precedence over personal fortune well into the nineteenth-century. The happy entrepreneur, ruthless in his worship of competition and personal gain, is not a heroic figure in English fiction. On the other hand, the French transform community into civil society, that is, into a world where the law of competition holds unmediated sway. Here, the individual grapples with the problem of society's rejection without comprehending the reasons why, especially if he has conducted himself according to the precepts of possessive individualism.

Certainly, the United States evidences more affinity to the English than to the continental model. The notion of transcendent social values that may overrule individual desire is as alien to our culture as it is to our literary and artistic traditions. The objectification of desire takes the form of conquest in nineteenth-century novels, the entire frontier literature particularly, but also finds its expression in our century. Success is defined in the novels of even the sharpest critics of American culture, such as Dreiser, in terms of the acquisition of personal fortunes. The criticism remains uneasy, however, because it lacks a legitimacy, because the ideology of community, according to which individuals have not only obligations but also benefits by conforming to a concept of social good, is lacking. The system of law, as interpreted in our country, is a system of restraints, not the codification of a tradition of cooperative behavior.

Network expresses the agony of the irreconcilibility of private and public life. The commentator who finally breaks out of his routine news reporting to become a popular social critic finds that he can only retain his individuality by transforming himself into an entertainer, and becoming integral to the spectacle of mass culture. The message that expressed his own subjectivity becomes commodified and ultimately neutralized. Thus the person disappears in the vortex of media production, even though the ideological element of individuality is the precondition of his success. But there really is no audience that constitutes a community that can mediate the power of the corporation to manipulate him. In the end, the network has him killed in order to perpetuate the spectacle. In this sense, the film provides some evidence for the thesis that the artistic perception of our era is that the world has become entropic, that the element of order that was present even in the midst of the bestiality of bourgeois greed is gone. Neither the corporation nor the individual has genuine power over the course of events, and the spectacle itself has provided an internal justification for its reproduction, even at the expense of human life. *Network* illustrates a salient aspect of the new problematic of modern life: while earlier in the twentieth-century art was obsessed with first the machine and then the commodification of almost everything, the spectacle represents a new stage in the degradation of culture.

The machine was heralded as humankind's great hope both to overcome grinding poverty for the majority of the population, and as a way to eliminate the backbreaking labor that had been our burden since the discovery of agriculture. However oppressive it turned out to be, when it was learned that the character of modern production was such that the machine seemed to dominate the individual rather than being her or his instrument of liberation, there remained the hope that the process could be reversed by a more rational organization of society. Even the transformation of everything into a commodity could be argued as a progressive social step if consumption was understood as a part of the struggle against scarcity.

The machine age and the consumer society were related to human purposes which could be disputed, but the level of discourse was framed in terms of the complementarity of means and ends. Critics of the machine and of consumerism argued that the ruthless employment of these means to achieve laudatory objectives would result in consequences that were in conflict with human purpose. From the captains

of industry who dominated the social and political life of the nine-teenth-century to some revolutionary faced with the problem of ra-tionalizing socialism with underdevelopment in our own period, the counterargument rested on the proposition that industrialization would lay the material groundwork for achieving a final end to human misery.

From the perspective of an ecologically damaged, advanced, in-dustrial society, these arguments now appear naive. But the plain truth is that both sides of the debate began from similar, if not identical, premises.

What *Network* shows is that these premises have been surpassed by a new form of human activity that requires no philosophical presup-positions. The spectacle appears as an internally coherent system, whose justification is its capacity to replace the awe and wonder associated traditionally with religious fervor with a totality that may be meta-phorically expressed by the feeling we get in a carnival when we taste our first bite of cotton candy. It lacks substance, it melts in our mouths, and it is sticky sweet. However, the candy cannot give us satisfaction. We always want more to eat and finally we get sick to the stomach. The spectacle is the colonization of desire. It replaces human relations with a spurious "higher" activity, one that gets us out of ourselves for a moment and appears to transform everyday life.

But if everyday life remains degraded, if the world of business affairs fails to provide the fulfillment that we are taught to seek, our desire to leave mundane affairs and be transported into a realm where reality is absorbed by fantasy becomes a need. The need is not only present among those who consume it, but it engulfs those who produce it as well. For Faye Dunaway, the prisoner of the spectacle, its endless re-production has been made a substitute for conventional sexuality. She has become a junkie of the spectacle, and like the quintessential addict, finds that there is no limit, either moral or spatial, to the requirement for an ever-expanding sphere of activity.

The hero of the film turns out to be a TV news producer who, faced with the prospect of joining the new order, chooses to fight it and is finally removed to private life. He has been a faithful manager of the old order, one that delivers the news in the boring, fragmented format of traditional television coverage. He is put in the strange po-sition of defending an exhausted genre of television entertainment and evokes, at one point, the ideology of objective journalism.

The character, played by William Holden, has successfully sepa-

rated his own ruthlessness in public or business affairs with a private life that is built around a family. However tenuous his hold upon private reality, the shocks of his public existence are cushioned for thirty-five years. When he loses out to the triumphant Dunaway, his family life comes apart. Ironically, he starts an affair with his vanquisher, only to discover that she is not his mistress, but has given her heart to the spectacle.

At this juncture in the plot, a very old problematic is introduced, the conflict in women between their careers and their personal existence. Dunaway chooses to surrender intimacy and family, and ends up surrendering totally to the glare of the visual culture which becomes her totality. Holden becomes the bearer of the news that since public existence has become brutalized and brutalizing to the individual, all that is left of our humanity resides in the family and in personal intimacy. He purveys the ideology that private and public, having become separate and forever unintegrated, force upon us a choice. Dunaway, having decided to remain in the cesspool of television production, will become bestial. She suggests, in the scene following the breakup of the affair, that the errant commentator be removed from the airwaves by killing. The spectacle is a sign of a fall from grace. It has replaced the machine and commodity as the scene of the devil's work.

What is remarkable about *Network* is the degree to which rather powerful, but by no means novel, ideological discourses surface in a film that purports to represent its own distance from the past. The film is rooted in the struggle between traditional values, those involving romantic love, intimacy, and the privacy of two persons, and a civil society that has become uncontrollable. The ideological content of the idea of the private *against* the public as a means to happiness has been as central to the problematic of the bourgeois individual as that of impossible love since the eighteenth-century in Western literature.

Far from constituting a "string of signifiers" without ideological reference, *Network,* as well as modern novels such as *Hopscotch* by Julio Cortazar, contain "typical" ideological problematics as their suppressed content even as the formal, gamelike writing seems to express mediated desire for the pure pleasure of the act of writing itself. The dream of happiness in an alien world remains the underlying theme of the modern novel. The narrative reveals a structure which is expressed in fairly classical ways.

One typical narrative runs like this; A man has had a wife and

family for some time. Since, the world of business occupies his time almost totally (he is "dedicated" to his work), either because he wishes to provide security for his family or because of the game of power or both, the family remains the "taken for granted" of his existence. Having forgotten the degree to which it constitutes his roots, the support without which his life has no significance, he takes a mistress. When his business collapses, he must seek refuge in his home. But his family has now become estranged from him, and his wife refuses to tolerate his new love life. He turns to his mistress who "dies" in the process of giving birth (in the case of *Network* she "dies" for *him* as she "gives birth" to the spectacle). The outcome has variants, but it turns into tragedy for the man who was not satisfied with everyday life, and sought impossible love instead. We cannot tolerate the boredom, the lack of style of everyday existence; but to turn to the other is no better. How can the individual keep morality intact when the taken-for-granted work does not offer both romance and "worldly success." Man is discomforted in the bourgeois world since neither civil society, nor the bourgeois family, nor romantic love are sufficient of themselves to fulfill the dream of the whole man.

Fragmentation remains the problematic of modern existence. Art evokes the problematic either realistically or by submerging it in a series of metonymic fragments, aphorisms, metaphors, games, allegories, that through their formal incompleteness express the inability of the artist to perceive the world as coherent. Barthes's extirpation of the *signified* from literature accurately represents the surfaces of the work of art. By deconstructing it, he succeeds in hiding its meaning structures. But the surfaces reveal the silences, perhaps the genuine repositories of "meaning". The ideological content of much modern literature and film resides precisely in the decomposition of narrative. To all appearances, *Network* concerns the guileless use of a broken-down television commentator as a commodity. His criticism of the corporate order sells soap, so he is permitted to stay on the air. The logic of the business requires his elimination as an unintended act of a spectacle that seems to have overcome the rationality of the business. But the story is not about a network or the television commentators. It is not even about an industry. Rather, the narrative resembles a folktale insofar as it retells an old story, embellished by a gaggle of technological devices and plush corporate suites peppered with political intrigue. Yet these elements do not tell the story. The visual splendor of the film, its trapping of social

criticism, may have constituted its conscious and purposive element. But its ideological issue, perhaps hidden from its makers, is the unconscious content of the film.

–V–

The function of academic criticism since the end of World War II has been, largely, to save high culture from its eclipse by the spectacle. In order to accomplish this feat, it had to find a way to elevate the work of art to its privileged place. Only by restoring the aura to the work could this task be done. While Walter Benjamin was certainly right to have noticed that the result of the mechanical reproducibility of art was to remove the aura from the artifact, he was not correct to have argued that aura itself was destroyed. The postwar era has been marked by the emergence of the conductor to the position of stardom, of the performer in popular music and film, and of the critic in literature and, to a lesser extent, in films as well.

The composer and the novelist no longer rank as the objects of creative admiration. Now, as Barthes himself has asserted, criticism must be regarded as a form of literature, a creative process which relies as little on the novel or poem as upon social or historical referentiality. The critic may, for convenience's sake, take a work of literature as his ostensible object. But the acts of interpretation or deconstruction are the real art, since the work contains no inherent signified or meaning. Meaning, if the category is permissible at all, is the property of the audience. And, as "serious literature" is almost exclusively intended for university audiences, the literary theorist or critic occupies the pinnacle of power in this sphere.

Clement Greenberg's power in the New York art world in the decades following World War II was awesome. While Greenberg's writing and criticism is certainly unremarkable, he was able to invoke the category of "cultivated taste" to a position of eminence. Judgment rested upon taste, and became a moral as well as an aesthetic criterion in Greenberg's later criticism.

Music critics have enjoyed less autonomy than those in the academy who write art or literary criticism. But the conductor as star, exemplified best by the careers of Toscanini and Leonard Bernstein, has outdistanced the significance of composers and instrumentalists. The eclipse of the performer may be attributable to the decline of craft in modern society, and the concomitant rise of the conductor is certainly connected to the

prestige and preeminence of the large-scale organization in all phases of modern life. The conductor is the quintessential artist because he manages a great number of disparate parts and welds them into a coherent whole. Just as the literary critic must make sense of the text, since it is bereft of its own necessary system, the conductor rather than the composer has become the object of public adulation in a period where nothing seems to be going right. Just as Howard Hughes, the mysterious empire builder, became a mass cultural figure, Leonard Bernstein became a high cultural pinup. In terms of the structure of the relationship between Bernstein and his audience, there was no essential difference from that which obtained between the Beatles and their audience. In both cases, the performance was a spectacular sign of a "bigger than life" event, in which the power of an individual to dominate the mass replaced the dialectical relationship of artist to public.

Power consists in the critic's capacity to construct a new work of art from the text, which now must be regarded as merely the raw materials for that construction. Recent structuralist and poststructuralist criticism has evolved a procedure for achieving this purpose: the first task is to deconstruct a text by "interrogating" its productive tools. That is, formal aspects are abstracted from the narrative content: the codes that are embedded in the narrative are identified and named. But since these involve the return to such proscribed areas as the social and historical, only those that pertain to the production of the text are discussed, such as the linguistic or semiotic codes. Even the hermeneutic codes, which might discuss the text as a commentary upon other texts or narrative paradigms, may be mentioned, but are certainly not probed to the same degree as those sign productions or linguistic elements that may have purely internal references.

On an even more general level the critic attempts to name the mode of discourse. Characteristically, the twentieth-century seems to have abandoned all but the ironic mode, having found no cause for employing tragedy or any of the more traditional discourses. The ironic mode is appropriate to the artist who wishes to obtain distance from a social reality which seems incapable of comprehension or appropriation. Irony becomes the self-commentary of the writer upon his own writing as well as upon that of others. Of course, criticism itself tends towards the ironic, because it has discovered the absurdity of its own power to create the text by deconstructing it. The discussion of irony is a way of relativization, for to transform a text into a form of mockery is a

way of abstracting its signification. And since signification is a way of valorizing the stance of commitment, the divestiture of meaning turns into the cynical.

Here again we can observe the convergence of high culture with its mirror image, mass culture. For it is clear that hardly anyone can take the manifest content of a science fiction, detective, or Western novel seriously, except by a process of its deconstruction. But this procedure requires the abstraction of form from content, so that mass culture can only become an object of study by transforming it into something else, namely, raw materials for critical creation. The exact fate awaits what is called "literature," that form of the narrative or poem which is valorized as art by critics. Having determined that the artifact is worthy of deconstruction, the critic is obliged to disregard the "art" that may defy analytic procedures, but instead would require a synthetic approach, particularly the effort to discover the relation of the work to its culture as much as to its internal structure. Such an effort preserved the truth value of the work of art against the effort to reduce it to a series of discrete objects for scientific investigation.

The reduction of the artistic totality to its serial aspects constitutes a self-fulfillment of the critical project. Its philosophical presupposition is that the real world is unknowable, and that art is not a form of knowledge even if comparable to normal science. Art is merely expressive of its own technical means and is a form of play, the play of words and images of things that are preeminently metaphorical or metonymic. Thus writing typically draws its representations from other representations rather than constituting a reflection of the real world. Alternatively, its explanatory technique relies on the simultaneous abstraction and fragmentation of a totality into a part which is taken as the whole. Under no circumstances does the novel represent more than itself. Its constructions are caught in a web of fictions, not just in the conventional sense that the plot is not literally true but is a product of the artistic imagination, but also in terms of its capacity to evoke such social phenomena as ideology, everyday life, historical activity, and so forth.

The reduction of art to fiction deprives it, or any discussion of it, of its truth value. In the hands of recent academic criticism, literature has become the object of a pseudo-science that declares, in advance, its purely speculative and asocial character. Thus, the critic becomes a philosopher whose object is to destroy philosophic discourse. That is,

the traditional task of philosophy, which was to discover the logical conditions for the discovery of the unitary nature of the world, is denied, as much as the presupposition of its knowability.

Most recently, having discovered that all discourse, whether philosophic, scientific, or literary, can be treated as a text because its truth value is *a priori* illusory, the critical project has turned to the task of showing that everything taken as truth is in principle reducible to the types of literary analysis. Hayden White has written a book whose object is to demonstrate that all historical writing is actually "metahistory." Far from constituting some description of what actually happened, he treats historiography as no more than a variety of tropes and modes of literary discourse. The historical takes the part for the whole, invents a theory of causation that is problematic because it adopts a conception of temporality based upon principles that may be recorded as drama. The narrative, then, consists of tropes whose presentation corresponds to modes of discourse which are essentially arbitrary in temporal terms. The idea of temporality, in which past, present and future are sequential, itself may be a construction of the human mind, and thus all historicity must be taken as myth. White, following Lévi-Strauss, levels a sharp attack on the concept of historical stages, especially in terms of the idea of their hierarchical character. Like literary critics who emanate from the structuralist school, White can offer nothing that is urgent about the study of history. For if past, present, and future are incapable, in principle, of demonstration, what follows is a view that history, like literature, is a type of writing in which the subject is the author, not a group of historical actors. The author deconstructs and constructs history according to a series of categories of thought and expression that frame events in their own image.

It may be that the tendency of modern cultural and metahistorical criticism to an extreme nihilism expresses the failure of history to provide the materials for retaining our faith in its progressive character. Certainly, the idea of progress has suffered severe attacks in the twentieth-century for reasons that have to do with the unintended consequences of revolutionary success as well as its failure. The exigencies of the social world, its apparent lawlessness, have finally been matched by the nihilism of intellectuals who see no hope for reconstruction, except as a creative act of criticism. We have entered the age of the critic as producer, replacing both the masses and the artist. If art can produce no more than fragments of reality, if the idea of subjectivity

dissolves in the reified object, if the character of politics is nothing but betrayal, the only task left is to interrogate all that has been held sacred, to reduce it to rubble, and to invest in the business of criticism, the only valid art or social theory.

The inheritance of the aura has clearly passed to the critic, the conductor, the director. Their interrogations of literature, painting, music, and other art forms replace the mediated relation to social and historical life that has constituted the basis of expressive forms. When the writer and the painter can only reproduce object relations, because they have lost the categories of mediation and have retained only technique, when culture no longer expresses an intrinsic meaning, except insofar as it expresses, unwittingly, certain linguistic and semiotic codes, then the act of interrogation becomes the source of signification. Hence, the critic as star.

NOTES

1. John Crowe Ransom, *The New Criticism* (Norfolk, Conn., 1941).
2. John Fekete, "The New Criticism: Ideological Evolution of the Right Opposition," *Telos* (20), pp. 2–51.
3. See, especially, Granville Hicks, *The Great Tradition: An Interpretation of American Literature Since the Civil War* (New York, 1933); Edwin Berry Burgum, *The Novel and the World's Dilemma* (New York, 1947); and Michael Gold, *The Hollow Men* (New York, 1941). A somewhat more interesting and more broadly based example of Marxist criticism in this period is Harry Slochower's *No Voice Is Wholly Lost: Writers and Thinkers in War and Peace* (New York, 1945).
4. Wilson's work is vast. Together with Van Wyck Brooks, he is probably the most representative American liberal critic of the 1930s.
5. *The Crisis of European Sciences and Transcendental Phenomenology* trans. D. Carr (Evanston, 1970).
6. See vol. six, *General Psychological Theory,* of Freud's *Collected Papers,* ed. Philip Reiff (New York, 1963).
7. Claude Lévi-Strauss, *Structural Anthropology* trans. C. Jacobson and B. G. Schoepf (New York, 1963), and *The Savage Mind* (Chicago, 1966), especially the last chapter.
8. This interpretation may seem controversial since all three consider themselves Marxists. But I think that, especially in Althusser and Balibar's *Reading "Capital"* trans. B. Brewster (London, 1970) and in Macherey's *Pour une theorie de la litteraire* (Paris, 1966), the strong structuralist positions are dominant.

9. See Jacques Derrida, *Of Grammatology* trans. G. Chakravorty (Baltimore, 1976), also *L'Ecriture et la différence* (Paris, 1967), and *Speech and Phenomena and Other Essays on Husserl's Theory of Signs* trans. D. B. Allison (Evanston, 1973). Also consult Michel Foucault, *The Order of Things: An Archaeology of the Human Sciences* (New York, 1970), and *The Archaeology of Knowledge* trans. A. M. Sheridan Smith (New York, 1972).

10. Max Horkheimer and Theodor Adorno, *Dialectic of the Enlightenment,* trans. J. Cumming (New York, 1972), especially "Enlightenment as Deception: The Culture Industry."

11. I am referring, of course, to *Gravity's Rainbow,* which may be seen as Pynchon's decisive break with the novel and his attempt to declare the world nothing more than a pastiche of history, fantasy, and conspiracy.

12. The term "deconstruction" is taken from its use in poststructuralism, where the text is taken as a sign of something other than itself, without necessary referent. Deconstruction, in its usage by Derrida, involves a process of decentering, that is, of trying to expunge the metaphysical assumptions of all thought by the privileged activity of writing. Much of my understanding of this concept is due to conversations with Emily Hicks.

13. George Bluestone, *Novels into Film* (Berkeley, 1957).

14. See Stanley Cavell, *The World Viewed: Reflections on the Ontology of Film* (New York, 1971); and Christian Metz, *Film Language: A Semiotics of the Cinema,* trans. M. Taylor (New York, 1974). In Metz's work the idea of a film ontology is mediated by his effort to show the semiotics of film. But the preoccupation of semioticians with visual culture seems to indicate that the theory of signs finds its most important object in visual "representation." Since the notion of representation is thrown into question by semiotics in its insistence on the disjuncture between sign and signified, the idea of film as ontology is generated by the theoretical presuppositions of the semiotic method itself.

15. Michael Fried, "Art as Objecthood," in *Minimal Art: A Critical Anthology,* ed. Gregory Battcock (New York, 1968).

16. Of course I am aware that in the recent past American art has returned to a kind of romantic realism that can only signal the exhaustion of painting as an art form in our era. Hyperrealism, which has emerged along side, continues the literalist tendency which I believe remains dominant in our culture.

17. Alain Robbe-Grillet, *For a New Novel: Essays on Fiction* trans. R. Howard (New York, 1965).

18. All quotes are taken from *For a New Novel.* Published in 1963, this work forecasts the central thrust of structuralist theory: the end of the subject. It may be understood as its first literary-critical expression, parallel to Lévi-Strauss's work in the same period.

19. Roland Barthes's introduction to Robbe-Grillet's *Jealousy* trans. R. Howard (New York, 1959).

20. Foucault, *The Order of Things*.

21. I am indebted to Debra Bazeley's unpublished paper on Alexander Pope for this knowledge.

22. The best treatment of the rise of advertising in the US is Stewart Ewen, *Captains of Consciousness: Advertising and the Social Roots of the Consumer Culture* (New York, 1976).

23. Theodor Adorno, *Introduction to the Sociology of Music* trans. E. B. Ashton (New York, 1976).

24. Theodor Adorno, *Philosophy of Modern Music* trans. A. G. Mitchell and W. V. Blomster (New York, 1973).

25. All citations from Roland Barthes, *S/Z* trans. R. Miller (New York, 1974).

4

OPPOSITES DETRACT: SONTAG VERSUS BARTHES FOR BARTHES'S SAKE

Imagine a Reader, arranged chronologically, that purports to offer representative selections from Albert Einstein's work but omits a text on the theory of relativity. The editor's introduction says that Einstein's writing "begins and falls silent on the same subject—that exemplary instrument in the career of consciousness, the writer's journal." Later we learn that Einstein's endeavor was quintessentially "a literary one . . . the theory of his own mind." Susan Sontag virtually ignores the Roland Barthes who constructed a theory of semiotics and applied this theory to the prose of the world. The scientific man is relegated to the margins of the *Barthes Reader*'s nearly five hundred pages. Sontag offers a single long essay, "Introduction to the Structural Analysis of Narratives" to thwart criticism that her Barthes is little more than a mor-

alist, a man of letters, and most of all, a "protean autobiographer." In short, Barthes is presented as an aesthete whose subject matter is Roland Barthes, the latest entry in the list of writers who are engaged in perennial advertisements for themselves.

Over the past thirty years, Susan Sontag has become the major American example of the critic as star. She is an enfante terrible of the literary establishment, a passionate advocate of high art, and a defender of some pop art. She is also a patron of writers who speak in foreign tongues, a collector of European stars, a would-be creator of literary canons, and, like Norman Mailer, that other ex-darling of the postwar literary avant-garde, an excellent publicist for herself.

Sontag has framed Barthes's work in the categories of sensibility, beauty, style, and taste—the very qualities for which she herself is known. Simultaneously, she has produced the version of herself she wants us to believe: a collection of her own writings lovingly introduced by Elizabeth Hardwicke. Sontag expresses stardom by disdaining explanations for the criteria that animated her choices. By juxtaposing the two collections, though, we get the answer: Sontag introduces Barthes to the American reader by remembering him in the image of the critical tradition from which she derives. She has recreated Barthes as her double. To drive this point home, she concludes the *Sontag Reader* with her introduction to the *Barthes Reader*.

In many ways Sontag is the antithesis of Barthes, who was often engaged in a brutal and even comical deriding of mass culture while at the same time trying to find the elements of its self-trancendence, the dimension that both signified contemporary social life and linked the most banal events (wrestling, for example) to the unchanging tropes of all culture. He was a Marxist in that peculiarly French manner, observing few rituals of the doctrine, mixing it with other traditions, yet proclaiming himself a "man of the left." Barthes's scientific preoccupations, his relentless efforts to find a model through which the cultural process could be understood, and his profound interest in everyday life contrast sharply with Sontag's obsession with writing as such, her single-minded insistence that art is about art. But as with Walter Benjamin, Antonin Artaud, and Robert Bresson—other writers she has championed—Sontag cleanses Barthes of his dirty materialism.

Early in her career, Sontag reacted against the desiccation of literature by sociology; her work offered, in its own time, a liberating vision. This world view has become conservative doctrine in the wake

of theories that have battered our shores from France and Germany. Unlike the early sociologism against which Sontag railed, theorizing is today sensitive to the fallacy of reductionism; it often succeeds in enriching our understanding rather than detracting from the pleasure of the text. Barthes, of course, is a theorist of this kind, a writer with a powerful will to abstraction, one who is nothing if not a philosopher.

In one respect, Sontag's take on Barthes is not all that difficult to understand. Barthes is the preeminent European example of critic as media figure. It is not only his self-preoccupation or even his glittering prose that draws the reader into the orbit of his mind as he rummages through paintings, photographs, graffiti, and other bits and pieces of the artistic casbah. Barthes's literary scraps become occasions for revealing himself. It is not the artifact itself that interests us in Barthes's commentary, but his relationship to it. His angle is always odd. In contrast to the ordinary literary critic or historian who approaches writing from the point of view of its main elements, treating the author as an object to be exhaustively drained of life, Barthes selects from the author's work those aspects that reflect upon the critic's imagination. ("There are three Mediterraneans in Racine: classical, Hebrew, and Byzantine. But poetically these three spaces form only a complex of water, dust, and fire.") Racine, Fourier, Pascal, the entire corpus of high French writing, is subject to his readings. But Barthes is unconcerned with the reifications we call literary criticism. His renderings are like a physician's effort to bring a patient back to life through artificial respiration. His own sensibility is the breath that makes the organs function again. He uses the work of art both to illuminate himself and to reconstitute the past in terms of the present. This process differs markedly from Sontag's advocacy of the self. In order to merge herself with Barthes, to fashion a single discourse, she has been obliged to uproot the Europeans she so dearly loves from the soil that nurtured them.

Susan Sontag is not only a product of her times, but of the tumultuous career of the avant-garde. She arrived on the intellectual scene at a time in which the past held little interest and the present offered little challenge. Sontag's generation reacted against the deep politicization and the partial Europeanization of American intellectuals in the 1930s. In that "red" decade, many discovered scarcity for the first time,

and were forced to dip their pens and brushes in the muck of practical politics. Those who had come to understand the 1920s as a cultural void, and fled to self-imposed European exile, returned with the names of Picasso, Malraux, and Gide on their lips, and the idea that the political avant-garde was not so different from the artistic.

After World War II, America told the intellectuals to return to their little magazines, their espressos and French cigarettes, or to become copywriters in advertising agencies. Some formed circles that proclaimed themselves an avant-garde. By the late 1950s, in the wake of the Cold War, the older political art and social criticism came under severe attack. Art and literary criticism were enlisted in the holy crusade to save Western culture, civilization "as we know it," from two mortal enemies: the influence of mass culture, and the penchant of intellectuals—especially those on the left—to apply political, ideological, or philosophical criteria to artistic judgment. For those who came immediately before Sontag—Lionel Trilling, William Barrett, the New Critics, the *Partisan Review* (in which she published some of her early essays)—art was the last refuge of humanism in a world dominated by political struggle and intellectual degradation. For some of these guardians of the true faith of high culture, the culprit was simply Soviet-style Communism, expressed as social realism. Dwight MacDonald and the writers for his journal *Politics* had a more sophisticated analysis. They saw the increasing power of mass communication as a major cause of the erosion. Art critic Clement Greenberg celebrated Jackson Pollock and abstract expressionism as the ultimate avant-garde.

For Greenberg, Sontag, and others, the chief mechanism of misunderstanding was a traditional conception of the Western philosophical tradition: art as imitation. Moreover, mimesis had become the flag of Marxist dogmatism. For those who had come "up" from the 1930s—the disillusioned critics who had championed the artistic avant-garde even as they remained partisans of socialism—art for art's sake, its freedom from political control, its self-referentiality, became a new battle cry. The irony of the 1950s was that political arguments were employed to justify the proposition that art was a creation requiring no social presuppositions, a subversive activity because it disdained politics in a politicized world. If these critics found themselves allied to the State Department and the postwar conservative attack on political art, it was a case of politics making strange bedfellows, a coalition of convenience. Many who had been reared in the heady era of Bolshevik revolution

mourned the severance of art from politics, but concluded that it was the price they had to pay.

Although Sontag produced her major work in the 1960s, she is the true inheritor of the fifties critical avant-garde. For her, the self, with its multiple manifestations and its Freudian dark sides, is the proper subject of art. Writing, painting, music, and film are explorations of the moral sense. She never tires of asserting the primacy of form, but unlike Kant, she returns sensibility to the receiver; it no longer enjoys an objective existence. Thus, "style," another of her favorite categories, becomes not a social form, as with Barthes, but the mark of individual achievement. Sontag is the prophet of genius. These characteristics are most evident in her magnum opus *Against Interpretation,* which carried on the tradition of those for whom art is the rebellion against society— the book became the *Fountainhead* of high culture. Her mission was removed from the Cold War, since (until recently at least) she wasn't obliged to invoke the rhetoric of anti-Communism. Instead, she became the idol of many, including the New Left and the emerging feminist movement, for whom the social world was inauthentic and the routines of everyday life an insult to their concept of moral existence.

This search for authenticity could not, despite her intentions, produce a new avant-garde. Instead, college students, estranged from bureaucratic institutions and antiseptic suburbs, took her condemnation of the intellectual establishment as an invitation to plunge into politics. As with many gurus, Sontag followed her followers for a while; she wrote polemics against the Vietnam War, temporarily leaving behind her searing renunciation of social reality as an object of critical exploration. None of these tracts appears in the *Sontag Reader.* The only remaining trace is her essay on Walter Benjamin, which reveals that she never abandoned the struggle to make art a vehicle for cosmic salvation and personal redemption. Sontag sees Benjamin as a writer obsessed with deciphering the self, an autobiographer and artist more than a critic. Benjamin, a peripatetic European intellectual, became, in turn, a careful student of German tragedy, a reader of the cabala, a friend of Brecht's, and a member of the Marxist-oriented Frankfurt Institute for Social Research. Sontag's Benjamin essay, included in *Under the Sign of Saturn,* joins the struggle to appropriate this elusive writer, taking the side of Benjamin's friend Gershom Scholem, who would make him a mystic, against that of writers like Fredric Jameson, who brought out his radical politics and love of political art.

Sontag is, in short, a modernist. And reading fragments of nearly all her major works, including her fiction (she has curiously omitted *Illness as Metaphor*), I was struck by the obsolescence of modernism. Her work contains echoes of Camus (there is an essay on Simone Weil); and early Sartre, the great tribune of the search for personal meaning, prowls silently through her writing. Her moral stance is strangely antiquated: as Alasdair MacIntyre has persuasively argued, the foundations of morality on which modernism rests have been undermined by the fragility of a social order that can give rise only to a situational ethics. We cannot assert the permanence of art or its capacity to suggest an unchanging human nature in an age where self-interest (displaced to irony) obliges us to postmodern forms. Contemporary writers—Pynchon, Dick, DeLillo—offer a metacommentary on genre fiction. Critics may no longer search the roots of our intellectual life because we are too jaded to forget that memory is selectively shaped by our own predispositions.

Roland Barthes is certainly a postmodernist, although Sontag has managed to squeeze a modernist image from elements of his work. Insofar as modernism contains a trace of nostalgia for the romantic past, and insofar as Barthes is a model for critics who want to make themselves a subject of infinite fascination, there's enough raw material for Sontag to create a canon of interiority, style, and self-involvement. Before his death in 1980, Barthes was becoming more and more fascinated by the process of writing. And in his last years he found in his own life an infinite source of subjects. He discovered that the text was not just an object for critical surgery but a pleasurable activity.

Although a distinguished professor (his appointment at the College de France is the highest academic honor his country offers), Barthes did not live the life of a scholar for whom the past is a monument to be revered. In his work, he wanders among the garbage cans of mass culture, as well as examining the corpses of past "high" literary production. Barthes selects the image as a system of signs; contrary to the ordinary view of the photograph or book illustration as representations of a specific object, he finds "a phenomenon of connotation (connotation, a specific linguistic notion, is constituted by the development of a second meaning)." Barthes challenges the efficacy of the "first meaning," the claim that images represent a definite object in time and space. Much of his work concentrates on second meanings, the implied sig-

nificance of an image that belies its denotative dimension. The second meaning refers to symbols and myths which, for Barthes, are clusters of images/signs that produce signification. These are inscribed in culture and make a ritual of everyday life.

He calls the first meaning the *information* level, the communication of details about the objects in a particular context. The second level is the *symbolic;* in his reading of Eisenstein's *Ivan the Terrible* (included in the *Reader*), this is signified by gold presented not as a metal but as a sign of greed, power, and above all transcendence. In this essay, "Third Meaning," Barthes draws signification from the sciences of psychoanalysis, economy, and so forth, where the same symbol possesses more than one connotation and is discovered through symptoms. The third level of meaning is that in which the image/sign signifies no definite content, neither representing a specific object nor a single symbol; it signifies an infinity of mutations of meanings which are transformed in different contexts. Barthes names poetics as the sphere "of infinite vibrations of meaning" emanating from the literal object. These infinite vibrations are the heart of Sontag's Barthes. She places the writer in this "ambiguous, obtuse" region of meaning where the theory of his own mind may be explored most deeply. For if meaning is infinite, it cannot be constrained by social, political, or even literary boundaries. Consistent with the impulse that runs through her own career, she prefers to aestheticize the critic's activity.

Semiotics, which for Barthes and his colleagues was an effort to generate a science of culture, is represented in the *Reader* only in its application. It is no longer a universal tool for understanding, merely a display of elegance. Hidden in the prose is an elaborate critical apparatus, a treasure of categories derived from Cartesian and Kantian thought, but also from Aristotle. Perusing the *Reader,* we wouldn't suspect that Barthes's cascades of insight are rooted not only in an exquisite sensibility, but also in a rigorous scientific purpose. Sontag's *Barthes Reader* unintentionally says a good deal about America's reaction to one of the most powerful influences in our intellectual life—the French connection. In the past fifteen years a new generation of American critics has been reared on structuralism and semiotics (which are by no means the same thing). The will to abstract from particulars, to identify the most general features of cultural life, to obliterate spurious distinctions between high art and popular art by showing that the juxtapositions of signs, codes, discourses are universal features and that

art is a kind of production rather than sensibility—these impulses have invaded every crevice of cultural inquiry in America. Not only literati, but also historians, anthropologists, philosophers, and social theorists have been infected with the will to deconstruction; their goal is to analyze discourses, whether of art or politics, as aspects of the same social reality. In universities and other places where critics gather, theorizing dominates literary criticism. Of course, a counterattack is underway. Sontag is linked, ideologically if not politically, to such critics as Denis Donoghue and others who write tracts *Against Theory* (the title of a new manifesto of the old guard). They contest the terrain of journals and professional associations that have become increasingly hospitable to Foucault, Derrida, and Barthes.

Sontag is in a strange position. Intellectually, she is allied with the conservatives, emotionally she is susceptible to the foreign virus. But she cannot avoid a critical conscience that is profoundly antithetical to theory. Thus, remarkably, she omits from her *Reader* the most trenchant illustration of semiotics as method, Barthes's book *S/Z,* an analysis of Balzac's *Sarrazine.* Contrary to other readings, particularly that of Georg Lukács, Barthes does not see Balzac as the quintessential chronicler of the transition from peasant to urban society, a master of critical realism who represents social and historical reality in terms of everyday relations of the French middle class. Instead, Barthes shows that the story can be broken down into a series of codes whose combination is relatively arbitrary. The significance of the story is produced by Balzac's juxtaposition of various cultural, literary, and historical tools, combinations that yield unintended consequences of which Balzac himself may have been ignorant. The seamless text is just the first level of meaning; Barthes understood that when we begin to snip the sutures, we discover a "thousand meanings," because language is not only a prison house, but an infinitely useful toolbox of significations.

Barthes was too shrewd to ignore the power of technology. Like Walter Benjamin, he knew that we can rediscover experience only by slashing through the gears, that any circumvention is doomed to failure or, even worse, to irrelevance. What gives Barthes's writing its sense of excitement is the degree to which it is *in* but not *of* the information society. Sontag, like the rest of us, is a part of her time. But her time is no longer ours. The self, still struggling to stay alive, will not survive the archaic avant-garde. My Roland Barthes is a writer who subverts technological society by burrowing his way through the apparatus, not

by avoiding it. He sticks one leg in the scientific and philosophical camp and keeps the other in art. He is the electronic musician of criticism. Barthes interests us because, like Benjamin, he slips from our prefigurations, because he is out there, poking in unexpected places and doing it in unforeseen ways. When we catch up with him, we will have spanned science and art; the aesthete will be dead, the technician overturned.

5

THE TENSIONS OF CRITICAL THEORY: IS NEGATIVE DIALECTICS ALL THERE IS?

I

The learned essay,[1] not the treatise, is the authentic genre of critical theory, the term adopted by scholars at the Frankfurt Institute for Social Research to encompass both their philosophy and their social theory. The term connotes an intention to oppose general social theory, which in its classical exemplars generates positive categories from which the propositions of social science may derive. Thus, in contrast to the treatise which, typically, sets forth definitions from which a series of empirical hypotheses may be tested, the essay form, which is both more discursive and more speculative, is employed because critical theory is suspicious

of the application of norms of physical and biological sciences to human relations.

In the first place, true to its Marxist roots, the leading exponents of critical social theory (CST), Theodor Adorno, Max Horkheimer, and Herbert Marcuse, were urgently concerned with history, not only that of society but also, perhaps predominantly, the break between natural and human history as regulative of relations within the social order. For the Frankfurt School, the domination of nature was a defining event in human history. With Weber, Horkheimer and Adorno understand the history of capitalism as a disruption of the relatively stable social order marked by a low level of technological development and a moral order in which nature was accorded substantial respect. An agrarian-based ethic is displaced by a new ethic in which nature becomes an antagonistic "Other" to society, and ethics are defined by the degree to which mankind devotes itself to exploiting its natural environment to meet historically defined human wants or needs (Horkheimer and Adorno 1972; Marcuse 1978).

However, while Weber privileges self-denial and work as the content of this spiritual upheaval, CST focuses on the changed relationship between humans and nature made possible by science and technology. On the one hand, biological science places "man" at the apex of natural history; on the other, science becomes a metaphor for dominion of the new capitalist social order over the natural order, the laws of which, having been discovered by experiment, become the foundation of human intervention (Horkheimer and Adorno 1972, 3–42). Scientific ideology postulates that we are no longer bound to our biological givens. As Parsons argues, fully consonantly with this tradition, society is governed by norms, by the cultural system. The organism constitutes only a boundary condition for other systems, but does not control human destiny (Parsons 1951, ch. 1; Parsons 1955, 627–33). In fact, after Weber, whose later investigations constitute a tacit critique of his earlier historical preoccupations, social theory loses its historical dimension, as time itself is taken as merely a framework for the structural and function relations between system and subsystem of the social and cultural order (Parsons 1951, 11). General social theory, true to Durkheim's rule to treat the social as a fact *sui generis,* generates hierarchically arranged categories of (social) Being (Durkheim 1966 [1938]).[2] The lower forms are, ineluctably, functionally linked to the higher forms,

and thereby retain only a relative autonomy from the system of which they are a contingent part; they owe their existence to the "control" by the higher system. Thus, while the biological organism is a condition for the personality, and social and cultural systems, in Talcott Parsons's theory the cultural system embodies the norms by which society retains equilibrium.

Parsons models his sociology on classical mechanics, with its categories of inertia and equilibrium, and borrows from biology a systems approach, according to which change, indeed any notion of temporality, results from external influences that disrupt the natural inertia of society. He follows Pareto in holding only the personality, which determines the organism's goals (within the framework of a relatively fixed normative order), to be subject to significant variation, and appears, at least until Parsons' later years, to be the wild card in an otherwise coherent system (see Pareto 1963 [1935]). This coherence is spatially arranged in a series of relations which are relatively fixed. What has become the fundamental departure of relativity and quantum physics from the classical Newtonian framework is assiduously ignored in Parsons' schema—the question of the space-time continuum and, more profoundly, the whole scaffolding of causality in the Newtonian system:

> Time relations present what, for us, is a simpler problem. All the empirical sciences take it for inexorable fact that certain events have occurred at given times and in given time sequence. Given certain antecedent time determinations other time determinations can be deduced by theoretical reasoning; this is what we mean by prediction in its temporal aspect. But time is never a manipulable variable; time is a frame of reference within which one can state and interpret the assumptions about and the consequences of the operations of manipulable variables . . . time is one fundamental aspect of the givenness of the empirical world which provides the empirical base from which any deduction or prediction can be carried out. (Parsons 1955, 638)

Of course, Parsons allows for "exigencies" between system and subsystem, but these are relegated to "deflections" in an otherwise invariate structure within which internal relations are fixed by determinations of hierarchy (ibid., 632).[3]

In the current revival of the philosophy and social theory of the Frankfurt School, two distinct modes of appraisal can be discerned: by

far the most prevalent is critical theory as a somewhat iconoclastic social theory that accounts for historical changes: the problem of technological domination in late capitalist societies; considerations in the cultural and political history of Fascism and especially the rise of the authoritarian state; the problem of mass culture and consumer society as subversions of democracy; the relevance of psychoanalytic theory to understanding social life. Some of these themes were taken up by others, although in a different way. For example, Parsons himself openly invokes Freud's categories of cathexis and the unconscious to explain disruptions in system maintenance. Like Horkheimer, but with a different political perspective, Hannah Arendt (1956) derives the fascist moral and political order from some aspects of the Enlightenment, refusing the liberal view of the Holocaust as an astonishing mutation from the norms of Western culture. And Ortega y Gasset (1932 [1929]) sees the decline of the West as a consequence of the rise of mass culture, but from a deeply conservative standpoint which nevertheless postulates an integrated past in which high culture flourished, a position not far from that of the Frankfurt School. Despite the many political differences among these writers, they share a common bond of humanism and, Parsons excepted, a penchant for negative philosophical assumptions. That is, their concern is to account for disruption as more than contingent, but rather as the mode of being of contemporary life. In this mode such categories as equilibrium and inertia are exceptional, rather than regulative of social relations, at least in the twentieth-century.[4]

The second line of discussion concerns the problem of what might commonly be called "method." Of course, CST has no method if by that term we mean a theory of object relations from which one may derive a series of algorithms to guide research and experiment about the empirical world. Hence its characteristic discourse is reflexive and hermeneutic rather than scientific in the eighteenth-century meaning of the term. For above all, critical theory (the general philosophical position underlying CST) is a discourse about the relation of subject and object exemplified in the texts of philosophy, literature, and social and cultural theory and criticism. In this sense it approximates, however unwittingly, the collective biography of intellectuals situated in a concrete historical moment, the period between the two world wars when nearly all the old assumptions about the equilibrium conditions appeared to have collapsed or were in the process of disintegration. Just as the

Weimar environment gave rise to a new physics which built upon the classical orientation of relativity physics, if only to radicalize it, so, following Lukács's revision of Marx, the Frankfurt School insisted upon the relevance of subjectively meaningful action to the constitution of social relations. Lukács, influenced by Simmel's theory of reification, situated the reversal of capitalism's collapse in the power of the commodity form over human consciousness, and restricted his inquiry to the level of philosophic and literary discourse. The Frankfurt School, however, having rejected metaphysical speculation as a vestige of bourgeois ideology, turned to performing relentless criticism of contemporary fashions in German philosophy, and, in addition, to the practice of sociology.[5] In the 1930s its studies of the institutional frameworks of advanced capitalist social life, particularly the family and mass culture; the historical legacy of science and technology; and finally its studies of that great absence in historical materialism, the state, were in their totality efforts to break from the economistic bias of Marxist social theory.[6]

In effect, the first major contribution of CST was to explain the failure of the Western working class in the interwar period to reverse the rise of totalitarian and authoritarian states in advanced capitalist societies. They sought answers in the psychosocial deformations of mass consciousness. Thus the central category of explanation for the rise of Fascism was not, at the root, the laws of economic life, it was the transformation of mass psychology on the one hand and, on the other, the transformation of science and technology from forms of subordinate knowledge—tools of human purposes—to a new normative order.[7]

These ruminations are shaped, but by no means determined, by contemporary intellectual influences (see Horkheimer and Adorno 1972; Adorno et al. 1950).[8] Besides Marx and Freud, each of whom influenced the scaffolding of critical theory, providing the key orientations, we must add that of German phenomenology, particularly Heidegger and Spengler, whose different, though closely linked, critiques of the scientific Enlightenment and its philosophical underpinnings stunned the postwar intellectual communities, including scientists themselves.[9] We must of course also include Hegel, who, as Foucault (1972) has said, prowls through the twentieth-century, reminding us of the price we have paid for our antifoundationalism, especially our refusal of the totality. By this, Foucault means the possibility of a historical process of emerging self-consciousness whose outcome is the

identical subject-object. With Hegel, critical theory insists that the subject-object dialectic constitutes the structuration of society, the starting point of which is the part played by labor in the formation of humans, and whose key category is that of domination. In contrast to the Marxist concept of labor exploitation as the foundation of social structure, CST borrows from both the early Marx and from Weber the more general term "domination" because it encompasses a wider sphere of social relations; it thereby refuses to locate the determination of social divisions in economic life (see especially Marcuse 1964). Consequently, the subject is not identical with itself. It is fractured not only by class relations (the unequal division of the product of labor) but also by civilization's greatest achievements, science and technology. In effect, Horkheimer and Adorno argue, we have subordinated ends to means: the power of our tools of dominion over nature have penetrated our social unconscious, so that the self in both individual and collective terms has become little more than an instrument of its own domination by technology and technology's most egregious form, administration (Horkheimer and Adorno 1972; Horkheimer 1947). In modern industrial societies, executive authorities rule persons in the model of the administration of things, since the reflexive self is inimical to the achievement of a conformist social order which requires an other-directed character structure (Horkheimer 1947). And, because the rewards of the awesome industrial machine mankind has constructed on its knowledge achievements are so seductive, we can no longer critically reflect on domination as a generalized social form, because we have lost the capacity to distance ourselves from the world we have constructed on the basis of science. The subject is object-dominated even as it, in turn, dominates its natural environment.

These constructed objects now constitute our second nature. Reason, which became the religion of the bourgeois Enlightenment, had through its permutations within science become thoroughly instrumentalized, and could no longer provide the way to any truth beyond the propositions of science and their technological application in the work of dominating nature and humans. In effect, ethical and philosophical inquiry, now subordinated to science, had lost their critical character (critical in the sense of transcending the conditions of the given, empirical world). People in advanced industrial societies are capable of solving technical problems associated with social, political, and economic development, but we can longer see the larger transformations

that have delivered us into a new kind of political and moral slavery. Long before the rise of the current ecological movement, the Dialectic of the Enlightenment presaged the imminent revolt of nature against its masters. Having completely subordinated the external environment to fulfill human needs as configured by capitalist social relations, humans were themselves in danger of extinction. Taking nature as pure, instrumentally mediated object was itself the product of our blind evolutionary ideology. According to this, all "lower" organic and inorganic forms are subordinate to our will, and inorganic nature is taken as inert "matter," a passive receptacle of human intervention. Precisely what Parsons posits, the control by the cultural system over all human relations, produces not equilibrium, but crisis. Although the crisis has not fulfilled the letter of Marx's fateful prediction of proletarian revolution, but has been displaced into what C. Wright Mills (1951) calls "private troubles," ecological disasters and permanent wars, for the Frankfurt School there is no question of characterizing our social world by terms such as inertia.[10] Thus, the historical sociology of the Frankfurt School grounded its research on the basis of a philosophical anthropology that became the surrogate for method. Accordingly, the starting point of CST was to define the problematic of human sociation in terms of the need to secure human existence against a vicious and recalcitrant nature (Horkheimer and Adorno 1972; Marcuse 1978).[11] This ontological need is mediated by historical needs which are ever-changing according to the development of our collective powers over nature, but remained the irreversible element, both the boundary condition of the social order and the content of its social unconscious. Where Parsons holds time constant to enable sociology to predict human action, critical theory problematizes the goals of prediction and control, since these are the stuff of domination. Parsons posits adaptation of actors, and the integration of the action situation into the larger system of control, as a natural event subject only to exigencies; critical theory views the project of system maintenance as a system of domination, as inimical to freedom. Freedom consists in the capacity of actors to make themselves subjects, that is, beings capable of reflexivity and, consequently, of self-management. Therefore critical theory must negate science as conventionally understood as unimpeachable knowledge. Its negative philosophy is premised on the requirement that we need to be jolted from the ideology of inertia and equilibrium. The categories of general social theory cannot be taken at face value, but must be subjected, in the

interest of emancipation from positive science, to critical reflection (Adorno et al. 1976).[12]

From the perspective of the contemporary worship of natural techno-sciences as the model for all knowledge, Critical Theory appears, on the one hand, as a legatee to the romantic movement in German philosophy for which science had become one of the obstacles to freedom and, on the other, a throwback to metaphysics, which science supposedly consigns to the past (see especially Schelling 1988). Critical theory refuses the radical distinction between science and ideology, but claims, to the contrary, that the goals of science—prediction and control—are forms of "interest."[13] To this I would add that the claims of science to value-neutrality, by means of the scientific method, presuppose the efficacy of the laboratory situation, that is, abstraction of the object or processes from the natural context.[14]

To the reductionism characteristic of idealist dialectics, in which the object is reduced to a form which permits contradiction, Adorno counterposes the notion that "dialectics is the consistent sense of non-identity" (Adorno 1973, 5). This view contrasts with that of Hegel and Marx, for whom contradiction and totality are inextricably linked by the requirement that difference be resolved by a synthesis in which the elements of opposition are simultaneously preserved and transformed on a higher level. The negative dialectic asserts only the ineluctability of difference, and, in Gaston Bachelard's somewhat differently rooted version (1984 [1934]) argues that new knowledge can be generated only by an epistemological break between past and future. In Bachelard's *Philosophy of No* (1968 [1940]), critical exploration of the foundations of knowledge replaces method. Bachelard distinguishes his conception of the dialectic from an effort to follow in Hegel's footsteps. "What Bachelard calls dialectic is the inductive movement which reorganizes knowledge and enlarges its base, where the negation of concepts and of axioms is only an aspect of their generalization" (Canguilhem 1983, 196; my translation). By dialectic Bachelard means difference—not difference as pure negation but as a determinate complementarity. His major concern is to oppose monologism as an impediment to the further development and enrichment of science. Nor does the notion of a synthetic dialectic appear in Bachelard, for synthesis implies reconciliation of opposites on a higher level of identical being. Bachelard's theory of the development of scientific knowledge as a series of epistemological "breaks" prefigures by a quarter-century the per-

spectives of Thomas Kuhn (if not Paul Feyerabend), which have become virtually canonical for the philosophy of science since the 1960s. Bachelard's best-known works, *The New Scientific Spirit* and *The Philosophy of No,* were really readings of the philosophical implications of developments in modern physics which may be taken as an unintended effort to bring the "subject" back into considerations of scientific knowledge. As a consequence of the "crisis" of representation, the reflection theory of knowledge and the correspondence theory of truth have been overthrown; because acts of measurement are part of the "field" of inquiry, all knowledge is relative to its frame of reference and its truth value is at best probabilistic. These changes have only begun to call into question social scientific knowledge, which appears firmly ensconced in eighteenth-century assumptions.

Thus in place of determinate categories of which positive science is so fond, negative theory, in its quest for the sources of transformation, is caught between a critique of categories as fulfilling an ontological need, and its own will to explanation, a program which requires positive, unhistorically mediated categories (see especially Adorno 1973a). Bachelard addresses this difficulty by relying on categories of physical sciences to trace the transformations in their meaning. For example, the opening chapter of his *Philosophy of No* is largely a historical exploration of the varieties of the use of the concept of "mass" within different theoretical frameworks in modern physics. By rigorously adhering to the actual movement of science, he is able to show the remarkable degree to which this so-called empirical category is suffused with philosophical, metatheoretical presuppositions. From this style of theorizing, Bachelard powerfully influenced not only French philosophy but also social theory. Like critical theory, however, Bachelard has had only marginal influence in Anglo-American social sciences.

A similar strategy is adopted by critical theory, with the important difference that the death of the subject is not made axiomatic at the theoretical level but is traced as the outcome of distinctive historical developments. At the most philosophical level, Adorno's work is an extensive metacritique of the Hegelian categories, showing that, intentions notwithstanding, they remain profoundly antidialectical by affirming the positive as the outcome of negation and synthesis. But its concrete critical objects are the categories of sociology. As a consequence of its disdain for system-building, critical sociology becomes a critique of sociology's own categories—society, group, social agents,

culture, science and technology, politics, and the state, considered as forms of social knowledge and social practices.

In their short volume *Aspects of Sociology* (1972), the Frankfurt Institute for Social Research (intellectually and administratively directed by Horkheimer and Adorno at the time of its original publication in the mid-1950s), announces its critical intention from the outset: Sociology "is a child of positivism," which, although commendably founded to "free knowledge from religious beliefs and metaphysical speculation," surrenders, in its quest for scientific accuracy, the sense of the totality and condemns itself to partial knowledge. Sociology is charged with having sought not the specifically social or human relations but the "natural laws" governing human action in order to modify or control them. The tacit claim in this critique of sociology is that it is concerned not merely with discerning the "facts," however they are construed, but with modifying and otherwise controlling human action. In effect, social science can study humans with the methods of natural science because it takes social relations as objective relations, and at a distance. That is, the process of investigation is abstracted from the object of knowledge. Further, by slicing up society into a series of domains, the investigator is able to better grasp the date and make (partial) generalizations. But these domains are conventionally defined, and do not possess the status of "natural" fact. After the critique of the epistemology of sociology, it is to the sources of conventional categorical construction that critical theory devotes its attention, except where, in the case of prejudice, a solution serves the interest of general emancipation. The critique of categories becomes, for critical theory, an alternative to the artificial positivities of mainstream sociology.

Yet, the Frankfurt School recognizes the legitimacy of the specific domain of sociology—to discern the "laws of sociation; that is of social formation and integration." If this is the case, then the sociological investigation of the individual, given an understanding of society as a mere aggregation of individuals, is faced with severe epistemologial and historical difficulties. Should sociology accept the liberal evocation of the autonomous, thinking individual as the foundation for social investigation? If, as critical theory claims, the basis of a satisfactory relation of individual to society is a healthy, humane social order, it follows that the individual fate is linked to that of society, and the liberal assumption of individual autonomy (whether as an ontological or a methodological concept) is put into question. Further, is the in-

dividual an irreducible unit or is the individual nothing other than "an ensemble of social relations," as Marx claims? The presumption of methodological individualism which forms the basis of much contemporary sociological research becomes untenable if either of these propositions is accepted. *Aspects of Sociology* argues that the individual is itself a historically constituted category and presupposes the emergence of civil society in the late medieval period, when market relations—with their concomitant characteristics of competition between independent producers and other owners of property—dominated economic, social, and ideological relations, and, as Habermas argues, the separation of the public from the private spheres constructs new conditions for human interaction. By denaturalizing the individual and other categories of sociology, critical theory tries to show that, abstracted from its frame of reference, sociological knowledge becomes ideological in the sense of interested inquiry. In its characteristic American form (against which Parsons was the most outstanding exception), sociology puts the idea of society itself as a social fact in question, and with it, structuring concepts such as system and classes as historical actors.

Thus, critical theory joins sociology's critics, such as Robert Lynd, C. Wright Mills, and Alvin Gouldner, in asking the fundamental question: "Knowledge for what?" (Mills 1964; Merton 1957).[15] However, science is not irrevocably debunked and philosophy installed as the arbiter of all knowledge claims, in which the criterion of the historical frame of reference mediates truth claims. Instead, this historical frame of reference constitutes a series of categories which, taken together, may be construed as a general social theory. It is to this social theory that I now turn.

II

Contemporary social theory is deeply enmeshed in a debate about the relation between social structure and social agency. All of the canonical figures of social theory (Marx, Weber, Simmel, Durkheim) and their later twentieth-century successors have puzzled over the question because of its saliency to the problem of historical determination. None of the major theorists can avoid dealing with structure and agency, but their emphasis usually focuses on one or another side. For example, Marx is alternately labeled an economic or historical determinist, or a

voluntarist. But it is plain that, as a thinker influenced by nineteenth-century science as well as by its economics and philosophy, he was obliged to name historical subjects—classes—but placed strong emphasis on naturalized social "forces" which propelled classes, groups, and individuals to engage in action of historical consequence. Conversely, Weber's strong sense of the influence of economic structure on the course of ancient history was tempered by his investigation of the transition from feudalism to capitalism, where the role of subjectively meaningful ideas (in the Kantian, not the Hegelian sense) in producing social change is accorded primacy. Similarly, at the pinnacle of Parsons's structured social totality stand values which powerfully influence action; the cultural system, really the internalized values of any society, controls relatively variable subsystems. Indeterminacy is produced by external and internal variability, but Parsons is constrained to insist upon the objectivity of belief systems and their controlling power.

Critical theory, which itself rejects the artificial totalizations of classical Marxism, criticizes sociology's rejection of the totality but refuses, equally, a conception in which society is conceived as the sum of its parts, whether constituted by differentiated systems, by Durkheimian categories of solidarity and other equilibria, or by a single hypostasized structure such as Simmel's money economy. Even more, as we have seen, does critical theory attack the positivistic penchant, following writers such as Robert Merton, to divide the field of social investigation into a series of social problems. The only unity of these problems is provided by methodological inscriptions, the dominant values of which are observation and quantification.

The empirical referent of critical sociology is the history of societies. Its crucial "method" is immanent critique, if by that phrase is connoted a close analysis of texts—historical, literary, philosophical—even, as in the atypical case of Adorno's magisterial study, *The Authoritarian Personality*, survey forms. For each of the examined texts, the object of reading is to disassemble and otherwise disrupt apparently seamless narratives to show the hidden text, particularly its linkages with knowledge, power, and action. This investigation takes the form of ideology-critique, showing that knowledges that purport to be neutral observation—value-free theory, empirically "verified" fact—are a veiled discourse of domination. Beneath this mode of inquiry is the assumption that narratives, scientific texts, "information" typically conceal their content, which can only be revealed by interrogation as to

underlying motives and values—regardless of whether they are consciously held. This "procedure" presupposes a sociological community which has freed itself of scientism, the doctrine according to which scientific facts can be established by rigorous methods of empirical research whose fundamental feature is the apodictic status of knowledge gained through the senses, supplemented by rational calculation.

Perhaps two texts, Horkheimer and Adorno's *Dialectic of the Enlightenment* (1972 [1944]) and Herbert Marcuse's *One Dimensional Man* (1964) exemplify best how critical sociology unwittingly generates new, one might say positive, categories—not in the course of constructing analytic categories such as system and structure, but as a concomitant (not the outcome) of historically and hermeneutically based inquiry. *Dialectic of the Enlightenment* problematizes the rupture between myth and science, and thereby begins an investigation of the Enlightenment by subverting one of its underlying claims: to have freed knowledge (and therefore humanity) of the thrall of superstition. This is accomplished by choosing as a starting point the viewpoint of its most articulate tribune, Francis Bacon. Following Weber's notion that the Enlightenment signals the disenchantment of nature, Horkheimer and Adorno show Bacon as a key ideologist of the domination of nature:

Despite his lack of mathematics, Bacon's view was appropriate to the scientific attitude that prevailed after him. The concordance between mind of man and the nature of things that he had in mind was patriarchal: the human mind, which overcomes superstition, is to hold sway over a disenchanted nature. Knowledge, which is power, knows no obstacles: neither in the enslavement of men nor in compliance with the world's rulers. . . . What men want to learn from nature is how to use it in order to wholly dominate it and other men. That is the only aim. Ruthlessly the Enlightenment has extinguished any trace of its own self-consciousness. (Horkheimer and Adorno 1972 [1944], 4)

In Bacon's own words, the acquisition of knowledge is not undertaken for the purposes of "satisfaction" but to achieve "the better endowment and help of man's life." The old mysteries are to be laid aside, the old rituals abandoned, and our relation to nature is conceived as purely instrumental. In the process by which knowledge is subordinated to the specific ends, all social relations are instrumentalized, that is, made

subordinate to the imperatives of production. In turn, the development of science and technology becomes the key to such commercial activities as navigation, mining, and trade. While the aim of Enlightenment thought and practice is to facilitate the return of the subject to the social process in which "men" make their own history against a feudal order which subordinated individuals to the dictates of ecclesiastical law (which was identical, in many instances, with civil law), its long-term effects have been to raise technology to the level of social principle. In the service of "endowing" human life, nature has been subdued, but so has mankind itself. "Scientific" evidence becomes the arbiter of human affairs. Following a certain reading of Darwin's theory, Herbert Spencer, Francis Galton, and others offered biologically-based views of human intelligence and, more broadly, social fate. Although these ideas were temporarily eclipsed in the wake of the Holocaust, which employed racial difference to justify Jewish, gay, and gypsy extermination, they have made their way back to public opinion in the 1970s, 1980s, if not (yet) to public policy. After a prolonged period and during which Freud's critical and hermeneutic theory of the unconscious powerfully influenced clinical psychology as well as sociology, biologically-based theories of the brain, the new eugenics, genetic engineering, and Edward O. Wilson's sociobiology signal the return of the repressed. Quantitative social science has formed the backdrop of social policy's legitimation, and has, in proportion as state economic and social intervention increased, become a technological value orientation in itself. What Marcuse calls the "technological imperative" replaces religion or, to be more precise, becomes the new religion.

Marcuse argues from the premise that social relations have become near-identical with this imperative. Speaking in historical materialist terms, the critique of technology is, in the late twentieth-century, descriptive of practices in both the infrastructure and the superstructure, so that the distinction between them has collapsed. We may no longer speak of ideology in the nineteenth-century sense, since this term implies a relation between relative truths to statements in which "interest" predominates. Now we have seen the merger of ideology and science such that knowledge's validity can only be considered as a local case; for the system as a whole, all ideas, including scientific knowledge, religion, ethical judgments, derive their validation from the degree to which they are instrumental to achieving specific ends. For Marcuse, the existence of the individual, let alone the historical subject, is in

grave danger; for even before Francis Fukuyama reviewed the idea at the end of the 1980's, we may have reached the end of history, if by that term we mean the possibility of control by self-conscious subjects over their own social fate. Horkheimer and Adorno try to show the wide gulf between the objective of Enlightenment thought to free humans from the shackles of superstition, and the reality of science and technology as the new superstition. Marcuse is primarily concerned with the problem of agents. If we live in a technological society where critical thought itself is occluded by the progressive narrowing of public discourse to problems soluble within a technocratic framework, where systemic alternatives have been marginalized to the point of extinction; if our language has lost its capacity for the eloquence associated with negation, and consciousness can no longer take itself as its own object because the other-directed self is overwhelmed by the object-world; if everyday life is suffused with buying and getting, and our work relations have dissolved in a solitary relation with machines in which the old factory system is displaced by homework and other isolating environments, what possibilities are there for history, or for collective action in the interest of emancipation?

Marcuse and Mills (whose social theory owed as much to pragmatism and Merton's understanding of it as it did to CST) derived little solace from the early signs of "postindustrial" culture. The new, automated workplace failed to address alienation, and may have exacerbated its main features. Suburban life merely reproduced the forms of white-collar alienation and displaced them to living situations. Consumerism, practiced in suburban and exurban shopping centers, may tap libidinal desire but sap community life which once flourished, albeit under sometimes impoverished conditions, in the huge industrial cities. In the absence of the historic conditions for collective action—culturally diverse large cities, heavily concentrated workplaces, vital radical political traditions, and a public sphere where political discourse was part of everyday existence—the emergence of new subjects was highly unlikely. Although at the end of his life Marcuse began to see such possibilities in feminism and ecological movements, he never fully reconciled this changed perspective with the negative dialectic; nor could he completely free his theory of agency from the fundamental premise of socialist and Marxist thought grounded in the problematic of the proletarian revolution. To have recognized in the new social movements genuine moral and political agents would have entailed radical revision

of the dialectic of labor as the core of human existence. In Marcuse's thought mode, heavily influenced by Heiddegger's *Dasein,* labor is an ontological as well as historical activity—the predominant form of life. Hence, the entire scaffolding of technological domination and its consequence—one-dimensionality.

III

Beyond the negative dialectic's metacritique of scientific sociology, critical sociology investigates the social world with categories derived from historical materialism's negation of Hegel's philosophy of history and dialectic of the spirit. It presupposes Marx's theory of social formations, if not his stage theory, but does not privilege the categories of political economy to account for historical transformation. Rather, with Weber, the concept of instrumental rationality becomes the driving force of modern civilizations. However, rather than accepting, as did Weber, its institutional forms—bureaucracy, science and technology, and mass culture—as egregious but necessary compromises on the road to progress, critical sociology raises the stakes of social theory. We must scrutinize the transformation of reason entailed by the Enlightenment and examine its consequences in the course of world history. Horkheimer, in perhaps his most radical article (1940), argues that the authoritarian states of the 1930s were direct outgrowths of the dark side of the logic of capitalist development and not, as the liberals and Communists contended, horrific mutations in a seriously impaired liberal social order. Recall that, at the outbreak of the war, predominant contemporary leftist thought still believed that bourgeois democracy was endemic to capitalism; the rise of Fascism represented a political, not a systemic transformation.[16] Horkheimer, following Spengler's prescient observations in the second volume of his *Decline of the West,* as well as the Institute's own sociological investigations into the state and social institutions of Weimar Germany, especially its families and culture, concluded that genuine democracy had never taken root, that the structures of patriarchal authority, reproduced in the workplace as managerial power, militated against whatever political democracy had been codified in the Constitution. Further, the growing power of executive authorities, corresponding to the requirements of capital for state intervention to cushion the effects of the profound international economic crisis,

strengthened authoritarian tendencies even before the rise of Hitler to power. Mass culture, condemned but also dismissed by Marxist and liberal theory as little more than the latest outlet for capital investment—whose audience, the masses, has always thrived on bread and circuses—is now understood as part of the long-term consequences of the penetration of the commodity form and technological thought to all forms of the social world. Where Marxism, in this framework, consonant with the assumptions of liberal thought, retains its optimism that social engineering can cure all or at least most of capitalist-wrought ills, critical theorists, under the influence of Nietszche and especially Spengler, are haunted by the dystopian vision of the West's decline amidst a surfeit of honey. The masses, once heralded by socialists and radical democrats as the hope of humanity, are, under this new regime, its willing victims, even as they benefit from the pleasures of a technology-wrought affluence. By the 1960s Marcuse, in *One Dimensional Man,* can cite only the world's poor, systematically deprived of even a small share in what Mills called the Great Celebration of capitalist progress, and intellectuals' Great (moral) Refusal as potential agents. Yet this invocation remains, in his discourse, more speculative and poetic than analytic. In the hands of CST, historical agency has collapsed into an ethical ideal, since virtually all people in advanced industrial societies are more or less well off. Surely there is still considerable poverty in the US but, if the poor protest and revolt, technologically rich societies are capable of coopting nearly all economic demands by modification of the system of redistributive justice. Critical sociology does not predict the end of social conflict or of agency. It foresees the end of historical change in the sense that the fundamental power relations are likely to remain unchanged, not only in political society but, more important, in civil society, the sphere of lived experience. In the darkest formulation, the negative dialectic exists but only as a simulation, as "artificial" negativity. Even a society of total administration requires some kind of agent to provide the dynamism without which the system cannot reproduce itself, much less grow. Jean Baudrillard developed the theory of the simulacra as a postmodernist intellectual game, but Philip K. Dick's novels develop the possibilities for a new morality from the agonies of the simulacra.

The many concrete sociological studies of culture which Adorno performed seem to reproduce the fundamental thesis that technology and its concomitant proliferation of products have enabled advanced

capitalist societies to offer to the underlying population both bread and roses (the familiar slogan of the turn-of-the-century socialist movement); but even as these societies appear more tolerant of dissent, the content of democratic participation is, more and more, repressed in a veritable orgy of consumption, which, contrary to accepted belief is the precise opposite of the private sphere. Or, in Marcuse's notorious formulation of the theory of repressive tolerance, dissent remains more or less uninhibited in Western societies, but the stakes have been lowered (Marcuse 1965). Radical ideas are largely unfettered in their utterance but are typically unheard. Even in that dissent which is provided by the corporate-controlled media, some voice must be shaped and therefore neutralized to fit into prevailing discourses. The opposition itself becomes an essential component of the prevailing order; its existence is tolerated to legitimate the democratic claims of the political and economic system. We get conflicts but no systemic contradictions. The American critical theorist Paul Piccone calls this phenomenon artificial negativity.

This paradox is nowhere more evident than in the spread of the culture industry to what had formerly been considered "high" art—especially classical music and painting. Adorno's pioneering work on the sociology of music (1988 [1962]) focuses on the ubiquity of the middle-brow audience that has become the soul of high art concert performances. The large symphony orchestra organization has become subordinated to the patrons and the audience for Top 40 classics—almost all of Mozart and Haydn, the Beethoven symphonies and concertos, the works of Chopin, Tchaikovsky, and Brahms, and a sprinkling of twentieth-century music: the neoclassical Stravinsky and works influenced by the late Romantic era or the nationalist phase of American music of the thirties and forties. At the publication of Adorno's book on the sociology of music in 1962, the works of Schönberg, Berg, Webern, and their followers were virtually absent in the classical repertoire, certainly among major US and European orchestras. Adorno took this fact to be one more empirical validation of the thesis that the fashion process governs the musical canon and forms middle-brow taste, an insight borrowed from Simmel but documented by him, with mixed results. The commodification of high culture has been amply demonstrated by world cultural history since the end of World War II; but Adorno's claim (1967) that jazz is merely a "perennial fashion" possessing little or no intrinsic aesthetic value (an Adorno

preoccupation in the forties and fifties) demonstrated the ultimate limits of the sociological understanding and indeed the artistic judgment of the Frankfurt School.

For critical theory, genuine high art was the last refuge of critical practice in a world completely dominated by total administration. Society was marked by a wizened lifeworld in which entertainment replaced a vital public sphere where citizens are competent to fully debate political issues and can really control their own affairs. The degradation of art consisted in its subordination to the technological colossus which controlled nearly every aspect of social life except that of the artistic avant-garde, whose subversive content was virtually assured by its distance from art forms consonant with popular taste. Expressionist and surrealist painting in the 1920s, the novels of Joyce, Beckett's novels and plays and the poetry of Pound were as dissonant in relation to mainstream aesthetic standards as Schönberg's seriality was oppositional to the sonorities of romantic and classical music. It was precisely at the margins of official art that the critical spirit stayed alive. For Adorno (1973b), Schönberg's project in the 1920s, with its fairly daunting rules, to systematize dissonance in terms of a "system" of atonality marked the end of his specifically critical intervention. In other words, when Schönberg succumbed to the positivities of method his art was dead. Schönberg has never been fully integrated into the symphonic repertoire, except through his late romantic works, such as *Transfigured Night* and *Pelleas and Melisande*. But in academic precincts in the United States in the period after World War II his method became *de rigueur*. Nearly all of the more important "serious music" composers, even the folk- and jazz-influenced Aaron Copland, were obliged to adopt variations of serial music by the late 1950s. On the other hand, performances of their works were confined, almost entirely, to small, university-sponsored concerts. The large orchestras, dominated by the alliance of the corporate patrons and middle-class subscribers, tolerated this music only to forestall embarrassment.

As for "society," critical theory appears to have been hoisted by its own petard. The very weapons the Frankfurt School used to convict advanced industrial society as "total administration," in which state, economy, and culture were integrated by technology (and, in turn, integrated the underlying population by means of every co-optation other than coercion) left it with an account resembling that of conventional general social theory. For critical theory, the dynamic di-

mension of society, more specifically its internal capacity for generating change, had yielded to repressive inertia, masked by ever-changing fashion and the appearance of opposition, and made particularly powerful by the reduction of all conflict to a series of problems subject to managerial solutions. These solutions were possible within the framework of system maintenance precisely because of the instrumentalization of nature and social life made possible by the repression of the critical function of reason. Now reason had become attached to the apparatus of domination. Change was possible only from without—from those excluded from partaking in the benefits and processes of the system. In any case, this possibility is time-limited, and is constrained by the great powers of the apparatus, under appropriate political pressure, to make even poverty, hunger, and disease subject to administrative solutions.

The subjectless discourse of late critical theory was predicated on the collapse of the working-class movement between the two world wars, the calamitous rise of totalitarian states, especially in those societies where Enlightenment ideology had sunk the deepest roots, and the virtual disappearance of the traditional intellectuals, that is, those still in contact with eighteenth- and nineteenth-century Western critical philosophy. The displacement of all but scientific philosophy by social and natural sciences, what Horkheimer termed the "eclipse of reason" in the wake of instrumental rationality, produced in critical theory a curious account of contemporary society as one of stasis. Notwithstanding its insistence on the ineluctability of difference, its refusal of *a priori* categories of Marxism or systematic sociology, CST reproduced contemporary sociology garbed in Hegelian rhetoric. Of course, as Adorno has argued (1973a, 54–6), rhetoric is not merely a question of style or a formal device; persuasion is, in the hands of dialectics, a content. This is true because language is not merely the means of expression but configures thought itself. Thus, close attention to the use of words, phrases, aphorisms, metaphors, and the presence of moral passion in CST signifies; and this signification cannot be separated from the so-called content. Yet one cannot avoid noticing the powerful parallels between Parsonian sociology and critical theory, despite these differences. From the perspective of critical theory, Parsons lacks history (except in his wonderful account of intellectuals, where the object is its history, even as he retains the notion of social definition as social role).

I claim that the core category for critical theory as sociology is what Parsons calls the cultural system, whose normative specifications surely differ from those named by Parsons. While Parsons assumes the religiously based value systems of the classical Enlightenment—parsimony, hard work, scientific reason—are still regulative of social action and can, therefore, produce equilibrium subject to the exigencies of the social and personality systems, CST castigates industrial societies for elevating means to ends. Neither conventional bourgeois values nor coercion constitute the essential condition for the stability of modernized society. For critical theory it is the conflation of reason with the technological requirement which permits the attainment of a soulless material affluence, which becomes a framework of social domination. Here we might compare Daniel Bell's generally joyous announcement of the coming of postindustrial society (1973), in which politics is largely collapsed into the quiet, computer-based process of technocratic decision-making, with the outcome of critical theory. What for Bell, a pioneer ideologist of technology as power, is a social forecast deprived of any critical content becomes the dystopia of the alienated traditional intellectual.

IV

Negative Dialectics, just like *The Philosophy of No,* was offered as a corrective to the tendency of knowledge to reproduce itself dogmatically in the wake of epochal changes in society. They are intellectual responses to both the new scientific and technological revolutions which had visibly transformed the social landscape in the twentieth-century, and the concomitant changes in the nature of power relations. In both cases, although in somewhat different ways, the question asked was: what are the sources and contours of historical changes? But critical theory as a sociology found itself, perhaps against its will, obliged to explain the radical departures from the Marxist script exhibited in all Western capitalist societies as well as the existing socialist countries. As a consequence of the crisis of socialism and the socialist movement which had by the 1950s become manifest, the category of dialectics underwent a profound shift that prefigured poststructuralisms of the 1960s to the present. Having rejected the Hegelian/Marxist schema according to which the subject and object are transformed by a series

of double negations and become identical after a long series, Adorno seeks recourse for the dialectic in Walter Benjamin's category of "constellation," in which "ideas are to objects as constellations are to stars. This means in the first place that they are neither their concepts nor their laws. They do not contribute to the knowledge of phenomena and in no way can the latter be criteria for which to judge the existence of ideas" (Benjamin 1977, 34). Therefore ideas cannot represent things. Adorno remarks that constellations as groups of ideas are the "more" pushed out by objects and unrepresented by concepts, and can be likened to Weber's ideal types.[17] Representation of the empirically actual is replaced by placing the object in constellation.

> Weber explicitly rejected the delimiting procedure of definition, the adherence to the *schema proximum differentia specifica,* and asked instead that sociological concepts be "gradually composed" from "individual parts taken from historical reality. The place of definitive conceptual comprehension cannot, therefore, be the beginning of the inquiry, only the end." (Adorno 1973a: 165)

These compositions are analogous to the notion of constellations which, despite their origin in fragments of social reality, are really ideas whose correspondence with any empirical object is problematic by virtue of the assemblage method itself. Adorno criticizes Weber's penchant in his last works for definition, and argues that the ideal-type succumbs to neither idealism nor positivism but is a critical category precisely because of its explicit admission of noncorrespondence. This is Adorno's most explicit attempt to appropriate Weber for a nonpositivist social science. Benjamin had transmuted Goethe's elective affinity to explain the unity of ideas and its objects, but only speculatively. Constellation infers the elective affinity of nonidentical objects/ideas whose relation must, thereby, remain unstable. The separation of the objects from which the constellation is composed opens up the possibility for the formation of new constellations. Hence, rather than positing the social world as a system of necessary, relatively invariant relations, critical theory in this most promising moment retains Heraclitian flux, even as its description of the contemporary world provides little hope that the prevailing constellation at the level of the social totality will obey this "law." Yet, since the affinities are "composed" and are not the outcome of inevitable synthetic processes, indeterminacy is preserved.

Adorno's critique of Spengler (1967) reveals the ambiguity of the negative dialectic. Despite the prescience of Spengler's major work—his prediction of the coming of a new Caesarism in Europe, his penetrating critique of the hypocritical actions of democratic states, his pioneering critique of scientism and especially positivism—Adorno finds fatal flaws in Spengler's own immanent positivism, his glorification of facts, of technology, and especially his anti-intellectual attacks on culture. Above all, Spengler's prognostications and the assumption that society is a closed system leave little or no room for agency, nor can he truly grasp the part played by the domination of nature in the cultural decline he so accurately chronicles. In the last analysis Spengler is, according to Adorno, a "metaphysical positivist . . . in [his] hatred of all thought that takes the possible seriously in its opposition to the actual." At the conclusion of this essay, Adorno delivers the ultimate blow against an unrelenting pessimism that makes no room for those rendered most powerless by a progressively decaying society:

> The powerless, who at Spengler's command are to be thrown aside and annihilated by history, are the negative embodiment within the negativity of this culture of everything which promises, however feebly, to break the dictatorship of culture and put an end to the horror of pre-history. In their protest lies the only hope that fate and power will not have the last word. What can oppose the decline of the west is not a resurrected culture but the utopia that is silently contained in the image of its decline. (Adorno 1967, 72)

The silently contained utopia consists of protest that refuses "fate and power" the last word. But this eloquent comment in the interest of emancipation, Adorno's stubborn insistence upon philosophy and social theory that, having no specific standpoint rooted in concrete historical actors, addresses its enunciations in the name of the nameless "powerless," matches Benjamin's rueful "it is only for the sake of those without hope that hope is given us." Thus does aphorism replace social theory. Marcuse:

> The critical theory of society possesses no concepts which could bridge the gap between the present and [civilization's] future; holding no promise and showing no success, it remains negative. Thus, it wants to remain loyal

to those who, without hope, have given their life to the Great Refusal. (1964: 257)

But the problem with this Refusal is that it resembles an exigency, since CST provides us with no specific theory that can account for the appearance of Refusal, protest, or revolt. Indeed in *One Dimensional Man* Marcuse argues:

> The totalitarian tendencies of the one-dimensional society render the traditional ways and means of protest ineffective—perhaps even dangerous because they preserve the illusion of popular sovereignty. Social transformation remains a utopian hope without a contemporary base in the actual social life; in fact, social life is counter factual to any hope for change unless we are somehow able to compose a constellation of differentiated elements. (Marcuse 1964: 256)

But this entails concrete social research for these are drawn from "fragments" of historical reality. For example, one would have to imagine the conditions under which disparate social movements—ecology, feminists, movements for gay liberation, squatters, even sectors of the working class—could collectively constitute an alternative culture and an alternative political power. This level of specificity was beyond CST's purview, since such an eventuality implies that the closed discursive universe so central to its historical judgment had somehow been pried open. And in this "somehow" lie the contours of a new social theory, one that would have to preserve the negativity of CST, but would also be obliged to abandon its unintended Spenglerian legacy.

By way of conclusion, I argue that no critical theory, including that of the Frankfurt School, can dispense with either categories or metacategories from which to make historical and empirical judgments. Surely, ideas such as the totally administered society, domination of nature, and one-dimensionality are "synthetic" categories upon which critical social theory depends. In turn, these are really constellations constructed from such abstractions as domination, bureaucracy, reason, ideology, nature and, in a different register, class, labor, the state, and so on.[18] Similarly, when Adorno writes on the "Culture Industry" or the Enlightenment, he is invoking capitalism, culture, science, and technology as basic categories from which the

concatenation is made. In short, just as doing science entails making judgments in the sense that its axiomatic structures may be interrogated, so those who would interrogate social life cannot avoid "science," if by this constellation we mean positing a hierarchy of existents without which empirical judgment is arbitrary.

When we seek to explain social relations, we must go beyond negative dialectics. From critical theory's own perspective, what lies beyond must necessarily be historically and practically situated. I believe that, just as Foucault is right to point out that intellectuals no longer work in categories of the "universal" truths, but theorize and do practical research in situated locations (either professional or within "their conditions of life"), so the categories of social knowledge must also be specific. We can no longer characterize entire societies by divisions into sectors, orders, or invariant relations of determination such as economic infrastructure or Great Ideas. One possible explanation for this perspective is the historically conditioned disaggregation of social totalities such as "organized" capitalism, socialism, the Third World, and other constellations from which these universals were crafted. On the other hand, poststructuralist historiography has maintained that the past was never constituted as more than unstable totalities of incommensurable discourses, the most powerful of which are underdetermined by the economic infrastructure. Rather, they may be considered the resultant of a conjuncture, particularly of the power/knowledge constellation.

Nevertheless, the intention to be specific, to avoid large abstractions, has not spared even the most meticulous of local histories from being generalized. Foucault's work has been shamelessly appropriated by his universalizing disciples who, nudged by academic environments, are prone to overtheorization. Foucault's fecund use of categories such as discourse, discursive formation, power/knowledge, produced the rudiments of an alternative social-theoretical paradigm from which history has been rewritten. As Derrida once readily acknowledged, we are not able to avoid logocentric Western culture, among whose leading themes is the high value placed upon intellectual knowledge and its core of abstract universals. It was, after all, in consideration of the dangers entailed by such a use of science that schools of social inquiry, including Marxism as well as positivist social science, bid us return to the concrete.

Although we need not return to what C. Wright Mills once called

"abstracted empiricism" to grasp the concrete, neither can we avoid general theory. I am persuaded that these debates will not end; a final solution will not be found.

NOTES

1. I owe this insight to Jonathan Lang, and to Fredric Jameson who is among our best essayists in this tradition.

2. As Talcott Parsons comments (1955, 631): "As an essential point of reference for defining the four functional exigencies or dimensions of the systems, we assume one law, or postulate according to the way it is viewed. Thus, we call the law of inertia, on the analogy (or more than that) of the use of the term in classical mechanics. The law may be stated as the proposition that a process of action (as part of the system of action) will tend to continue with its direction and potency . . . unchanged unless it is deflected or otherwise changed by the impingement of some other process (in the system or its situation)." In this extract, the influence of Pareto's analogy between mechanical phenomena and social phenomena is striking. See Pareto 1966, 106–7.

3. "We define the 'tendency to seek goals' not in terms of any specific propensity of organism or personality or social system, but in terms of the concepts of inertia and equilibrium as applied to a system. From the concept of cathectic orientation it follows that an actor-unit or system will develop differential evaluations of different objects, and of different relations to the same object (or category of objects) in its situation in different circumstances" (Parsons 1955, 632). In turn, cathexis is the "optimum relation" to a given object "an approximation to which we may call the 'consummatory' or 'maximum-gratification state.' " To this Parsons hastens to add that it is not a "static" relation because it varies with "rates of inputs and outputs to the object."

4. Given their collective antipathy for science, the physical analogy is rarely, if ever, invoked by these writers. However, one cannot avoid, at the discursive level, the articulation between their collective reading of the twentieth-century as a massive break with the past and Einstein's comment that Relativity physics does not "surpass" the Newtonian model; instead, it relegates classical mechanics to a special case in the general theory. If mass society, new information and communications technologies, the rapid pace of scientific discoveries, economic restructuring can be grouped under the indefinite rubric "postmodernism," conservative and radical critics of contemporary culture, even if they differ about modernity (democracy, industrialization, the emergence of the mass "subject"), surely converge in their hostility to "technological" society and culture.

5. In Lukács 1971 [1922], Marcuse 1968, and other works, the concept of ideology is

linked either with the vicissitudes of the commodity form or the transformations of rationality from traditional to instrumental forms. In both formulations domination of nature and of humans is the objective, but Marcuse retains the dialectical relation of "interest" and the construction of technological domination: "The very concept of technical reason is perhaps ideological. Not only the application of technology but technology itself is domination (of nature and men)—methodical, scientific, calculated, calculating control. Specific purposes and interests of domination are not foisted upon technology 'subsequently' and from the outside; they enter the very construction of the technical apparatus. Technology is always a historical-social project: in it is projected what a society and its ruling interests intend to do with men and things. Such a 'purpose' of domination is 'substantive' and to this extent belongs to the very form of technical reasons" (Marcuse 1968, 223–4).

In contrast, Weber leaves little room for this sense of the concept of ideology because, like most social theorists, he considers explorations of "intention" a teleological fallacy or, worse, an example of psychologism.

6. These studies began in the early thirties with Studies in Authority and the Family, a research project directed by Horkheimer. During this period, the Institute actively sought contact with psychoanalytical theory and recruited Erich Fromm, who until the late thirties was among those who tried to link Marx and Freud, and Otto Fenichel. Of course, critical theory was profoundly influenced by Wilhelm Reich's Mass Psychology of Fascism (1970 [1946]) and other works of his Marxist period. The struggle to develop a mass social psychology is a major preoccupation of critical theory into the 1960s.

7. Of course, I refer here to "really existing" Marxism of the socialist and Communist Internationals, which heavily emphasized the study of political economy as the preeminent paradigm for understanding politics, culture, and ideology.

8. Adorno and his colleagues specifically acknowledge the influences on their views of authoritarianism: Fromm, Erik Erikson, A. Maslow, M. Chisholm, and Reich (Adorno et al. 1950, 231n). Of these, it is Reich's monumental work, Character Analysis (1972 [1927]), which elaborated the authoritarian character structure, that was, after Freud, the fundamental theoretical work on the transformation of the subject in our century.

9. For a thorough description of Spengler's influence on Weimar science, see Forman 1971; on Heidegger's influence, see Friedman 1981, ch. 5. For a direct example of this, see Marcuse 1973; and for a perhaps more convincing case, Marcuse 1987 [1932]. Marcuse's effort here is to reconcile Heidegger's ontology with history, a synthesis rejected by Heidegger, with whom Marcuse had studied for the five years just prior to Hitler's assumption of power in 1933. In the Introduction to her translation of this work, Seyla Benhabib suggests that the general interpretation that Heidegger rejected the book because of political differences should be tempered on Marcuse's own authority.

10. White Collar (1951), together with Mills's Power Elite (1956), were to have profound impact on Marcuse's subsequent social theory. I would argue that, having been

influenced by mass society theory, in which critical theory played an important part, Mills provided both the "empirical" demonstration for its crucial conclusions and contributed to critical theory by linking bureaucratic rationality to questions of work and power.

11. These were written in the same period, the late thirties and early forties, when the shift from studies of authority to studies of science and technology is evident.

12. In this symposium, whose contributions were made, at various times, in the 1960s, Karl Popper and Hans Albert extensively debate the "logic" of the social sciences with Adorno and Jürgen Habermas. It is perhaps the fullest statement from the standpoint of CST on the presuppositions of social theory. This is not the place to exhaustively mine its riches. For our purpose it is enough to quote Adorno's comment on Parsons: "The harmonistic tendency of science, which makes the antagonisms of reality disappear through its methodical processing, lies in the classificatory method which is devoid of the intention of those who utilize it. It reduces to the same concept what is not fundamentally homonymous, what is mutually opposed, through the selection of the conceptual apparatus, and in the service of its unanimity. In recent years, an example of this tendency has been provided by Talcott Parsons's well-known attempt to create a unified science of man. His system of categories subsumes individual and society, psychology and sociology or at least places them in a continuum. The ideal of continuity current since Descartes and Leibnitz, especially, has become dubious, though not merely as a result of recent scientific development. In society the ideal conceals the rift between the general and the particular, in which the continuing antagonism expresses itself. The unity of science represses the contradictory nature of its object" (Adorno et al. 1976, 16–17).

13. For a succinct statement of critical theory's position on science, see Habermas 1976.

14. For a discussion of this point, see Aronowitz 1988.

15. Their reading of pragmatism as well as the history of the physical and biological sciences warned both Mills and Merton against large generalizations, even general theory. Merton's famous argument that science develops by empirically verifiable hypotheses, which inevitably can only be of the middle range, became the basis for Mills's celebrated but misunderstood *Sociological Imagination* (1959). In this essay, Mills takes both Parsons and his antimonies, the empiricists of dominant American sociology, to task for failing to observe both the critical and the middle-range routes to knowledge.

16. For a classic example, see Dimitrov 1935. This is the main report to the seventh world congress of the Communist International, in which its general secretary "refutes" the leftist argument that Fascism is continuous with capitalism and argues, to the contrary, that it is the rule of a fraction of capital, "its most openly terroristic" imperialist wing.

17. In *Negative Dialectics* (1973a), Adorno cites this formulation by Benjamin only to signify the superiority of Weber's category of Ideal Type for its avoidance of a mystical element. Nevertheless, the possibility of acquiring knowledge through noncorres-

pondence, in which the idea exceeds its object, is clearly rooted in one strain of Kantian as well as Hegelian thought, which appears systematically expunged by empirical science.

18. Among the sadder aspects of the legacy of critical theory is the fate of its epigones. Despite all, Adorno and Marcuse kept watch for social agents whose "protest and revolt" could mitigate, if not disprove, their political prognostications. But the watch is today kept by others. Russell Jacoby dismisses the intellectuals associated with the new social movements as "specialized" and in no way does their appearance contradict the finding in his *Last Intellectuals* (1987) that the game of social transformation is up since the incorporation of intellectuals into the academic system after the sixties. As we have seen, Piccone labels these movements merely recent examples of "artificial negativity" within the totally administered society. Although little has been said in *Telos,* the American journal of critical theory, about the upheavals in Eastern Europe, Africa, and the US—movements particularly concerning sexuality—we can imagine how easily they can be discounted by intellectuals cathected to Berlin, 1923.

REFERENCES

Adorno, Theodor W. 1967 [1955]: "Jazz: perennial fashion" and "Spengler after the decline," in *Prisms,* translated by Samuel and Sherry Weber. London: Neville Spearman.

——. 1973a [1966]: *Negative Dialectics.* New York: Seabury Press.

——. 1973b [1949]: *Philosophy of Modern Music.* New York: Seabury Press.

——. 1988 [1962]: *An Introduction to the Sociology of Music.* New York: Continuum Books.

——. et al. 1950: *The Authoritarian Personality.* New York: Norton.

——. et al. 1976: *The Positivist Dispute in German Sociology.* New York: Harper & Row.

Arendt, Hannah 1956: *The Origins of Totalitarianism.* Glencoe, Ill.: Free Press.

Aronowitz, Stanley 1988: *Science as Power.* Minneapolis: University of Minnesota Press.

Bachelard, Gaston 1968 [1940]: *The Philosophy of No.* New York: Orion Press.

——. 1984 [1934]: *The New Scientific Spirit.* Boston: Beacon Press.

Bell, Daniel 1973: *The Coming of Post-Industrial Society.* New York: Basic Books.

Benjamin, Walter 1977: *The Origin of German Tragic Drama.* London: New Left Books.

Canguillhem, Georges 1983: *Etudes d'histoire et de philosophie des sciences.* Paris: Vrin.

Dimitrov, George 1935: *The United Front against Fascism.* New York: International.

Durkheim, Emile 1966 [1938]: *Rules of Sociological Method.* Glencoe, Ill.: Free Press.

Forman, Paul 1971: "Weimar culture, causality and quantum theory," in *Historical Studies in the Physical Sciences.* Philadelphia: University of Pennsylvania Press.

Horkheimer, Max 1947: *Eclipse of Reason.* New York: Oxford University Press.

————. 1940: "The authoritarian state," in *TELOS* #27.

————. and Theodor Adorno 1972 [1944]: *Dialectic of the Enlightenment,* translated by John Cumming. New York: Seabury Press.

Jacoby, Russell 1987: *The Last Intellectuals.* New York: Basic Books.

Lukács, Georg 1971 [1922]: *History and Class Consciousness,* translated by Rodney Livingstone. Cambridge, Mass.: MIT Press.

Marcuse, Herbert 1964: *One Dimensional Man.* Boston: Beacon Press.

————. 1965: "Repressive tolerance," in Herbert Marcuse, Robert Paul Wolff, and Barrington Moore, *A Critique of Pure Tolerance.* Boston: Beacon Press.

————. 1968: "Industrialism and capitalism in the work of Max Weber," in *Negations: Essays in Critical Theory.* Boston: Beacon Press.

————. 1973: "Foundations of historical materialism" (1932), in *Studies in Critical Philosophy.* Boston: Beacon Press.

————. 1978: "Some social implications of modern technology," in Andrew Arato and Eike Gebhardt, eds., *The Essential Frankfurt School Reader.* New York: Urizen Books.

————. 1987 [1932]: *Ontology and the Theory of Historicity,* translated by Seyla Benhabib. Cambridge, Mass.: MIT Press.

Merton, Robert 1957; 2nd edn 1968: *Social Theory and Social Structure.* New York: Free Press.

Mills, C. Wright 1951: *White Collar: The American Middle Classes.* New York: Oxford University Press.

————. 1956: *The Power Elite.* New York: Oxford University Press.

————. 1959: *Sociological Imagination.* New York: Oxford University Press.

————. 1964: *Sociology and Pragmatism.* New York: Oxford University Press.

Ortega y Gasset, José 1932 [1929]: *The Revolt of the Masses.* New York: Norton.

Pareto, Vilfredo 1963 [1935]: *The Mind and Society,* translated by A. Livingston and A. Bongiorno. 4 vols. New York and London: Harcourt Brace Jovanovich.

Parsons, Talcott 1951: *The Social System.* Glencoe, Ill.: Free Press.

————. 1955: "An approach to psychological theory in terms of the theory of action," in Simon Koch, ed., *Psychology: A Study of Science,* vol. 3. New York: McGraw-Hill.

Reich, Wilhelm 1972: *Character Analysis.* New York: Farrar, Straus & Giroux.

————. 1970 [1946]: *Mass Psychology of Fascism.* New York: Farrar, Straus & Giroux.

Schelling, F. 1988: *Ideas for a Philosophy of Nature.* Cambridge and New York: Cambridge University Press.

II

LITERATURE AS SOCIAL KNOWLEDGE

6

LITERATURE AS SOCIAL KNOWLEDGE: MIKHAIL BAKHTIN AND THE REEMERGENCE OF THE HUMAN SCIENCES

INTRODUCTION

Scholarship is seldom more charming than when it exhumes and re-cycles dead souls. In the late sixties, a social theorist was resurrected on the mistaken premise that he was primarily a literary critic. Mikhail Bakhtin was introduced to English-speaking readers as a new voice in late medieval studies, perhaps the greatest commentator on Rabelais. We are only now realizing, twenty years after the first English-language translation of his work, that Bakhtin is one of the giants of twentieth-century social and cultural theory.

Since Bakhtin's death in 1975, his writing has slowly made its way into literary circles, and a small cottage industry has grown up around

him in the American academy. One curious feature of his reception is that no one is quite sure which "Bakhtin" works were actually written by Bakhtin, despite a recent full-scale biography by Katerina Clark and Michael Holquist.

Born in 1895 to an aristocratic family, Bakhtin was an early convert to the life of the mind. He entered Saint Petersburg University in 1914 and immediately became involved in both philosophical and religious study. According to Clark and Holquist, he appeared to be less interested in political activity. After the revolution, he found himself in Nevel, a small town near Petersburg, teaching school. There he discovered a scattering of intellectuals similarly dealing with hard times by working in the provinces. A "circle" formed to study philosophy and debate ideas. The Bakhtin Circle was unique, even for Russia, because it combined study with collective literary production in sufficient volume to constitute a "school" of social theory and criticism. But it also presented future scholars with a problem. The work of "Bakhtin"—books about Freud, the philosophy of language, and literary formalism—was first published under the names of other members of the Bakhtin Circle.

It is even curious that Bakhtin has been received so warmly by the same generation that was so smitten by formalism it forced even Marxism to take the French way. Bakhtin and his friends were the precursors of *antiformalist* criticism: *Freudianism* is a pitiless critique of psychoanalysis from a sociohistorical perspective; *Marxism and the Philosophy of Language* takes the linguistics of Ferdinand de Saussure to task for its biophysiological view of language. Against Saussure's argument that the structure of language is given to all humans, Bakhtin counterposes the idea that language derives its meanings from dialogue, which in turn is grounded in a social context. He insists that the study of language and literature provides a crucial clue to understanding such social questions as class conflict, the construction of communities, and history. While structuralism and Russian formalism emphasize the spatial dimension of social life and literary texts, Bakhtin adheres to the idea that social and aesthetic forms are produced under particular circumstances, and the task of language study is another kind of historiography: the analysis of everyday life.

All of us have submitted to a historical pedagogy that highlights "great men" and abstracts "key events" from the details of daily existence. The heroic has no place in Bakhtin's historiography. For him,

traditional histories are the narratives from which the myth that the past belongs only to the victors is fashioned. To hear the voices of the "people," Bakhtin seeks out imaginative rather than scientific literature; the novel is constructed from the details of ordinary existence, just as discourses are the stuff of communication between people.

Bakhtin is neither modernist nor postmodernist. On the contrary, his work may be described as populism of a special type. As Bakhtin becomes the center of a history revival, his literary executors, like Benjamin's, are fighting over the treasure and its interpretation. Slavicists such as Michael Holquist have recruited Bakhtin in the struggle against Soviet repression, and have portrayed him as a "religious man" persecuted by the Russians for his faith. His writings about Rabelais and Dostoyevski, as well as his work about language, psychoanalysis, and literary forms, are said to be a coded antiauthoritarian response to the Stalin era.

In Dostoyevski, Bakhtin discovers his Moby Dick, his Dora, his Molly Bloom. The Dostoyevski in *Problems of Dostoevsky's Poetics* is not the existentialist precursor of Sartre and Camus, but a master of polyphony, creator of a multiplicity of voices and consciousnesses. According to Bakhtin, the interior voice is not a monologue, but is in constant dialogue with the outside world. It is through dialogue that the self is constituted in Dostoyevski's fiction; his psychology is always a signifier of the ways in which social life sets the boundaries of individual will. In Bakhtin's reading, there is no solitary hero. Rather, Dostoyevski dredges up the voices of those excluded from history, revealing the details of everyday life in order to decode the social world, not aestheticize it. Although Bakhtin acknowledges that Dostoyevski is a novelist of ideas, those ideas are transformed by the characters; they never appear as an aspect of the authorial voice. This point is no more strongly made than in Bakhtin's interpretation of *Notes From Underground:*

> There is literally nothing we can say about the hero of *Notes From Underground* that he does not already know himself: his typicality for his time and social group, the sober psychological or even psychopathological delineation of his internal profile, the category of character to which his consciousness belongs, his comic as well as his tragic side, all possible moral definitions of his personality, and so on . . . he stubbornly and agonizingly

soaks up all these definitions from within. Any point of view from without is rendered powerless in advance and denied the finalizing word.

Instead of reflecting a powerful, alienated, inner self, the Underground Man is a mirror of what everybody else says about him: "he knows all possible refractions of his image in those mirrors . . . and he takes into account the point of view of a 'third person.' " Dostoyevski's Underground Man is engaged in furious dialogue with opposing consciousnesses; he is the condensation of the "other" of society. His self-consciousness is constructed, not primal.

Despite Bakhtin's critique of formalism, his magisterial study of Dostoyevski demonstrates the power of a formal method. This method presupposes a theory that places the relation of the individual to his social context at the center of the novel's formation of character, its ideas and ideology; even its narrative structure. Bakhtin is not a literary critic either of the school where the reader becomes the subject of discourse, or of the scientific formalism that focuses primarily on language and its vicissitudes. He is a *social* theorist. Bakhtin's main purpose in studying literature is to plumb the depths of social, not psychological, relations. He wants to discover how we negotiate our circumstances, how we constitute ourselves as eminently individual yet supremely typical characters of our time, our social class, our social relations. And his point is to discover history in and through works of art as privileged.

I

In recent years, literary methods have been widely used to reread some of the texts of social sciences, particularly ethnography. Clifford's and Marcus's collection, *Writing Culture*,[1] showed us that "evidence" can be taken as discourse, specifically, that the ethnographer engages in rhetoric and other weapons of persuasion—metaphor and metonymy, tropes and so on—which render power to discourse. Moreover, as the recent debate over ethnography has shown, the researcher is bound, ethically, to take responsibility for her or his choice of subjects as well as the method of inquiry. The notion that anthropology, for example, is assigned by a neutral division of intellectual labor to study the subaltern in "Third World" settings is today completely shattered. The

investigator is obliged to set out her or his social and political presuppositions, including what may be described as the "intention" of the investigation. In sum, knowledge for knowledge's sake is under severe attack.

The problem of taking literary and other artistic works as reliable sources of social knowledge presents somewhat greater difficulties. In the first place, artists, critics, and philosophers have, since the eighteenth-century, insisted upon the "autonomy" of art—especially from the economic and political matrix we call "society."[2] Others have modified this judgment by admitting that art is intertwined with moral and ethical precepts of a given culture, in which case the relation of art to philosophy and other forms of systematic knowledge is a reasonable inference. At the same time, the art world—artists, critics, theorists, patrons—tends to acknowledge an internal relation of art to everyday life or, in another register, to what Bakhtin often refers to as "culture."[3] Literature may be self-referential insofar as its formal attributes, such as narrative and linguistic traditions, play a significant part in artistic production, and aesthetics insists that the creative act is autobiographical, that is, objectivates what Bataille has called "inner experience."[4] Yet, as we know, the common root of both self and other precludes a purely subjective origin.[5] We are ineluctably bound to our social relations; culture may be taken as *both* the civilizing process—where the assimilation of art and its traditions is understood as one of the crucial elements of self-creation—and in the anthropological sense, as the practices (and as Bakhtin argues, utterances) that constitute everyday life.[6]

The second difficulty is the conventional separation of science, including the sciences of society, from art. According to the so-called "two cultures" thesis,[7] the methods and the apprehended knowledge derived from these spheres of human existence are both logically and existentially separate. While literature provides insight into the subjective or psychological aspects of being, its ability to provide reliable systematic, conceptual, and generalizable knowledge as compared to, for example, history or sociology is, considered within this reprise, quite limited.

Until the discovery of the work of Mikhail Bakhtin by European and US theorists and critics, the debate concerning the possibility that literature may be a source of social knowledge was determined by the tenets of realist epistemology, according to which the literary text corresponds to an objective reality and, in fact, is determined by it,

albeit not in a one-to-one copy. Even in the more sophisticated versions of this position, such as that of Georg Lukács, the problem of the epistemological status of representation is never avoided. Within this framework one needs no theory of language, only a theory of narrative. Recall that in Lukács's second excursions into literary criticism and theory (chiefly in the 1930s) he argues that narratives are constituted formally by social types derived as an abstraction from social life and are, consequently, independent of the text or literary traditions. The "great" novelists in his canon—among them Balzac, Scott, Thomas Mann—draw their sources from these typifications of bourgeois society; the contradictions of everyday existence refer to real, historical contradictions and, in the best novels, narratives lose their self-referential character. Lukács draws his canon of European literature from those works that conform to the requirement that the economic and social character of a period are expressed in and through concrete characters and situations.

Of course, in this paradigm of literature as social knowledge literary forms themselves are taken as mediations of an external reality that is quite independent of them. In our time of keen interest in formal methods of criticism, Lukács's work has become a monument to an important but apparently surpassed discourse, precisely because of its realist historical epistemology. Consequently, for much of the interwar period, when literature and art were not understood in their formal-aesthetic dimensions to the exclusion of any possible social referent (a move conditioned by Marxism's intellectual hegemony over much of the literary intelligensia during the 1930s), the social investigation of literature was subordinated by conceptions according to which literature may be taken as a kind of language game that obeys certain rules, some of which owe their effectivity to literary conventions. In semiotic criticism the text is a signifying practice whose meaning can only be derived from how it functions with a specific context. In turn, "context" connotes not chiefly a sociohistorical "reality" but a system of codes. For example, Roland Barthes's *S/Z*—which may be taken as anti-Lukács—purports to show that the literary text of Balzac is actually fractured by a gaggle of codes, the interplay of which constitutes the narrative. Barthes transforms the social code from a master discourse into only one of six relatively autonomous systems the juxtapositions and combinations of which constitute the text. As with other works of structuralist criticism, diachronicity is subordinate to synchronicity, but

equally important, the social loses its privileged place in reflection upon literary production. Barthes's methodological move consisted not in obliterating the social referent, a position easily dismissed by the perspective of critical realism. Rather, the social code is relativized; its effectivity becomes indeterminate in advance and must be evaluated anew in every concrete situation.

At first glance, the recent interest in Bakhtin may be considered paradoxical, since he appears to privilege *parole* over *langue,* time (history) over space, and, perhaps more puzzling, his work may be interpreted as profoundly ensconced in a subtle but unmistakable realist epistemology which, despite its differences from Lukácsian Marxist criticism, shares a sociohistorical referent.[8] Indeed, the similarities in these respects between the two are by no means frivolous. Yet, as I argue, by exploring Bakhtin's category of chronotope, and perhaps more urgently his use of the musical figure of polyphony, we have here neither a conventional materialist discourse abetted by dialectical logic, nor a precursor to poststructuralism. For the chronotope, along with Bakhtin's other key categories—heteroglossia, dialogic narrative and polyphony—may be seen as a critique of historicism from the perspectives of a new conception of historicity.

Bakhtin offers a theory of language which privileges agency over structure but works with, but not within, linguistic boundaries.[9] Most important of all from the perspective of social and cultural theory, his perspective addresses, within a critique of literary texts, the complex relationships between humans and nature and social relations, without, however succumbing to correspondence theory. In fact, as I shall argue below, Bakhtin offers an incipient theory of the relation of nature to human relations which falls into neither biological nor social reductionism. It remains virtually singular in the past century of literary scholarship, during which the culturalist position of the *Geisteswissenschaften* (spiritual or human sciences) have dominated cultural studies.

Perhaps his stature as a social historian is unknown to literary scholarship. But Bakhtin's wide influence on European social history is largely due to the pertinence of his "method," not uncontested, to historical sociology of the medieval and early Renaissance period. For what Bakhtin achieved, long before the richly detailed historical and sociological studies by George Rude, Eric Hobsbawm, and E. P. Thompson, to name only some of the best known, of what is variously termed the Crowd, the "people" or simply popular culture, was to

provide a series of rigorously constituted categories of description. Yet some admiring historians have persisted in privileging social scientific methods that purport to achieve direct knowledge of the past. Here is Carlo Ginsburg:

> The stereotyped and saccharine image of popular culture that results from this research is very different from what is outlined by Mikhail Bakhtin in a lively and fundamental book on the relations between Rabelais and the popular culture of his day. Here it is suggested that Gargantua or Pantagruel books, that perhaps no peasant ever read, teach us more about peasant culture than the *Almanach des Bergers,* which must have circulated widely in the French countryside. The center of the culture portrayed by Bakhtin is the carnival, myth and ritual in which converge the celebration of fertility and abundance, the jesting inversion of all values and established orders, the cosmic sense of the destructive and regenerative passage of time.[10]

According to Bakhtin, this vision of the world, which had evolved through popular culture over the course of centuries, was in marked contrast to the dogmatism and conservatism of the culture of the dominant classes, especially in the Middle Ages. By keeping this disparity in mind, the work of Rabelais becomes comprehensible, its comic quality linked directly to the carnival themes of popular culture: cultural dichtotomy, then—but also a circular, reciprocal influence between the cultures of subordination and the ruling classes that was especially intense in the first half of the sixteenth-century.

> These are hypotheses to a certain extent and not all of them equally well documented. But the principal failing in Bakhtin's fine book is probably something else. The protagonists of popular culture whom he has tried to describe, the peasants and the artisans speak speak almost exclusively through the words of Rabalais.

But what is the epistemological status of Ginsburg's own text? Can the "reports" of his own protagonist the miller Menocchio's captors be called more "reliable" than Bakhtin's protagonists of popular culture read from Rabelais's Gargantua? Says Ginsburg:

the very wealth of research possibilities indicated by Bakhtin makes us wish for a direct study of lower class society free of intermediaries. But for reasons already mentioned, it is extremely difficult in this area of scholarship to find a direct rather than an indirect method of approach.[11]

Ginsburg believes that we can avoid the "indirect approach," yet is properly concerned that this claim exposes him to the charge of positivism:

But the fear of falling into a notorious, naive positivism combined with the exasperated awareness of the ideological distortion that may lurk behind the most normal and seemingly innocent process of perception prompts many historians today to disregard popular culture together with the sources that provide a more or less distorted picture of it.[12]

Ginsburg implies that something other than "distortion" can be derived from a direct method of research, that historical research can reliably get back to the "things themselves," that history can be recovered in some extratextual manner. So, like other social historians such as the Annales school (Bloch, Braudel, Fevre, Le Roi Ladurie), he scans official records in an effort to capture the moral economy of the period, the rhythms of everyday life, and the elusive, but discernable agency of the people. Yet his method is inevitably indirect; the people rarely if ever "speak for themselves." They cannot represent themselves, either because they cannot read or write, or because they are denied access to preserved documents. They must be represented through the reports of official bodies which, until fairly recently, monopolized the means of communication, and whose texts are always edited. Social history is, regrettably, an indirect history, subject to the exclusions and inclusions of interested informants. The texts of social history, however valuable, are warranted inferences whose epistemological status may be compared in their documentary status to that of the novel. Events are inevitably and doubly fictionalized: by the institutional authority of the Church and its courts, and by the professional authority of the historian. While it is admirable that some, notably the various schools of social history, choose to construct the agency of the people, the methodological ensnarements are frequently severe.

Bakhtin seems to anticipate these criticisms. In his essay on the "text" he claims that:

The text (written and oral) is the primary given of all these distinct disciplines and of all thought in the human sciences and philosophy in general (including theological and philosophical thought at its sources). The text is the unmediated reality ... the only one from which these disciplines and this thought can emerge. Where there is no text there is no object of study and no object of thought either.[13]

Even the social historian (of which genre Carlo Ginsburg is an unsurpassed practitioner) relies on texts—letters and diaries, and in order to get at everyday life (especially of the nonliterate classes) the historian or ethnographer is obliged to construct a narrative out of the raw materials provided by public records—court transcripts, tax rolls, among which Ferdinand Braudel and other members of the Annales school found lists of agricultural products and their money or barter values, property deeds, and so forth. And others such as Ladurie and de Goff worked in the genre of historical scholarship that relied, in part, on civil and ecclesiastical courts. If Bakhtin is right that whatever its form "the implied text (if the word is understood in its broadest sense as any coherent complex of signs),"[14] then even the study of art deals with texts. For Bakhtin "our discipline" is not literary criticism or social history, but the "human sciences," which, for him, are distinguished by the centrality of interpretation in them, in contrast to the natural sciences' penchant for direct modes of authentication.

However, if it can be shown that natural sciences themselves are theory-laden and, therefore, evidence is heavily mediated by interpretation, we may refer to the postivist doctrine of authentication through experiment, rational calculation, or whatever, but the actual as opposed to the imputed difference between the two broad disciplines begin to break down. Bakhtin:

We will give the name chronotope (literally 'time space') to the intrinsic connectedness of temporal and spatial relationships that are artistically expressed in literature. This term (space-time) is employed in mathematics, and was introduced as part of Einstein's Theory of Relativity. The special meaning it has in relativity theory is not important for our purposes; we are borrowing it for literary criticism almost as a metaphor (almost but not entirely). What counts for us is that it expresses the inseparability of space and time (time as the fourth dimension of space). We understand the chronotope as a formally constitutive category of literature; we will not deal with the chronotope in other areas of culture.[15]

For Bakhtin, in literature the primary category of the chronotope is *time*. And, as this essay shows, time constructs narratives by its intersection with social and symbolic space. Moreover, in the sections on Rabelais in the Chronotope essay, Bakhtin shows that the history of the novel itself may be configured in relation to chronotopic categories, as multitudes of spatiality whose cores are forms of temporality. Bakhtin abstracts from the texts of Rabelais, for example, no less than seven forms of what he calls "productive and generative time"[16] in the preclass agricultural stage of human societies (the folkloric time), all of which are marked in various ways as "unified and unmediated" totalities in which means of production, ritual, and everyday life are not yet differentiated into private and public spheres. Rabelais's *Gargantua* comes at the end of this epoch: its series are primarily spatial since, as Bakhtin says, "the folkloric basis of (even) the entire grotesque images is patently obvious."[17]

Laughter and grotesquerie mark these series of eating, copulation, death, and so forth, that are, despite their phantasmagoric imagery, still ensconced in the worldview according to which we are part of natural history. Thus, in contrast to the sublimated form of sexuality— love—that transmogrifies the romantic novel in the eighteenth-century, Rabelais invokes the popular conception according to which sex is a natural practice unmediated by extrinsic influences such as religious morality, all of which are concentrated in the spatio-temporal specificity of the carnival.

In contrast, modernity is marked by the separation of public from private, that is, the separation of means of production, ritual, and everyday life, each of which becomes the site of the well-known fragmentation of the social world in which the commodity form, in all of its permutations, gradually displaces (but does not destroy) popular culture.[18] With the rise of the individual, the social chronotope is replaced by the individual chronotope. We must now speak of the multitude, not so much of series, but of voices, the combinatory effects of which are polyphonic, a term that signifies the dissonant harmonies of individual voices.

Bakhtin:

When the immanent unity of time disintegrated, when individual life-sequences were separated out, lives in which the gross realities of communal life had become merely petty private matters; when collective labor and

the struggle with nature had ceased to be the only arena for man's en-
counter with nature and the world—then nature itself ceased to be a living
participant in the events of life. Then nature became, by and large, "a
setting for action" its backdrop; it was turned into landscape it was frag-
mented into metaphors and comparisons serving to sublimate individual
and private affairs and adventures not connected in any real and intrinsic
way with nature itself.

But the treasure-house of language and in certain kinds of folklore this
immanent unity of time is preserved insofar as language and folklore con-
tinue to insist on a relation to the world and its phenomena based on
collective labor. It is in these that the real basis of the ancient matrix is
preserved, the authentic logic of a primitive enchaining of images and
motives.[19]

In these lines we can hear echoes of the neo-Marxist critique of
modernity associated with Lukács and the Frankfurt School, but with
a significant and perhaps a decisive difference: Bakhtin insists on the
primacy of the popular which, itself, is associated with the unity of
humans and nature mediated through labor. His vision—against all priv-
ileging of high culture—is the idea that what appears as trivial to culture
as what Norbert Elias calls the "civilizing process,"[20] may be taken as
the authentic when seen from the perspective of its historicity. For a
unique conception of historicity underlies Bakhtin's chronotope, within
which all categories of social space-time are employed. Since in the
final accounting language is subject to temporally induced transfor-
mations but also stands outside, one may infer its relative transhistoricity
as well. Otherwise how could language "preserve" the "immanent"
unity of time? But folklore enjoys the same status. Contrary to the
myths of modernity, Bakhtin shows that, although fundamentally
marked by the totality (in which subject-object are unified by the body),
folkloric time is anything but static. Unlike the later incarnation, his-
tory is not coded as a series of external events to which private life is
consigned to "petty affairs," but consists in the chronotope of the car-
nival which, however, is part of everyday existence. Although Bakhtin's
object of knowledge are the texts of literature, from the sources lit-
erature derives its narratives are plainly "extraliterary": folklore (pop-
ular culture) which are part of the oral tradition.

Surely the idea that literary texts may be, among other sources,
taken as reliable objects of social knowledge is precisely what Bakhtin
has in mind in his *Rabelais* or *Dostoevsky*. The distinction between the

social sciences, including history and the so-called humanities, is refuted in Bakhtin's invocation of the *Geisteswissenschaften* (human sciences), a term he employs to signify what he calls "the unity of culture" to describe his own discourse.[21] Of course, the appropriation of his categories by the disciplines and subdisciplines in the United States, without showing the implications of the large claim represented by the chronotope for constituting categories of experience, literary or otherwise, is entirely conventional, just as Bakhtin's own disclaimer for the universality of the chronotope in relation to the natural sciences may be comprehended within the framework of Marxist-Leninist scientism to which he was subject, at least bureaucratically. However, if we recall the ambiguity of his own statement, he proposes to employ space-time as a fourth dimension in literature but not really metaphorically. For his meticulous typology of the various series that constitute the temporal-spatial contexts for the medieval and Renaissance novel and the modern novel illustrates the claims of contemporary philosophy of science that all empirical science is theory-laden. The "chronotope" as a physical category mediates observation, measurement, and their results. Bakhtin uses space-time in a fairly rigorous way, from which he derives his own categories of narrative.

Moreover, in the work of Vernadsky, Oparin and other biologist contemporaries, from whom Bakhtin drew as much as from Einstein's relativity theory, the chronotope, one of main ideas that appears in the *Rabelais* has become a crucial element in the study of the evolution of the biosphere and problems such as the origin of life.[22] In the mid-1920s Soviet biologists and biochemists, together with some German and British colleagues, developed a theory of biochemical evolution that abandoned the older view that posited the appearance of life in images of linear temporality. They held that green plants fed by radiation made the earliest appearance, followed by other organisms. These scientists, led by Vernadsky and Oparin, advanced the hypothesis of heterotrophic sources for life, the simultaneous appearance of life-forms and the close relation and ultimate interdependence of organisms and their organic and inorganic environments, which interact interdependently. That is, once having emerged, life-forms enrich or impoverish the environment. And Vernadsky employs the category of chronotope to describe and explain that the series of events that constitute evolution. It is a Darwinian hypothesis, but also one in which synchronic relations of a horizontal kind remain pertinent.

So, although Bakhtin identifies with the view according to which literary studies are part of the human sciences, he departs from one of its major tenets: the logical and existential divide between natural and human sciences corresponding to a parallel gulf between nature and history. The concept of the "unity" of culture refers to art, everyday life, and postmodern scientific culture. But unity does not assume identity. Into time-space he inserts polyphony; that is, the multiplicity of voices which are definitively *not* dialectical, if by this term we connote internal contradictions that are resolved through the subordination of one of the terms by the other and its incorporation into a "higher" unity.

Thus, Bakhtin's philosophical position resumes more that of Nietzsche than of Hegel. While the rhetoric of the eternal return is absent from his discourse, there is also an emphatic, albeit implied, argument for the continuity of formal categories in the wake of historically determined transformations of speech genres. Yet the chronotope is constituted as a heterogeneity of voices. Utterance is a dynamic category through which time may be apprehended. The importance of utterance in Bakhtin's later thought can be understood in several dimensions: its role in literary production, its centrality to what we mean when we speak of "style." But Bakhtin's ambition is, finally, to read history through discourse, especially through a close reading of the transformations of utterances. In his essay on speech genres, Bakhtin comments on Goethe's description of geographical terrain in his *Italian Journey:*

> The living, dynamic marker provided by flowing rivers and streams also gives a graphic idea of the country's water basins, its topography, its natural boundaries and natural connections, its land and water routes and transshipment points, its fertile and arid areas and so on. This is not an abstract geological and geographical landscape. For Goethe, it reveals potential for historical life. This is an arena of historical events, a firmly delineated boundary of that spatial riverbed along which the current of historical time flows. Historically active man is placed in this living, graphic, visual system of mountains waterways, boundaries and routes. . . . One sees the *essential* and *necessary* character of man's historical activity.[23]

Bakhtin draws on travel genre as he draws on novels, to demonstrate

that embedded in the writer's craft of invoking nature is human activity, that writing is a kind of speech whose status is fundamentally historical even when its ostensible referent is the natural world.

II

Bakhtin commends his work to our attention now because, underneath the current fashion of European-inspired formalisms, other currents are struggling for a place in the critical sun: the new literary history, much of which is not new; a strong claim inspired by the later works of Roland Barthes for relieving criticism of its obligation to produce science in favor of a return to the text of fiction, to discover its pleasures. In some ways, interest in Bakhtin is unlikely in either literary criticism or linguistics because, until now, his social perspective on literature was out of fashion. Since the sixties American critics have been smitten by formalisms of various sorts: structuralism, semiotics, and deconstruction; and a considerable coterie hangs onto the New Criticism. Even Marxism, which is historical, whatever else it might be, was forced to adapt to the French turn or face marginality in current debates. Bakhtin and his friends were the collective precursor of antiformalist criticism; *Freudianism* is a pitiless critique of the fundamental psychoanalytic ideas from the point of view of a social linguistics. Their theory of language, which forms the basis of all of work of what became known as the Bakhtin Circle, is fully developed in *Marxism and the Philosophy of Language*—like the Freud book, ostensibly written by V. N. Volosinov. In the language work, Volosinov's fire is directed against Saussure's *Course in General Linguistics,* which took Soviet linguistics of the 1920s by storm and provided a broad basis for a new literary formalism against which the Bakhtin circle argued throughout the decade. *Marxism* is perhaps the most persuasive statement in our century of an alternative conception of language to that of Saussurian structuralism, for which the structure of language really inheres in the biophysiological makeup of humans and, like the gene, is relatively independent of its social and historical environment. Long before Saussure's French legatees discovered the pragmatic rule that signification was situated not chiefly in its structure but in the uses of language, Bakhtin insisted that, even if the capacity for language is given, its structure as well as its meaning derive

from its uses (and its consequences) within a definite social context. Words and sentences do not refer principally to their structure but to the dialogues in which they are employed.

Speech, or as Bakhtin calls it, utterance, is intimately linked to the space-time (chronotope) which constitutes the speech act as well as narrative. In fact, the analysis of utterances in literature as much as in daily communication is the crucial source of knowledge about modernist daily life. We learn about what people are saying, but even more important, inner and outer dialogues (conversations between people and between the self and its own other) tell us by the mode of expression who these people are.[24] And, as we have seen, descriptions of the external world are signifiers of conditions of historically situated time—signs of the self-production of humans.

So, although taken up in the United States mostly by literary critics because most of the translated work under his own name concerns methods of literary theory or studies of such novelists as Dostoyevski and Rabelais, Bakhtin may be considered better as a close student of culture, both in the anthropological and in the art sense; his wide use of historical, sociological, and aesthetic categories defies the neat cubbies of academic disciplines, although this has not prevented them from recoding his work in terms of their specialized debates.

Like Walter Benjamin, whose writings animated the literary critical scene in the late 1960s and 1970s,[26] Bakhtin is rapidly becoming the subject of literary studies. Among others of course, the Slavicists have appropriated him. In the context of the anti-Stalinist revival of the post-Brezhnev era, he is portrayed as a "religious man" persecuted by the Soviets for his faith. Consequently, his writing, ostensibly about Rabelais and Dostoyevski, as well as works about language, psychoanalysis, and literary forms, is sometimes taken as codes of an antiauthoritarian political intervention precisely during the Stalin era.[27] On the other side, the Marxists have gravitated to Bakhtin after long years in the modernist wilderness, where their insistence on socially rooted interpretations of literature were considered by the critical avant-garde to be quaint, when not dangerous in the light of Zhdanovian repression of artistic dissent until the partial thaw of the late 1950s.[28]

More than Benjamin who, despite his communist fellow-traveling, was among the first of the truly modernist critics, Bakhtin rails against modernism in art and criticism on both technical and ideological grounds. His attack against formalism, the revolution's most daring and

internationally appreciated aesthetic experiment, not only puts him, at least in the immediate postrevolutionary decade, outside the cultural mainstream in his own country, but also places him out of step with modern art of the first half of the twentieth-century. If he remained relatively obscure after the 1920s until his belated and conjunctural discovery in the highly charged political context of the waning years of the Khrushchev era, modernists could argue "with good reason," that his obscurity was well deserved for even when Bakhtin reads Dostoyevski, he looks for different things. What he wants to discover in the novels are the voices of those excluded from written history; he wants to dredge up the details of everyday life, not until very recently a legitimate object of the historian's eye.

But Bakhtin is not just another critic for whom the popular voice constitutes the basis of the aesthetic and social value of a literary work. Although there is a good case to be made that he is not a literary critic, historian, aesthetician, but is really a social theorist and a social linguist for whom literature functions as social knowledge, his great attraction for us, despite his denunciation of formalisms of all sorts, is his penchant for category-making which corresponds, ironically, to our (if not Bakhtin's own) will to scientificity. Bakhtin's "will to scientificity" is revealed most saliently in his penchant for category-making, an elective affinity that places him, loosely, in the Kantian mode of cultural criticism that was extremely powerful in the years just prior to and immediately after the Russian Revolution. At the same time, his great admiration for Goethe belies any facile attempt to place him in either the religious or the Kantian camp:

> All we have said reveals the exceedingly chronotopic nature of Goethe's mode of visualization and thought in all areas and spheres of his multifaceted activity. He saw everything not *sub specie aeternitatis* (from the point of view of eternity) as his teacher Spinoza did, but in time, and in the power of time. Everything—from an abstract idea to a piece of rock on the bank of a stream—bears the stamp of time, and is saturated with time and assumes its form and meaning in time.

To Goethe's world of "emergence" Bakhtin counterposes the "mechanical materialism of Holbach and others. . . . These same two aspects clearly separate Goethe from subsequent romantic historicity as well."[29] Unlike the old literary essayists whose discursive meditations grabbed

the reader by their sheer force of style, and who performed criticism by making the assumption that the work of art violated or was sympathetic to our collective sensibilities, Bakhtin's power is to get us to think in his categories. If you already know that Dostoyevski is the modernist whose major achievement was to capture interior dialogue, really our first great modern psychological writer, Bakhtin shows that this is merely an instance of a far greater contribution—his polyphony, the multitude of voices that inhabit his texts, the master narrator of the vissitudes of modernity where the petty affairs of private life become identical to the excluded history of the space-time that his characters inhabit.[30]

Bakhtin contrasts the monologue in which the authorial voice dominates the text, and dialogue where characters speak for themselves, voices that Dostoyevski articulates against his own political will, speaking of values and ways of life that are in profound disagreement with his own precepts. For Bakhtin, Dostoyevski's greatness consists in his loyalty to truth, even if this truth of diversity, of plurality, opposes his own exquisitely hierarchical religious worldview. Like his critics and biographers, Dostoyevski may have believed he was a chronicler of the existential choices to which humans were ineluctably wedded, but Bakhtin persuades us that his work provides, first of all, a window to the Russian middle class which forms the context of nearly all his most important novels and stories. Not that Bakhtin's Dostoyevski is a sociological naturalist who, like Emile Zola, contents himself with recording the world as a botanist classifies the forest flora. The novels and stories do not describe a social environment "objectively." Bakhtin:

> Not a single element of the work is structured from the point of view of a nonparticipating "third person." In the novel itself nonparticipating 'third persons' are not represented in any way. Dostoyevski has created a plurality of equally authoritative ideological positions and an extreme heterogeneity of material.[31]

This achievement Bakhtin calls polyphony. The musical metaphor could be transposed to a political metaphor, since Bakhtin's study was published when Stalin's dominance in Soviet life was just taking hold. And 1929 was the year of Bakhtin's arrest for his religious activities, an event which led to his exile from the Soviet metropolis to the provinces, where he was to spend most of the rest of his life, except for

the last decade, after being "discovered" by a post-Stalinist student generation. He returned to Moscow in the late 1960s when the Soviet Union was still in the first period of post-Stalin-era reform. In fact, this obscure provincial teacher of linguistics and literature was rediscovered in the context of the debate, initiated by Nikita Khrushchev, about the political and cultural monologism of the previous era, may have made the important contribution. For a new intellectual generation Bakhtin became a democratic prophet, but also a great Marxist critic. Certainly it is this "Marxism" that many current claimants to the Bakhtinian legacy would deny, substituting instead an aestheticist interpretation of this work which may be perhaps the least literary of all twentieth-century schools of thought for which textual criticism is the crucial method.

The first chapter of *Problems of Dostoevsky's Poetics* lays out his standpoint: Dostoyevski has invented the polyphonic novel out of his own ambiguous and ultimately contradictory personality and ideological position. Although the work is rooted in its own time, the validity of the achievement does not die when the conditions under which it was produced have been surpassed. Like only Dante, and perhaps Dickens, Dostoyevski has the gift of presenting many voices simultaneously and with equal amplitude. The dialogic imagination reaches its highest point here, precisely because Dostoyevski cannot resolve the conflicts that constitute his life and art. Nor can Bakhtin. For he was a religious individual, profoundly at odds with postrevolutionary Russia. At the same time that he is influenced by Marxism's *intention* to deliver literature from its formal bonds, especially in his attempt to develop a truly social theory of literature in which not only whole discourses and even sentences embody the dialogic principle, but even the word itself become an instance of discursive activity a sign of the "subject." A member of the so-called Bakhtin Circle (Medvedev) writes a harsh critique of Russian formalism, and another, Volosinov, produces a theory of language as a system of signs, the meaning of which depend upon their use within the context of communication. The social semiotics suggested in this work is sufficiently compelling to members of French poststructuralist circles, particularly Julia Kristeva, who finds in Bakhtin a precursor to her own work, which, however formalistic, nevertheless adopts the idea that language means as language acts.[32]

We resonate to Bakhtin, particularly his conception of the plurality of voices, and the intimate link of language to action, in part because

his position bears some affinities to pragmatism, which I understand here as democratic philosophy, according to which a discourse may be evaluated chiefly not in relation to a transcendent "truth," but in terms of its practical consequences. He offers criticism a way to explore the relationship between text and context that is resolutely antireductionist, but instead insists that social life is imbedded in the narrative in a way not available to more abstracted disciplines such as sociology, economics, and even historiography.

For what is found here is the experience of the ordinary—retold and recast in the novelistic text which, since the seventeenth-century, has taken the quotidian as the discursive object. For Bakhtin there are no resolutions of the contradictory, "heteroglossic" nature of human interactions in terms of categories of class, history, or other categories that inevitably transcode experience into information. Which is not to deny that Bakhtin is acutely aware of the class dimension to the novels of the bourgeois epoch. What he refuses, precisely, is the tendency towards class reductionism, to encode all experience and its aspects in terms of a version of social relations that derives from *a priori,* eternal essences such as those he perceives in Spinoza.

This is Bakhtin's strong program for a criticism that seeks to recover experience, wiped out by the processes of abstraction—both social and scientific—among other monologisms. Bakhtin demands that we reconstruct history through explorations of literature because, in his view, "life below the waist" is erased from our collective memory by official historians, those employed by the victors to tell the past in images of the present. This perspective is perhaps made clearest in his dissertation, *Rabelais and His World,* published belatedly after Bakhtin's rehabilitation in 1963. Judged by leading historians and critics to be "merely" a comic masterpiece, Bakhtin argues that the two major Rabelais novels, *Gargantua* and *Pantagruel,* are profound constructions of the popular critique of aristocratic society and culture, monuments to the power of laughter as political and social criticism. Moreover, the novels are veritable snapshots of the social worlds of the transition between peasant and bourgeois societies, portraits hidden in the preponderant histories for which peasant culture remains otherwise invisible.

Bakhtin's *Rabelais* has become a major influence on recent social history of the sixteenth-century, as we have seen in the work of Carlo Ginsburg, discussed earlier. Rabelais's peasants work hard all year, too hard, under the stern authority of the Church and the aristocracy, and

their retainers, the local officials. The carnival is that time when the peasants are free to break the rules, rules imposed from on high, and to appropriate by inversion the sacred practices of high culture by means of parody and ridicule. The carnival is a *ritualized transgression,* the place to display gross violations of conventional sexual morality, to engage in a temporary raucous public celebration of the body, a sphere strictly interdicted by established authorities. Bakhtin shows that the wild peasant dances, the laughter, and other outrages creep into high culture just as popular culture absorbs, albeit in comic form, the art of the masters. Even the Church is infected with popular art, so that, although possibly not a single peasant could or did read *Gargantua,* Rabelais's novels represent the intervention of the popular into literature, an art of the ruling classes by definition.

Ginsburg, still tied to the positivist premises of historiography, does not grasp the full power of Bakhtin's approach. It is not that Bakhtin has somehow avoided dredging up direct evidence to demonstrate resistance through popular culture and other means; he is making a two different points. The first is that high culture does not stand as the polar opposite of the popular. The split between intellectual and manual labor is a wall created by ideology, but does not, in fact, describe the real relationship between the two. And he is tacitly making a crucial historiographic point: he challenges the positivist assumptions of social historians who, since Thompson's magisterial *Making of the English Working Class* and Trompe's *Les mineurs de Carmaux,* have revolutionized the writing of working-class history through their archaeological investigations of everyday life. Bakhtin invokes the social world through literature because, among other things, he holds that the novel is the premier form through which the popular is defined by an oral tradition not available to historiography except through *indirect* accounts. Moreover, he shows that much of high culture is constituted, in part, by its appropriation of the popular, and that since the popular is an oral tradition, it can speak only indirectly through its incorporation by high cultural works. The people of Rabelais's time cannot speak for themselves directly, but in order to enter "history" require intermediaries.

Our knowledge of their hidden history, even information culled from records, of ecclesiastic courts in Ginzburg's justly famous studies, or of manorial rolls where clerks record commodity exchanges between lord, serf, and merchants, and accumulated debits and credits, is always

filtered information, since our informants are servants of the mighty. Of course, Rabelais's account differs only in degree; his eyes and ears are unique only because the novel is a form that depicts everyday life and is not restricted by the function within which peasants appear—as defendants, debtors, or whatever additional subordinate position they occupy. The historian is not likely to discover the grotesque—as representations of aristocratic culture or the orgies of pleasure—in the trial of a heretic, or a highwayman apprehended by the county police (the trial records are sources from which many social histories of the last centuries of the old regimes are gleaned). Nor can members of the lower classes emerge as real subjects, no matter how much we learn about them through dredging official records, without the historian's narrative constructions. The formal context of a tribunal tells one thing, a novel another.

Consistent with his work on the early modern novel, Bakhtin investigates later novels to reveal the underside of the space-time of the characters they represent. Unlike criticism derived from structural linguistics, which recognizes that signification derives from its use, but disdains its historicity, Bakhtin holds language as a historical category; utterance is the clue to the "socioideological" situation of characters:

> the novel is an expression of a Galilean perception of language, one that denies the absolutism of a single and unitary language—that is, that refuses to acknowledge its own language as the sole verbal and semantic center of the ideological world. It is a perception that has been made conscious of the vast plentitude of national and more to the point social languages . . . all of which are equally relative, reified and limited, as they are merely the languages of social groups, professions and other cross-sections of everyday life.[33]

According to Bakhtin, the modern novel is marked by "linguistic homelessness of literary consciousness," by which he means that authorial individuality, prized by some critics as the mark of great writing, is "decentered" by what might be described as the experience of modernity itself. The fragmentation of the social world, the relativity, and relationality of the worldviews of any of its actors, is the real subject of the novel. Against poetry, which preserves the myth of language—that the singular voice may be contained in the form itself—the "truth" of the novel is its "vast plentitude" of voices. The best works of fiction

dissolve the singular voice of the author—the characters take over, as in Pirandello's play, *Six Characters in Search of an Author* where the authorial voice is sought but has, regrettably, disappeared.

This theory of literature, and its companion theory of language, are analogous to the propositions of relativity and quantum physics, both of which put the observer in the observational field, and therefore can make no statements about nature that are independent of the framework of investigation. Poetry may be described as the Newtonian period in art; its ideological assumption is the separation of the inner and outer life, its language is characteristically the monologue. This was precisely the reason that the New Criticism privileged poetry over fiction. Stories and novels have a quality of anonymity, especially if they fulfill Bakhtin's critical criteria, while poetry is still the work of the ego, whose sole possession, a mythic yet individual language, aspires to transcend the muck of everyday existence to achieve higher truth. Of course, much of twentieth-century poetry has violated these rules by its aspiration to descend "below the waist." One hears the otherwise muffled voices of the populace in the epic of William Carlos Williams, or in the declamations of Mayakovski. These are not the world-weary consciousness of a Pound or Eliot, who speak the unified voice of their generation, however distinctively. What many critics find wanting in Williams is precisely the degree to which his utterance approaches the vernacular; they complain that there are too many separate voices in his long poem, *Paterson,* that the transcendental monologic subject, the unique personal voice that has become the subject of modern poetry, disappears. Besides the cardinal sin of merging aesthetics and politics, Mayakovski feels too "prosy": he has taken everyday speech as the vehicle of his poetry.

Still, despite the blurring of the lines between prose and poetry in a growing genre of poetic works that explicitly renounce the evaluative criteria enunciated by high cultural critics for this form, Bakhtin prefers prose, because:

> In the poetic image narrowly conceived (in the image-as-trope) all activity—the dynamics of the image-as-word—is completely exhausted by the play between the word [with all its aspects] and the object [in all its aspects]. . . . The word forgets that its object has its own history of contradictory acts of verbal recognition, as well as that heteroglossia that is always present in such acts of recognition.[34]

The word cannot stand alone apart from its object, but the object does not exist solely for the wordsmith; Bakhtin insists that language refers to something outside the speaker's sensibility. Or, to be more precise, the poetic trope cannot be the product of pure consciousness or stylistic convention, but points to an inexhaustible variety of expressions whose reference is the space-time of the world. For Bakhtin, rather than stretching the multiplicity of its uses and its references, poetry closes down the word.

My point in this chapter is emphatically distanced from an attempt to appropriate Bakhtin for the social sciences but to show instead how Bakhtin, through his paradigm shift from the standpoint of the disciplines to that of the human sciences—makes an antidisciplinary intervention into the construction of knowledge, to transform the disciplinary basis of historical, literary and social knowledge, all of which are separated in contemporary culture by parameters which are institutionally and ideologically derived. Bakhtin's is the way of the transgressor, for the disciplines have fiercely defended their respective domains and, with few exceptions, have clung to that portion of their canons and methodological presuppositions that justify their separate existences.

Needless to say, this work points to the emergence of the intervention that has appeared under the rubric of "cultural studies." This intellectual movement has been marked by three distinct features, all of which have been elaborated by Bakhtin. We have already seen the interplay of the "low" culture of Rabalais's peasants with high church culture, that there is *mutual* appropriation of each by the other, although the forms of utterance are dissimilar: peasant appropriation is accompanied by mockery and laughter; the Church incorporates peasant culture within its own rituals, but without calling attention to it. The second feature is cultural studies' alternative to the monologism of the dominant culture's canonical works of literature and art, proposing instead that the human sciences recognize the diversity of voices, not only with respect to the emerging discourses of women, people of color, lesbians and gays, and workers, but also the criteria for privileging utterance. This request articulates with Bakhtin's emphasis on *genre,* which provide space for "emotion, evaluation and expression" which are foreign to the mainstream.[35] Finally, as I have argued, Bakhtin introduces the concept that literature may be an authentic site, perhaps *the* privileged site of social knowledge, precisely because of its poly-

phonic character, as opposed to the monologisms of the philosophy of language and historical writing that remain unaware of their passive character.

I suspect that it is Bakhtin's challenge to the claims of science with its positivist methodologies of discovery, particularly its artificial separation of fact and fiction, of theory and observation on one hand, and "expressive" forms on the other, that is the most enduring contribution of this amazingly prescient thinker. If we are on the verge of a paradigm shift in the constitution of social knowledge, in which the categories developed by literary theory, especially of discourse, utterance, and polyphony, are no longer conceived as an internal, aesthetically saturated discourse, and where the distinction between nature and culture is once more blurred, then it is in Bakhtin's work that we will find a beacon for the new.

III

Bakhtin proposes to abolish literary history and criticism in favor of a poetics that aims to uncover the social relations other critics reify or submerge. Despite its formal elegance, this is a kind of populism, and therefore likely to cause anxiety in American academic critics. For just as Benjamin is often approached from his kabbalistic side, his Marxism regarded as an aberration better left unexamined, so Bakhtin is dubbed a pluralist, a freedom fighter, a soldier in the new Cold War. His Marxism is dismissed as the necessary compromise any intellectual had to make in the Stalin era. Clark and Holquist find themselves in a cul-de-sac when they claim that almost all of the work, including the Marxist critiques of structural linguistics, formalism, and Freud, was written by Bakhtin himself, or that he was the primary author *and* that he wrote the work in which such overt ideological positions are not emphasized, such as the Dostoyevski and Rabelais books. To Clark and Holquist, the Marxist discourse was Aesopian; it could not be Marxist and formally complex, since Marxism is a crude economic determinist doctrine explicitly excoriated by Bakhtin.

"*Marxism and the Philosophy of Language* is the most comprehensive account of Bakhtin's translinguistics. It sets out the major presuppositions on which all his other works are based," write Katerina Clark and Michael Holquist of a work that they attribute to Bakhtin, though

it bears Volosinov's name.[36] Not that they don't have reason to be confused. The controversy still rages over the issue of authorial voice. Some recent research purports to show that the writing in the language book differs from Bakhtin's unique style. But this is a relatively trivial consideration, of interest only to the cognoscenti.

The real issue is whether the claim that Bakhtin's Marxism is really a cover for another orientation can be supported. Clark and Holquist insist on Bakhtin's conception of language as a primarily social field, yet they ignore the Marxism of *Marxism and the Philosophy of Language* along with the contribution of Volosinov. This omission is not, of course, innocent, since the biographers try to show that both the circle and Bakhtin himself were quite separated from Marxism in the post-revolutionary twenties.

We can understand this mode of appropriation only if we remember that literary resurrections intervene in the conflicts of the present, in Bakhtin's case, recent developments in Eastern Europe. That Bakhtin could have been a practicing religionist and a political and literary radical is a proposition never entertained by his anti-Marxist interlocutors. Clark and Holquist show the link in the circle's theory of Language between ideology and systems of signs, but they offer no independent discussion of the concept of ideology either in Bakhtin or in Marxism. Yet here's Volosinov-Bakhtin:

> Any ideological product is not only itself a part of a reality (natural or social) . . . it also, in contradistinction to these other phenomena [physical bodies, instruments of production, products for consumption] reflects and refracts another reality outside itself. Everything ideological possesses *meaning;* it represents, depicts or stands for something lying outside itself. In other words, it is a sign. Without signs there is no ideology.[37]

For the Bakhtin circle, ideology is not located in consciousness as a subjective reflection on reality. It consists of practices, not disembodied thoughts. Ideology is inscribed in the way we deal with the practical problems of daily life, in the things we buy and eat, the ways we "spend" time, which movies and TV shows we watch, the kinds of friends we choose to keep. The idea of ideology as objective, linked to systems of signs, is fully consistent with several tendencies in mod-

ern neo-Marxist thought. The work of Fredric Jameson, Raymond Williams, Terry Eagleton, and others echoes the Bakhtin circle's interpretation of language as a social semiotic whose meaning theory and criticism try to decode by integrating text and context. But you would never know this from Clark and Holquist's Bakhtin.

Bakhtin's biographers could relax if they realized that it matters little whether he wrote all, most, or none of the books and articles upon which his name does not appear. If the circle was really an intellectual collective, then Bakhtin is a movement, not a new academic icon. Bakhtin hoped that his social semiotics would change our view of social life and shed new light on history. His work prefigures some recent critical accounts of historiography that suggest this activity is little more than mythmaking, where reverence replaces archaeology. Bakhtin recommends Dostoyevski's portrayal of contradictions that never get resolved. In this tableau, the passage of time does not equal progress, and history is not a dialectical spiral from lower to higher levels. Everything exists on the same plane, an insight that foreshadows Lévi-Strauss's "ahistorical" polemic against Sartre's progressivism. Bakhtin's explorations of excess in rural culture were meant to remind the middle class of the price it had paid for the mind-body split, for its self-sacrifice on the altar of modernity. Sadly, the Bakhtin "revival"—its discussions of the significance of utterance, of social context, its passionately baroque metaphors—seems to invoke a time out of joint with ours.

It may be that the age of epic appetites is over. We have experienced a massive assault on our own excessive moment, complete with regrets, self-renunciations, communitarian journeys cloaked in the garb of religious fundamentalism, or of humanism, the "left wing" of neo-conservative discourse. Humanism is just another kind of religion: the idea of progress is more or less unimpeachable; rationalism enjoys the status of holy writ. Yet, just as art often prefigures politics and everyday culture, we can speculate that the rediscovery of Bakhtin, which antedated *glasnost* by fifteen years, will mesh with a postmodern social theory that challenges the assumptions of the scientific-technological age. Bakhtin is the social theorist of difference, who, unlike Derrida and Foucault, gives top billing to historical agents and agency. For Bakhtin, there are no privileged protagonists, no final solutions, only a panoply of divergent voices which somehow make their own music.

NOTES

1. James Clifford and George Marcus, eds., *Writing Culture: The Poetics and Politics of Ethnography* (Berkeley and Los Angeles: University of California Press, 1988).
2. Herbert Marcuse, *The Aesthetic Dimension* (Boston: Beacon Press, 1978).
3. M. M. Bakhtin, *Speech Genres and Other Late Essays* (Austin: University of Texas Press, 1986), p. 3–6. In this interview with the cultural journal *Novy Mir,* which appeared in November 1970, Bakhtin reveals clearly his argument that one may not consider the literary text apart from "the history of culture." He explicitly resumes his earlier critique of the formalist tendency to abstract text from context.
4. George Bataille, *Inner Experience* trans. Leslie Anne Boldt (Albany: State University of New York Press, 1988).
5. George Herbert Mead, *Mind, Self and Society* (Chicago: University of Chicago Press, 1934).
6. "Insofar as stratification of the communal whole into social classes occurs, the complex undergoes fundamental changes; the motifs and narratives that correspond to those strata are subject to a reinterpretation. A gradual differentiation of ideological spheres sets in. Cultic activity separates itself from undifferentiated production; the sphere of consumption is made more distinct and, to a certain extent, compartmentalized. Members of the complex experience in internal decline and transformation. Such elements of the matrix as food, drink, the sexual act, death abandon the matrix and enter *everyday life* which is already in the process of being compartmentalized." M. M. Bakhtin, *The Dialogic Imagination* (Austin: University of Texas Press, 1981), p. 211. In this description, Bakhtin accounts for the appearance of everyday life in terms of the critical idea of differentiation.
7. C. P. Snow, *The Two Cultures.*
8. However, Bakhtin's referent is the "rich treasury of folk humor" in his study of Rabelais or, as in the studies of Dostoyevski's poetics, the multiplicity of voices or "consciousnesses" that do not reduce to a series of "types" as in Lukács's Weberian formulation.
9. V. N. Volosinov, *Marxism and the Philosophy of Language* (New York Academic Press, 1973).
10. Carlo Ginsburg, *Cheese and the Worms.*
11. Ginsburg, Ibid., pp. vii–viii.
12. Ginsburg, Ibid.
13. M. M. Bakhtin, "The Problem of the Text in Linguistics, Philology and the Human Sciences," in *Speech Genres,* p. 103.
14. "The Problem of the Text," Ibid.
15. Bakhtin, *The Dialogic Imagination,* p. 84.
16. Ibid., p. 206.
17. Ibid., p. 209.

18. Georg Lukács, "Reification and the Consciousness of the Proletariat," in *History and Class Consciousness* (London: Merlin Press, 1971). Of course, Lukács would not agree with the judgment that popular culture is "displaced, but not destroyed" by the penetration of the commodity form to all corners of the social world, the division of labor and its consequent alienation effects.

19. "Forms of Time and the Chronotope in the Novel," in *Dialogic Imagination*, p. 217.

20. Norbert Elias, *The Civilizing Process* (New York: Urizen Books, 1980).

21. M. M. Bakhtin, "Discourse and the Novel," in *Dialogic Imagination*, p. 270.

22. M. M. Kamshilov, *Evolution of the Biosphere* trans. Minna Brodskaya (Moscow: MIR Publishers, 1978), pp. 40–41.

23. Bakhtin, "The Bildungsroman," in *Speech Genres*, p. 37.

24. "The Problem of Speech Genres," in *Speech Genres*.

25. *Speech Genres*, pp. 72–73.

26. The boom was initiated by Hannah Arendt who, in 1967, edited the first collection in English of a selection of Benjamin's essays. Walter Benjamin, *Illuminations* ed. with an introduction by Hannah Arendt (New York: Schocken Books, 1967). But it was not until Fredric Jameson's discussion of Benjamin in *Marxism and Form* (Princeton: Princeton University Press, 1972) and articles in *The New York Review of Books* and other periodicals in the 1970s that he was recognized by scholars and critics beyond the Germanists and Frankfurt School mavens.

27. These themes are repeated in the various works of Michael Holquist, Caryl Emerson, Saul Morson, and Tzvetan Todorov. Todorov's pithy remarks on the subject of Bakhtin's relation to Marxism are extremely instructive in this regard. While, as he points out, Bakhtin never published a "single polemical text under his own name," there is, according to Todorov, little doubt that the Marxist works of members of the circle to which he was affiliated had his approbation, and their debates with various orthodoxies were conducted from inside Marxism. See Tzvetan Todorov, *Mikhail Bakhtin: The Dialogic Principle* (Minneapolis: University of Minnesota Press), pp. 9–10.

28. Andrei Zhdanov, "The Richest in Ideas, the Most Advanced Literature," in Maxim Gorky, et al. *Soviet Writers Congress 1934* (London: Lawrence and Wishart, 1977).

29. *Speech Genres*, p. 42.

30. Mikhail Bakhtin, *Problems of Dostoevsky's Poetics*, ed. and trans. Caryl Emerson, Introduction by Wayne C. Booth (Minneapolis: University of Minnesota Press, 1984).

31. *Problems*, p. 18.

32. Julia Kristeva, "Word, Dialogue and the Novel," in *Desire in Language* (New York: Columbia University Press, 1980). In this essay Kristeva underlines dialogism as "transgression giving itself a law," p. 71.

33. "Discourse and the Novel," in *The Dialogic Imagination*, pp. 366–367.

34. Ibid., p. 278.

35. This point is elaborated in "The Problem of Speech Genres" in *Speech Genres*.

36. Katerina Clark and Michael Holquist. *Mikhail Bakhtin* (Cambridge: Harvard University Press, 1984).

37. VN Volosinov, *Marxism and The Philosophy of Language* trans. Ladislav Matejka and Irtitunik (New York Seminar Press, 1973) p. 9.

7

BETWEEN CRITICISM AND ETHNOGRAPHY: RAYMOND WILLIAMS AND THE INTERVENTION OF CULTURAL STUDIES

According to conventional institutional history, the three founding spiritual parents of the intellectual movement known as cultural studies are E. P. Thompson, whose revival of historiography "from below" changed the face of history-writing for several generations; Richard Hoggart, who insisted on the continuing salience of a popular, working-class culture in the wake of the pervasive influence of the media, and founded the Centre for Contemporary Cultural Studies (CCCS) to document this culture and directed it for its first five years; and Raymond Williams, who, despite his lack of institutional connections to the CCCS and its progeny in some twelve British colleges and universities, was perhaps the most important influence on the movement.[1]

At first glance, Williams may be viewed as an unlikely candidate

to inspire a movement that in the end veered substantially from his own intellectual orientation and specific political vision. For example, Williams never swerved from his conviction that the labor movement—the Labour Party as well as the unions—was the fundamental cultural institution of the working class, contrary to 1960s radical cant, according to which they have become bureaucratically and even oligarchically addled. Moreover, even as in the late 1970s many practitioners of cultural studies were beginning to challenge historical materialism's faith in the redemptive character of the working class, and were discovering new agents—particularly women and working-class youth subcultures—for him, to the last, the workers remained the key to any possible emancipatory social transformation. And even as many intellectuals embraced the two major "posts" of contemporary social and cultural thought—postmodernism and post-Marxism—after publishing almost exclusively in cultural history and popular culture, he wrote extensively in his later years in Marxist theory. In fact, Williams only first seriously engaged Marxist theory in the 1970s, precisely the decade when it came under fire from, among others, many proponents of a version of cultural studies that tacitly identified with Marxism's dethroning.[2]

But as we will see, it is neither his version of Marxist cultural theory nor his specific ideological perspective that continues to commend Williams to cultural studies. His early contributions, still controversial in literary studies, consisted of two crucial moves: he adopted and elaborated F. R. Leavis's position that took literature as a sign of *culture,* rather than a repository of the "best that has been thought and said" in aesthetic or formal terms; and he extended the purview of critical studies to television and other communications media.[3]

As important as these innovations might have been, especially in the 1950s and 1960s, I want to argue that Williams is less a critic than an ethnographer. He reads poetry and novels in a way that is profoundly at variance with any accepted critical methodology, even that ascribed to conventional Marxism, which is, intentions to the contrary notwithstanding, honed in a disciplinary mode. For, as I shall argue, he is less interested in the intrinsic merit of the work in terms of criteria of aesthetic value, such as felicitous writing style, formal innovation, or narrative elegance, than in the extent to which it is a *signifying practice* of a concrete historical conjuncture. His object is whether the novel or poem provides *knowledge* of what he calls the "structure of feeling" of

a specific historical moment, and even more concretely of a given *class,* not whether it is a source of pleasure. Few among literary critics, even the historians, have followed him into these precincts; while some may teach courses in various genres of mass or popular culture, the object of "reading" is to plumb the formal character of the artwork. Alternatively, some critics choose to elucidate the ways in which film or other popular media may be taken as "art." Their point is to argue that aesthetic value inheres in these forms. And especially from the 1930s through the 1950s, Williams's Marxist colleagues, notably Christopher Caudwell, Ralph Fox, and later, Arnold Kettle subjected English literature to historical materialism's ideology-critique. Of these, Caudwell's was clearly the most interesting since, while pitilessly critical of the class standpoint of most works of the canon, by situating them in their historicity he was able to acknowledge their greatness.

In contrast, Williams's readings are pieces in a puzzle: how to construct the space between economic and political structures to forms of "thought"; how to get at the "structure of feeling." For in the contexts he variously calls "feeling" or "experience" lies what may be called the "lifeworld," a sphere that theory-saturated abstractions such as "ideology" invariably miss. From his writings on drama and criticism in the 1950s to his magnificent *The Country and the City,* narrative fiction and poetry are the raw materials from which one can construct the ways in which vast historical changes are interpretively configured and the ambiguous sphere of the lifeworld is revealed. Williams pieces this world together from the fragments of experience of which literature is a register, rather than performing the convention "connection" between pristine literary representations and the world to which, putatively, they refer. Just as Bakhtin reads Rabelais's *Gargantua* as a chronicle of the underside of sixteenth-century French peasant life, so Williams grasps the meaning of the transition from agrarian to urban society as a multifaceted process of which contemporary reflections are coded experiences.

I

Williams's excursions in Marxist cultural theory are marked by a certain wooliness. The reader comes away from his essays in this genre unsure of what she or he has read. We know that Williams is earnestly trying

to enter the discourse of theory free of deterministic economism and its antinomy, voluntarism, that had tainted Marxism between the wars and carried over to the early postwar period. In a large measure he succeeds, but in the wake of his rejection of the linguistically infused "French turn" in Marxist theory—which was heavily influential in cultural studies during the late 1970s—and the fact that only in the last decade before his death in late 1987 was he aware of the work of the Bakhtin circle, his major theoretical interventions, particularly *Marxism and Literature* (1977) are labored compared, say, to the evocative *The Country and the City* (1973).

For example, between his many explorations of literature and social context and his theoretical work, there is a distinct problem in the lucidity of the writing itself. Although Williams is never the graceful stylist, his voice was, before the adventures in theory, clear and forceful. As an ethnographer, there is never a doubt that he is thoroughly in charge of his material; he knows what he thinks about it, and his utterances are crisp and almost invariably to the point. In contrast, the theoretical formulations are riddled with qualifiers; the sentences bulge with digression; the circularity of the prose is all too evident. Williams struggles to get a handle on elusive concepts by adopting a strategy of evolving category definitions. But, like Thomas Kuhn's famous key word, "paradigm," which he uses in no less than twenty different ways, Williams's unique idea, "culture," suffers from nearly as many usages. Here is a not atypical instance:

> At the very centre of a major area of modern thought and practice, which is habitually used to describe, is a concept "culture," which in itself, through variation and complication, embodies not only the issues but the contradictions through which it has developed. The concept at once fuses and confuses the radically different experiences and tendencies of its formation. It is then impossible to carry through any serious cultural analysis without reaching towards a consciousness of the concept itself: a consciousness that must be, as we shall see, historical. This hesitation, before what seems the richness of developed theory and the fullness of achieved practice, has the awkwardness even the gaucherie, of any radical doubt. . . .[4]

From which issues a disquisition that fails to clarify, but sinks into multiple locutions, all of which are suggestive and none fully satisfying.

So begins the chapter "Culture" of *Marxism and Literature.* Wil-

liams never succeeds in getting out of awkwardness either of thought or expression which, as it turns out, is characteristic of the entire book. Williams is plainly uncomfortable in the theoretical twists and turns of contemporary Marxism and, where there is no concrete text—literary or visual—Williams is at sea. What commends Williams to us is not his theoretical perspicacity but his powerful ethnography. His great innovation, before the Bakhtin Circle enjoyed wide celebrity, is to have transformed the study of literature and other art forms from a conservatory of the "best that has been thought and said" in Arnold's terms, into a form of social and cultural knowledge. His tacit assumption, expressed in the concept of "cultural materialism" is that these signifying practices are immanent in the material world; that thought and its object constitute not an unbridgeable gulf or even logically separate spheres, but together comprise a single substance. Here the silent figure of Spinoza comes into play, as it does more openly in Althusser and Deleuze.

Since Williams is no philosopher, but instead works *de facto* less in criticism than in historical ethnography, he is interested less in weighing the aesthetic value of poetry and novels than in assessing the ways in which they constitute, as well as are constitutive of, historical *experience*. Of course, what he means by experience may not be confused with the ruminations of the classic English empiricist philosophers; Williams employs experience most saliently in terms of his category, the "structure of feeling." Among the clearest expositions of what he means by the notions cultural materialism, structure of feeling, and perhaps most importantly his celebrated distinction between emergent, dominant, and residual cultures is expressed in his otherwise failed, even if well-known, essay "Base and Superstructure in Marxist Theory":

> Now if we go back to the cultural question in its most usual form—what are the relations between art and society?, or literature and society?—in the light of the preceding discussion [in which Williams develops his proposition that the "dominant mode of production, therefore dominant society, therefore dominant culture exhausts the full range of human practice"], we have to say first that there are no relations between literature and society in that abstracted way. The literature is there from the beginning as a practice in the society. Indeed, until it and other practices are present, the society cannot be said to have fully formed . . . we cannot separate literature and art from other kinds of social practice. . . .

Williams goes on to say that literature, including theories, goes on in "all areas of culture."[5]

To be sure, literature does not correspond to an independent reality of which it is a (mediated) reflection. Instead, Williams's texts and those he examines—the poetry of Goldsmith and Wordsworth no less than the novels of Jane Austen and George Eliot—are interpretive recordings which are, themselves, part of the historical conjunction within which they occur. Williams consistently argues, by description more than anything else, that the object of knowledge is history, of which beliefs, values, and especially "feelings" are an ineluctable component and must be studied, in conjunction with economic and political institutions, as a "whole." The awkwardness of Williams's theoretical discourse may be ascribed to his own ambivalence about "theory" as opposed to his own ethnographic criticism and historical method. Since he lacks the categories of explication for a concept of totality in which experience is not a representation, Williams gropes for a vocabulary of immanence as he treats works of art as constitutive material signs, and this is the reason that, despite the tortured expression surrounding his theoretical interventions, he continues to exert so much influence on his and succeeding generations.

Williams is reading social and historical context through the text, an orientation to criticism he learned from Leavis. Compare Williams's insistence that literature is valid social knowledge to the following passage from Leavis's *Great Tradition*, perhaps his most influential work. Discussing *Middlemarch*, which for him is Eliot's "only book [which] can be said to represent her mature genius" Leavis remarks:

> The necessary part of great intellectual powers in such a success as *Middlemarch* is obvious. The sub-title of the book, *A Study of Provincial Life* is no idle pretension. Te sheer informedness about society, its mechanism, the ways in which people of different classes live (if they have to) earn their livelihoods, impresses us with its range, and it is real knowledge; that is to say, it is knowledge alive with understanding.

Then the corroborating footnote on the same page, a citation from Beatrice Webb's *My Apprenticeship* " 'For a detailed description of the complexity of human nature . . . I had to turn to novelists and poets' "[6] (p. 80). Unlike many of his erstwhile acolytes, Williams was a populist even less than he was an orthodox or "Western" Marxist. Rather, as a

cultural historian, he plumbs the canonical works of English literature to reveal the ways in which, in Leavis's terms, they may provide "real knowledge" not only of the complexity of human nature, but also of the density of everyday life with which economic and political structures invariably intersect. We see no better example of this work than in *The Country and the City* which, from a methodological perspective is exemplary. Indeed, in his long, autobiographic interview, "Politics and Culture," with the editors of the *New Left Review* (1979), Williams readily acknowledges the powerful influence Leavis had on his own, early thinking about culture:

> The immense attraction of Leavis lay in his cultural radicalism, quite clearly. This may seem a problematic description today, but not at the time [1939–1940 sa]. It was the range of Leavis's attacks on academicism, on Bloomsbury, on metropolitan literary culture, on the commercial press, on advertising, that first took me.[7]

But it was Leavis's stress on the importance of education that became, for Williams, a most enduring mandate. Before becoming a Cambridge Don, Williams was inspired to seek a teaching position in Oxford's Workers Education Association, an adult education night-school, a vocation that attracted other left intellectuals as well, notably E. P. Thompson. And it was from these experiences that one of the founding concepts of cultural studies emerged: that cultural education, as much as trade union and political education, in the strict sense, was an important task of the labor movement, and to confine the study of culture to the academy was to risk deradicalizing it. Although Thompson, and especially Richard Hoggart, shared some of these ideas, Williams, ever the pedagogue in writing as much as teaching, became the most important figure in "English" cultural studies precisely because he made the explicit connection between cultural study and educational policy. But for Williams "education" was not identical with formal schooling. Instead, his was a broad, political notion of education that led him to what might be termed cultural "policy," the most important aspect of which in the postwar era was the study of communications media, in virtually all of its crucial manifestations.

An example of the degree to which these experiences informed early ventures into cultural study may be found in the 1968 preface to his textbook *Communications,* first published in 1962. Williams's study

of communications media—not only television and films but also books, advertising, and theatre—is framed in terms of the idea of *permanent education:*

> What I have said about growth can be related to the idea of permanent education, which is now so important in French cultural thought, and with which I have had valuable recent contacts. This idea seems to me to repeat, in new and important idiom, the concepts of learning and of popular democratic culture which underlie the present book. What it valuably stresses is the educational force (education as distinct from *enseignement*) of our whole social and cultural experience. It is therefore concerned, not only with continuing education, of a formal or informal kind, but with what the whole environment, its institutions and relationships actively and profoundly teaches. To consider the problems of families, or town planning, is then an educational enterprise, for these, also, are where teaching occurs. And then the field of this book, of the cultural communications which, under an old shadow, are still called mass communications, can be integrated as I always intended with a whole social policy. For who can doubt, looking at television or newspapers, or reading the women's magazines, that here, centrally, is teaching and teaching financed and distributed in a much larger way than a formal education? (p. 4)[8]

While many—Williams himself but especially Thompson and Christopher Hill—uncovered the treasures of popular tradition in order to contest, intellectually, ruling-class hegemony over the national past, few were prepared to enter the muddy waters of institutional controversy, to perform the often-mundane sociological research as a necessary concomitant to making a more direct intervention. In *Communications* we find Williams using that staple of mass communications research, content analysis, to "measure" (his term) the growth of advertising in the respective print media in Britain, followed by a detailed examination of news coverage—both the type and the standpoint—to determine the degree to which newspapers become increasingly beholden to those who provide substantial advertising income. Of course, Williams's discovery is fairly well known: he who pays the piper calls the tune. But what is remarkable about his study is not its assertions, but the degree to which he is prepared to engage in statistical research to serve his pedagogic ends, to, in Audre Lorde's terms, "use the master's tools to dismantle the master's house." This exercise describes, as well as any

other, Williams' rhetorical strategy. A Cambridge Don, he explored English poetry, drama, and prose, not to celebrate it as a signifier of the greatness of English civilization, but to disrupt the powerful pastoral images which, since Blake's own deconstruction, remained a characteristic feature of ideological hegemony. But he was not willing to rest comfortably within disciplinary boundaries. His bold adventure into empirical social science reveals how seriously Williams took his role as a teacher. His methodological catholicity was a function of the essentially political context within which he placed problems of culture.

In *Communications* Williams is not content to stop where direct intervention begins. After an extensive analysis of the ambiguity of the high-low debate, in which he finds himself straddling the line between advocacy of the Great Tradition of English culture and a more complex critique of its relation to both the popular and the "mass" culture, Williams directly enters the dangerous waters of policy, where at the outset he reiterates the starting point that, with a few detours, guided his entire career as a public intellectual:

> that men [sic] should grow in capacity and power to direct their own lives—
> by creating democratic institutions, by bringing new sources of energy into
> human work, and by extending the expression and exchange of experience
> on which understanding depends. (*Communications,* p. 125–126).

From this declaration issues a host of proposals, ranging from suggestions to improve teaching of writing, the institutions and extending "criticism" to include newspapers, women's magazines, advertisements; "comparative visual studies" not only of television but of modern architecture as well; and "a comparative study of 'social images' of particular kinds of profession"[10] (p. 135), the object of which is "to bring all cultural work within the same world of discourse: to see the connexions between Elia and the manufactured television personality as well as the difference in value between *Lord Jim* and *Captain Condor*" (Comm., p. 133).[11] At this juncture, Williams declares that "academic criticism does nothing to help" generate "confidence in our own real opinions," still a controversial pedagogic aim, especially among those who fear that an open pedagogical environment might work to the detriment of the Great Tradition's standing—and their own.[12] (Ibid 133–135.)

II

Despite his distance, both institutionally and, after 1970 when Stuart Hall boldly moved the CCCS in the direction of the structuralist Marxism of Louis Althusser, ideologically, more than anyone else Williams theorized the incipient movement that came to be known as *cultural studies*. His earlier work, particularly *Modern Drama from Ibsen to Eliot* (1952) and *Culture and Society* (1956), remained basically within the Leavisite and even Arnoldian mode of moral literary criticism, despite the strong political concerns of the latter. But with *The Long Revolution* (1961) he began a twenty-year effort to provide a solid conceptual basis for a new approach that would embrace historical, anthropological, and social conceptions of culture. Perhaps the most important move in this work was to "define culture as a whole way of life," thereby obliterating the conjunction "and" between culture and society.[13] This strategic intervention introduced into social, as well as literary, theory the significance of culture in the anthropological sense; that is, the ways in which everyday life rituals and institutions (perhaps his most startling and original conception) were constitutive of cultural formation. Williams was, at the end of the day, a somewhat murky theoretical thinker whose thought manifests itself in a characteristic British disdain for abstraction and complex theoretical formulations. But more than any writer of his generation, it was his insistence on the persistence of practices, such as those of trade unionism, that were ordinarily viewed by critics as outside culture, that inspired the groups that elaborated cultural studies after 1965. For the crucial shift between the regime of cultural studies in Hoggart's era to that of Hall's stewardship at the CCCS consists, precisely, in the latter's privileging ethnography over criticism. Field studies, such as those of Paul Willis's *Learning to Labour* and Dick Hebdige's *Subculture,* done in the early 1970s marked a new direction for cultural studies that had been signaled by Williams's implicit repudiation of the premises of high literary criticism in the *Long Revolution,* and by his studies of television and communications.

In what sense is Williams straddling the boundary between addressing representations such as literary texts and the "pressing of the flesh" that forms the core of ethnographic study? Surely, he did no traditional "field" work. Rather, it is his epistemological stance that marks him off from traditional criticism. Like Bakhtin, Williams takes the fiction text not as "representation," if by this term we signify the

problematic of correspondence between text and context that is independent of it. Rather, the text embodies its unique space-time, the characters of a novel or the poet's evocations are as constitutive of the lifeworld as a conversation between two bikers or school-leavers in Hebdige's and Willis's texts. In fact, like most good ethnographies, much of the "Hammertown" case study of twelve nonacademic working-class kids is written as dialogue; although the narrative employs a quasi-theoretical discourse, Willis's account of the "lads' " own speech reveals a writerly ear:

BILL It's just hopeless round here, there's nothing to do. When you've got money, you know, you can get to a pub and have a drink, but, you know, when you ain't got money, you've either got to stop in and just walk round the streets and none of them are any good really. So you walk around and have a laff.

JOEY It ain't only that it's enjoyable, its that it's there and you think you can get away with it . . . you never think of the risks. You just do it. If there's an opportunity and the door's open to the warehouse, you're in there, seeing what you can thieve and then, when you come out, like, if you don't get caught immediately, when you come out you'm really happy like.

BILL 'Cos you've shown others you can do it, that's one reason.

JOEY 'Cos you're defying the law again. The law's a big tough authority like and we're just little individuals yet we're getting away with it like.[14]

Of course Richard Hoggart's early work, especially his extremely influential book *The Uses of Literacy* (1957), had been suffused with this dimension, but only implicitly. And, unlike Williams, Hoggart never considered the *institutions* of the labor movement, especially unions, as signifiers or even sites of working-class culture. Nor did Hoggart's understanding extend explicitly to the category of *practices* rather than representations as the core upon which cultural formation is constructed, although the best parts of *Uses* concern what, in contemporary terms, would be "discursive" practices that might be considered distinctly working class. On the other hand, Williams significantly broadened the concept of culture to embrace its materializations.

Now, the notion of language as material practice had, by the late 1960s, been introduced by critics and linguists who wished to break from the Cartesian premises of the discipline. At one moment, Williams

appropriates this shift in his definition of culture as "signifying prac-
tices" thus preserving, not unwittingly, the distinction between the
production of meaning and the objects to which it refers. Similarly, in
the wake of Althusser's frontal assault on Marxist orthodoxy's separation
of base and superstructure by acknowledging the determination of the
economic, but only in the "last instance" (which, according to Althusser
never comes), Williams struggled to retain a class perspective despite
his fairly tangled effort to show that determination was not a one-way
street (the "superstructure 'determined aspects of the infrastructure as
well as being determined by it"). Of course, in his essays on the subject,
especially the chapter in *Marxism and Literature* resuming his earlier
discussion of base-superstructure, Williams acknowledges complexity.
Yet in the end he remains reluctant to throw out the power of the
Marxist formulation of the primacy of the economic, lest the political
significance of class relationships be diluted. It is as if, presciently,
Williams grasps the fundamental tendency of Althusserianism and its
Spinozian roots: when you effectively give up the determination by the
economic, and retain the formula, but only as an incantation, it is a
short distance to giving up the maxim "all history is the history of
class struggles." From this issues Althusser's own assertion of the prior-
ity of the mode of production, taken by his "school" as a structured
totality of which class relationships are derivative, only one sphere (the
others, virtually equal in weight, are political and ideological relations).
In fine, while Williams in the late 1970s came to appreciate some
elements of structuralism, he resisted its crucial entailment: turning a
back on the Hegelian social dialectic whose core is the master-slave
relation. For the son of a railroad worker and a former Communist
whose break with the party was quite "soft," such a move was tanta-
mount to discarding the centrality of the working class as historical
agent.

Of course, this obstinacy was Williams's strength as well as his
weakness: strength, because it was precisely his lifelong connection with
the workers' movement that contributed, even determined, his capacity
to take the emanations of high culture as "data," rather than cultural
ideals to which the working class should aspire, and to insist upon the
cultural significance of working-class communities. Beyond the ques-
tioning of canonicity, which runs like a thread throughout his work
after 1960, is his attempt to leave open all questions of artistic value,
and more controversially, to remove the argument from the exclusive

purview of academic experts. Weakness, because, smitten with what Wright Mills once termed the "labor metaphysic," his theoretical range remained limited. It was as if hanging on to the primacy of class was a shield against the dissolution of his socialist faith. As events after his death have unfolded, one can only admire this "weakness." For many who were theoretically lighter on their feet than Williams, including some of his students and erstwhile admirers, have drifted away from socialism, let alone Marxism. It may be said that they have confused the concept of "crisis" which, indeed, suffuses the contemporary socialist and workers' movements with their obsolescence. Such a conflation seems more than convenient in the wake of political agony for the left.

What is at stake here is more than the specific collapse, consecutively, of the Berlin Wall, of the Soviet Union, and the Eastern European Communist states. It is important to recall that by the 1960s, in such documents as the May Day Manifesto (1967), written as a prelude to a still-born New Left political initiative, Williams had already called attention from a democratic perspective to the insufficiency of parliamentary institutions, and argued alternatively for a *participatory democracy,* but, in his self-critical view, not strongly enough. In fact, Williams moved leftward in the last decade of his life:

> the distinction between representation and popular power has to be now sharply put. I have tried to do that recently in *Keywords.* But I still find that when I criticize representative democracy, even to quite radical audiences, they react with surprise.[15]

By the 1960s Williams had joined with a group of former Communists of his generation and of younger intellectuals who attached themselves to a long-suppressed tradition of antibureaucratic, antistatist, popular power that had been associated with traditions that were hostile, not only to Leninism (if not always to Lenin) and Stalinism, but also to modern social democracy. What for many of them was a short-lived left-libertarianism (many drifted into the Trotskyist movements or became left-wing labourites), was to become Williams's political creed for the remainder of his life. In the last twenty years he openly espoused a radical democratic politics within a militant socialist framework. There is no evidence that either Williams or the British New Left recognized the anarchist and left-communist roots of this critique. But

there is no doubt that, despite his frequent excursions into educational reform, a tacit acceptance of the statist framework for broadening democratic participation, Williams's radicalism was unmistakable.

In tandem with this orientation, the burden of Williams's later work marches steadily in the direction of sundering the older Marxist categories. Williams spent nearly a quarter of a century trying to resolve the dilemma of spanning representation and material practices, to cobble a conception of culture that avoids the land-mines of epistemological realism which, it is fairly clear to see, is merely the expression of a politics of representation. That he did not succeed is not surprising. The problem of all efforts to overcome correspondence theories, which posit the distinction between the knowing subject and its object, resides in the political as well as philosophical question of *agency*. If there can be knowledge without a knowing subject, and objects are always constituted discursively, how are human agents constituted? Together with his colleagues, especially those at the CCCS, for whom he was a constant referent and inspiration, by the late 1970s Williams had determined that culture is not entirely encompassed by art, artifact, or those representations that have been hegemonically valorized as "civilization." At the same time, unsatisfied with the persistence of the base-superstructure gulf, he worked with a play of alternative formulations that could satisfactorily overcome, if not entirely overturn, the scientific worldview, such as categories of determination and mechanical causality. That his work remained relentlessly discursive, and bore the telltale traces of his moral training, remained an object of pity and even scorn for the next generation of Marxist theorists, notably his pupil Terry Eagleton, and Perry Anderson who wished to produce a sophisticated but ultimately orthodox "scientific" Marxist theory of culture on the basis of analytic cateogies from which what Williams understood as *experience* could be properly interpreted.

Marxism and Literature and *The Sociology of Culture* (1983) failed to shed elements of empiricism and especially historicism that had marked his earlier writings. Williams was trying to figure out how to articulate the two meanings of culture:

> it became a noun of "inner" process specialized to its presumed agencies in "intellectual life" and the "arts." It became also a noun of general process specialized to its presumed configurations in a "whole way of life."

In the latter instance, culture is seen as "constitutive social process."[16] Thus it cannot be understood as a category of the superstructure within the framework of determination by the economic infrastructure. This conclusion permeates all of Williams' work in the last fifteen years of his life, and in consequence it is not difficult to discern his skepticism about the effectivity of base-superstructure distinction, as well as its premises, the reflection theory of knowledge and the correspondence theory of truth, themselves grounded in epistemological realism. At the same time, and not unexpectedly, he was unable to generate a satisfactory alternative, in part because of his deep-seated ethical belief in the class basis of socialist politics, and the suspicion, shared by many of his generation, that the many varieties of post-Marxism that began to surface in the late 1970s threatened the emancipatory project to which he had devoted his life.

Still, Williams, like Stuart Hall, Richard Johnson, and many others in cultural studies, was plainly influenced, as Thompson and Hoggart were not, by many of the tenets of structural linguistics, and the epistemological claims for language and discourse that informed it. Meanings were not embedded in history or in the Mind underlying the utterances of essential subjects, but were produced locally, within specific contexts; language had no fixed referent, but instead was constituted as practices whose "meanings" were spatio-temporally contingent. Williams never went so far as, say, Laclau and Mouffe, for whom the social itself is impossible precisely because, following Foucault, the concepts of society and of social relations connote an essential ontology of social being. Rather, they maintained that human relations are interpellated by discourse. Moreover, if the idea of a subject is problematic, so is the notion of human or social relations, for "relations" imply subjects who interact, a posit that is logically inconsistent if, indeed, the constitution of "subjects" is context-dependent. In place of the conscious subject, Foucault, Laclau, and Mouffe substitute a "subject position" whose rules constitute the space within which discourse takes place.

In contrast, Williams never adopted the position that language-discourse displaces human agency. He remained wedded to what might be termed the "ontology of consciousness," according to which intentional human practice is an effective counterweight to both mechanistic materialism (associated with some versions of Marxist orthodoxy that

emphasized the determination of cultural, ideological, and political practices by the already-given economic infrastructure) and idealism which, while insisting on the active side of cultural practices, lost sight of all but the signifying subject. We might express this formula by inverting Marx's famous dictum: specific social circumstances condition how history is made, but history is made by humans.

In what is perhaps the most powerful statement of his position, Williams displays the most "dialectical" of all his cultural writings, showing the degree to which he wants to separate himself from the passivity associated with structural linguistics, while at the same time declaring that "language is material" and the sign active. Here, Williams makes plain his adherence to a concept in which relations between various aspects of the social totality are indeterminate *in advance*.

Williams seems to agree on the conventional distinction between economic and cultural relations, even if he inferentially refuses a one-way determination of culture by production relations. Nevertheless, in context, he was drawn ineluctably to a position that "cultural production was material," a perspective that leads to this:

> Because once cultural production is itself social and material, then this indissolubility of the whole social process has different theoretical ground [than classical Marxism]. It is no longer based on experience, but on the common character of the respective processes of production.[17]

Here Williams adopts a productivist conception of culture within a broad theory in which material production loses its exclusive connection to what might be described as "physical" need. Thus, production of various kinds *together* constitute the whole social process whose relations of determination are contingent not on *a priori* metaphysical categories but on concrete circumstances.

The course of British cultural studies has been fundamentally altered since the mid-1970s by these shifts. Following Williams, and despite the profound influence of what has been termed "poststructuralism," much of British cultural studies refuses to abandon the emancipatory telos of Marxism, even while shifting away from the "always already" privileging of the working class to a more contextualized position, where the subcultures of, say, race, gender, and generation may constitute the primary identity of social groups. However, cultural

studies, in the interest of maintaining a political as well as theoretical standpoint, is required to retain categories such as production and agency, without imputing finality to the ways in which they are employed; and to work out a theory of the totality, albeit altered from its Hegelian connotations.

Armed with some elements of the democratic ethos Williams helped to generate, cultural studies enters its greatest period of growth as it opens itself to the critique of scientificity, to feminism, and to other subaltern discourses that arise on the ruins of a withered ideology of class. From the methodological standpoint, Williams bears considerable responsibility for the crucial movement within cultural studies away from criticism and toward ethnography, although this has not always been in the way Williams would have wanted. For, after an initial decade during which cultural studies embedded its work within the humanities, especially literary history and criticism with the departure of Hoggart in 1969, the CCCS turned away from representations, and engaged almost exclusively in subcultural ethnographies—except Stuart Hall, who, as its leading theorist, directed his efforts towards textual analyses of, among other objects, television.

What distinguishes Williams from critics and theorists, Hall among them, who followed Althusser in the mid-1970s, is his refusal, implicitly, of the distinction between the representations found in literary and other (high) artistic texts and other forms of cultural practice, such as culture in the anthropological sense—the interactions of small groups whose practices, rituals, rules, rewards and punishments were the privileged objects of study for the social-scientifically oriented center at Birmingham. In fact, the CCCS and its friends turned from Williams out of a misunderstanding. With the exception of the persistence of Stuart Hall's largely textual criticism of the media and its products, works of so-called "high art" were abjured.

But if the object of cultural studies a priori is a "whole way of life," then one may not take the path of rejecting high cultural works. "High" is part of this way of life no less than bikers' banter, the response of women to daytime "telly," or shop-floor culture in a car assembly plant. For if fiction is a form of social knowledge, one may treat literary texts ethnographically, and this is the culmination of Williams's methodological legacy. To understand the subtlety of Williams's approach—one that reveals the degree to which his democratic passion is upheld, even

as he insists on the importance of retaining elements of the Great Tradition—we may consult his comments on the pedagogical significance of addressing the high-low controversy.

Williams reminds us that many of the works included in the canon were themselves considered " 'low' in terms of the 'high' standards of the day." Williams argues that such forms as film and genres such as jazz and the theatrical musical have been regarded by guardians of high culture as a threat to "standards." But, he remarks, the "distinction between art and entertainment may be much more difficult to maintain than it looks." Although he acknowledges that we are "in danger" of losing the Great Tradition, for which Williams never lost affection, he also points out that it may not be a problem of the works, whatever their conventional categorization, but the standardization of all culture, the flattening of difference that appears endemic to social life. Williams insists that, if the power of the Great Tradition is to challenge us to change our routine ways of thinking, this property may be experienced in the reception of journalism or popular genres as well as the so-called "minority" culture.

In the end, Williams calls into question the conventional high-low distinction without making the postmodern turn away from the Great Tradition; he does not insist that considerations of "value" are merely ways to preserve elitist art. Rather, he wants to democratize the scope of those works that may be included in a canon, but he refuses the aestheticist criteria for determining its formation. Rather, Williams's democratic move is to shift the terms from categories of beauty to categories of pedagogy and the social knowledges to which both the art and the teaching refer.

Finally, when we are relieved of the pointless questions associated with evaluating Williams's work in literary theoretical terms, and can come to terms with his position as a teacher and public intellectual, the contemporary relevance of his work for cultural studies is crystal clear. What we learn from his vast corpus is that the point of cultural studies is to empower ordinary people to take control over their own lives by, among other means, fully appropriating cultural things, whatever their status in the hierarchy. That he remained, despite this perspective, close to literary studies, is more a function of the intellectual division of labor than intention. Nonetheless, more than any theorist of his or the subsequent generation of British intellectuals, he points the way out of the antinomies that continue to plague us.

In this moment when cultural studies is rapidly being absorbed by universities and, in the process, is losing its political edge, overcome with, in Meagan Morris's word, "banality," Williams's example may be taken as a "tradition" worthy of emulation.

NOTES

1. Richard Hoggart, *The Uses of Literacy* (Boston: Beacon Press, 1961); EP Thompson, *The Making of the English Working Class* (New York: Alfred A. Knopf, 1963); some of Raymond Williams's most influential works are discussed in this chapter.
2. See especially the essays in Raymond William's *Problems in Materialism and Culture* (London: New Left Books, 1980).
3. The earliest of Williams's major works on contemporary culture is *Communications* (London: Penguin Books, 1962).
4. Raymond Williams, *Marxism and Literature* (London: Oxford University Press, 1977), p. 11.
5. Williams, *Problems* . . . pp. 43–44
6. F. R. Leavis, *The Great Tradition: A Study of the English Novel* (New York: Doubleday Anchor Edition, 1954), p. 80
7. Raymond Williams, *Politics and Letters* (London: New Left Books, 1979), p. 66.
8. Williams, *Communications* . . . p. 4
9. *Communications* pp. 125–126
10. Ibid p. 135
11. Ibid p. 133
12. Ibid p. 134–135
13. *Politics and Letters,* p. 135.
14. Paul Willis, *Learning to Labor* (New York: Columbia University Press, 1981), p. 41.
15. *Politics and Letters,* p. 415.
16. *Marxism and Literature,* pp. 18–19.
17. *Politics and Letters,* p. 39.

III

CULTURAL POLITICS

8

REFLECTIONS ON IDENTITY

-I-

The Cold War, which dominated nearly all public life for most years of the latter half of the twentieth-century, interrupted a debate about the crisis in modernity that had erupted at the turn of the century and occupied much of philosophical and social thought until World War II. Most anti-Stalinist intellectuals were fiercely committed to modernity's putative achievements—individualism, democracy, and social (if not always cultural) pluralism—ideas as old as the era of revolution, which accompanied the rise of the middle class in the seventeenth-century and reached their apogee with the liberal revolutions during the following two centuries. For both socialist intellectuals and modern liberals who accepted the invocation of more equality and social justice through public action—these values were typically framed in terms

ineluctably connected to universalism, of which a faith in progress through scientific and technological innovation was among the cardinal first principles.

According to this doctrine, the history of humankind was teleologically motivated, in Croce's felicitous phrase "the story of liberty."[1] The narrative featured the beneficent effects of industrialism, driven by scientific and technological knowledge and the division of labor, which stood alongside liberal democracy and individual rights as goals whose achievement was as inevitable as the eventual eradication of poverty and hunger. At the center of progressivism—the political expression of modernity—was the striving individual. One of the perplexing questions for English philosophy was how to establish the ground for individuality in an increasingly complex social world, one dominated by the growth of large economic enterprises and a centralized state that protected them.

Of the proposition that the individual was identical with itself Locke has no doubt. For even if identity cannot be established by means of the posit of unique substance, the agency of *reflexive consciousness,* of which memory was the crucial faculty, united past and present:

> Thus it is always as to our present sensations and perceptions: and by this every one is to himself that which he calls *self:* it not being considered in this case, whether the same self be continued in the same or diverse substances. For, since consciousness always accompanies thinking; and thereby distinguishes himself from all other thinking things, in this alone consists personal identity i.e. the sameness of a rational being: and as far as this consciousness can be extended backwards to any past action of thought, so far reaches the identity of the person; it is the same self now it was then; and it is by the same self with this present one that now reflects on it, that that action was done.[2]

Locke's doctrine of consciousness is meant to solve the problem of demarcation of man from animals, and the more difficult issue of how individuality is possible in progressively more complex urban environments where identities are constantly buffeted by what he calls Laws: those of "God . . . politic societies . . . and the law of fashion or private censure." The laws of God provide the basis for morality, but the rules of civil law and the "law of opinion or reputation" are, from the standpoint of individual identity, more troubling, for these are the procedures

whereby humans govern themselves, and they have at best an ambivalent relation to the tenets of divine law. But Locke himself recognizes that what passes for virtue in one place may be considered vice in another. The aporias of civil law are unsettling enough, but Locke's unease is most apparent in discussing the weight of the formation of the self where people encounter each other in everyday life. While most of us never seriously reflect on "the penalties that attend the breach of God's law" and "flatter themselves" that they may attain "impunity" with respect to the laws of the commonwealth,

no man escapes the punishment of their censure and dislike, who offends against the fashion and opinion of the company he keeps, and would recommend himself to. Nor is there one of ten thousand who is stiff and insensible enough, to bear up under the constant dislike and condemnation of his own club.[3]

Locke has offered one of the earlier dialectical theories of socialization. The self is constituted both by consciousness and by constraints of the external environment, of which conformity to the current fashions of one's own "club" is the most powerful. Identity, which cannot rely on "innate principles" such as substance, is confronted by the rules laid down by the divine and civil law, and especially the private sphere where personal identity becomes ineluctably, in the context of this lifeworld, a social self. In this theory we see the ground for later formulations, notably by Freud, of the problematic of the human psyche in terms of the conflict between individual and society, and for the social psychology of William James and George Herbert Mead.

Yet Locke's notion of identity has already dispelled a conception of the *essential* individual since, in his theory of the self, substance—either in its corporeal or its spiritual manifestations—gives way to "consciousness." For Locke, consciousness turns out to be *constituted* by the faculties of memory and reflection, and by *relations* between the self and others. Although he is constrained by an objectivist theory of time and space, at the same time he is keenly aware of the relativity of both of these categories, even if, in terms of the question of identity, this awareness is tempered by moral obligation.

Eighteenth and nineteenth-century political and economic philosophy is deeply influenced by Locke's penetrating discovery of the social constitution of individuality, but by the late eighteenth-century, the

emphasis of social theory had decisively shifted to concepts such as "society," "history," and "progress." Although nineteenth-century German philosophies pay some tribute to the notion of the individual, this category now becomes, especially in Hegel, the outcome of a long dialectical process in which the state is the material embodiment of the unity of humankind, otherwise mired in conflict at the level of the family and economic relations. For Hegel, individuality is *produced,* but neither by God and the law nor by social interaction with significant others. Criticizing the widespread view that the development of this "civil society" is the final arbiter of human affairs, Hegel opposes Adam Smith's assurance that the hidden hand of God can make whole the otherwise incessant war of all against all.[4]

For Marx, the individual is the outcome of the evolution of private property and the universal marketplace, where possessors of different commodities confront each other. As Marx and other critics point out, everyday life remains a battlefield in Hegel's account of universalism; the contradiction between the individual, the marketplace, and the state remains.[5] And since Marx regards the individual as nothing more than an "ensemble of social relations," the ideology of the individual's autonomy is linked to the development of the conditions for the rise to capitalism. The emergence of an authentic individual, and hence, a self, awaits Communism.

By the turn of the twentieth-century, nearly two hundred years after the appearance of Locke's *Essay,* William James bases his own theory of the social self on Locke's ruminations. However, responding to the evidence of social and cultural fragmentation that in every industrial society appears to pervade modern life, James carries the argument a step further:

> Properly speaking, a man has as many social selves as there are individuals who recognize him and carry an image of him in their mind. To wound any one of these images is to wound him. But as the individuals who carry the images fall naturally into classes, we may practically say that he has as many different social selves as there are distinct *groups* of persons about whose opinion he cares. He generally shows a different side of himself to each of these different groups . . . from this there results what practically is a division of the man into several selves; and this may be a discordant splitting . . . or it may be a perfectly harmonious division of labor. . . .[6]

What is, for Locke, the social pressure exerted by the immediate "club" to which a person belongs, has now been transmuted into the influence of the many groups to which the individual is related. The long process by which social identity has been fractured—first by the refutation of the Aristotelian concept of substance as the basis of identity and difference; then by the perception, shared widely by social and cultural critics and theorists, that modern identity is constituted both by the "material self" and an indeterminate multiplicity of social selves. James even deconstructs the notion of the material self. He points out that the self presents itself in clothes, which are more than mediations, but are fundamentally constitutive.

> We so appropriate our clothes and identify ourselves with them that there are few of us who, if asked to choose between having a beautiful body clad in raiment perpetually shabby and unclean, and having an ugly and blemished form always spotlessly attired would not hesitate a moment before making a decisive reply.[7]

Only under special circumstances, can we speak of a "spiritual self"; for James, consciousness is no longer given. Few of us are capable of reflection, but all of us are subject to feelings which, after sorting out the vagaries of the soul, may be the content of the "I." Concluding these observations, James says:

> it is difficult for me to detect in the activity any purely spiritual element at all. Whenever my introspective glance succeeds in turning round quickly enough to catch one of these manifestations of spontaneity in the act, all it can ever feel distinctly is some bodily process, for the most part taking place in the head.[8]

From the perspective of the problematic of identity, the most interesting and prefigurative discussion of his monumental *Principles* concerns the body-self and its relation to the social self. For James, then, our various selves are arranged hierarchically, and a "certain amount of bodily selfishness is required as a basis for all the other selves." However, lest pleasure overcome responsibility, James distinguishes between the "immediate and actual and the remote and potential." In

the end, James argues that "most of us" strive to achieve recognition by the highest possible interlocutor, which, for him, are those charged with preserving the moral standard, "religious men."

This position is simultaneously a meditation on ways to escape the ties that bind the self to the vicissitudes of everyday life, and to create its own "image" of propriety by reaching for a spiritual and moral existence. Yet the hope for transcendence remains just that; the burden of James's argument is the dominance of the specifically bodily and *social* self; the spiritual self is, at best, a vanishing horizon reserved for the few. Although for James there is an irreducible "I" that thinks, remembers, and reflects, it remains uncertain of itself, precisely because of its dependence on the body and the multiplicity of social relations. Inevitably, group life is the home of individual identity.

It remained for George Herbert Mead to break from the spiritual posits of Locke and James. Now the social contradiction between the I—the individual ego which remains the ideological *a priori* of all liberal thought—and the "me"—the social self—is resolved outside the ethical appeal to a higher authority. For Mead, there is only a biological self which is mediated by a social self formed by the interaction between the individual and "significant" Others—family members, civil authorities, peers—all of whom underdetermine what we mean by the individual. Like Freud's superego, these together constitute a *generalized other,* the totality of values, beliefs, and, even more important, rules of conduct by which individuals live. Again, like Freud's concept of introjection, Mead's notion of *internalization* describes how society and its constitutive institutions, including Locke's "club," *determine* individuality.

> The environment of living organisms is constantly changing, is constantly invaded with other and different things. The assimilation of what occurs and that which recurs with what is elapsing and what has elapsed is called "experience."[9]

Experience, then, is a process of "assimilation" of the environment, but is understood to be inescapably part of the self. Mead's notion of the social self entails two moments: the constantly changing environment and its assimilation by a living organism. The two terms are constantly in motion, and their relation is always indeterminate from the point of view of the subject. For Mead, the past is present as mem-

ory. And the environment is present in the distinction between "I" and me, where the former is immediate consciousness, and the latter is the mediated representation of the environment, both the physical resistance of things and the significant others, including the generalized other. Consequently, our conversations are not only with external others, but also with their representations in the form of the "self"; the formulation is Mead's appropriation of Hegel's concept that consciousness takes itself as its own object. But Mead's formulation, "consciousness," is no innate entity, but has already passed through a process of transformation through its interpenetration with the other.

Mead states, in his "Fragments" on Whitehead and Relativity, that the theory of relativity has abolished absolute space and absolute time, substituting relative spaces and times within which objects move. Each object has its own space-time that is constantly in motion. The relation of any two bodies is always a four-way interaction, so that even the object (self) is never identical to itself. Its identity can only be apprehended in relation to its own space-time and the space-times with which it intersects. "Identity" is the name we give the product of this intersection, and is necessarily always relative and temporary to the process, more specifically to "events" that constitute it.[10] We can speak of individual identity only in terms of what Marx calls the "ensemble" of social relations, whose historicity is a fundamental aspect of its existence.[11]

From this perspective we may derive some of the aporias of the contemporary politics of identity. Put directly, there can be no "essential" identity. What in one context appears clear, say, that oppression is firmly situated in skin color, sexual practices, national origins—in which cases identity appears anchored in the human condition—may, in other contexts, be entirely different. Even as Newtonian physics assumes that if one object in space is in motion the other is at rest, the theory of identity tends to posit "society" and the "individual" as fixed: when one is in motion the other is at rest. For example, the sociological theory, according to which individuals are crucially formed by a fixed cultural system containing universal values that become internalized through the multiplicity of interactions between the "person" and her external environment, now comes under radical revision. We may now regard the individual as a process constituted by its multiple and *specific* relations, not only to the institutions of socialization such as family, school, and law, but also to significant others, all of whom are in motion,

that is, are constantly changing. The ways in which individuals and the groups to which they affiliate were constituted as late as a generation earlier, may now be archaic. New identities arise, old ones pass away (at least temporarily).

Let me cite a single example from some oral histories. In connection with a larger project on two periods of Latin and Caribbean immigration to the United States, I participated in the winter of 1992 in producing several extended interviews with community activists who had migrated to New York in the late 1920s and early 1930s. One case stands out: A migrant male youth from Puerto Rico in 1929 could live through the thirties without being crucially identified as a Puerto Rican—both by himself, by social and economic institutions, and by others—but instead saw himself as a worker, a Communist, and a trade unionist of Puerto Rican nationality, much as Jewish-Americans, Italian-Americans, and Finnish-Americans of the same spatio-temporal location may have adopted "ethnic" identities as a part of their *strategic* political and social arsenal, but never confused this with anything but a relatively small part of the "self."

By the late 1940s, the massive postwar Puerto Rican migration conjoined with a new cultural and economic environment to produce the event of "racial" formation. By 1950, buffetted by the Cold War that resulted, among other things, in expelling thousands from the unions, especially industries that were considered vital to US security, this young worker, now a left-wing trade unionist discovered that his primary identity and his frame of group reference shifted to "Puerto Rican," and political discourse shifted from class to "oppressed minority."

Whereas in the thirties and forties, his frame of reference was that of industrial labor—he worked as a shipyard worker and then as a seaman—and of the left-wing movement within which some trade unions played a crucial role, it was now El Barrio (East Harlem) where he became an unpaid tenant organizer. He no longer spoke English in daily life, except at his job, and when he represented "his people" to city and state agencies, and to Anglo politicians. Among members of the generation of migrants who came to New York and other large cities after World War II, Spanish was the privileged language. And, equally important, the key word "community," in part a term of distinction, became a euphemism for this new frame of reference. By 1957—on the heels of the breakup of the Communist movement and

the dramatic shrinking of its institutions and organizational sites in the United States—the political identities of thousands of its once-loyal adherents were transformed. At the same time, since these identities were intimately linked to "personal" identity, these activists were obliged, in some respects, to assume new identities when their networks of group associations were radically altered.

From the perspective of identity formation, Communism and socialism may be viewed as counterhegemonic universals to those of prevailing liberalism. During the first half of this century, these movements were understood by those who affiliated with them, became part of their peripheries, or opposed them as centers both for fundamental change that contributed significantly to the altered economic discourse, politics, and institutional matrix of late capitalism, (even if only incrementally), and as counter*cultures* within which personal identities and, from the perspective of its leading concepts, the anomalous idea of community became part of the lived experience of its adherents. For the Communist parties (including its Leninist split-offs) were also social movements, insofar as they pressed for changes in the external social environment and demanded (encouraged in some accounts) radical transformations in the relation between public and private life. At times (but less so during the popular-front 1930s) to be in the CP or its Trotskyist opposition entailed merging one's professional, family, and avocational life with that of the movement. At its best the Communists, like the European social democrats, made space for the cultural and social "needs" of community members; at worst, a narrow interpretation of Leninist doctrine led to egregious prescriptions and proscriptions of personal behavior. The activists could not expect to "change the world" unless they underwent a profound personal transformation, unless they ultimately shed the old habitual structure of capitalist social relations. To be in the "movement" signified, despite all of its political limitations, that one had adopted, as a matter of principle, the proposition that one's life had world-historical meaning. Especially in the early days of the Communist movement, the concept of the inextricable link between personal and political transformation was more than an article of faith: bourgeois character was poor material for forging a cadre of professional revolutionaries.

The decline of the ideological left over the past forty years, not only in the United States, but in Western Europe as well, signals that one of the more powerful alternative means of identity formation that

promises to overcome the vicissitudes of the "primal" identities acquired through family, school, and the market, is no longer available. At the same time, neither are individuals obliged to subject themselves to a privatized existence in which political identity is, at best, episodic. Instead, new social and cultural formations—of nationality, race, gender, and sexuality, among others—have provided new bases of group and individual identities. It is not entirely accurate to claim that the social movements that provide the context for these social selves may be reduced to instances of *particularity,* that is, binaries of the universality of both liberalism, with its global individual as the basis for political and cultural agency, and Marxism, whose discourse of power is rooted in the discourse of class, historically considered.

However, in the terms defined by the problematic of the bourgeois revolutions of the eighteenth- and nineteenth-centuries, these new identities may be found lacking in philosophic depth. They are accused, thereby, of providing vehicles for the amelioration, within the existing system, of grievances or, on the other side, of reifying identities on the basis of partial totalizations.

II

Any social movement that manages to go beyond the politics of "interest" by proposing, even if tacitly, *a new way of life,* attracts tendencies that array themselves on the spectrum whose subject-positions span amelioration, reform that may be described as "liberal," and radical transformation of the lifeworld, at a minimum to recognize the ineluctability of its demands. Indeed, the movement's identity as a collective *moral* as well as political agent depends on the universality of its claims; that is, it presents itself as united not only by a list of grievances, but also by a specific identity which may be said to challenge *everyone* (at least in democratic societies) to examine her or his own commitment to justice, equality, freedom, and other ethical precepts.

Intellectuals within these social movements invariably generate historical and philosophic accounts of the larger, if not "world-historical," significance of the identity in question, and provide refutations of the purely contingent characterizations of detractors. For example, everyone knows this hypothetical comment: "yes, gays and lesbians suffer

discrimination, but their status as cultural and political identities can be doubted. After all, what is at stake is merely the issue of the 'right' to privacy, one that articulates quite well with the general appeal to civil liberties for individuals. Hence, the movement is inherently liberal, not oppositional."

As Lisa Dugan points out, perhaps the mainstream of gay and lesbian organizations corresponded to this description:

> For nearly fifty years now, lesbian and gay organizations have worked to forge a politically active and effective lesbian and gay "minority" group, and to claim liberal "rights" of privacy and formal equality on its behalf.[12]

She argues that positioning gay and lesbian rights within the "pantheon of unjustly persecuted groups is everywhere unstable and contested" because it ultimately depends on the willingness of more-or-less mainstream organizations to adhere to inclusion. At the same time, she criticizes what she calls "nationalism"—the reaction to the vagaries of liberal gay and lesbian politics. Nationalism claims an essential sexual and cultural identity that Dugan argues is, in the final accounting, untenable. Instead she, together with others propose a broadly social-constructionist "queer community" which, rather than being defined "solely by the gender of its members' sexual partners" is "unified only by a shared dissent from the dominant organization of sex and gender" (p. 20). Thus Dugan shifts the ground from identity to sexual radicalism; community ceases to remain a mark of separation, but becomes a new marker of inclusion. At the same time, she warns that to challenge prevailing sexual arrangements entails a new understanding of the degree to which "the production and circulation of sexualities [are] at the core of Western cultures, defining the emergence of the homosexual-heterosexual dyad as an issue that *no* cultural theory can afford to ignore" (p. 23). Needless to say, perhaps more than avoidance of class and science in cultural studies, the challenge posed by queer theory uncovers what may be considered the latent conservatism of cultural studies.

This claim is applied to feminism as well. The constellation of oppressions suffered by women may be grouped under a variety of headings: discrimination in employment and other public sites; rape and other acts of violence against the person of individual women; and, of course, cultural barriers to equality or, at least, equality of oppor-

tunity. Missing in these accounts is one fundamental dimension of the "second wave" of feminist politics. This politics has been constituted not only by the history of exclusions, violence, and discrimination against women, but also by the economic exigencies of postwar US economic expansion. The period between the mid-1950s and the late 1980s produced a pull to recruit women labor reserves that required the reversal of the "normal" ideology that women's place was in the home. It is not surprising that the contradiction between the ideology of women's "place," and their massive entrance into the paid work force helped generate affirmative identities that resulted in new feminist cultural formations, which among other grievances protested the "double shift" to which women were now subjected. But these formations also consist of the development of unique political and cultural institutions, organizations for the improvement of women's social and economic position, and informal sites such as social clubs and other gathering places. By the late 1970s one could speak of a new, culturally and politically powerful, community of women that consisted of these sites but was not limited to them. Women's identity was forged by the collective perception, by women themselves as well as men, that they had become a politically potent social category. Of course, as this identity becomes historical, that is, begins to become a frame of reference for politics and culture, it cannot help but produce a global counterattack that realigns hitherto "fixed" political and ideological identities.

In the course of identity development, feminism, at least in its more radical manifestations, acquired the elements of a social theory that explained the position of women in their contemporary situation and also in history. The theory of patriarchy as the root explanation for women's oppression was buttressed by anthropological, historical, and philosophic arguments: critics examined canonical literary texts to tease out patriarchy in action; psychologists and sociologists demonstrated that femininity was itself "socially" constructed. In short, notwithstanding the attack against foundational thinking, essentialism, and so forth, in one of the aporias of our current situation, theory was inextricably linked to the formation of gender identities in the postmodern era.

Like the Black and the incipient queer communities, feminist intellectuals have generated a powerful tradition of writing and speech that provides the *universal* signifiers by which the movement retains its solidarity. Historians, philosophers, and literary critics have formed

themselves as a kind of collective "organic intellectual" of the movement. Their work consists chiefly in erasing the erasure: contesting the moral and intellectual hegemony of male domination of legitimate knowledge.[13] The power of this movement toward the creation of a counter public sphere of feminist discourse may be indicated by the remarkable explosion of the readership for feminist writing—fiction and nonfiction—and simultaneously, the extent to which feminists have succeeded in implanting themselves in universities, providing a basis for the claim that this mode of scholarship is legitimate intellectual knowledge. Whereas an older generation of women and lesbian and gay intellectuals were, under the sign of subordination, more or less successfully integrated within the disciplines, observing the canons and producing traditional scholarship in sciences and the humanities, it is today more typical that intellectuals affiliated to feminist standpoints have chosen to orient their work, both in content and its reception, to people who occupy similar social space. Without such a shift, the successful dissemination of these standpoints would be inconceivable.[14]

Yet the creation of a self-enclosed universe of identity discourse has its dangers, particularly in periods like our own, when the tenets of modern liberalism—pluralism, democracy, and intellectual freedom—are under severe attack from the right. The right was defined during the New Deal period as "reactionary," presenting itself as stubborn, but minoritarian defenders of the past who stand in the way of "progress." However, in the 1970s the right forged a new identity. No longer isolationist, quaintly economically liberal, and antimodernist, it armed itself with "something old, something new." Now the right has become the staunch proponent of internationalism, powerfully statist, and clearly modernist while, paradoxically (but only from the standpoint of reason) maintaining both a refurbished (and convincing) economic liberalism and a peculiar, but extremely effective version of populism that, incidentally, revealed one more time its racist and sexist core. The conjuncture of the emergent discourses has produced an intellectual crisis for the social movements that have embodied them. Having rejected Marxism, indeed all universalist claims, the discourses of the most ubiquitous of the antiestablishment social movements—feminism, gay and lesbian, and ecology—respond to the changing frames of reference by adopting three alternative strategies: (1) some return to modern liberalism, the discourse of human rights, and social justice, and substitute ethics for social and historical theory, which brings univer-

salism back, but through the side door; (ii) there is a renewed resolve for community-building, some of which, *in effect,* abjures all politics except cultural separatism or, in its virulent form, tries to impose its own particularist ideology on the polity cloaked as a universal moral imperative;[15] (iii) some of these movements acknowledge, in the wake of the vigorous right-wing attack against ecological gains, abortion rights, and freedom of sexual association, the need for entering coalitions with others on the basis of common minimum interests. But as urgent as these coalitions are to meet the current emergency, they cannot hope to regain the offensive unless they develop a *theory* or at least a broader explanation for the current state of affairs, from which an overall program and series of policies may emerge.

For one thing, can these movement afford to ignore the degree to which right-wing discourse has captured the hearts and minds of large sections of middle- and working-class people? As the 1992 Democratic presidential primaries amply demonstrated, the old New Deal slogans are woefully inadequate to the contemporary situation, but as long as the opposition abjures, much less lacks a convincing theory that can speak to the economic crisis as, in part, a cultural and political crisis, coalition politics will almost certainly fail to stem the conservative tide.

Evident in the past decade is the lesson of Mead's appropriation of relativity theory. As the frame of reference shifts, so do positions forged in other spatio-temporal contexts. Yesterday's answers become today's obstacles to answers. Where postmodernism effectively subdued, if not defeated, modernism's most virulent aspects, in a period of counter-revolution, it is unarmed. Since countercultural formations are crucial for the survival of subaltern identities, the agony of addressing the fact of the simultaneity of the motion of the movement and its environment leads in two directions. Mindful of the disastrous consequences—common to Marxism and Christianity—of imposing a universal discourse and rules of political conduct, even where none exist, and thus lacking even a secure strategic referent from which alliances can emerge, one tendency moves steadily towards accommodation with the dominant discourses. " 'We' have to take liberalism seriously again" is a response often heard among intellectuals linked to social movements. Here, the attraction is born not only of the retreat and defeat of the historic left, but of the equally distressing assessment that freedom has only flourished, even in deformed terms, within liberal-democratic formations.

A second tendency is to batten down the hatches and reproduce

Hegel's unhappy consciousness by asserting identity even more fiercely. Faced with an increasingly hostile political and cultural environment, people in subordinate positions frequently choose separatist directions. Accordingly, the left and the remnants of the labor movement cannot be trusted in the light of their penchant for master discourses, unprincipled programs, and tactical opportunism. Of course, these charges are entirely justified. Yet community-building may have its own authoritarian implications, whether intended or not. An example: the cultural feminist proposals in Minneapolis and some other cities to ban the sale or purchase of pornography, and the subsequent congressional legislation written by a leading cultural feminist, Catherine MacKinnon, and sponsored by Strom Thurmond and other right-wing senators to punish pornography publishers for the criminal acts of their users. Here, cultural feminism makes an overt alliance with the Victorian right's effort to subvert First Amendment guarantees, presumably arguing that, as the most abject of oppressed groups, it has the moral sanction to take such action.

The best that some have offered is the hope for tactical alliances among social movements that share, in one degree or another, the space of subordination, victims of the seemingly unceasing onslaught of prevailing domination. These putative alliances would be based, for the most part, on the underlying perspective of coalition politics—unity around single issues based upon self-interest rather than considering the possibility that there can emerge a common perspective, even one that recognizes the *identity of the dominated,* that takes the history of subalternity as a "universal" cultural as well as political basis for a political *strategy.* Coalitions are safer, for they cannot challenge hard-won fundamental identities, nor can they impose a master discourse on the movement.

The politics of difference cannot, however, admit of the possibility of forging either a paradigm of explanation or a theory that is inclusive of a plurality of identities. The idea of *difference* becomes, in effect, the new universal that cannot be overcome but, instead, must be celebrated. Some have even suggested a politics based upon a hierarchy of oppressions—the more abject the identity, the more privileged its claims among others who may experience "some" oppression, but not one that may be said to challenge the underlying premises of the cultural order. In these circumstances, a discourse of the self is possible only in terms of "others" who are identical with it in terms of the reduction to the

most abject characteristic. In this framework, identity entails metonymic selection of certain characteristics—race, gender, or whatever—that are taken as *irreducible,* and are privileged over all competitive claims.[16]

The underlying justification for this position is well known: identity politics arises not only on the ruins but on the perfidy of the universalist discourses, left and liberal, and the political apparatuses that sustain them. Politically and intellectually, the prevailing master discourses have, throughout history, denied the validity of difference as both a philosophical warrant and a series of social and cultural practices, and have thwarted, even prohibited its exercise. In this century, particularly since the 1960s, difference has enjoyed a wide variety of theoretical justifications. From Adorno's negative dialectics and Memmi and Fanon's graphic discussions of Otherness, to Derrida's critique of logocentricity and especially Deleuze's profound materialization of difference, its ineluctable character provides the intellectual unity from which, paradoxically, the politics of identity received crucial sustenance. The grip of the old Stalinist left over the French intelligentsia was broken in part by this work. After 1968, Marxism as a master discourse of revolution was discredited. By the late 1980s the same fate befell state socialism.

Yet, like the outpouring of recent and influential work within this tradition, it must be acknowledged that the conditions of emergence, namely the revolt of an entire generation of French intellectuals against the corrupt and overbearing discourse of party Marxism, have been surpassed, even as in the United States the New Left's belated embrace of orthodoxy belongs to historical rather than contemporary politics. While the emergence of identity politics was a breath of fresh air compared to the stifling environments of liberal and Marxist hegemonies, has the moment arrived when identity politics remains necessary but not sufficient in a period when the Right moves swiftly everywhere into a power vacuum, closing the spaces for the play of difference?

Faced with the delegitimation of the old universalisms, must we remain in positions where the infinite regress of binaries continues to hold us in thrall? Or can we envision, say, a new radical democratic polity where citizenship is constituted by cultural difference, but is at the same time "identical," insofar as there is a shared sense that it defines itself by what it faces as its own erasure—the patriarchies of power. Of course, such a radical democracy awaits specification, es-

pecially if it hopes to go beyond the invocation of an indefinite future, but proposes itself as a politics, as an ideology that takes freedom seriously both for individuals and communities.

Radical democracy as a political identity may be viewed as an expression of the perspective of both the pragmatic and the psychoanalytic refutations of substantial self-identity. It recognizes the temporality of all possible subject-positions, their ineluctable internal differences and, most of all, their contingency. But the synthetic abstraction, "radical democracy," corresponds to no existing group identity, and on principle refuses fixed positions.

To be sure, overcoming the fragmentation of political discourse that attends differential subject-positions is no small matter. Such a constellation of radical democracy would require considerable openness and criticism among its participants, but would be required to abjure "political correctness," the moralism that did not die with the Old Left, but is alive and well in its displacements (nationalism, cultural feminism, Marxism-Leninism, and so forth).

For one thing, we must stop pretending that there is no possible class discourse, even as we firmly reject its antecedent expressions. Rethinking class is plainly a necessary step in any social movement, and in any political discourse that takes among its leading premises both equality and autonomy. And we must come to terms with the plain fact that the renunciation of solidarity is a formula for the eternal recurrence of fragmentation among us, and an invitation for the inheritors of the old universalisms to maintain their hold. We were right to throw out the reductionist "class analysis" that was the theoretical basis of the Old Left and, with variations, much of the New Left as well. This version of social and political theory virtually excluded all other considerations, or regarded them as displacements of the class struggle. In the course of this rightful rejection, class was occluded from the lexicon of radical terms, when not entirely excluded on the basis of its pernicious history. But in the light of the current debate between and among the two major parties for what is euphemistically called the "working middle class" (more precisely the middle working class), how can questions of class remain outside the discourse of opposition? To say that there are no longer master discourses of history precludes neither history nor its agents.

We need to break with old habits. The traditional left presented itself as the latter-day saints of the Enlightenment engaged in a fierce

battle against mass "false consciousness," which it regarded as an anachronistic but potent holdover from feudal society. This is the foundation of political correctness. Armed with the Science of Marxism (a rough analogy to the truth of Christian doctrine), the left is appointed (by History) to judge political virtue, just as its Christian counterparts are annointed gatekeepers of morally approved personal behavior. Political correctness and moral correctness are twins, but the latter seems more acceptable, since it draws on the certainties of the cultural system, while the former can only draw on its own arrogance.

We are obliged to live the irony of needing theory and explanation, even as we distance ourselves from comprehensive formulaic paradigms. A solution is to offer theoretical formulations as *strategic*. That is, to adopt the philosophical position that generalization is always subject to revision, to see theories in their relation to the spatio-temporal dimension within which they function as fundamental to their validity. Moreover, agents would acknowledge that all explanation is relative to standpoint: all claims to universality is contradictorily mediated by changing circumstances, including those of the agents themselves.

You will have noticed that we are inevitably drawn to a perspective that relies, at the end of the day at least, on the position that instances of subalternity have a claim to ethical stature that overrides that of dominant groups. This standpoint cannot obliterate the aporias of the politics of difference. But neither would it be content with the minimalist notion of coalitions of convenience. The argument for theory and strategy does not depend merely on the power of the right; it relies on the view that oppressions cannot be reduced to their relative quantitative measures, because they are incommensurable with respect to their development. But even if there is no synchrony, neither are we condemned to be attentive exclusively to nonsynchrony. Between them lies a political problematic in which the struggle for social space is shared by those who, day by day, have experienced the progressively narrowing possibility for their public voices. To recover these voices requires a coherent explanation for why they are made the object of exclusion, and requires forging an alternative in which the art and politics of identity-difference make spaces for dialogue.

NOTES

1. Benedetto Croce, *History as the Story of Liberty* (New York, 1937).
2. John Locke, *An Essay Concerning Human Understanding* two vols. (New York: Dover Publications, 1959), vol 1, p. 449.
3. Ibid.
4. Georg Wilhelm Friedrich Hegel, *Philosophy of Right* trans. by T. Knox (London: Oxford University Press, 1965).
5. Karl Marx, "Critique of Hegel's Philosophy of Right," in *Early Writings* ed. David Fernbach (New York: Vintage Books, 1973).
6. William James, *Principles of Psychology* two vols. (New York: Henry Holt and Co., 1890), vol. 1, p. 295.
7. Ibid., p. 292.
8. Ibid., p. 301.
9. George Herbert Mead, *The Philosophy of the Act* (Chicago: University of Chicago Press, 1938), p. 53.
10. Mead, *Philosophy of the Act* pp. 523–599.
11. *Philosophy of the Act* pp. 523–599.
12. Lisa Dugan, *Socialist Review*, Jan–March 1992, vol. 22, no. 1, p. 13.
13. See, especially, Sandra Harding *The Science Question in Feminism* (Ithaca: Cornell University Press, 1986); Donna Haraway, *Primate Visions* (New York: Routledge, 1990).
14. Witness the proliferation both of feminist journals in the past two decades and of feminist scholarship within traditional disciplinary journals. Before 1970 there were almost no significant feminist scholarly journals, and the subject of "women" was treated exclusively within the parameters established by the disciplines. Women writers were simply excluded from the literary canon, and there was little distinctly feminist social and cultural theory. Today, there is a vast readership for feminist fiction and poetry as well as feminist approaches in the humanities and the social sciences.
15. Judith Butler, among others, has attempted to establish a hierarchy of abjectness upon which to ground ethical claims. See Judith Butler, *Gender Troubles* (New York: Routledge, 1990).
16. But 'irreducible difference' may constitute, behind the lacks of its advocates, a new assertion of socialism. The "others" are now conceived as belonging to something other than "our" community. This is one of the perils of particularity.

9

BIRTHRIGHTS

For twenty years, historians have been reshaping our understanding of slavery: they have defined the American slave system as a mode of production and slaves as a form of property, a type of labor. Now, nearly two decades after the intellectual revolution initiated by Eugene Genovese and Herbert Gutman, Orlando Patterson has taken another step toward a radical redefinition of slavery. Patterson's bold thesis—that slavery is, first and foremost, social domination—should stir up not only historians, but everyone interested in class, race, sex and gender oppression.

Although slavery has always been an American obsession, for nearly a century after the Civil War we resisted seeing the degree to which

we were not a land of the free. We knew that the Emancipation Proc-
lamation had not really freed the slaves, but almost no significant schol-
arship was produced to explain the ubiquity of racism throughout
American history. The only exception was work by W. E. B. Du Bois
and John Hope Franklin, Black intellectuals who could not ignore the
issue without erasing their own heritage.

The explosion of the civil rights movement in the 1950s and early
sixties, with its civil disobedience, lawsuits to prohibit segregation, and
ringing rhetoric of freedom denied, pulled a small army of historians
and social theorists out of the library to cure our social amnesia. Ken-
neth Stampp spoke for many of them when he called slavery a "peculiar
institution"—he assumed that it violated the broad patterns of our po-
litical and social life. Even as it received new attention, Americans
preferred to treat slavery as an anomaly. More recently, some of our
talented younger historians have made slavery a cottage industry; re-
views and journals have been filled with polemics explaining it as an
economic phenomenon, as a problem for all of Western culture, as the
formative experience of our politics, as a stigma that has blighted our
arrogant claim to be the most emancipated of societies.

Eugene Genovese, writing in a Marxist framework, asked whether
slavery was a barrier to American capitalist development. His answer
was "yes," confirming an older view that the Civil War was an in-
evitable conflict, that slave labor could not exist if capital wanted Blacks
to work in the new factories, build railroads, and provide the services
needed by an urban industrial society. Herbert Gutman demonstrated
that the Black family from slave times on has provided both moral
education and considerable social cohesiveness to its members—contrary
to the argument advanced by Daniel Patrick Moynihan and Nathan
Glazer (a variation on U. B. Phillips's thesis that Blacks exist in some
kind of precivilized state). Gutman also showed that Black people pos-
sess a rich culture of their own—that poverty does not produce a sep-
arate, "deprived" culture.

One reason slavery has occupied such a privileged place in the
revival of historical studies among an entire generation is that it con-
centrates our moral unease around race and class. Orlando Patterson
has immeasurably enriched this dimension of the inquiry. Patterson, a
novelist and Harvard sociologist, has written a richly detailed and the-
oretically provocative study of more than one hundred slaveholding
societies. His central thesis is that slavery is not a legal relation but

"one of the most extreme forms of the relation of domination, approaching the limits of total power from the point of view of the master and total powerlessness from the point of view of the slave." To call slavery a relation of domination disputes one major claim of most recent theorists—that the slave system is defined primarily as a mode of production in which labor is the most important social relation.

According to Patterson, slavery is not a specific precapitalist institution that passed out of existence; it is simply one end of a spectrum of oppression. And, as Patterson's book amply demonstrates, slavery's importance extends not only into the twentieth-century but also into the future. By superseding specifically economic and legal definitions, and at the same time placing historical features of slavery in a larger framework, Patterson has opened a whole new controversy. For if he's right, even the wonderful work that has forced us to see slavery in a new light—as a prefigurative power over contemporary politics and social life—is sadly lacking.

Patterson has defined the master-slave relation as social parasitism in which the master is as dependent as the slave. And he opens a crack that invites further speculation, showing that there are "hidden conceptual accretions" of the language of slavery: "Consider the term 'master.' According to the Oxford Dictionary, the word has 29 shades of meaning"—including "a man having control or authority," "a teacher or one qualified to teach," and "attributive uses and combinations in the sense of 'superior,' for example 'mastermind.' " When U. B. Phillips convinced himself that the plantation was a kind of "pastoral" college where slaves advanced from savagery to civilization by learning the proper Christian work ethic and its moral code, he identified mastery with education. What is at stake here is the idea that the master-slave relation is ambiguous and, as Hegel noted, could be taken as a metaphor for all social relations in a hierarchical society.

Patterson contends that the basic condition of domination is social death—deracination of the slave's status as a person. In all cases, the slave is stripped of ancestry, family tradition, a name and the right to a personal identity through a process Patterson calls "natal alienation." The master controls the slave both through inflicting violence and monopolizing the symbols of social intercourse. By rendering the slave a "socially dead" person, an alien, the master is free to use him.

Reversing conventional wisdom, Patterson maintains that the eco-

nomic role of slaves throughout history presupposes the creation of an elaborate symbolic universe to make the slave socially dead:

> symbols, private and public, constitute a major instrument of power when used directly or indirectly. Herein lies the source of authority. Those who exercise power, if they are able to transform it into a "right," a norm, a usual part of the order of things, must first control . . . appropriate symbolic instruments. They may do so by exploiting already existing symbols or they may create new ones relevant to their needs.

Slaves lose their collective memory of a natal community by suffering self-rejection. In many societies, the ritual of natal alienation entails an explicit renunciation of a family past. In these societies, resistance consists of the slave's desperate effort to *remember,* through story and song and rituals of confirmation. These are the components of personal and social identity—the concept through which freedom acquires social meaning. The significance of Patterson's theory extends far beyond the history profession, which is charged with restoring our own collective memory.

Gutman was making a point parallel to Patterson's when he attempted to show how slaves developed an oral tradition and close family ties as forms of resistance. Patterson himself notes how the ideology that the slave lacked a moral economy is contradicted by the "fierce love of the slave mother for her slave child . . . attested in every slaveholding society." But Genovese, in *World the Slaveholders Made,* supported Phillips's notion that slave culture was an illusion, and that the master, as the bearer of civilization, gave the slave more than a culture of poverty and oppression. Though Genovese's view was widely attacked for its apparent fantasy of plantation culture, he was merely playing out the modernist ideology of Karl Marx, who believed the brutality of early capitalist society toward workers and peasants was the price humanity had to pay for social and economic progress.

Marx provided a framework for understanding the way all forms of domination, private and public, are constituted in all societies. Patterson has removed social domination from a specific location in space and time, and suggested that the struggle over the issues of slavery is part of the problem of achieving honor. As anthropologist Julian Rivers contends, honor is the condition of power, the base from which groups and individuals achieve autonomy; it is the sign of personal dignity. To

deprive a person of her claim to honor is to render her a nonbeing in the eyes of the community.

Patterson does not set up a romantic image of exploitation. Drawing on his remarkable repertoire of examples—from Africa, Asia, the Caribbean, as well as the US, from the fifth-century BC to our own times— he shows that different societies employ slaves in tasks along the entire range of occupational hierarchies. His case becomes all the more convincing because he avoids the shibboleth of slave as beast of burden. Patterson wants to say that cultural domination, supported by an array of coercive weapons, is far more important than our older conceptions in understanding the institutional process of enslavement.

The struggle for social power entails a heroic effort by the dominated to find an independent voice, to reclaim a heritage, even one constructed out of myths, since there is often no written record to support the ritual of self-naming. It is only by giving ourselves a genealogy that we are constituted as human beings. As Patterson argues, the outsider is always the object of subjection. Writers from Dostoyevski to Camus and Ellison have seen alienation as inspiration, the position of the outsider as a badge of honor. This switch in signification is not, according to Patterson, a possibility for those whose choices are severely limited. Blacks and other slaves may have been rewarded for hard work and valued service by their masters, but even when they were freed, the mark of the slave remained. "Since the slave is natally alienated and culturally dead," Patterson writes, "it follows logically and symbolically that the release from slavery is life-giving and life-creating." When the master gives up his power, "the slave gives up something too: his redemption fee. But not only does this not pay for what the master loses—his power—it is not even possible for it to pay for anything, for whatever the slave gives already belongs to the master." The slave has not purchased his or her freedom; the master has made a gift:

> In India between the second-century BC and the fourth-century AD slavery had been considerably mitigated . . . and manumission (the ritual of giving freedom) and its implications were both significant and well-defined. The ceremony, accordingly, was more elaborate. "A master desirous of manumitting his slaves will take away a jar full of water from the shoulder of the slave and break it. He will then shower some parched grain and flowers on the slave's head and repeat thrice, "you are no longer a dasa" (slave). This act symbolized the cessation of his duty of carrying water. With this cessation all servile duties were discontinued for him."

The symbolic act, says Patterson, destroyed the social death of the slave in the

> simulation of a sacrificial act: the broken body of the jar and the burned rice. Death is negated and there is the hint of renewal . . . in the flowers thrown on the slave's head.

But Patterson implies that a gift from on high is no road to freedom. The dominated must take freedom by means of the exercise of power. Redemption cannot be secured by acts of grace; nor can freedom be purchased by self-alienation. The dominated achieve freedom by defining their own conditions of emancipation—which, Patterson tacitly argues, is the outcome of a zero-sum game. The gain of the slave is the loss of the master. Power must be wrested. It cannot be awarded.

Reading *Slavery and Social Death,* I was struck by Patterson's theoretical arguments in relation to American cultural life as a whole. One of the most distinctive features of US social development is that many of the democratic gains which in Europe required centuries of struggle were apparently rendered to Americans as a gift—the struggle for universal male suffrage dominated the political landscape in England for fifty years, and similar battles had to be waged on the continent before working men won the right to vote. In every country, women and people of color have occupied, at best, spaces of marginality, straddling the chasm between human status and animal subordination. Now, after more than two decades of the modern feminist movement, our consciousness has been jarred by the recognition that women have suffered the symbolic annihilation characteristic of slaveholding societies—when she marries, a woman loses her name. Or to be more exact, she exchanges her father's name for her husband's.

The feminist movement has insisted that struggle against patriarchy is as important as achieving legal rights and securing economic opportunity. Recently, such feminist demands have produced sharp differences among supporters of women's rights. Some, like Betty Friedan, have argued that the movement should not focus on social domination because that would exacerbate the passions of those sympathetic to women's struggles for more equality, but frightened by the cultural and sexual revolution demanded by radicals. Similarly, righteous activists in the Black freedom movement have disagreed with followers of

Malcolm X, who argued that freedom could be won only through creating an autonomous Black community. Malcolm's critics insist that such separatism splits the movement, alienates white support, and thereby forfeits the chance for economic justice. In the trade union movement, there's an analogous split between those primarily devoted to fighting for job security and those who want higher wages, better social benefits, a voice in investment decisions, and a larger say in management. Patterson's book is likely to play a role in these debates—encouraging radical perspectives on the three most explosive forms of social domination: racism, sexism, and class exploitation.

"To belong to a community is to have a sense of one's position among one's fellow members," Patterson writes, "to feel the need to assert and defend that position and to feel a sense of satisfaction if that claimed position is accepted, a sense of shame if rejected." Black people, workers, and women have been obliged to create their own communities because they have, in many cases, understood that freedom can never be given by their masters. Degradation, the absolute precondition for slavery and all social domination, occurs when the slave fails to take his own freedom as well as when the master imposes his will.

The worst feature of domination is probably not the lash, for that merely inflicts physical pain; moral brutalization, the rendering of invisibility, is far more degrading. But creating separate communities of the dominated is only a first step toward freedom. Where interaction among unequals defines social relations, separatism is less a real choice than a sort of avoidance among those who cannot face the fact that they've been condemned to social death.

One of the controversial aspects of Orlando Patterson's position is his explicit rejection of the doctrine that defines freedom as the rights and duties of individuals in society. Patterson asserts that freedom has little to do with "rights" unless they have been secured by victory over the master or until the master's symbolic monopoly has been crushed. For those of us who have learned to accept subordination at work or at home, Patterson's argument is unsettling. The American political tradition has remained silent on social freedom while identifying legal rights as the legitimate path to equality and social justice.

American ideology has stressed individual autonomy in the eyes of law, and the freedom to work where we please, or to starve. Our sense of community responsibility has always been weaker than our passion for individual prerogatives; and it has led to the most unequal social

and economic system in the Western world. Patterson reminds us that individuals are constituted collectively, that their identity is shaped by social relations. Perhaps his Caribbean roots account for this stress on collective fate. Whatever the reason, it is important to be reminded that even the master is dependent on the slave, and that the free development of all is the condition of the free development of each.

10

PAULO FREIRE'S RADICAL DEMOCRATIC HUMANISM

THE FETISH OF METHOD

The name of Paulo Freire has reached near iconic proportions in the United States, Latin America, and, indeed, in many parts of Europe. Like the cover comment by Jonathan Kozol on the US edition of Freire's major statement *Pedagogy of the Oppressed* (1990), his work has been typically received as a "brilliant methodology of a highly charged political character." Freire's ideas have been assimilated to the prevailing obsession of North American education, following a tendency in all the human and social sciences, with *methods*—of verifying knowledge and, in schools, of teaching; that is, transmitting knowledge to otherwise unprepared students. Within the United States it is not uncommon

for teachers and administrators to say that they are "using" the Freirean method in classrooms. What they mean by this is indeterminate. Sometimes it merely connotes that teachers try to be "interactive" with students; sometimes it signifies an attempt to structure classtime as, in part, a dialogue between the teacher and students; some even mean to "empower" students by permitting them to talk in class without being ritualistically corrected as to the accuracy of their information, their grammar, or their formal mode of presentation—or to be punished for dissenting knowledge. All of these are commendable practices, but they hardly require Freire as a cover.

Consequently, Freire is named a master teacher, a kind of Brazilian progressive educator with a unique way of helping students, especially those from impoverished families and communities. The term he employs to summarize his approach to education, "pedagogy," is often interpreted as a "teaching" method rather than a philosophy or a social theory. Few who invoke his name make the distinction. To be sure, neither does the Oxford Dictionary.[1] Yet a careful reading of Freire's work, combined with familiarity with the social and historical context within which it functions obliges the distinction: nothing can be further from Freire's intention than to conflate his use of the term pedagogy with the traditional notion of teaching. For he means to offer a system in which the locus of the learning process is shifted from the teacher to the student. And this shift overtly signifies an altered *power* relationship, not only in the classroom but in the broader social canvas as well.

This type of extrapolation is fairly typical of the US reception of European philosophy and cultural criticism. For example, after more than a decade during which many in the humanities, especially literature, made a career out of working with the concept "deconstruction" as formulated by Jacques Derrida, treating the French philosopher as a methodologist of literary criticism, one or two books finally appeared that reminded the American audience that Derrida is, after all, a philosopher, and that his categories constituted an alternative to the collective systems of Western thought.[2] Some writers have even begun to grasp that Derrida may be considered as an ethicist. Similarly, another philosopher, Jürgen Habermas, has been taken up by sociology as well as by a small fraction of younger philosophers and literary theorists, and read in terms of their respective disciplines. What escapes many who have appropriated Habermas's categories is his project: to recon-

struct historical materialism in a manner that takes into account the problem of communication, and especially the nonrevolutionary prospect of the contemporary world (Habermas 1979). Whether one agrees or disagrees with this judgment, the *political* configuration of his theoretical intervention ought to be inescapable, except for those bound by professional contexts.

None of these appropriations should be especially surprising. We are prone to metonymic readings, carving out our subjects to suit our own needs. In all of these cases, including that of Freire, there are elective affinities that make plausible the ways in which these philosophers and critics are read. For example, with the progressive education tradition, Freire rejects the "banking" approach to pedagogy, according to which teachers, working within the limits imposed by their academic discipline and training, open students' heads to the treasures of civilized knowledge. He insists that no genuine learning can occur unless students are actively involved, through *praxis,* in controlling their own education (here "praxis" is understood in the sense employed by several strains of Marxism—political practices informed by reflection). He is firmly on the side of a pedagogy that begins with helping students achieve a grasp of the concrete conditions of their daily lives, of the limits imposed by their situation on their ability to acquire what is sometimes called "literacy," of the meaning of the truism "knowledge is power." Freire emphasizes "reflection," in which the student assimilates knowledge in accordance with his or her own needs, rather than rote learning; he is dedicated, like some elements of the progressive tradition, to helping the learner become a subject of his or her own education rather than an object of the system's educational agenda. Like many progressives, Freire assails education that focuses on individual mobility chances while eschewing collective self-transformation.[3]

There are enough resemblances here to validate the reduction of Freire to the Latin John Dewey. Accordingly, if one adopts this analogy, his frequent allusions to revolutionary left-wing politics can be explained as a local phenomenon connected to the events of the 1960s and early 1970s, especially the advent in Brazil of the military dictatorship in 1964, the resistance to it, and the powerful popular social movements, particularly in Chile, with which he worked. Presumably, given a more thoroughly democratic context such as that which marks the political systems of North America and Western Europe, the core of Freire's teaching, the Method, would become apparent.

Similarly, while Dewey wrote on science, ethics, logic, and politics, among a host of other topics, outside the tiny band of Dewey specialists within schools of education, educational theory and practice routinely ignores the relationship between his general philosophical position and his education writings. And until very recently he was virtually unread by professional philosophers. Once at the center of American philosophy, his ideas have been deployed (in the military sense) by an insistent minority in full-scale revolt against the prevailing analytic school. Needless to say, just as Freire's revolutionary politics are all but dismissed in the countries where he has been elevated to a teacher-saint, Dewey's engaged political liberalism is generally viewed as a (surpassed) expression of the outmoded stance of public intellectuals at the turn of the century until the immediate postwar period. What can professional Dewey scholars say about his role in the founding of the American Federation of Teachers in 1916, or his role as chair of the commission that investigated the murder of Leon Trotsky?

Since American education has been thoroughly integrated into the middle-class cultural ideal that holds out the promise of individual mobility to those who acquiesce to the curriculum, engaged intellectuals like Dewey and Freire remain "relevant" to the extent that they can be portrayed within the dominant paradigms of the social sciences upon which educational theory rests. It is not surprising that Kozol can refer to Freire's "methodology," given the depoliticization of educational theory and practice in the United States; that is, the relative isolation of education issues, at least until recently, from the wider economic, political, and cultural scenes. Seen this way, his characterization of Freire as a "highly charged politically provocative character" seems almost an afterthought, or more to the point, a personal tribute not crucially intertwined with the "brilliant methodology."

Ivan Illich's statement on the same cover that Freire's "is a truly revolutionary pedagogy" comes closer to capturing what is at stake in his writing. The modifier "revolutionry" rather than "progressive" signifies an intention that is carefully elided by many of Freire's followers and admirers in schools. Or the term must be instrumentalized to mean that the pedagogy itself, as a methodological protocol, represents a radical departure from banking or rote methods of instruction. Therefore it is possible, if not legitimate, to interpret the significance of Freire's work not in the broader connotation of a pedagogy for life, but as a series of tools of effective teaching, techniques that the dem-

ocratic and humanist teacher may employ to motivate students to imbibe the curriculum with enthusiasm instead of turning their backs on schooling.

True, Freire speaks of "method," especially in chapter 2 of *Pedagogy of the Oppressed*. In the early pages of this chapter, Freire seems to focus, in the narrow sense, on the "teacher-pupil" relationship as if to valorize the tendency of much educational theory toward microanalysis. For example, he provides a detailed "list" of characteristics of the banking method. Aside from obvious choices, such as who speaks and who listens, Freire makes his central point: "the teacher confuses the authority of knowledge with his own professional authority, which he sets in opposition to the freedom of the student." From this and the other specifications issues the conclusion that in the banking method "the teacher is the Subject of the learning process, while the pupils are the mere objects" (Freire 1990, p. 59).

To this "method" Freire counterposes "problem-posing education" where "men [sic] develop their power to perceive critically *the way they exist* in the world with which and in which they find themselves; they come to see the world not as a static reality but as a reality in the process of transformation" (Freire 1990, p. 71). This is where most American educators stop. Taken alone, the tacit thesis according to which Freire, notwithstanding his political provocation, is essentially a phenomenological progressive who uses language not too distant from that of psychologists working in this tradition, such as, say, Rollo May, seems to be justifiable. There is reference here to seeing life not as a static state of being but as a process of *becoming*. This spiritually laced education talk might be found as well in the writing of George Leonard and other American educators. American educators influenced by phenomenology are, typically, concerned with saving individuals from the dehumanizing effects of what they perceive to be an alienating culture. With few exceptions, they have adopted the implicit pessimism of most of their forebears which, despairing of fundamental social transformation, focuses on individual salvation.

But I want to argue that the task of this revolutionary pedagogy is not to foster critical self-consciousness in order to improve cognitive learning, the student's self-esteem, or even to assist in "his" aspiration to fulfill his human "potential." Rather, according to Freire,

Problem posing education is revolutionary futurity. Hence it is proph-

etic. . . . Hence it corresponds to the historical nature of man. Hence it affirms men as beings who transcend themselves. . . . Hence it identifies with the movement which engages men as beings aware of their incompletion—an historical movement which has its point of departure, its subjects and its objective. (Freire 1990, p. 72)

It is to the liberation of the oppressed as historical subjects within the framework of revolutionary objectives that Freire's pedagogy is directed. The "method" is developed within a praxis, meaning here the link between knowledge and power through self-directed action. And contrary to the narrow, specialized, methodologically oriented practices of most American education, Freire's pedagogy is grounded in a fully developed philosophical anthropology, that is, a theory of human nature, one might say a secular liberation theology, containing its own categories that are irreducible to virtually any other philosophy. What follows is an account of this philosophical intervention and its educational implications.

FREIRE'S HUMANISM

To speak of a philosophical anthropology in the era of the postmodern condition, and a poststructuralism which condemns any discourse that betrays even a hint of essentialism, seems anachronistic. Indeed, any superficial reading of Freire's work can easily dismiss its theoretical scaffolding as quaint, however much it may be sincere. For example, we read:

The Pedagogy of the oppressed animated by authentic humanism (and not humanitarian) generosity presents itself as a pedagogy of man. Pedagogy which begins with the egoistic interests of the oppressors (an egoism cloaked in the false generosity of paternalism) and makes of the oppressed the objects of its humanitarianism, itself maintains and embodies oppression. It is an instrument of dehumanization. (Freire 1990, p. 39)

Now, we have already learned about the "fallacy of humanism" from the structuralists, especially Althusser and Lévi-Strauss. In Althusser's critique, humanism defines the object of knowledge, "man," as an essential being, subject to, but not constituted by, the multiplicity of

relations of a given social formation (Althusser 1970). In adopting the language of humanism, Freire's debt to the early Marx and to Sartre is all too evident. He relies heavily on Marx, the Feuerbachian, whose materialism is severely tempered and reconfigured by a heavy dose of philosophical idealism. Recall Feuerbach's critique of religion, in which human suffering is displaced to God's will (Feuerbach 1957). Feuerbach argues that religion is made by humans and the problems to which it refers can only be addressed here, on earth. As if to underscore his own formation by this "flawed" tradition, Freire goes on to argue that the pedagogy he advocates addresses the problem of the authentication of humans by means of their self-transformation into a universal species:

> The truth is . . . that the oppressed are not "marginals," are not men living "outside" society. They have always been "inside"—inside the structure that made them "beings for others." The solution is not to "integrate" them into the structure of oppression but to transform the structure so they can become "beings for themselves". . . . They may discover through existential experience that their present way of life is irreconcilable with their vocation to become fully human. . . . If men are searchers and their ontological vocation is humanization, sooner or later they may perceive the contradiction in which banking education seeks to maintain them and then engage themselves in the struggle for their liberation. (Freire 1990, pp. 61–2)

Echoes of Hegelianism here. Freire invokes the familiar humanistic Marxian project: the revolution's aim is to transform what Frantz Fanon terms "the wretched of the earth" from "beings for others" to "beings for themselves," a transformation that entails changing the conditions of material existence, such as relations of ownership and control of labor, and the lordship-bondage relation which is the psychosocial expression of the same thing.

Freire invokes the notion of the "ontological vocation" to become human. In a brief dialogue with Lukács, who, in his tribute to Lenin (Lukács 1970), endorses the role of the political vanguard to "explain" the nature of the oppression to the masses, since their consciousness has been victimized by commodity fetishism Freire emphasizes the idea of self-liberation, proposing a pedagogy whose task is to unlock the intrinsic humanity of the oppressed. Here the notion of ontological vocation is identical with the universal, humanizing praxis of and by

the most oppressed rather than "for" them. For a genuine liberatory praxis does not cease, even with the revolutionary act of self-liberation. The true vocation of humanization is to liberate humanity, including the oppressors and those, like teachers, who are frequently recruited from among the elite classes to work with the oppressed, but who unwittingly perpetuate domination through teaching.

Note here that Freire theorizes the class struggle, not as a zero-sum game in which the victory of the oppressed constitutes a defeat for the oppressor, but as a praxis with universal significance and, more to the point, universal gain. For, as Freire argues, as oppressors of their fellow humans, the "dominant elites" lose their humanity, are no longer capable of representing the general will to complete the project of humanization. *This* is the significance of working with the most oppressed, who in Brazil and the rest of Latin America are poor agricultural laborers and the unemployed huddled in the city's *flavellas,* shantytowns, which in São Paulo, for instance, harbor a million and a half people. Many of these are migrants from forest and agricultural regions that are in the process of being leveled for wood processing, mining and "modern" corporate farming.

As we can see in the citation above, Freire plays ambiguously with Marx's notion that the working class is in "radical chains." Where Marx sees the working class "in" but not "of" society, Freire insists they are "inside the structure" that oppresses them. As we shall see, this phrase signifies Freire's move toward psychoanalytic theory as a sufficient explanation of which material circumstances are the necessary conditions for accounting for the reproduction of class domination.

In the light of this admittedly humanistic discourse, what can be said about Freire's philosophy that rescues it from the dread charge of essentialism, and thereby relegates the entire underpinning of Freire's pedagogy to its own historicity? A closer examination of the crucial category of the "unfinished" shows the tension between his secular theology of liberation and the open futurity of the pedagogy. Taken at face value "liberation," "emancipation," and "self-transcendence" are teleologically wrought categories that presuppose an outcome already present in the "project." In this aspect of the question, the goal, liberation, has the status of a *deus ex machina* of revolutionary action. For some critics, intellectuals, not the oppressed themselves, have designated the telos. It is intellectuals who have nominated themselves to deliver the subaltern from the yoke of material deprivation and spiritual

domination. The oppressed must be the agent of universal humanization which, for Freire, is the real object of praxis. Taken at the surface of discourse, Freire can be indicted for reproducing the Leninist dictum according to which the task of the avant-garde intellectuals—in this case teachers—is to lead the masses into liberation.

But as we shall see, this judgment, however plausible, turns out to be misleading. I want to show that Freire's specific deployment of both psychoanalytic theory and phenomenological Marxism leads in exactly opposite directions. Moreover, Freire is aware that his rhetorical moves may easily be interpreted as another kind of elitism and takes up this issue. Freire's overt debt to Erich Fromm's psychological equivalent of material oppression, *the fear of freedom,* comes into play (Fromm 1940). Freire takes from Freud, Reich, and especially Fromm the insistence that oppression is not only externally imposed but that the oppressed introject, at the psychological level, domination. This introjection takes the form of the fear by members of the oppressed classes that learning and the praxis to which it is ineluctably linked will alter their life's situation. The implication is that the oppressed have an investment in their oppression because it represents the already-known, however grim are the conditions of everyday existence. In fact, Freire's pedagogy seems crucially directed to breaking the cycle of psychological oppression by engaging students in confronting their own lives, that is, to engage in a dialogue with their own fear as the representation within themselves of the power of the oppressor. Freire's pedagogy is directed, then, to the project of assisting the oppressed not only to overcome material oppression but also to attain freedom from the sado-masochism that these relationships embody. For Freire, profits and accumulation may account for exploitation of labor, but are insufficient explanations in the face of brutal domination. The dominating elites have a collective sadistic character corresponding to the masochism of the dominated. Freire quotes Fromm:

> The pleasure in complete domination over another person (or other animate creature) is the very essence of the sadistic drive. Another way of formulating the same thought is to say that the aim of sadism is to transform man into a thing, something animate into something inanimate since by complete and absolute control the living loses one essential quality of life—freedom. (Freire 1990, p. 45)

Freire goes on to say that "sadism is a perverted love—a love of death, not of life." The specific form of masochism is the "colonized man," a category developed by Frantz Fanon and Albert Memmi. Memmi (1973) argues that the colonized both hate and are fatally attracted to the colonizer. In the educational situation this takes the form of deference to the "professor"; the student may begin to generate themes but suddenly stop and say, "We ought to keep quiet and let you talk. You are the one who knows. We don't know anything" (Freire 1990, p. 50). Although Freire does not mention the term "masochism," that in this context manifests itself as the will to be dominated through introjecting the master's image of the oppressed, psychoanalysis insists that it is the dialectical inverse of sadism and that the two are inextricably linked. This introjection is, of course, the condition of consent, without which sadism could not exist without resorting to utter force to impose its will. Or, to be more precise, it would be met by resistance and a violence directed not horizontally among the oppressed, but vertically against the master.

It is not at all excessive to claim that the presuppositions of psychoanalytic theory are as fundamental to Freire's pedagogy as the existential Marxism that appears, on the surface, as the political and theological motivation of his discourse. For by positing the absolute necessity that the oppressed be self-emancipated rather than "led," on the basis of struggles around their immediate interests, by an avantgarde of revolutionary intellectuals, Freire has turned back upon his own teleological starting-point. For, the achievement of freedom, defined here as material, that is, economic and political as well as spiritual liberation, is a kind of *permanent* revolution in which the achievement of political power is merely a preliminary step.

Freire posits the absolute necessity of the oppressed to take charge of their own liberation, including the revolutionary process which, in the first place, is educational. In fact, despite occasional and approving references to Lenin, Freire enters a closely reasoned argument against vanguardism which typically takes the form of populism. In contrast to the ordinary meaning of this term in American political science and historiography, Freire shows that populism arises as a "style of political action" marked by mediation (he calls this "shuttling back and forth between the people and the dominant oligarchies" [Freire 1990, p. 147]). Moreover, he makes a similar criticism of some elements of the

"left" which, tempted by a "quick return to power," enter into a "dialogue with the dominant elites." Freire makes a sharp distinction between political strategies that "use" the movement to achieve political power (a charge often leveled against the Bolsheviks as well as the Communist parties) and "fighting for an authentic popular organization" in which the people themselves are the autonomous sources of political decisions.

Freire's political philosophy, in the context of the historical debates within the revolutionary left, is neither populist, Leninist, nor, indeed, social-democratic in the contemporary sense, but libertarian in the tradition of Rosa Luxemburg and the anarchists. Recall Luxemburg's sharp critique of Lenin's conception of the party as a vanguard organization, particularly his uncritical appropriation of Kautsky's claim that the working class, by its own efforts, could achieve merely trade union but not revolutionary consciousness. Inspired, in part, by Mao's conception of the *cultural* revolution, in which the masses are, ideologically and practically, the crucial force or the movement is nothing, Freire's pedagogy can be seen as a set of practices that attempts to specify, in greater concreteness than Mao did, the conditions for the fulfillment of this orientation.

Having proclaimed the aim of pedagogy to be the development of *revolutionary initiative from below,* Freire nonetheless rejects what he views as the two erroneous alternatives that have plagued the left since the founding of the modern socialist movements: on the one hand, leaders "limit their action to stimulating . . . one demand," such as salary increases, or they "overrule this popular aspiration and substitute something more far reaching—but something which has not yet come to the forefront of the people's attention." Freire's solution to this antinomy of populism and vanguardism is to find a "synthesis" in which the demand for salaries is supported, but posed as a "problem" that on one level becomes an obstacle to the achievement of full "humanization" through workers' ownership of their own labor. Again, workers pose wage increases as a solution to their felt oppression because they have internalized the oppressor's image of themselves and have not (yet) posed self-determination over the conditions of their lives as an object of their political practice. They have not yet seen themselves *subjectively* (Marx 1975).

Freire's philosophy constitutes a tacit critique of poststructuralism's displacement of questions concerning class, gender, and race to "subject-

positions" determined by discursive formations. The oppressed are situated within an economic and social structure, and tied to it not only by their labor but also by the conditions of their psychological being. The task of his pedagogy is to encourage the emergence of a specific kind of discourse which presupposes a project for the formation of subjectivities that is increasingly separate from that of the structure. Freire's construction does not *necessarily* repudiate the theoretical principle that the world and its divisions is constituted as a series of discursive formations into which subjects pour themselves. But he is addressing himself not to the bourgeois subject to which the old humanism refers—an individual "consciousness" seeking the truth through reason, including science—but to the possibility of working with a new problematic of the subject. Unlike twentieth-century Marxism, especially in Third World contexts, which accepts the ineluctability of domination based upon its position that underdevelopment breeds more or less permanent dependency (just as Lukács and the Frankfurt School essentially hold to reification as a permanent barrier to self-emancipation) in all of its aspects, Freire's is a philosophy of *hope.*

Recall Freire's statement, "problem posing education is revolutionary futurity." Its prophetic character crucially depends on specific interventions rather than declarations of faith. The teacher-intellectual becomes a vehicle for liberation only by advancing a pedagogy that decisively transfers control of the educational enterprise from *her or himself* as subject to the subaltern student. The mediation between the dependent present and the independent future is *dialogic* education:

> Dialogue is the encounter between men [sic], mediated by the world, in order to name the world. Hence dialogue cannot occur between those who want to name the world and those who do not wish this naming—between those who deny other men [sic] the right to speak their word and those whose right to speak has been denied to them. Those who have been denied their primordial right to speak their word must first reclaim and prevent the continuation of this dehumanizing aggression. (Freire 1990, p. 76)

Thus, Freire's deployment of psychoanalysis is not directed toward *personal* liberation but instead to new forms of social praxis. The basis of this praxis is, clearly, the overriding notion that humans are an unfin-

ished project. This project, for Freire, is grounded in his conception that to be fully human, in contrast to other species of animals, is to shed the image according to which only the "dominant elites," including leftist intellectuals, can be self-directed. His pedagogy, which posits the central category of *dialogue,* entails that recovering the voice of the oppressed is the fundamental condition for human emancipation.

FROM REVOLUTION TO RADICAL DEMOCRACY

I have deliberately abstracted Freire's social, psychological, and political philosophy from the social context in which it emerged in order to reveal its intellectual content. However, one cannot leave matters here. Without completely historicizing the significance of this intervention, we are compelled to interrogate this revolutionary pedagogy in the light of the sweeping transformations in world economic, political, and cultural relations, to re-place Freire's philosophy and pedagogy in the emerging contemporary world political situation.

Of course, I need not rehearse in detail here the extent of the changes that have overtaken revolutionary Marxism since, say, the fall of the Berlin Wall in December 1989. It is enough for our purposes to invoke the world-transforming events in Eastern Europe. They were simultaneously liberating—the Soviet Union and the nations of that region may be entering a new epoch of democratic renewal—and disturbing. We are witnessing the collapse of bureaucratic and authoritarian state rule in favor of liberal democracy, the emergence of capitalism, or at least radically mixed economies, but also nationalism, accompanied by a burgeoning anti-Semitism and racism, even signs of resurgent monarchism.

In Latin America, the site of Freire's crucial educational practice, not only in his native Brazil but also in pre-Pinochet Chile, revolutionary perspectives have, to say the least, suffered a palpable decline, not only after the defeat of the Sandinistas in the Nicaraguan election, but also in the choice by much of the erstwhile revolutionary Marxist left to place the struggle for democracy ahead of the class struggle and the struggle for socialism. Some have even theorized that, despite deepening poverty and despair for much of the population, socialism is no longer on the immediate agenda of Latin American societies in

the wake of the world shifts that have decimated their economies, shifts that also encourage the formation of totalitarian military dictatorships. In this environment, recent political liberalizations have shown themselves to be fragile. For example, presidential democratic regimes in Argentina and Chile had hardly taken root before the military threatened to resume power to restore "law and order."

Some political theorists of the left, notably Norberto Bobbio, have forcefully and influentially argued that parliamentary democracy within the framework of a mixed economy dedicated to social justice is the farthest horizon of socialist objectives (Bobbio 1987a and 1987b). Following him, many leaders of the Brazilian left have acknowledged the limits of political transformation under conditions of underdevelopment. Others, while agreeing with the judgment according to which the revolutionary insurgencies of the 1960s and 1970s were profoundly misdirected, dispute Bobbio's thesis that *radical* democratic perspectives suffer from romantic nostalgia and would inevitably fail. What is important here is, in either case, a decisive scepticism concerning the prospects for revolutionary socialism, at least for the present.

Which raises the question of whether there can be a revolutionary pedagogy in nonrevolutionary societies. Is it not the case that Freire's philosophy has been historically surpassed even if, in the context of its formation, it possessed the virtues of perspicacity? Under present circumstances, is it not enough to preserve Freire's work in a more modest form, as a teaching method? To be sure, Freire himself is excruciatingly aware of the changed circumstances of the late 1980s and the 1990s. On the occasion of his appointment to the post of secretary of education for the newly elected Workers' Party (PT) municipal administration in São Paulo, Freire told an interviewer that he saw in this unexpected victory "a fantastic possibility for at least changing a little bit of our reality" (Williams 1990). The prospect for this radical left democratic administration was to achieve some reforms in health, transportation, and education. His perspective in accepting the post was to "start the process of change" during the PT's four years of elective office.

Even before assuming office, Freire was aware of the severe limits to change posed by the economic and political situation. But he was also facing schools in which sixty to seventy percent of students dropped out and had barely four years of schooling, the majority of whom will be day laborers working for minimum wages. He was responsible for thirty thousand teachers in the city's school system, many of whom

lacked training for the awesome task of helping students break from the fatalism of Brazilian society.

In 1990, after a year of reform, Freire and his associates were speaking about democracy—social democracy—rather than "revolution" in the strict political sense. The term "popular democratic school" is counterposed to the "capitalist" school. The capitalist school "measures quality by the quantity of information it transmits to people," says Freire's associate, Gadotti (Williams 1990). The popular school, on the other hand, measures quality by "the class solidarity it succeeds in establishing in the school." In order to achieve this objective the school must be "deformalized," debureaucratized, a measure that entails democratizing schools so that "the community" elects the school director, and there is direct accountability. This means the director can be removed at any time by the base, but also that curriculum and other decisions are broadly shared. Freire uses the term "accountability" to describe this desired relationship.

In the postdictatorship period, one might say in the postcolonial situation, the popular-democratic philosophy has not changed, but the discourse is now eminently practical: as a schools administrator Freire speaks the language of praxis, rather than merely invoking it. The PT and its education secretary must address issues of teacher training, school-based decision-making, administration and curriculum, but from the base of a *working-class-oriented political formation that holds radical democratic reform toward popular power as its core ideology*. Freire is still trying to transfer power to the oppressed through education, now framed in the context of state-financed and controlled schooling.

SHARING POWER

In his "spoken" book with Antonio Faundez, *Learning to Question* (1989), prepared before the PT victory, Freire had already altered his discursive practice. Throughout the text, Freire returns to the vexing relation between theory, ideological commitment, and political practice. Here I want to give just one example of the degree to which his fundamental framework remains constant, even in the wake of the shift from revolutionary to democratic discourse. In one section Faundez and Freire engage in fascinating dialogue on intellectuals.

Faundez begins by reiterating a fairly well-known Marxist idea:

that there is a social "science," a body of knowledge which is not merely descriptive of the present state of affairs, but "guides all action for social change, how can we ensure that this scientific knowledge . . . actually coincides with the knowledge of the people" (Freire and Faundez 1989, pp. 55–6). At this point Faundez contrasts the science possessed by intellectuals with the "ideology" of the dominant classes that suffuses the people's knowledge, as well as the diverse elements of practical knowledge, inconsistency between theory and practice, and so forth. The intellectuals as bearers of science find themselves caught in an excruciating paradox. On the one hand, they are bearers of scientific knowledge, owing not so much to their talent, as to their social position which gives them access to it. On the other hand, only by merging their science with the internalized knowledge of the people and, more particularly, fusing their vision of the future with popular imagined futures can the elitism of the various political vanguards be avoided.

As in most leftist discussions of intellectuals, Faundez draws from Gramsci's undeniably pioneering writings, especially themes which Mao and Foucault are later to elaborate and develop: that all knowledge is specific, and that it is are situated in a national context. Freire responds by objecting to the view that the future is *only* particular. He wants to preserve the universal in the particular, and argues that we already have, in outline, a vision. But the nub of the problem remains: are the radical intellectuals prepared to share in the "origination" of new visions with the masses, or are these fixed so that the problem of coincidence is confined to strategy and tactics? Freire presses Faundez here to clarify the role of intellectuals in relation to the popular movements. Freire is plainly uneasy with the formulation that intellectuals are the chief bearers of scientific knowledge, and wants to assert that, to achieve radical democratic futures, a fundamental shift in the relationship between intellectuals, especially their monopoly over scientific knowledge, and the movements must take place. Moreover, he is concerned to remove the curse, "bourgeois," from the concepts of democracy. A radical democracy would recognize that there are no fixed visions. And if visions are fashioned from knowledge of the concrete situations gained through practice, there can be no science that provides certitude, in its categories, its descriptions, much less its previsions.

Reporting on a conversation with workers' leaders in São Paulo, Freire *defines* class consciousness as the power and the will by workers and other oppressed and exploited strata to *share* in the formulation of

the conditions of knowledge and futurity. This demand inevitably alters the situation of power: intellectuals must be consistent in the translation of their democratic visions to practice. In other words, they must share the power over knowledge, share the power to shape the future.

This exchange is a meditation on Latin American revolutionary history and current political reality, most especially the failure of Leninist versions of revolutionary Marxism and socialism. Explicitly, Freire warns against defining the goal of radical movements exclusively in terms of social justice and a more equitable society, since these objectives can conceivably be partially achieved without shared decision-making, especially over knowledge and political futures. *The key move away from the old elitist conception in which the intellectuals play a dominant role is to challenge the identity of power with the state.* Faundez sets the stage for this shift:

> I think that the power and the struggle for power have to be rediscovered on the basis of resistance which makes up the power of the people, the semiological, linguistic, emotional, political and cultural expressions which the people use to resist the power of domination. And it is beginning from the power which I would call primary power, that power and the struggle for power have to be rediscovered. (Freire and Faundez 1989, p. 64)

Freire's reply sets a new ground for that rediscovery. Having focused traditionally on workers' and peasant movements, he now enters significantly into the debates about the relationship between class and social movements. He names movements of the urban and rural poor who, with the assistance of priests from the liberationist wing of the Catholic Church, began in the 1970s to redefine power as the power of resistance. But he goes on to speak of movements of "environmentalists, organized women and homosexuals," as "new" social movements whose effectivity must inexorably influence the strategies of the revolutionary parties:

> It is my opinion today that either the revolutionary parties will work more closely with these movements and so prove their authenticity within them—and to do that they must rethink their own understanding of their party, which is tied up with their traditional practice—or they will be lost. Being lost would mean becoming more and more rigid and increas-

ingly behaving in an elitist and authoritarian way vis a vis the masses, of whom they claim to be the salvation. (Freire and Faundez 1989, p. 66)

With these remarks, Freire distances himself from elements of his own revolutionary Marxist past, but not from a kind of open Marxism represented by Gramsci's work. For there can be no doubt that this comment is directed towards those in the revolutionary left for whom class defines the boundaries of political discourse. Without in any way renouncing class as a fundamental category of political struggle, Freire places himself in the company of those theorists, some of whom are situated in the social movements and not within the parties, who have challenged the priority of class over other social categories of oppression, resistance, and liberation. His intervention is also postmodern when he puts into question the claim of political parties to "speak in behalf of a particular section of society." In his latest work Freire takes a global view, integrating the democratic ideology of the Guinea-Bissauan leader Amilcar Cabral, with whom he had forged a close relationship.

Freire is sympathetic to Faundez's reminder that knowledge and its bearers are always specific, that historical agency is always situated in a national context. Yet, with Cabral, he reiterates the need to "overcome" some features of culture. This overcoming means that tendencies towards the valorization of "localism" which frequently are merely masks for anti-intellectualism among populist-minded leaders, should be rejected. So Freire's postcolonial, postmodern discourse does not sink into the rigidities that have frequently afflicted these perspectives. Finally, at the end of the day, we can see that to appreciate difference does not resolve the knotty issues of judgment. Freire is an implacable opponent of bureaucracy that throttles popular initiative, but suggests that workers for social change must retain their "overall vision" (Freire and Faundez 1989, p. 123).

Redefining power democratically entails, at its core, interrogating the concept of "representation." The claim of revolutionary parties to represent workers, the masses, the popular majority, rests in the final analysis on the status, not of the demand for social justice, for liberal parties may, under specific conditions, also make such claims. Instead, it rests on the rock of scientific certainty, at least as to the descriptive and prescriptive propositions of a body of knowledge whose bearers,

the intellectuals, thereby legitimate their own right to leadership. Freire's call for *sharing* recognizes the unique position of intellectuals in the social and technical division of labor, and thereby disclaims the stance of populism that almost always renounces the role of intellectuals in social movements, and with that renunciation is left with a vision of the future in the images of the present. But, by breaking with the "state," that is, coercion and representation as its key features, it also rejects the notion that liberation means the hegemony of intellectuals—political, scientific, cultural—over the movements.

In this way, any attempt to interpret Freire's recent positions as a *retreat* from the revolutionary pedagogy of his earlier work is entirely unjustified. On the contrary, Freire reveals his undogmatic, open thought in his most recent work. In fact, it may be argued that the Christian liberation theology of the past two decades is a kind of vindication of his own secular theology, with its categories of authenticity, humanization, and self-emancipation. The paradoxes in his political thought are not apparent, they are real. For like the rest of us, Freire is obliged to work within his own historicity, an "overall vision" that is at once in global crisis, and remains the only emancipatory vision of a democratic, libertarian future we have.

NOTES

1. "Pedagogy—The work or occupation of teaching. . . . the science or art of teaching." *Oxford English Dictionary* (complete edition), (New York: Oxford University Press, 1971), p. 604.
2. See, especially, Stephen W. Melville, *Philosophy Beside Itself: On Deconstruction and Modernism* (Minneapolis: University of Minnesota Press, 1986).
3. John Dewey himself is a model for the idea of *collective* self-transformation; see his *Democracy in Education* (Glencoe, Illinois: Free Press, 1959).

REFERENCES

Althusser, L. 1970: *For Marx.* New York: Vintage.

Bobbio, N. 1987a: *Future of Democracy,* Minneapolis: University of Minnesota Press.

———. 1987b: *Which Socialism?* Minneapolis: University of Minnesota Press.

Feuerbach, L. 1957: *The Essence of Christianity,* New York. Harper Torchbooks.

Freire, P. 1990: *Pedagogy of the Oppressed,* New York: Continuum.

Freire, P. and Faundez, A. 1989: *Learning to Question: A Pedagogy of Liberation.* New York: Continuum.

Fromm, E. 1940: *Escape from Freedom.* New York: Holt, Rinehart and Winston.

Habermas, J. 1979: "The reconstruction of historical materialism," in *Communication and the Evolution of Society.* Boston: Beacon Press.

Lukács, G. 1970: *Lenin.* London: New Left Books.

Marx, K. 1975: "Thesis on Feuerbach," in *Early Writings,* ed. D. Fernbach. New York: Vintage.

Memmi, A. 1973: *The Colonizer and the Colonized.* New York: Holt, Rinehart and Winston.

Williams, E. 1990: Interview with Paulo Freire, São Paulo.

11

THE POWER OF POSITIVE THINKING: JÜRGEN HABERMAS IN AMERICA

For decades, it seems, the US exported cars, washing machines, and steel to Europe, and in return received European philosophers, literary critics, musicians, and scientists. Since World War II, much of our foreign cultural capital has been imported from France, along with truffles, pâté, wine. We like the French because they're properly ironic, and during the 1960s and seventies, while we learned how to grind coffee beans and smoke Gauloises, they gave us a taste of that elusive commodity called "theory." Writers like Foucault and Derrida confirmed our sense of cultural and political skepticism; our attraction to them signals the beginning of the end of American innocence—which, though satirized by Mark Twain at the turn of the century, still animated the tales of Hemingway and Fitzgerald forty years later. The

Germans, preeminent between the wars (remember Einstein, Brecht, Arendt, Mann, the Frankfurt School—all refugees from Fascism) supplied a few stars, but failed to penetrate the American market in a big way. Germans have always been too somber and apocalyptic—their thought runs counter to Anglo-American linearity, and their theoretical language is too arcane for most of us, even in translation. The French presented some of the same problems, but they spoke to our growing preoccupation with the quotidian, shunning the global in favor of personal relations, language and speech, everyday life.

Since the age of Reagan, the wheel has turned: the power of positive thinking is in the air. We no longer despair about consumer society, or bemoan the stupor brought on by mass culture. We're no longer outraged by the excesses of post-scarcity because scarcity has returned with a vengeance. Deprivation has reintroduced the gospel of gee whiz; intellectuals yearn for somebody to put Humpty Dumpty together again. Jürgen Habermas, the hottest property in German philosophy and sociology, has recently hit the American charts—edging out the seventies fashion for French structuralism. Habermas has star quality right now because he's the Great White Hope of modernity. Habermas still ruminates in the tangled syntax of his teachers at Frankfurt. Unlike the illustrious but gloomy Max Horkheimer and Theodor Adorno, Habermas offers an optimistic program for achieving new rationality— which, he maintains, can preserve civilization by helping it learn from its mistakes.

Habermas belongs to the generation of German intellectuals who grew up during the Cold War, that struggle between the US and the USSR for the hearts and minds of a world grown weary of conflict. In the late forties, Germany badly needed a way to bury its past, to make restitution for its many crimes, not the least of which was the wholesale exiling of its most brilliant intellectuals. Adorno and Horkheimer returned to Germany because they refused to choose between the authoritarianism of Western culture and the dogmatic certainty of Soviet Communism. A born-again democratic state gave them an institute for social research, and basked in the reflection of their moral integrity and intellectual celebrity. Like his teachers, Habermas disdained the East-West dichotomy offered by the Cold War—except, of course, that he and most of his contemporaries preferred the relative affluence and freedom of capitalist democracies to the grim regimentation of Communist states.

In his early work, Habermas tried to find another way—a path between the perils of mass democracy, in which the public is reduced to passivity, and the forced march toward industrialization offered by the "people's democracies" within the Soviet orbit. His first book combined an ideological attack on mass consumer culture with a utopian program for recreating the myth of the eighteenth-century bourgeois revolutions: a citizenry that makes decisions through open debate rather than casting ballots for representatives and then retreating into private life. Habermas's version of the Third Way was a society of popular participation. The book appeared in the sixties, when the postwar generation was obsessed with the problem of spiritual impoverishment amid material plenty. Although Habermas found Marxism inadequate for explaining the "postindustrial" world, he kept on wrestling with Marxist questions: How can workers and other subordinate classes be empowered? How can popular democratic institutions be formed and dominant forces contested? But in 1973, he broke the cord that bound him to Marxism. *Knowledge and Human Interests* concludes that the real issue for social theory is not analyzing the fissures produced by economic, political, and cultural domination; the goal is understanding our social ills as a product of what Habermas called "distorted communication." With this idea, he cast aside the categories of social analysis he had inherited from the Frankfurt School.

In his recent book, *The Theory of Communicative Action,* Habermas continues to get rid of his European legacy, relying instead on American sociology and social psychology. For his purposes, this new frame of reference makes sense. Unlike European theorists, who tend to focus on class, bureaucracy, and political power, Americans have traditionally explored the microsocial level—interactions between individuals and small groups. Even when American social theorists have attempted to deal with social structure, the idea that society is composed of individuals acting on their personal interests governs what they mean by *society.* Since the 1930s, American social scientists have allied themselves with toothpaste companies, political aspirants, and government agencies to find out what people want—especially what will make them buy or vote in a certain way. Survey research has become the technology of political and economic power, the means of getting products to individuals who "want and need" them. C. Wright Mills saw market research, advertising, and political manipulation as the heart of our cul-

ture, our main sphere of communication; social science has happily subordinated itself to the task of selling that culture.

Gazing toward America, Habermas casts aside Weber's insight that a major source of our collective woes is the rationalization of relations in modern society, particularly the tendency toward bureaucratization; he understands Weber's doleful critique of modern society, but refuses to shed tears. The last section of The First Volume of *The Theory of Communicative Action* is a farewell to his Frankfurt fathers. He doesn't misconstrue the Frankfurt argument that facts depend for their validity on the social context within which they're discovered; he simply sees no point in disputing scientific rationality. The point, for him, is to find an alternative.

Habermas makes a case for communicative action as the way out— the Third Way between Western rationality, which tackles economic problems but sacrifices spiritual needs, and the Eastern knack for subordinating everything, including the economy, to politics. He feels smothered by Marxism's pessimistic emphasis on the structural limits of what people can do. He wants to create a science of transcendence— so it's off to America, where the carefree natives focus on action rather than structure. With this book, Habermas brings our culture back to us—he's become the theoretical Beatles or Rolling Stones (though without their bite, since irony always seems to elude him). He gives us a taste of our own medicine, the version of consensus theory that hung over academia during the Cold War and became slightly embarrassing to American social science after Vietnam.

Habermas is not a political conservative. But his utopian vision— enlightened citizens living in a rational culture that promotes communication in the search for truth—draws him to American cultural pluralism writ large. The cornerstone of his theory is an open embrace of liberal culture; he doesn't share Weber's grief about the decline of liberal democracy. Habermas takes this democracy for granted, just as he accepts an idealized version of neutral science. His idea of conflict— reduced to what he calls "differences"—isn't rooted in social movements that contest public space and possess antagonistic interests and contradictory moral norms. He argues that we share universal values; and that through communication we can find universal standards for practical conduct. Social life becomes a version of the I-Thou relationship, in which the central problem is how we make our subjectivities intel-

ligible. Habermas lets science, bureaucracy, and the state off the hook by maintaining that institutions, though incomplete, are organized to achieve rational ends. He's seeking a pristine speech act, a "context-free" condition for undistorted communication based on agreement about meanings of sentences and methods of arriving at knowledge.

By zeroing in on communication, Habermas avoids the messy web of social relations embodied in institutions. His discourse reminds me of the New Criticism's admonition to tear art from its social and historical context, ignore the conditions of its production and distribution, and focus instead on its linguistic, aesthetic, and emotional significations. Habermas wants to get down to a tiny definition of the social: the encounter between two people who are searching for an aesthetics of the human. In his quest for a theory of consensus, he naturally turns to Talcott Parsons and George Herbert Mead. Parsons, while domesticating Weber for the postwar academic market, virtually ignored the parts of his work that criticized the fruits of rationalization. He made Weber's theory of conformity the centerpiece of his own theoretical system, and gave American social science a theory of "socialization," positive idea rather than a critical one. Parsons believed the individual was obliged to adjust to society through family, church, schools, and work—institutions that preserved and reproduced society by inculcating approved values and norms. Where Weber shuddered at increasing specialization, Parsons celebrated it. He saw society as an organism and said the objective of human action was to achieve equilibrium.

Habermas swallows this homeostatic model and grafts it onto theories of moral and ego development. The result is a chart of individual traits that promote the formation of a culture marked by rational discourse and undistorted communication (this new culture, alas, sounds like a parody of the scientific community). Though Habermas claims to have gone beyond Parsons because he's defined rationality in terms of communicative action rather than goal-directed behavior, he retains the Parsonian ideal of change without pain. Habermas is arguing that the fate of society does not depend on the outcome of struggles between haves and have-nots, ecologists and polluters (indeed, his sanctification of science prevents him from addressing ecological disaster), men and women, Blacks and whites: these conflicts belong to a lower order of action. What worries Habermas is that we've lost sight of our essential humanity, which resides in communication. Our pressing problem, he asserts, is that we don't know how to unite our intentions with the

meanings we communicate. Society cannot learn because we cannot separate language from its cultural—that is, distorted—context. In his society of communicative competence, these old conflicts will take a backseat to the universal task of creating a "lifeworld" in which communication becomes an art form, and art itself is the fundamental human relation.

Habermas, in volume II of *Theory of Communicative Action,* completes his prescription by offering a new interpretation of George Herbert Mead. According to David Miller, the leading commentator on Mead's philosophy, his task was "to show that the formation of the self emerges out of the social process in which there is communication, but a process in which individual participants are not yet aware of the meanings of their gestures." Mead maintained that the process of self-formation depends on the ability to use language: we become what we are by interacting with "significant others." Habermas's theory can be seen as an extension of Meadian behaviorism, which really comes down to a doctrine of learning by doing. It's a very American theory—glorifying the practical over the theoretical, the individual over the social, function over structure.

Habermas's synthesis has no room for gloomy prognostications or provocations to the system of order, because it is part of that system. He affirms Western culture, and fears only that this, the highest system of rationality any society has evolved, will self-destruct through a breakdown of its communicative competence. In his discussion of Weber—the most brilliant section of volume I—Habermas emerges as the last great modernist. He holds fast to Weber's formulation of the major feature of modernity; the separation of science, morality, and art—which the religious worldview conflated, to the detriment of technological progress. He's scathing about attempts to see early societies as models for correcting postindustrial defects. And he's equally critical of theorists who find virtue in mysticism because they yearn to transcend the Enlightenment's separation of science and religion. From his point of view, the fashion for antiprogress is impermissible. Modernity *is* progress. Habermas defines civilization as the triumph of reason, and follows Wittgenstein in claiming that language is not merely a means of communication but a form of life that takes the place of cultural tradition.

When the Frankfurt School proposed that social action should resolve the antagonism between us and nature, including our own erotic

nature (an essential element of psychoanalytic thought), they were making a crucial break with modernism. Marcuse's late work is filled with arguments for a new science to negate the gulf between us and nature, and Marcuse's student William Leiss took the argument a step further, claiming that a truly ecological perspective would entail respecting nature's autonomy as well as its rhythms. This formulation is just a step short of endowing nature with properties that cannot be subsumed by reason. To all these ideas, Habermas responds with thoroughly conventional modernist arguments. His defense of the Enlightenment is as relentless as it is old-fashioned: a realist theory of knowledge, according to which propositions refer to an objective world, a "context-independent standard for the rationality of world views." Among other things, this formula means that the validity of scientific laws is not relative, either to culture or to limitations imposed by ideology on the methods and results of investigation. Habermas's new work, meant to wrench communication from its historical conditions, is a theory about theories.

What's implied in this mode of theorizing is the view that either society is unknowable or its contradictions are no longer the fundamental issues facing us. I think Habermas holds both positions. He substitutes progress for power, and has a blindingly naive grasp of science and technology that's consistent with the views of scientists and technicians who labor in the "vineyards" of progress. Habermas's decision to abandon the critique of social relations is more complicated and more significant: by reducing the complexity of interactions in the social world (which he now calls the *lifeworld*) to problems of communication, he entirely dismisses the question of hierarchy and relegates the issues of labor and politics to the scrap heap. This move is not without its logic. Social theory hasn't done well by the issue of communication; popular culture, the political implications of technology, and the cultural outcomes of the new information society have been virtually ignored. When threatened, the disciplines close ranks, steadfastly refusing to admit this issue into the hallowed precincts of the academy. Habermas's most important contribution is to bring communication to the front. But in doing so, he sacrifices the critical edge of his Frankfurt forebears.

In one sense, however, his program resembles the older critical theory. Having exhausted their critique of society by proclaiming total administration, technological domination, and the eclipse of reason,

Adorno and Marcuse found refuge in the pleasures of art. In his last book, *The Aesthetic Dimension,* Marcuse concluded that all social movements were subject to integration within the prevailing order, but that because art was marginal, it constituted a critique of total administration. He knew, of course, that art unwittingly reconciles its audience to society by giving an aesthetic dimension to otherwise tawdry lives, but insisted that it retained a subversive edge. Though art might be reduced to just another commercial product, its exchange value could not exhaust its worth. Bought and sold, relegated to mere "entertainment," it nevertheless offered a glimpse of the utopian future. The Frankfurt School abandoned all consideration of art's social dimension; by decontextualizing art, Marcuse and Adorno hoped to preserve its independence.

Similarly, Habermas's rejection of the social, political, and biological context of communicative action aspires to find space for the uniquely human. What he's written is a manifesto for the vilified, marginalized intellectual: his utopian community is based on the ability of these intellectuals to overcome social differences through persuasion. Philosophers, in effect, become the representative artists of modernism. This is very much like the idea proposed by John Locke, as science broke away from the speculative activity of philosophy and embarked on its search for empirical truth. Habermas's philosopher-artist triumphs because everybody else has submitted to instrumental rationality; the intellectual can guide us out of the swamp of banality. The trouble with this theory, on its own terms, is that the intellectual no longer exists as an independent critic of society. Intellectuals have become technicians: in matters of state, they advise the mighty, as scientists, much of their work is subordinated to its technological (read: commercial or military) uses. They're professional managers who see their interests as identical to those of their employers, or see themselves as workers with restricted autonomy. Unfortunately, Habermas's program is addressed to an agent mired in the contradictions of work, family, and an impoverished social life.

Sixty years ago, Thorstein Veblen argued that workers wouldn't be able to transform society because they didn't control the means of production. His bet was on engineers, who did have power at the workplace, at least potentially, but were so valuable to capital that they were bound to be bought off. In the late sixties, Habermas put his money on students because they were alienated from the prevailing

cultural assumptions of late capitalist order. Now he's retreated into the realm of pure thought—a formula for marginality that derives its appeal from the failure of practically everything else in the West. But engineering the mind is no better than Veblen's attempt to make technocrats the be-all and end-all. Habermas's theory is a kind of morality that accords supremacy to intelligence; yet what he's really up to is elevating the activity of thought to ethical preeminence. And that's the deception in the theory of communicative action. Though he skillfully uses the weapons of criticism to get beyond the dirty practical world, he ignores the fact that intellectuals have to struggle along with everybody else for material and emotional existence. Jürgen Habermas's dread of the real reduces his brilliance to yet another gaggle of words, words, words.

EPILOGUE

Since this essay appeared in 1984, the second volume of *The Theory of Communicative Action, Moral Consciousness and Communicative Action,* and his widely read critique of postmodernism, have appeared in English translation. None of these works contravene the essential judgment of my critique, especially the assertion that Habermas seeks a positive alternative to the politics of power. In addition, he remains committed to a version of the public sphere in which common norms and procedures provide the basis for rational decision-making. In short, except for his focus on language and discourse, he has even more firmly established his work as perhaps the major cornerstone of the Third Way, one in which an updated Kantian ethics replaces social theory. As Thomas McCarthy points, out in his introduction to *Moral Consciousness* (1991), Habermas is "closest to the Kantian tradition," in that he separates questions of judgment from those of being.

For Habermas, our distance from natural history, and the consequent *independent* functioning of thinking, are only the beginning of a much larger claim: that questions of politics are ineluctably ethical questions whose presupposition is the autonomous individual. This is the sense in which, ten years ago, I claimed that Habermas has adopted the crucial elements of American ideology. For, if the individual is not merely the outcome of a social process but is virtually identical with

it, questions concerning the constraints of social structure on action are relegated to limiting conditions, but have no explanatory value.

In the later work on moral consciousness, Habermas is concerned to revive universalization in the light of the widely accepted view, at least among intellectuals of the younger generation, that foundational thinking was passé. To be sure, his argument does not stem from a transcendent perspective but from what he terms a "transcendental-pragmatic" view. Universalization, as much as the posit of individuality, is a necessary condition for argumentation that has practical consequences. According to his position, we must share the same values and norms, as well as observe the same rules of discourse, in order to resolve mutually acknowledged problems.

Habermas's ethics preserves what became apparent in his work as early as his critique, *The Structural Transformation of the Public Sphere* (1962). In this work, Habermas broadly prepares the project that has occupied him for more than thirty years. It is this: since he regards the constituent classes of modern industrial societies as hopelessly mired in the politics of interest which, in turn, are tied to a productive system whose rewards they constantly seek, human societies have found themselves incapable of addressing problems that lie outside the "rational-purposive" action of economics and technology. Communicative action is intended to fulfill the early bourgeois aspiration to reproduce the Greek polis—a civil society where individuals freely choose to participate in collective decision-making, not primarily in the act of mass voting, but as the outcome of a series of rule-directed conversations that, however, have practical consequences.

In earlier works, Habermas warned that societies that could not address problems lying beyond the domain of instrumental action—where industrial and state bureaucracies and laws prevail—would, increasingly, fall into stagnation and decline. He feared that perhaps the worst consequence of the astounding successes of late capitalist societies was to have subsumed all questions under *policy;* as a result, people have learned to seek spiritual guidance from private individuals and groups which work outside the public sphere. For him, the crisis of these societies is not primarily economic, but moral. We have no universal pragmatics within which moral questions can be resolved, and as a consequence there are no avenues to address the burning concerns of a postindustrial, but not postmodern, culture. I use the term "postin-

dustrial" to describe a situation in which the task of subordinating nature to human needs has been, in the main, completed. There are no *world-historical* issues of production and distribution, only technical problems.

The reduction of great social conflicts, let alone contradictions, to specifying formal conditions for the construction of what Habermas calls a "discourse ethics," is not new. It is a broad register of the utter collapse of the oppositional and dissident ideologies that prevailed throughout this century. Habermas's unique contribution is to have offered an algorithm for making the shift from social theory to ethics. Although there are many other philosophers who labor in this field, Habermas's roots in the Frankfurt School, and especially his tireless proclamation that he is "reconstructing" Marxism, put him in a special category. He claims the mantle of critical theory without pretending to continue its blistering critique of the Enlightenment.

Habermas has a clear affiliation with the good old things and disdains the bad new things. This penchant for the past is perhaps best exemplified by his polemic against postmodernism and poststructuralism. In a celebrated confrontation with Foucault, as well as in several essays, Habermas has made these points: that the death of modernism is an overstatement; that modernism has room for innovation; that the various "posts" of French philosophy border on irrationalism. But as a staunch defender of rationalism, Habermas is constrained to throw out even the last vestiges of engagement with the social world. For even a cursory examination of the contemporary situation would oblige the most blinkered observer to acknowledge its unexpected upheavals, its indeterminacy from the perspective of either causal or ethical precepts.

I cannot rehearse the modernism debate here. Suffice it to say that Habermas is the last great figure in Western philosophy and social theory for whom the project of the Enlightenment remains sullied but unsurpassed. For he has not only rejected Hegel's critique of Kant's abstracted transcendentalism, but has utterly refused to acknowledge the historicity of the ratio between the "is" and the "ought." Instead, as McCarthy insists, basing himself on "empirical research"—especially Mead's and Kohlberg's respective social psychologies, both of which concern the formation of the "self"—even more than a decade ago he occupied an unrivalled niche in the never-ending struggle to preserve the "Western" tradition against the philosophical barbarians poised at

the gates. In the process, he resumes the lost Utopian project that ended with Ernst Bloch's *Principle of Hope,* science fiction of the 1960s, and the New Left. However, where these utopias are fashioned out of the "not-yet," tendencies that are forged in the social furnace, Habermas, resuming the classic German Ideology, remains above the battle. He has provided for the league of weary radical intellectuals a vehicle to be of, but not in, the world.

IV

POLITICAL CULTURE

12

THE DECLINE OF AMERICAN LIBERALISM

There is a desperate effort among left intellectuals and activists to revive modern, i.e. social justice liberalism as the best hope for creating an alternative to the prevailing conservative ideology and program. It is a panacea born of a pervasive sense that they are now isolated and impotent after a brief moment of influence in the 1960s; and that only in a liberal environment can radical ideas regain currency. Whatever the limited merit of these perceptions, they should not obscure the reality that liberalism manages to survive, more or less, because its left-wing alternative has been discredited and the right has reemerged as a viable political and ideological movement. Actually, the heart of liberalism barely flutters, lacking the stamina to defeat conservatism, or to reassert itself as a potent ideological or organized force. The time

and energy involved in futile efforts to resuscitate the patient would be better spent on trying to rebuild a vital American radical movement. To explain why this is so is a major purpose of this chapter.

WHAT IS LIBERALISM?

One source of liberalism is the Lockean focus on the rights of property as the content of both liberalism and its concomitant term, democracy. This view revolves around preserving the free market to buy and sell goods and labor power. The ideology of the free market has always been more powerful than its practice, for, from the dawn of capitalism, the state has constantly been pressed into the service of capital. In addition to curbs on the working class and protection of property, the bourgeoisie has required roads, trade routes, armies, and the regulation of its own internal relations in order to exploit labor and achieve market advantages. These services have been provided by the state.

After the American Revolution, most of the framers of the Constitution tended to conflate democracy with the rights of capital, and sought to limit the freedom of those who would challenge this "natural" state of affairs. Of course, there has always been another strain in the democratic tradition, also brought to America from seventeenth-century England, that saw democracy as a "humane doctrine, emphasizing the worth of the individual, and assigning the rights of private property to a subordinate and instrumental position." (Robert McCloskey, *American Conservatism,* New York: Harper & Row, 1951). In its Jeffersonian version, this doctrine enjoyed some prestige in the early part of the nineteenth-century, but beginning in the 1840s it was overshadowed by market liberalism.

Since the rise of trusts after the Civil War, we have come to designate market liberalism as "conservatism," and humanism as "liberalism." Each has a competing conception of democracy and well-being. As I shall argue below, there are significant divisions within liberalism that arose from differing emphases placed upon forms of government intervention among groups that constituted the movement. But after the 1870s, there is no doubt that liberalism and conservatism faced each other as the two great opponents in American politics. The conflict between these ideological tendencies obscured their common ground; each believed that a principal purpose of gov-

ernment was to facilitate capital's free access to markets for goods and for labor. The differing paths they advocated to arrive at this goal resulted in several paradoxes: the "progressive" liberals favored an interventionist state to prevent the growth of monopolies that would restrict trade and thwart human freedom, while conservatives generally opposed business regulation but advocated regulation of labor unions, on the ground that they restrained trade and limited capital's access to labor. On the other hand, conservatives only sporadically opposed government subsidies to assist business to remain competitive internationally; nor did most object to the socialization of infrastructural investment when sectors such as rails and communications proved unprofitable.

Still, it is important to note that what Europeans call liberalism is generally called conservatism in the US, and both major wings of American liberalism are roughly parallel to what is sometimes designated as "right-wing" social democracy in Europe. American liberals, like many European socialists, came to regard the social welfare state as the core of the good society, and even more, as the necessary extension of the doctrine of democracy inherited from the French and American Revolutions. On the other hand, conservatives have gradually renounced the ideas of liberty, except in the economic sense, as a necessary doctrine underlying foreign and domestic policy. For them, the protection and extension of capitalism became, in itself, justification for the support of authoritarian work relations in the industrial system, and political and military dictatorships abroad.

I define American liberalism as an ideology that accepts state economic intervention aimed at securing a better life for the majority of citizens, especially those who own no productive property and earn their living by working for wages. This liberalism usually identifies with labor's right to organize and bargain collectively under law. It supports full civil rights for all citizens, defends the right of political minorities to dissent, and favors equality of opportunity for women in employment and public accommodations (although there is no consensus about abortion rights). It is this liberal tendency that has often been identified as the American left. Democratic socialists, who have frequently felt obliged to merge with the liberal movement (and, at present, seem to be identical with it) have, in recent times, rarely been able to articulate specific politics that differ from those of the liberals.

REVISIONISM AND LIBERALISM

As early as the turn of the century, the Socialist International declared the old market liberalism a thing of the past, replaced, in its view, by monopoly capitalism, or organized capitalism, or finance capital. But the Second International had its revisionist wing helping to give liberalism a new lease on life. It was the evolutionary socialist doctrine of Eduard Bernstein, above all, which can be credited with having reformulated the liberal project in the age of frequent and deepening crisis.

In Europe, Christian Democrats and liberals borrowed Bernstein's idea that the state was more than a repressive instrument for reproducing the economic and political authority of capital, more than a watchman for private property in the means of production. For many liberals, as well as socialists, the market was no longer "free," and could not function efficiently to produce full employment for workers and a rising rate of profit for capital. An interventionist state had to be invented to harmonize both objectives without disrupting social relations. Even those socialists who remained skeptical that such reconciliation was possible, given the ineluctable contradictions of the system, were forced to admit that state intervention could benefit labor in the short run.

All Bernstein accomplished was to codify this compromise as a new socialist doctrine, to argue that the struggle for reform unexpectedly aided capital in its quest for rationality. The state had become a terrain of struggle between labor and capital, but the workers' victories could not be relegated to the margins of political life. For Bernstein, they irrevocably altered not only the role of the state, but also the prospects and the strategy for achieving socialism. Capitalism, according to Bernstein, was becoming increasingly organized. Like Rudolph Hilferding, he argued that the concentration and centralization of capital, the merger of banking and industrial capital, its globalization and increasing bureaucratization, constituted a new field for political and economic action. As capital became organized, the state was mobilized to accelerate its rationalization. Bernstein concluded that, while the danger of crisis had not abated, its probability was reduced; socialism had to contend with a new state, which could no longer be viewed through the lens of the early period of the workers' movement. The state might not break strikes as its characteristic response to workers' organization, but instead might yield to workers' demands for the enlargement of

the social wage, education, transfer payments, pensions, as well as protections for the conditions of labor. As part of its function of setting favorable conditions for investment, the capitalist state might also, under certain circumstances, own and operate key industries. In other cases, it would provide incentives for investment through contracts that would result in increased employment.

Social reformism had a profound influence on the labor movement which became the cornerstone of the interventionist state's mass base. In Europe after 1910, a definite wing of social democracy drew closer to modern liberalism in its vision of a good society, as well as its program for achieving it. Reform was no longer seen as a tactic for winning concessions from capital, but was understood as a series of steps that forged a new social contract. Many socialists differed from liberals about whether this contract was permanent or not, but there was no question of its desirability, especially when the labor movement was strong enough to dictate some of the terms of the agreement. Bernsteinism became a form of corporatism in the era of class political stalemate, when the working class and socialist movements were powerful enough to impose their will within the capitalist framework but still not able to change social relations.

From a commitment to preserving the unencumbered function of the market system, modern liberalism came to mean the reverse. The market system could be supported only in a limited sense. For competition to flourish, the state was obliged to regulate relations among differing firms within the same industry, provided the public interest was at stake. From a doctrinal faith in a weak state, liberalism came to mean advocacy of a strong state in order to rationalize capitalism, and to secure social peace with labor on the basis of a degree of distributive justice.

TWO STRAINS OF LIBERALISM

In the United States, statist liberalism was marked by two strains, progressivism and populism. Progressivism stressed that a strong state corresponded to the national interest, that a new "republicanism" was needed to secure justice for all. The pursuit of private interests was to be subordinated to the "public" interest. Consequently, progressivism became identified, at the same moment that Bernstein was revising

social-democratic doctrine, with a tripartite conception of corporatism: labor, capital, and the public had to work in concert to secure a just society. Since business tended to ignore the public interest, and labor was infused with partisanship as well, the state had to become the mediator of conflicting interests within a corporate framework. Because class politics and ideology were relatively weak, progressivism became the dominant form of American liberalism in the first half of the century. Its strength partly derived from its coincidence with traditional American ideology, which denied that society was cleaved into opposing classes, and proposed instead that the nation constituted an objective interest that superceded contending forces. Progressivism was a movement of the enlightened elite. Its key ideologists, Herbert Croly, Walter Lippmann, prolabor industrialists like Gerard Swope and the Harrimans, political figures such as Senators Borah and La Follette representing the by-now beleaguered middle classes in rural areas and small towns—all proceeded on both nationalist and republican premises. They defined liberalism in explicitly American terms, that is, as a movement that preserves the basic institutions of representative democracy in the political sphere, while trying to rationalize economic life through government regulation.

Populism has often been confused with progressivism, but its premises are quite distinct. In its original, left-wing form, it was in the first place a movement of popular sovereignty against the power of large corporations, and sought to use the state to redress the balance between workers, farmers, and capital. Secondly, although its proposals for economic reorganization stopped short of a socialist solution, populism promoted various forms of cooperative economic relationships. Thirdly, populism did not accept the existing system of representative government as adequate to a democratic society. It proposed radical reforms in electoral procedure: turn-of-the-century populists favored the direct initiative for making policy, instead of leaving decisions to elected officials; they fought for direct election of senators, shorter terms of office, and smaller units of representation. In short, populism did not seek reconciliation with big capital and government bureaucracy (even though it believed the state could be "used" by the people to achieve their aims). Instead, it demanded new economic and political forms that transferred power to small farmers and small business. In this sense, it was a defensive struggle against emergent big business on behalf of the free market, a Jeffersonian movement in the age of monopoly capital.

Yet populist leaders such as Tom Watson argued that the free market presupposed breaking the power of the monopolies, and this could only come about through state action forbidding "trusts."

According to some historians, the best years of the populist movement were the 1880s and early nineties, when organizations such as the Farmers Alliance, building on an interracial basis, were a powerful lobby against big capital. When key figures such as Tom Watson sundered this alliance in favor of racism, a new, right-wing populism was born that still lives. But the decline of populism was also intimately connected with the rise of progressivism as an alternative. Progressives sympathized with populist demands for market liberalism, substituting regulation for trust-busting as the mechanism of economic justice for small business. But populism also had a radical side, not shared by the progressives: it advocated grass-roots democracy to replace the centralist state. Its tacit assumptions were split between reluctant support for a national state which could curb monopolies, and a local state under the direct control of producers and consumers, especially of agricultural products and other consumer goods. Many populist leaders sought an anticapitalist farmer-labor alliance. They assumed that farmers could not go it alone, that reforms, such as curbing the power of railroad magnates and steel companies, required an alliance with a strong labor movement. However, the labor movement, by the turn of the century, had begun to embrace progressive ideas. By 1900, Gompers was altering his famous pure and simple trade unionism in favor of corporatism. In return for procuring recognition by large corporations of workers' right to organize and bargain collectively, he advocated that the unions enter a tripartite partnership with these corporations and the "public," a euphemism which during the war became the state. Thus, Gompers was a progressive, not a populist. Like many other labor leaders, he had no concern for grass-roots democracy. Instead, he was prepared to support the formation of a strong national state to redress the balance between labor and capital, a goal which, as Teddy Roosevelt had already claimed, was fully consistent with America's imperial aims.

From the turn of the century, imperialism and welfarism became compatible. In fact, it might be argued that the welfare state and its programs presupposed America's global reach. The more rapid economic growth, the more capital had available to share with labor. Of course, the socialists were vehemently opposed to this formulation, but alas, they were not able to displace either Gompers or Gompersism.[1]

The consequence of this new corporatism was that a farmer-labor alliance was, for most of this century, a dead letter, and the left-populist dream failed, except in such states as North Dakota and Minnesota. There the farmers' agenda dominated alternative politics, and the labor movement, for its own survival, determined it expedient to go along. Midwest populism became the regional form of modern liberalism until the New Deal successfully eroded its most democratic and class-conscious premises.

FROM THE NEW DEAL TO NEOLIBERALISM

The New Deal was the American version of Bernsteinism, with the important difference that American labor never achieved the social and political weight of the German workers' movement, and could not impose the advanced welfare states that emerged in Germany and in the Scandinavian countries. After World War Two, the New Deal was progressive rather than populist. Members of Roosevelt's "Brain Trust" were nearly all progressives who favored more central planning and, above all, corporatism. But it was the Congress of Industrial Organizations (CIO) that provided a popular base for the Democratic Party and a democratic ideology that New Deal intellectuals were unable to generate on their own. This ideology was propounded by the organizers and intellectuals connected to the industrial union upsurge. The development of democratic ideas was intrinsic to the rise of the CIO and its radical precursors. For the first time in US history, workers were recruited *en masse* into a labor movement that declared that the unskilled (immigrants, Blacks, Southern assembly line workers, women) should be part of the union movement and entitled to full industrial citizenship. These ideas, which became commonplace, were entirely novel in the 1930s, compared to the rigid American Federation of Labor skilled trades traditions. Roosevelt offered the legitimacy to organized labor that many unionists sought, and many socialists of diverse tendencies gradually became convinced that the New Deal represented a transition to a new, more equitable economic and social order, despite its unreserved commitment to capitalism.

This ideological shift created confusion concerning the redistributive aspects of the welfare state. In fact, welfarism was not the dominant emphasis of the Roosevelt administration; it was always a sub-

ordinate and, for most of the Depression, an expendable feature of state intervention. The New Deal owed its defining features to the progressive, not populist, tradition of state planning, state investment, regulation, and permissive monetary policies to encourage private capital expansion. Until 1935 to 36, there were few, if any, indications that Roosevelt intended more social participation in economic or political life. The Wagner Act, in response to the mass worker upsurge, signified a switch from the elitist strategy pursued by the administration. But even here, labor's rights were subsumed under the regulatory functions of the state, just as the National Industrial Recovery Act had included a weak provision for the right of workers to organize within its program of corporatism. In the context of a coalition within which labor played an important but subordinate role, the pressure to consolidate the achievements of the welfare state derived as much from political expediency as it did from economic considerations.

Today the progressive side of liberalism is in question. The period since 1975 has been marked not only by a concerted assault on what is commonly understood as the welfare state, but a partial dismantling of some of its interventionist functions, particularly regulation. Liberalism seems to have discovered its pristine roots as a doctrine of the free market and free trade. And the attack is not merely from the right, but has also taken place within the liberal camp. "Neo"-liberalism is nothing more than the accommodation of erstwhile progressives to the market-liberal offensive, an accommodation that calls into question the New Deal, corporatist, social contract between labor and capital, Blacks and the state. But the doctrine of the free market has actually been invoked to restructure rather than dominate the interventionist state. State intervention is now aimed at preserving capitalism by tuning the market, stimulating investment through both the tax system and government contracts, and regulating relations among capitalists within a specific sector, through price and organization controls that restrict mergers. In addition, transfer payments have become a form of political control.

In the United States, and Britain as well, it is fairly obvious that a wide consensus has been forged to adopt the program of state intervention in the forms of investment incentives to capital. Conservatives have no intention of relaxing such state intervention. The rhetoric of "free market" only applies to business regulation and labor's rights.

THE COLLAPSE OF WELFARE LIBERALISM

In the 1980s, the United States was forced to adapt to serious international economic competition, especially from Japan and Germany. In this context, the frailty of the free market as the mechanism able to protect its national interest has become all too apparent. Foreign competition has also been invoked to attack the notion that social welfare is a "right" of workers and the poor. In both the US and Britain, the administrations have argued that welfarism is a form of monopoly over resources leaving the nation vulnerable to economic invasion from abroad. Both Reagan and Thatcher sought to roll back welfare, in fact, to cut the real wages of the working class, reverse the declining profit rate, and stimulate capital accumulation. And both were committed to mobilizing the state to assist in this program. In fact, Reagan increased the federal budget in the form of arms spending, and emerged as a military Keynesian in free-market garb. There is absolutely no question of restoring the free market or dismantling the economic centrality of the state. It is merely a question of how and when to dismantle the mechanisms of transfer payments or, more exactly, to effect reverse transfer payments.

The basic difference between the US and Britain is the degree of resistance of the labor movement to government policies. Thatcher meant to undertake a complete disengagement from such programs as the National Health Service, no less than Reagan would have liked to make social security voluntary, thus freeing billions for consumption and, more important, investment. Both were been obliged to retreat from their maximum program, but they achieved astounding success. Thatcher eroded income maintenance for the unemployed, halted the public housing program, and took on the powerful miners' union by closing nationalized pits. Her path was thorny because the labor commitment to welfare is much stronger in Britain than it is in the US.

Here, Reagan eliminated or sharply curtailed many income programs, froze federal employee wages, broke an important air traffic controllers union and, most significant, led private employers in an all-out assault on wages and health and pension benefits. In contrast to the mass struggles in Britain, the American labor movement and its liberal allies, under the influence of nationalism and corporatism, identified, even if reluctantly, with "their own" state and employers. With the exception of the congressional Black Caucus and a few remaining "pro-

gressives," there is no discourse about social justice in the US, autonomous from the national interest, particularly the imperative to preserve American economic viability in the world market.[2]

So we are witnessing the virtual collapse of welfare liberalism, which was the foundation of the coalition of unions, some sections of capital, the Democratic party and minorities that set the agenda for American politics from 1936 to 1968.

With the rise of the mass civil rights movement in the sixties, ideas of "affirmative action" became the new liberal common sense, in part because the war-driven prosperity of the late sixties and early seventies permitted such a turn. In defending affirmative action, liberalism had to defend the concept of collective rights in addition to individual rights which, after all, is one of the profound distinctions between socialism and liberalism. Unable to oppose equality of opportunity, the Reaganite offensive against affirmative action retreated to the position that collective rights constitute a kind of reverse discrimination. Although liberalism's commitment to affirmative action has not been entirely erased many liberals have since fallen back before the conservative onslaught. As we have learned in the early eighties only under conditions of economic growth and relatively full employment have most whites been prepared to entertain Black demands for social efforts to eradicate inequality and discrimination. As the economic belt has tightened, so has white resistance, especially among workers hard hit by plant closings, technological unemployment, and job losses resulting from economic stagnation.

Welfare liberalism was always premised on economic growth. Its "pragmatic" anti-ideological orientation assumed that immediate and concrete victories were possible as long as America dominated world markets and transnational corporations could both invest heavily in the Third World and Europe, *and* maintain high levels of investment within the US. Even after the war, when key corporations in the monopoly sector undertook heavy investment programs in technology, the rising productivity levels were offset by the increased volume of production. Fewer workers produced more goods by working faster and using modern machines, but long-term layoffs in the leading sectors were relatively rare until 1970. Under these conditions, the sky was the limit. The American dream was within reach for a large segment of the working class; monopoly-sector industrial workers could expect to purchase a one-family house, a car every three or four years, and keep up

with improvements in appliances without too much strain. If justice was confined to individual consumption, leaving the workplace as authoritarian as it had always been (with the important caveat that workers could grieve through the unions), at least the grinding poverty of early times seemed ended.

ORGANIZED LABOR AND WELFARE LIBERALISM

After World War II, trade unions were increasingly integrated in the new social and economic order. While unions such as the Auto workers, Electrical workers, and many others had strong formal democratic procedures for conducting union affairs, the dead hand of bureaucracy increasingly overcame their rank-and-file traditions. In part, this was the inevitable result of contract unionism. In contrast to earlier periods, when unions were genuinely constituted by membership activity precisely because they were unrecognized either by law or employers, in the postwar era they achieved national agreements with major corporate chains, grievance procedures for adjudicating complaints on the shop floor, and in some cases the ability to administer substantial pension and health funds. These gains made many unions eminently respectable. Leaders regarded the contract as the workers' bill of rights, a bible to be cherished above all other forms of union action. The concept of unions as "representatives" of workers, rather than constituted by them, grew almost unintentionally out of the new conditions of class arrangements. From the point of view of the officials, the task of the union was to achieve class peace. Strikes, slowdowns, and other disruptions of production, longtime tactics in labor's struggle against capital, were renounced in favor of negotiations. The art of wheeling and dealing replaced the idea that union power was drawn out of workers' militancy. Indeed, the frequently militant rank and file came to be regarded as "irresponsible," "impetuous," and "disruptive" to the carefully planned and executed efforts by unions and management to achieve a *modus vivendi* in the service of more production and higher wages and benefits.

The labor movement came to resemble an army; unions were structured hierarchically and had a fairly clear chain of command. Although the rank and file jealously guarded its right to approve or disapprove

contract settlements and elect union officials, and retained a measure of local autonomy, the centralized conditions of collective bargaining itself, which mirrored the structure of capital, seemed to dictate centralization of decision-making. Yet, these arrangements did not always work smoothly. Indeed, beginning in the late 1950s, the Auto Workers and the Steelworkers were but the most prominent of a dozen industrial unions that experienced rank-and-file discontent and political turmoil. In some cases, such as auto, this was manifested in frequent illegal strikes conducted on the shop floor against the will of the leaders; in others, such as steel, the late fifties were marked by a sustained rank-and-file revolt against a leadership that had grown distant from the membership.

Later, in the sixties, Black caucuses sprang up in many unions, and by the end of that decade, insurgent and wildcat movements were common among younger workers, Blacks, and union militants in auto, trucking and the post office, to cite only the most visible. Union democracy was subject to different interpretations. One tendency understood the union as an institution with formal democracy: the membership could elect leaders, but after that, leaders were free to administer the organization and the contract as they saw fit. This was, and remains, a time-honored conception of democracy, but it invites bureaucratic formations. The second idea has remained inchoate, lacking a clear ideological and programmatic focus, but its outlines are enunciated by every rank-and-file caucus that seeks to replace a docile and authoritarian leadership, or to remake the union contract. It is based on the idea of continuous membership participation in union affairs, especially at the shop-floor level. It wants the freedom to act according to its needs, and eschews no-strike agreements, even for a limited period. It wants the real power to reside at the bottom rather than the top, and wants to replace union leaders frequently, as a matter of principle, even to have the right of recall at any time.

These issues have not been openly debated in the labor movement for more than thirty years, since the last of the radicals had some influence in the trade unions, and intellectuals oriented themselves to labor as a political article of faith. Nonetheless, during the past thirty years, the labor movement remained central to whatever progressive social and political change was possible in the US. The power of organized labor, even if more potential than actual, seemed to offer hope

for liberals and left intellectuals and activists "if only" it could overcome its congenital conservatism.

In the 1950s Walter Reuther, leader of perhaps the most democratic of the industrial unions that arose out of the Depression, was still a paragon of visionary liberalism compared to his increasingly business-oriented counterparts in the AFL and his own CIO. Unions remained on the front line of the struggle for reform throughout the decade, when many others fell by the wayside or became open-throated supporters of Imperial America. And although the Truman and Eisenhower years were marked by a nearly complete halt in the expansion of the social wage within the state, trade unions negotiated the welfare state within many collective bargaining agreements.

Typically the contract provided health and pension benefits, paid holidays and vacations, and, after the introduction of automation in the 1950s, many industries provided a supplementary unemployment benefit to laid-off workers which, together with state benefits, almost equalled the prevailing wage. Of course, these gains had their dark side: the gap between the organized (never more than thirty percent of the labor force) and the unorganized workers grew, and labor appeared to have narrowed the circle of privilege when it, too, withdrew from the struggle to expand the frontiers of public benefits. With the single exception of the battle to achieve medical care for the elderly, in which labor played a key role, the progressive program did not succeed in traditional areas, largely because employers resisted picking up the costs for company retirees. On the other hand, the most impressive postwar gains were made by Blacks, who regarded the corporatist coalition that included the trade unions as one of their obstacles.

THE RISE OF COLD WAR LIBERALISM

The dominant strain of liberalism supported the basic thrust of American foreign policy in the postwar era. Soon after the war, a "left" consisting of Communists, liberals, and politicians coalesced around the figure of Henry Wallace. In effect, Wallace became the focus for what we would now describe as détentism—the doctrine according to which the United States and the Soviet Union could live in peace on the basis of the Potsdam, Yalta, and Teheran agreements that divided Europe into spheres of influence. The second wing, which became dominant

as the forties wore on, insisted that Stalinism was expansionist, that the division of the world was undemocratic, and in any case unfeasible, because the Russians could not be trusted, and the democratic impulses of the Eastern European people could not be repressed.

This tendency, which founded the Americans for Democratic Action, united most of the CIO leadership, a substantial group of liberal intellectuals, and many within the Truman administration and Congress. It supported Truman's Cold War and ultimately his containment policies. This stance produced several unintended consequences, however: for a time, many liberals found themselves sanctioning restrictions of civil liberties for Communists. Some, like Senator Hubert Humphrey, actually introduced legislation to outlaw the Communist party. Sidney Hook, Arthur Schlesinger, Jr., and other intellectuals opposed restricting the party's legality, but favored the exclusion of Communists from membership in voluntary organizations such as trade unions, on the ground that they were political agents of a totalitarian power, the Soviet Union, and therefore did not support democratic institutions. It is important here to note the effect the Cold War-inspired split in the liberal movement had on the development of postwar progressive movements. In the first place, by 1950, especially after the outbreak of the Korean War, most anti-Stalinist liberals were prepared to support the permanent war economy as the price labor and other popular forces had to pay for national security. It was not merely a question of patriotism or anti-Sovietism, for this collaboration signalled the final integration of labor and liberals into a new corporatist arrangement with capital. For labor, cooperation was not confined to support for the Truman war budget or US intervention in Southeast Asia.

Cooperation also meant the UAW signed a five year, no-strike contract with the major auto corporations, and the Steelworkers pledged cooperation with U.S. Steel and other producers to achieve higher production norms. Other unions followed similar paths. It meant, in addition, that the International Affairs departments of both the AFL and the CIO gave added emphasis to combatting Communist-led unions in western Europe and Latin America, and worked closely with government agencies to promote US foreign policy in these and other areas. Union leaders sat on federal government bodies seeking closer ties between government, business, and labor. And it meant that the Cold War liberal wing of the CIO, to its eternal discredit, expelled "left-led" (read, CP-inspired) unions from the CIO.[3]

After four years of war and two uncertain postwar years of shortages and joblessness, Americans yearned for private comforts, not class struggle. And the postwar prosperity was real enough. It was driven by an unprecedented growth in demand, which was in turn fueled by billions in savings accumulated during the scarcity years of the war. The government helped by providing low-interest housing loans to veterans, and finally to anyone who could afford the mortgage payments. Some anti-Communist radicals found that their country was eager to make room for them. Whether activists or intellectuals, the prospects for coming in out of the cold seemed good. For many, this meant a regular paycheck for the first time in their lives, jobs teaching in schools and universities, or working on the staffs of progressive labor unions and other organizations devoted to promoting the reform program of the New Deal coalition.

Many socialists at first believed that the postwar reconstruction in Europe was beyond the means of capitalism, and that the process of conversion to peacetime in the US would witness serious dislocations and even economic crisis. Since World War I had produced revolutionary activity in several crucial European countries, and destabilized capitalism for two decades, there seemed to be no reason to doubt that World War II would yield even greater opportunities for the left. Yet, by 1950, barely five years after the war, it was apparent to all but the politically blind that capitalism had indeed revived, that Western democracies were more or less intact, and that a veritable economic "miracle" was underway, aided by a less-than-benevolent United States which had delivered the goods for a price. Socialism was in retreat everywhere in Europe. Third World independence movements were on the march, but with uncertain outcomes. China broke from the West, but entered the Soviet orbit. Apart from a small group that held firm to a third-camp perspective, most anti-Stalinist socialists and radicals soon surrendered to the pro-Western liberals.

In 1949 the young Arthur Schlesinger, Jr. followed *The God That Failed*, the testimony of a dozen ex-Communists, with a liberal manifesto for ex-socialists: the *Vital Center*. He announced a Cold War liberalism that accepted the permanent war economy as the necessary price for freedom, but asserted the commitment to welfare as the far horizon of social justice. The perspective of systemic change gave way to that of slow but persistent reform, a morality tied umbilically to Keynesian economics. Recall that Schlesinger had become famous with

his proto-Marxist *Age of Jackson* in 1943, and had been on the *Partisan Review* periphery. In 1947, his article "The Future of Socialism" helped pave the way ideologically for the accommodation of postwar liberalism to the American state. Here, Schlesinger argued several closely related propositions that became the basis for liberal accommodation. He insisted that the New Deal, as the American state-form that crystallized economic and welfare interventionism, was the most representative political expression of democracy against the will of a hesitant and cowardly capitalist class. He also maintained that progressivism could lead to socialism, and that the Cold War was in the immediate and long-range interest of American leftists, especially of labor. Schlesinger agreed with ex-Marxist Sidney Hook that there was no Third Way opposed to Stalinism and the West, and implied that those who did not choose the West chose betrayal.

Schlesinger's contempt for capitalists and his desire for a socialist future did not prevent him or many of his cothinkers from joining in the postwar American celebration. Indeed, they became militant collaborators of New Deal legatees Truman, Marshall, and Kennedy, whom they now saw as mankind's last best hope. And even though Schlesinger, and a few others who shared his earlier views, temporarily broke from US foreign policy toward the end of the Vietnam War, it was not because they came to see that American foreign policy was imperialist. These liberal intellectuals were given temporary pause by Vietnam because they saw it as a colossal misadventure which undermined the American democratic imperium. We could not win such a war with direct military intervention, they argued, because it was not our terrain, not in the vital interest of the United States.

Therefore, it was not surprising to hear Schlesinger in November 1985, more than thirty five years after the publication of the *Vital Center,* singing the old tune. Now, late in his career, the historian rediscovered a version of Arnold Toynbee's cyclical theory. For him, the latest conservative triumph was simply an aspect of the metabolism of American politics. The present phase would last until the early 1990s, after which liberalism—still defined as the gradualism that slowly, haltingly, leads to more "socialism" (read welfarism) would revive and resume the reigns of government. Not to worry, then. America is still in fairly good shape, and the destiny of liberalism is tied to its strength as a world economic, political and military power.

LIBERALISM AND THE COMMUNIST PARTY

The demise of the Communist left both within the labor movement and in American politics generally was by no means simply a consequence of the Cold War. The CP rose to prominence in many political circles after the Seventh World Congress of the Communist International partially reversed its disastrous "Third Period" policies which, among other things, promoted dual unionism, and denounced social democrats as class traitors and worse. But as was the wont of Stalin and his entourage (which included the American CP leadership), one extreme gave way to another. After 1935, the Communists virtually renounced the class struggle in favor of joining with all "democratic" forces in the struggle against Fascism. Not only did the party refrain from attacking socialists, but it openly embraced liberalism as the most practical course for the working class. Along the way, it presented the most minimalist program imaginable. The sum and substance of its domestic policy was the achievement of the welfare state. Its foreign policy consisted of uncritical support for every turn required by Soviet national interests, which included support for the antiradical Republican Spanish government, the Nazi-Soviet pact, and, during World War II, the subordination of workers' immediate demands for higher wages and better working conditions to the "win the war" effort. The party and its trade union cadre were obliged not only to advocate but to enforce the no-strike pledge in defense industries, a policy which led to the blatant suppression of trade union militants.

Given these policies, the Communist party grew enormously during the later years of the New Deal and the war (except for the period of the Stalin-Hitler pact). Its membership was swelled by officeholders and would-be officials who saw leftism as a smart career choice, as well as by sincere activists for whom the Soviet Union was the beacon of world peace and progress. In 1944 the party was summarily dissolved under orders from the Soviet Union, a measure designed to convince Roosevelt and the "progressive" wing of capital that it meant no harm. The CP's leader, Earl Browder, even speculated that the postwar period would be an era of unexpected and unparalled cooperation between labor and capital. With the Communists functioning as cops in the labor movement and fervent New Dealers in the Democratic Party, it was hard to tell the reds from the pinks. The party was hostile and

abusive to the independent left, especially those who insisted on the class struggle.

After the war, the CP entered its second ultraleft period, when the ostensibly defunct Comintern sent word to the American and other parties that, in the interest of the Soviet Union, it was time to resume the struggle against capitalism (read US imperialism). The American party, forever obedient, dutifully expelled Browder, and reconstituted itself in both open and underground forms, preparing for the inevitable, although temporary, triumph of Fascism. The party's feverish delusions led to profound and irreversible errors, not the least of which was the wholesale sacrifice by expulsion and self-imposed isolation (in the name of underground work) of some of its most talented people. For the rest, absolute obedience was the price of legitimacy: either subordinate yourself or face expulsion.

In the early fifties (Fascism having refused to appear despite the party's predictions), the Communists made feeble efforts to return to the Popular Front. Only there was no front and what there was, was not popular. All that remained was nostalgia for the Soviet Union and the good old days, when the Communist left rode high.

Needless to say, by the mid-fifties, the party's destruction was all but complete, the result of its own self-immolating policies and the Cold War in which the Soviet Union played a major role.

In the almost forty years since the Khrushchev report "revealed" Stalin's crimes and caprices, the American CP has steadily lost ground, but its fealty to American liberalism has rarely wavered. Its depleted legions are to be found in the liberal wing of the Democratic party, labor officialdom, and similar organizations.

NEO-MARXISTS AND NEOCONSERVATIVES

Recent neo-Marxist writers have given powerful economic explanations for the decline of welfare liberalism. They have argued that demand-side economics, the hallmark of Keynesian liberalism, is not really the point of the welfare state. In their view, direct income to individuals is a much less effective way to stimulate economic activity than massive injections of investment into the capital goods industries. Even the institutions of welfarism such as hospitals and schools provide less eco-

nomic power than the arms expenditures and other direct inputs into production. The welfare state, according to such writers as James O'Connor, Claus Offe, and Jürgen Habermas, is not principally geared to accumulation but to "legitimation," a term borrowed from Max Weber. In this theory, capital cannot rule on the basis of repression or economic development alone. Increasingly, especially in countries with a mature working class, the reproduction of the capitalist state requires the consent of the governed. Welfarism is part of the politics of consent. Although economic in character, its various institutions also serve the ideological function of securing the adherence of the population to the existing order. Thus, progressivism may be seen as more than simply the provision of certain benefits to those displaced by the vicissitudes of the world and national economies. The institutions of the state such as social security take on a life of their own. They cultivate a constituency that protects them politically even as it fights for expansion of the program; the institution becomes a part of the daily lives of many of its participants, insofar as agencies supply noneconomic services such as helping "clients" negotiate with the bureaucracy in order to achieve distributive justice, and the program is fostered as an emblem of the fairness of the state and of capital, its commitment to national rather than class solidarity.

There is a tendency to assume that the welfare state has become an irreversible feature of late capitalist societies, and that liberalism will retain its social base regardless of the variability of its political fortunes. This proposition relies on a most controversial notion—that "corporate" liberalism is permanently ensconced in the economic and political fabric of national culture and retains the adherence of a substantial section of the capitalist class. But this is precisely what the resurgent conservative forces have sought to challenge. Their record over the course of the Carter and Reagan years has been stunningly successful, a fact that raises crucial questions for progressives and Marxists who believe that this aspect of the interventionist state is inviolate.

Institutional explanations for the durability of the welfare state fail to recognize that social movements have always constituted the foundation of its support. Given the decline of these movements, in the first place the trade unions, the fate of the welfare state is in doubt. Second, institutionalist progressives underestimate the weight of right-wing populism. Remember that populism does not presuppose a commitment

to the social wage, only a radical democratic antipathy to big corporations and large public bureaucratism. We can therefore understand the emergence not only of right-wing populist movements and their convergence with traditional conservatism, but also their ability to mobilize against the welfare state. Although right-wing populism is not democratic, its rhetoric of antibureaucratism is often effective in masking its own authoritarian proclivities. Third, as already noted, corporate liberalism was predicated on American economic expansion, which has come to a halt.

THE FLIGHT FROM LIBERALISM

Welfare liberalism is also currently suffering serious internal defections. While liberals such as Arthur Schlesinger have retained their commitment to welfare and a renewed liberalism within a nationalist framework, a significant wing of the liberal intelligentsia and political center has moved rapidly to the right. Many who once combined strong commitment to the progressive agenda of the interventionist state, with a firm allegiance to anti-Communism discovered before the fall of Communism that welfarism was antithetical to a strong national defense against Communist encroachment. They therefore dropped their economic progressivism without renouncing it.

The trend toward neoconservative thought among ex-radicals and liberals derives, in part, from a shared sense of the degradation of traditional democratic values in the modern world, a judgment prompted not only by the rise of authoritarian regimes in the East and South of the globe, but also by authoritarian currents within the left of this country. For many liberals, *democracy means representative democracy* and doctrines of direct democracy—radical decentralization of economic and political institutions—are corollaries of authoritarian doctrines because they are unaccountable to a definable electorate. Thus, rulers derive their power from the consent of the governed, and ideas of mass participation are dismissed as both utopian and disingenuous. Negative examples here are plainly the Russian Revolution and the American New Left, each of which combined collectivist ideas of power with notions of direct democracy. Neoconservatives believe that the inherent weakness of socialism is its proclivity for subordinating the individual to state power. The state is elevated to supreme sovereignty under au-

thoritarian socialism, just as the mob takes on supremacy within populist cant. For neoconservatives then, "liberalism" does not mean the just distribution of economic goods and political power, but individual liberty to climb the social ladder. Sexism and racism are opposed to the extent that they deprive people of such opportunities. But this is the limit of freedom.

Neoconservatism is the reconciliation of a group of intellectuals with the prevailing system of power. That these people revert to some classical liberal doctrines of the nineteenth-century should not be surprising in a time of economic limits. It is not that they oppose the welfare state which, after all, is constituted to cushion the effects of economic shifts on individuals, it is only that such institutions cannot be fully supported when the totalitarian menace abroad and the authoritarian threat within require a state of emergency to defend freedom.

Liberalism is fatally wounded by the demise of progressive ideology and the social practices to which it corresponds. Yet its persistence can be explained, at least partially, by the crisis of socialism itself.

When Fascism was finally defeated in Europe, the labor and socialist movements integrated themselves into liberal states in France, Germany, and Italy, achieving substantial welfare states but refusing to democratize the economic, educational, health, and other systems. In time, both Communist and Social Democratic parties in Western Europe ceased to represent a determined opposition to capitalism. In a triumph of Bernsteinism, Western socialists have abandoned the idea of replacing parliamentary democracy with a popular democracy of direct self-management of all social, political, and economic institutions. They have defined socialism as parliamentary democracy, plus social ownership of the *key* means of production, plus the market, which leaves plenty of room for the mixed economy. This kind of "real" socialism permits liberalism to survive.

However, contrary to the traditional reformist argument, capitalism has not avoided economic disasters by creating the interventionist state, with its institutions of economic control and ideological hegemony. None of the Western capitalist countries has solved its most pressing economic problems. Further, to the degree that the labor movement here and in Western Europe remains in thrall to its corporatist commitments, the capacity for mass resistance is weakened. In France, Brit-

ain, Germany, and the United States, events have overtaken the traditional progressive belief that neocapitalism could survive its own contradictions.

Parliament has increasingly revealed itself to be helpless in the face of the power of central bureaucracies to set the agenda for what passes for politics in the West. These bureaucracies—corporate, transnational, and state—remain relatively immune from popular control through representative institutions or other mechanisms. The idea that representative democracy "works" in the United States has been persistently undermined by the massive entry of corporate political action committees, which today have achieved political hegemony within Congress to match their traditional weight in the executive. The autonomy of such European states as France, Germany, and Britain is surely questionable in light of the limits imposed on socialists operating in those countries by US domination. The power of transnational corporations also calls into question the autonomy of the national state and, indeed, the power of politics at the national level to guarantee popular sovereignty.

Those who glorify the market as a "democratic" arena forget that the interventionist state was called into being because of the weaknesses of the market. It is not that an argument for markets cannot be made within a rational socialist society. Rather, it is a question of elevating such considerations to the level of principle, holding that markets are institutions necessary for the development of a democratic society. Alec Nove has shown how the denial of the market distorted the quality of life in the Soviet Union. But Nove's basic premises implicitly accepted the Soviet Union and other Eastern European countries as really existing *socialism,* rather than holding that these regimes represented a new form of society that is neither capitalist nor socialist in the classical meanings of these terms. Thus, while it is sheer madness for countries at a fairly low level of economic development to statify all of their means of production, including agriculture, and centralize their exchange relations, it is quite a different matter to claim that the market under all circumstances is the best guarantor of freedom and democracy. The social ownership of the means of production does not imply state control; collective control could be radically decentralized, and exchange relations could be carried on in some sectors without a market. The point is that any talk of socialism becomes problematic when applied to societies burdened by scarcities as a result, in part, of oligarchy and

bureaucracy; societies in which an oligarchy holds all of the commanding heights of political and economic power. Further, it may be that socialism is only possible in the most advanced societies, but is not possible today confined to Third World and semiperipheral countries.

These circumstances are by no means incidental to the course of socialist movements in advanced capitalist countries. In the wake of the breakdown of capitalist prosperity in the last decade, we might have expected, at least in Europe, a new socialist energy. This did occur, but was unfortunately short-circuited by the fact that socialists came to power under conditions of mass *demobilization* in France, Spain, and Greece. These were not felicitous conditions for profound change in economic or political arrangements. When combined with the failures of "really existing" regimes calling themselves socialist, it is not surprising that so many on the left have returned to the failed ideas of liberalism.

SOCIALIST POLITICS AND LIBERALISM

The decline of liberalism has not deterred the democratic left mainstream from pursuing its traditional policy of working in the progressive wing of the Democratic party. Fearing isolation from a possible mass base, and mindful of the often disastrous sectarianism of the Old Left, democratic socialists and many radicals apparently remain committed to merger with liberalism, in the guise of the Popular Front during the thirties, and today in a peculiar non-Stalinist reincarnation of Browderism. Members of the remaining small socialist groups and many independents seem unaffected (except privately) by the demise of the liberal movement. In fact, the American left is the only consistently liberal tendency in American politics, with the possible exception of the organized Black movement and a scattering of trade unionists.

The hopes of those on the left tied to conventional New Deal politics rest on the discredited doctrine of realignment. Born in the 1950s, realignment was conceived as a means of transition to a mass socialist party. Socialists were to enter the Democratic party and in alliance with progressive trade unionists, the civil rights and other social movements, move the Democratic party to the left, thereby forcing its right wing to join the Republican party. Labor and its allies would

then take over the Democratic party and transform it into a European-style labor party. This doctrine captured a working majority of the post-sixties left, as well.

Thirty years later, the Democratic party has less in common with its New Deal forebears than ever before, and its "progressive wing" has never been smaller. Still, the left realignment forces persist, waiting for the inevitable economic crisis to drive the labor movement and the Democratic party to the left or, as with Schlesinger, for the pendulum of history to resolve the anomalies in their theory and analysis. But the economic crisis has come and things are getting worse politically. The pendulum is at a standstill.

The fact is, there is no independent left in the US worthy of the name. A genuine democratic left would have as its main task to define and disseminate the ideas of democracy among political activists and the general population. It should work out an approach to democratic participation, the state, racism, and sexism and the specific features of US-based multinational capitalism.

This would not mean ignoring the necessity for uniting with a wide variety of social forces to wage struggles to save the remnants of the welfare state and protect the existence of militant trade unions. To refuse cooperation with militant liberals prepared to resist the conservative onslaught would be a major error, reproducing the worst features of left elitism. But the current practices of the left confuses these important coalition efforts with the substance of an alternative politics. With the exception of a handful of magazines and journals, these burning questions at home and abroad are no longer discussed among activists.

Many fail to see the "relevance" of radicalism or even fundamental reform to the day-to-day work of building movements, while others are becoming increasingly pessimistic or cynical. The example of France is often cited by those who have given up thinking in terms of the socialist vision. Even with a clear majority, some argue, socialist governments seem unable to accomplish more than a few moderate reforms. At worst, the Mitterrand government became a vocal NATO supporter, and its austerity programs simply repeated the policies of all conservative governments since 1970.

Others, stung by the negative examples of Third World or Eastern Bloc "socialisms," have concluded that "really existing socialism" is

identical with the socialist ideal and, if so, less desirable than advanced capitalist democracies. These familiar arguments have often been used by left-liberals on their way to the right.

The truth is that, without an explicit left politics, tactical "radicalism" is bound by the terms of reformism. That is why conservative columnist George Will struck a tender nerve when he labelled a 1980's interview with socialists Michael Harrington and Irving Howe in the *New York Times,* "tepid porridge." The sad fact is that democratic socialism is suffocating in the politics of the possible, both in the US and in Western Europe. And the "possible" is sadly, a self-fulfilling prophecy. It defines the narrow limits of debate, concluding that radicalism is always either sectarian or utopian.

If Trotsky once called the French socialists a party of dentists, American leftists including socialists today are a nonparty of professors and functionaries. (The dentists left with the demise of the old Socialist and Communist parties that once provided a miniwelfare state for their members and periphery.) The new socialism is mostly sentimental or, when slightly more serious, a replacement for academic professional associations for those radicals seeking more bite in their intellectual tea. And, while they are good functions to have, annual Debs Day dinners and socialist scholar conferences are not substitutes for a political movement.

As the first year of the Clinton administration demonstrates the simple wisdom of pendulum politics cannot be taken seriously, since there is no reason to believe in the iron law of cyclical politics, a belief that tends to justify quiescence. Social movements ebb and flow according to "objective" conditions, provided that a political vehicle is in place as the repository of ideological traditions, political background, and social solidarity.

Such is not the case when the left merges with decrepit liberalism. And therein lies the tragedy. The left, in hopes of remaining meaningful, has surrendered its reason for being.

The artificial lease on life provided to a liberalism that has never been true to its own professions should not blind us to the necessity of finding a deeper and more satisfying model—one that understands that the oppression of workers, Blacks, and women, problems of social life such as family, sexuality, and individual freedom are not resolved by state planning, plus socialization of the means of production. Liberalism as a political and ideological form rests on two ideas: possessive indi-

vidualism in the sphere of what Marx called civil society, and the negative liberty to be free of the arbitrary authority of the state. In contrast, radical democracy rests on the idea of positive liberty, the possibility that social arrangements may enable individuals and groups to realize their full potential as human beings, and that all institutions of social life are, in principle, subject to self-management by those who inhabit them. These are fundamentally opposed principles. The historic tendency of the left to equate them was based on a misplaced idea of practical necessity. It has resulted in near catastrophe for radicalism. One can only hope that the results of the breakdown of liberalism will foster a new debate on the alternatives.

NOTES

1. Gompers himself did not favor social legislation to benefit labor, preferring to win these gains through bipartite collective bargaining with employers. He argued that the labor movement was weakened to the extent that its gains were procured through the state. Needless to say, even a conservative like George Meany was obliged by the industrial union movement to surrender this aspect of Gompersism.

2. This claim is bound to be disputed by social welfare advocates who, relying on public opinion poll data, have argued that somehow liberal legislators have misinterpreted the Reagan "revolution." What is missing in their optimistic prognosis that liberalism will rise again is the simple secret of Reagan's success: he revived ideological politics that had been dormant on the right since the mid-1930s, when they had a mass base but were soundly defeated by the New Deal. In contrast, liberals and left-wing activists remain imprisoned by single-issue politics, and renounce ideology (such as anticapitalist appeals) in favor of simple justice.

3. The isolation of the Communists from the leading sectors of the labor movement was, however, only the most significant symptom of their growing isolation from social movements. Since the CP was the most important left-wing organization in the US, its demise had a disintegrating effect on the alliance it had built with the forces around Wallace. The Wallace movement was stillborn precisely because it adopted the discredited international position of its leading elements, the CP and its periphery. Socialists were simply in no position to fill the vacuum left by the CP's decline, which began in 1947 and reached its nadir in 1956, after Khrushchev's secret report that detailed Stalin's crimes.

13

PAST PERFECT

And their sun does never shine
And their fields are bleak and bare
And their ways are fill'd with thorns
It is eternal winter there.

For where e'er the sun does shine
And where e'er the rain does fall
Babe can never hunger there
Nor poverty the mind appall.

Thus wrote William Blake on the triumph of industrialism, circa 1790. Today there are no romantic rhymemongers to rail against poverty, hunger, and disease. Nor are the bookstalls littered with utopian tracts promising deliverance from this world of alienation and want. Instead there are prophets of doom and promise; futurists herald the new information society, a gleaming, bookless future where a giant television screen is worn like a wraparound. Sound replaces newsprint, and we are named by numbers. This future comes to us as science fiction, distopias of despair.

The new utopians envision an ethical life lived according to the canon of justice, equality, and ecology. Now that Herbert Marcuse and René Dubos are gone, Murray Bookchin stands at the pinnacle of the

genre of utopian social criticism, the successor to the many generations of Diggers, Levellers, and Ranters who have chosen the impractical path of reminding us of our pretensions to freedom and democracy. It hasn't been easy for Bookchin. His pioneering *Our Synthetic Environment* appeared in 1962, long before most of us had even discovered granola. He called the shots on an increasingly chemical-penetrated culture while most of us wallowed in the pleasures of disposable napkins and sugar-free everything. Bookchin railed against these conveniences as evidence of a suicidal industrial order, and he was ahead of his time in other ways as well. In *The Limits to the City*—published in 1973, but culled from his 1950s essays—he extolled the virtues of the humanistic community, that elusive goal which has preoccupied dreamers since the Greeks. At times Bookchin wrote under pseudonyms because radical declamations were dangerous to his economic health. When, in the 1960s, social criticism became chic, Bookchin emerged as America's most provocative anarchist theorist, a distinction that enabled him to get a steady university job after many years as a radical nomad.

The Ecology of Freedom is Bookchin's magnum opus, a confirmation of his status as a penetrating critic not only of the ways in which humankind is destroying itself, but of the ethical imperative to live a better life. Bookchin's argument is that concern for the environment is not enough; to focus on the problems technology has created for human survival is to miss an important point. The ecological perspective shows the link between cultural issues and technology, and insists that we cannot solve one problem without addressing the other. Bookchin begins with the premise that the domination of nature by humans is the core of our troubles: until we understand that hierarchy—not technology as such—is the basis of the unfreedom implied by pollution, dirty water, and the health hazards produced by synthetic materials, we won't solve the environmental crisis. Bookchin calls his science *social ecology* because he wishes to establish the link between our destructive relation with nature and our destructive human relations. We can clean up the rivers, preserve the forests, and make the air safe to breathe only if we reorganize our human relations and find a new nature morality.

Bookchin calls for the reenchantment of nature. He wants to restore our sense of an organic life, because he holds that such a life is the precondition for human survival. Thus, rather than focusing on the problem of the physical destruction of human beings (the main point of the no-nukes movement, the Sierra Club, and other environmental-

ists), Bookchin suggests that these concerns are somewhat trivial if we continue to reproduce domination and suffering. His major critique of traditional environmentalists is that they are willing to leave the structure of society intact, if its rulers will only agree to save the whales. The organic world is threatened, in the final analysis, by the social structure, and the logic that produces natural disasters has to be uprooted if they are to be avoided. So much for the liberals. They are content to attack the biospheric holocaust by banning aerosol cans. Ask them to change consciousness, to alter our way of living, and they respond: "That's utopian." Yet if ecology is the way not only to preserve the species, but also to give meaning to a social world infused with the ethic of personal gain, Bookchin's thesis is hard to dismiss with the epithet that he's impractical.

The Ecology of Freedom is peppered with delicious polemics. Standing outside the left consensus that condescends to ecology either as "middle-class" narcissistic preoccupation or as misdirected antiscience, Bookchin takes the offensive against these characteristic Marxist reactions. He accuses Marxism of remaining wedded to the nineteenth-century idea of technological progress; Marxists are uncritical of technology's "fruits" except insofar as they enslave labor. Accordingly socialism would free the forces of production from the shackles imposed upon them by capitalist relations. For Bookchin, technics are no neutral tools of production; they're integrated into the system of domination as long as the ecological view does not direct their uses. Bookchin argues that Marx, like Freud, was imprisoned in the values of contemporary civilization, a culture of hard work based on the repression of pleasure. He wants to revive an idea of technics proposed by Aristotle: techne, living an ethical life according to an originative and ordering principle of "potency." Bookchin wants us to rediscover our subjectivity in work, not merely to use it for the purposes of consumption and gaining power over others. It will not do, in Bookchin's conception, to dismiss "nature idolatry" as Marx and his Victorian contemporaries did. Marx imbibed the human-centered sensibility of his times, and unwittingly promoted a hierarchical vision even as he advocated classless society.

Bookchin's attack on sociobiology is no more merciful. According to this new "science," we live in a world "tainted by hierarchy command and obedience" because human nature is essentially aggrandizing and competitive. Or in sociobiology's more benign manifestation, the

opposite position is argued: despite contrary evidence, the human world is cooperative—doesn't the division of labor show how interdependent humans are? For Bookchin, our originary nature is playful, spontaneous, pleasureful. The mind feels and the body thinks. The hierarchical inheritance of past civilizations, not our genetic makeup, has distorted our social relations and our individuality. Although, like all great anarchists, Bookchin has a conception of human nature that is prior to the civilizing process, he is not locked into the dichotomy of good and evil.

His strategic move in arguing that we can create a new world is to propose a new past. Where most utopians look ahead, Bookchin's Marxist training comes to the fore: like Engels, he adduces anthropological evidence to prove that there once existed an organic society. Then humans did not hold nature at arm's length. They understood themselves as part of natural history, and refused to distinguish between themselves and the "external" world, a distinction that permits nature to become alien, and opens the way to its exploitation.

This picture of the past pays tribute to our skepticism. We can no longer respond to mystics, preachers, and moralizers without a sigh of weariness; we need the gratification of reason, since we are children of the Enlightenment. Bookchin has many harsh words for the ambiguous legacy of Francis Bacon, René Descartes, and Isaac Newton, but he has wisely taken account of the fact that facts are the name of the game of persuasion. In often aphoristic and rich prose, Bookchin addresses the wary, seducing us with poetry; yet he also constructs a narrative of desire, punctuated by a graceful and assured erudition, to show the doubters that ethics is not trivial, that utopia has a practical function, that we need not abandon our hope for a better life. After all, if we were once kind to each other, we can achieve that state of happiness again.

Bookchin's brilliant creation of an organic past is entirely justified by his critical discourse. But when he tries to lay claim for the thesis on strictly scientific grounds, using the work of anthropologists such as Radin and others for whom the past was constructed in the image of their own hopes, the holes in his rhetorical strategy become apparent. Given the scope of his work, it would be too much to expect that *The Ecology of Freedom* could embrace the history of the world and provide a critical commentary on one of the major debates among anthropol-

ogists: were early civilizations free of the domination of women by men, humans over nature, and other hierarchies? The answers are not clear, and Bookchin has contributed little to clarify the issue.

He is a better critic than a philosopher. Yet he insists on justifying his powerful social argument with excursions into ontology.

> Finally, from the ever greater complexity and variety that raises subatomic particles through the course of evolution to those conscious, self-reflexive life forms we call human beings, we cannot help but speculate about the existence of a broadly conceived *telos* and a latent subjectivity in substance itself that eventually yields mind and intellectuality.

Why can't he avoid such speculation? Broadly or narrowly conceived, this is an adventure into the religious belief that the end is implied in the beginning. When Bookchin is dazzling us with his critique of everybody else who works the same side of the ecological street, he puts his weapons of criticism in our own hands and radiates hope in these sorrowful, mediocre times. But he blurts out his theses awkwardly, ungrounded in the prolonged argument they deserve.

The historical despair of our century—with its two world wars and multiple economic crises, its revolutionary betrayals and will to destruction—has produced, among other things, a philosophical tradition that has tried to found a new ontology. From Heidegger to Gadamer, German thought has asserted the spirit is indomitable because it has lost its temporal moorings. Philosophers seek the absolute when history disappoints them; the rest of us sometimes turn to the eternal when we can't find meaning in daily life. For some contemporary thinkers, spirit and purpose inhere in the constitution of the world. The separation of thought and matter is denied in a manner reminiscent of early Greek philosophers who claimed that time and its vicissitudes were not what life is all about; forms remain unchanging even when particular content disappears. This is the core of Bookchin's faith—he wishes to grasp victory from the jaws of defeat, to assure us that hope is no mere daydream, but rooted in the nature of things. It would have been better to leave these sentiments implicit in the analysis, rather than trying to *prove* historically and philosophically that past and future are linked by a shared spirit.

Bookchin is nevertheless a great utopian, a major builder of a mythic past, a shaker and mover of social consciousness, a preacher, a

Ranter. Like Georges Sorel, who argued that the workers' movements of his times required a sustaining myth to mobilize the masses for liberation, Bookchin has provided a sustaining myth of the indestructible spirit and another of the organic civilization, to give us the hope to forge ahead. I don't mind these myths. It's too late to believe them entirely, but I'll take Bookchin any time over the prophets of the apocalypse who are concerned only to save our skins, and those who remain mired in the naive belief that science will save us.

14

SEEING GREEN

In *Green Politics,* Austrian expatriate Fritjof Capra (whose *The Tao of Physics* argued for a parallel between Eastern philosophy and Western science) and Charlene Spretnak, an American journalist, describe the old paradigm: it assumes that our major economic problems can only be resolved by encouraging open-ended growth, that our national security requires an arms race (which in turn requires high levels of military spending), that technological change is synonymous with progress, and that all these goals should be pursued within a patriarchal social system and a strong, centralized state. Liberals, conservatives, and socialists may differ on whether this state should be of the militarist or the militarist-welfare variety; they may fight over how to distribute the economic pie or how best to make it grow; but for the authors these

differences don't matter much. As Greens, they advocate a new paradigm that they see as equally critical of the right and the conventional left. *Green Politics* provides a fascinating, richly detailed report on the impressive gains of the West German Green party and similar European parties, and makes a tentative appeal for the formation of a national Green movement in the United States.

Founded in 1979, the Green Party is a West German version of the Rainbow Coalition of citizens and social movements. It includes four major ideological factions: the "holistic" Greens (sometimes labeled "fundamentalists" by skeptics), concerned with changing the character of personal relationships and our relationship with nature; environmentalists determined to save the planet from industrially caused extinction; radical leftists who have fled from Communist movements but remain strongly committed to working-class issues; and pacifists, for whom the central issue is nuclear annihilation. These groups, with their different roots and priorities, have joined around a common theme: "We find ourselves in a multifaceted global crisis that touches every aspect of our lives: our health and livelihood, the quality of our environment and our social relationships, our economy, technology, our politics—our very survival on this planet." Although many left-wing German social democrats and a fraction of the Democratic party in the US may assimilate some of the Green demands, particularly peace and environmental initiatives, *Green Politics* argues that they cannot resolve this crisis because they adhere to the politics of growth.

At bottom the Green program calls for more than a new public policy; it challenges the foundations of economic modernity, even as it accepts some political and social aspects of the Western secular creed, especially democracy and feminism. As the Greens see it, industrial societies suffer from a "spiritual impoverishment" whose roots lie in the Western secular religion of growth, technology, and progress—an ideology that underlies economic, political, and cultural life in both capitalist and state socialist societies, and expresses the aspirations of most Third World countries. For the Greens, ecology is more than a series of proposals to clean up the environment or adjust the economy to no-growth policies; it's an alternative "system" to Marxism and liberalism, the dominant frameworks for working-class and middle-class politics in Western societies. Rudolph Bahro elegantly describes the Greens as having swept past Marxism just as Einstein leaped over Newton: both old theories were valuable, "but their time was up."

Instead of placing nature in the context of social and economic history, the Greens place human relationships in the context of natural history, and hold that we cannot exploit nature for human purposes without lapsing into exploitative social relations.

The Greens propose to reorganize the economy into smaller, autonomous units of production, and subordinate the quantity of output to the quality of working life (they believe the labor process should be "spiritually gratifying"—you know, not just garbage in, garbage out). Economic planning must be consistent with a grass-roots democracy that gives workers and communities a voice in production decisions. If the computer and other electronic technologies require hierarchical structures, we should reject them. If a task must be so rationalized that it reduces people to a factor of production (one of the cardinal principles of modern management "science"), it should be scrapped.

The Greens' democratic principles extend beyond the economy to the entire realm of political and personal life. Unlike populists, who often embrace social and sexual conservatism in the guise of commitment to "work, family, community," Greens use the term "grass-roots democracy" to mean abolition of all social hierarchies. In particular, they oppose male supremacy—in the home, at the workplace, in the party and allied citizens' movements. They have adopted an internal quota system that insures women leaders at all levels; their most prominent female leader, Petra Kelly, was one of several women at the highest levels of the party. Structurally, the Greens resemble a federation rather than the usual centralized, bureaucratic Western European party. Local Green organizations vary from city to city in their ideological emphasis and procedural rules, and the concept of "party discipline" is anathema to most Greens.

Yet Capra and Spretnak acknowledge that despite the Greens' intentions, they suffer from many of the same ills as other social movements: males tend to dominate their activist core; meetings are pervaded by bitter disputes and polemics which exclude those lacking rhetorical and intellectual skills. Making the movement prefigure the "beloved community" so fervently desired seems the most elusive goal, certainly less attainable than elective office. Indeed, the Greens' success in winning elections has exacerbated the problem. Elections offer a chance to reach millions of people who would not otherwise hear the Green message; in West Germany it also brings government subsidies at a rate of about $1.40 a vote. In a mid-1980's national election the Party won

more than 5.6 percent of the vote and collected three million dollars. This "victory"—which gave the Greens proportionate membership in the Bundestag—and local wins in cities like Hamburg and West Berlin have forced them to take on the trappings of a real parliamentary party. Now the "new paradigm" often takes a backseat to the old rules of the parliamentary game.

As every radical knows, liberal democracies' openness to reform creates a radical separation between the pragmatic present and the utopian future, a contradiction the left has struggled with since the turn of the century, when its proposals to reform the most onerous features of industrialism won a mass constituency. Predictably, many of the Greens' internal battles center on whether to form temporary coalitions with the far stronger Social Democrats. The radical leftists in the party tend to favor such alliances, and they are frequent at the local level. But Greens for whom the party embodies, above all, an ideological break with the traditional left are more resistant: they know that the socialists and their working-class constituents are ensconced in the politics of growth, and they fear cooptation by a more powerful partner. (Like other features of Green politics, this fear reflects the influence of the American New Left, constantly beleaguered by liberals' capacity, real and imagined, to appropriate slogans like "Let the people decide" and "Jobs or income now.")

Many Greens are nonetheless concerned with building alliances and programs that deal with class issues. *Green Politics* contains a chapter, "Restructuring the Economy," which shows considerable sophistication about workers' needs. The party has offered some imaginative proposals for creating jobs through small-scale production, increasing worker and community control over economic decisions. It has also called for shortening the work week as a major step in combatting unemployment, a demand raised by the striking Metalworkers Union, and now at the center of German labor's antirecession strategy. More controversially, the Greens insist that their ecological principles do not "sacrifice the quality of life," a reference to trade unionists' fears that by curtailing some types of production and consumption, Green economics would lower the standard of living. Instead, they argue, their "qualitative" growth program, emphasizing renewable energy sources and self-sustaining agriculture, would replace "wasteful" products like arms and "frivolous household gadgets" with "socially necessary" goods produced by "ecologically benign" methods. In their view, the demand

for wasteful production is sustained by advertising, which creates false needs; the solution is restrictions on ads. The argument will be familiar to Americans, who since the fifties have been subjected to interminable left put-downs of consumerism and mass culture. (As for me, if I can't watch Roseanne, it's not my revolution.)

Such moralistic preachments are unlikely to allay workers' fears. From labor's point of view, the Greens' rejection of quantitative growth means job losses under the present system. The mass socialist parties do not share the Greens' vision of fundamentally restructuring social and cultural relations; they want to make the system more responsive to the needs of a labor base that demands to know, "What do we do Monday morning at 9 A.M.?" The Greens don't want socialism in the currently understood sense. Though they favor collective, democratic management of the economy, they part company with mainstream socialists who view the state as the crucial vehicle for economic redistribution and planning. This distinction is especially important to libertarian, free-market conservatives who joined the Greens because they found the Christian Democrats too statist, but it also holds for many radical leftist Greens who abandoned overly centralized, traditional, Marxist parties and sects, and rejected East European-style socialism.

Capra and Spretnak are obtuse about this. They exaggerate the left faction's support for orthodox, state-socialist solutions, and conflate concern about class politics with old-style Marxism. They do not seem to understand that contemporary Marxism is also a rainbow, and one of its colors is Green. Nor are they aware that the German new left prefigured much of Green politics. Such sixties figures as Danny Cohn-Bendit and Rudi Dutschke, and more recent groups like the Socialist Bureau, began to define a politics that transcended the traditional left-right dichotomy. A significant wing of the new left was inspired by the German Marxist philosopher Ernst Bloch, who argued for the utopian spirit as an integral part of history, and the work of the Frankfurt School (especially Horkheimer and Adorno, whose *Dialectic of Enlightenment* anticipates the Greens' ecological thinking by at least thirty years); these radicals entered the Green movement because its leading ideas corresponded to their own.

Still, Greens and cultural reds are not identical, especially on class issues. The authors' view of the radical left as a menace to doctrinal purity is an unfortunate lapse, but it is not merely a "mistake." Their reductive account of the troubled relationship between Greens and reds

expresses the paranoia of activists who stand outside the social and cultural traditions of the older working-class parties. Those parties were rooted in shop-floor culture, in neighborhoods inhabited by several generations, in social clubs, bars, singing societies, and churches. Their world view was an extension of Western intellectual and cultural traditions, rather than a break. The appeal of the mainstream labor movement lay in its claim that capitalism introduced universal democratic ideas, but failed to make good on its promises. Labor fought to win the vote for wage earners—to bring them into the system. Marxism, which has dominated the ideology of the labor movement in this century, was in one sense a break with the past, yet in good Hegelian fashion claimed to fulfill the history of Western thought. While boasting about its revolutionary character, the socialist movement has had to reject any suggestion of cultural and social radicalism until after the revolution, or risk losing its mass base.

The Greens don't speak the language of continuity, nor does their constituency live lives grounded in geographic space. For Greens, "community" is a global concept; it does not mean the neighborhood or the workplace. Just as the old communities have broken down in the new urban societies of the West, the Greens have renounced the politics of particular interests, and insisted on universalism as a working principle. It's not merely that the Greens are anti-red; they live in a different time from the workers, the farmers, and the old middle class. And it won't do to simply call them "new middle-class" professionals. That way of seeing the Green revolt reduces it to ordinary class and group politics, rather than grasping its originality.

Despite their postscarcity mentality, the Greens are deeply concerned with Third World oppression; they attack the Western monopoly of the world's energy and productive resources. But instead of arguing that the Third World should achieve equality through industrialization and national liberation, the Greens support redistribution and Third World exploration of ecologically sound energy; they argue from planetary, not national premises, speaking not as Germans or Belgians but as humans.

The Greens' concept of social responsibility entails considerable moralism and *noblesse oblige*. They want to "help" the Third World and not "hurt" the workers with ecopolitics, but they speak from a standpoint of privilege. When they say Green is neither left nor right but "front," they mean that survival and social emancipation take prece-

dence over traditional class and race issues. This perspective has enormous appeal for the economically secure and for those who center their lives on art, politics, and ideas. The problem is that the no-growth ethic produces a zero-sum concept of politics. Since the Greens function where the honey is thickest, when they talk of redistribution many workers hear "from us to them"—a message that's particularly unpalatable coming from middle-class idealists. And when the Greens proclaim themselves world citizens trying to bring morality back into political discourse, those who speak the traditional, particularist language of interest-group politics may wonder if the idealists mean to sell out a century of hard-won social-democratic gains.

It's also problematic, from labor's perspective, that many Greens espouse nonviolence as an absolute principle. Petra Kelly, the party's most resolute advocate of this stand, has proposed it as a litmus test:

> I cannot say that the violent people are part of the Green movement. I would like to include them but I realize their aims are diametrically opposed to an ecological society. They still divide up by good and evil and think in terms of being stronger or weaker than other people. Both our methods and our goals must be non-violent; if any among them is corrupt, everything will become corrupted. That is the power of the so-called truth. It must be the right way because it means never hurting or misusing anyone.

Not everyone in the movement shares Kelly's position or her high moral tone. During the antimissile demonstrations at Krefeld in the summer of 1983, some demonstrators threw rocks at the police, provoking a violent response that in turn moved more demonstrators to join in. The rock-throwing proved a provocative and destructive tactic, and most of the Greens' leaders condemned it. But the issue goes deeper than tactics. Although nonviolent methods have been effective in the peace, civil rights, and feminist movements of the past two decades, deploring force on principle is a different matter. In the sixties antiwar movement, individual pacifists like A.J. Muste and groups like the War Resisters League and the Friends Service Committee argued for nonviolence as the best strategy for victory; they rarely tried to impose their moral views on the movement. Kelly's remarks show that the pacifist Greens mean to translate their principles into a party line. Though Capra and Spretnak oppose authoritarianism when it comes from the radical left, they have no trouble with Kelly's version.

Ultimately, the moral argument for nonviolence rests on the notion that there is no such thing as a just war or righteous force. This fundamentally religious belief is consistent with the survivalist strain in ecological thinking, and with a politics based on the concept of universal humanity rather than group solidarity. But in practice it excludes groups who see no alternative but to use force when confronted with a powerful aggressor. The labor movement has always preferred peaceful means to gain workers' rights, but most workers are prepared to defend themselves against unprovoked attacks rather than turn the other cheek. When an employer hires scabs during a strike, the union can't afford not to stop them—the price, not only in joblessness but in despair, defeatism, and the collapse of solidarity, would be too great. The universalist might argue that after all, the scabs also have families that need to eat. But for the workers, accepting that argument means bowing to the employer's violence in forcibly depriving them of their livelihood. Similarly, feminists who see a woman's right to control her body as essential to sexual equality will resist the argument implicit in an absolute pacifist position—and made explicitly by a few pacifist Greens—that abortion is killing, therefore immoral. In short, Kelly's exclusionary thinking is a serious obstacle for radicals who embrace the basic assumptions of the Greens' new paradigm but do not share the moral imperative of nonviolence, even if they sympathize with its strategic rationale.

The Greens' nuclear pacifism coincided with the West German government's dramatic announcement that it would permit the US to plant missiles on West German territory. While left Social Democrats wrestled with party conservatives, including former Chancellor Schmidt, who favored the move, the Greens seized the initiative and found themselves leading a mass movement against the government's policy. Suddenly nonviolence lost its abstract quality and became a battle cry for large numbers of people. The movement then built on this success by challenging foreign policy in other areas. Advocating unilateral nuclear disarmament, German withdrawal from NATO, and militant opposition to the conventional wisdom about German security, it captured the moral offensive and moved the nonpacifist Social Democrats closer to its position, especially after the SPD's defeat by the Christian Democrats and Helmut Kohl. For a time the Greens became a plausible alternative for voters disenchanted with the Social Demo-

crats' pro-Western foreign policy, they were undoubtedly responsible for the growing strength of the SPD's left wing.

The last section of *Green Politics* explores the chance that "it can happen here." The authors begin by suggesting several forms an American Green politics might take, ranging from a loose network of activists who would share information and coordinate common actions, to a full-fledged electoral party. Though they reject both extremes (the first is too weak, the second too ambitious given the Greens' potential strength and the limits imposed by election laws), they favor a national movement with a coherent worldview and a set of working principles that would discourage leftists who were merely looking for a home.

Despite the antinationalism of the European Greens, the authors go through the ritual of identifying many Green ideas—grass-roots democracy, decentralization, environmentalism—with American traditions. I say "ritual" because, like other radicals (remember "Communism is twentieth-century Americanism"?), they feel constrained to dispel any impression that they're peddling another European import. Whenever they get a chance, they press the point that feminism and populism are American-made, and even nonviolence is a home-grown Thoreauvian product. Though such apologias may be necessary, the argument suffers from Mad Ave overkill. If you're not already convinced that Green politics is universal, this section won't sway you; it's the least convincing part of the book because it lacks a probing analysis of contemporary American politics. The authors never speculate on whether the Greens could split the Democratic party, a discussion that might have brought these mechanical and didactic pages to life. On the other hand they've included a bibliography on relevant issues (which unfortunately omits Murray Bookchin's *The Ecology of Freedom,* probably the most visionary American work on the subject) and a great list of a hundred "Green-oriented" organizations in the US, in case you want to get involved. In some cases, they've just rounded up the usual suspects—New Alchemy Institute, Women for Life on Earth, The Cornucopia Project. But there is a sprinkling of farfetched and naive entries—the Association for Workplace Democracy, Citizen Action, the Conference for Alternative State and Local Politics, and the Coalition for a New Foreign and Military Policy—all of which are as much left, in the American sense,

as Green. Some even have new-wave Marxists on their staffs—I mean Marxists who favor grass-roots democracy, community autonomy, and market socialism, and eat sprouts and whole wheat bread. Some even include pacifists who are sensitive to class issues.

The plain truth is that in America, Bahro notwithstanding, the left-Green split is not so wide (though there are rigid Greens and orthodox reds who deserve each other). If Green politics is to make good here, it will have to come to terms with the insidious reality of pluralism and tolerance, the mush of American progressivism. In America, only the right has been able to pursue ideological politics successfully (and it's frequently forced to retreat). Since the progressive opposition is too fragmented to respond to a single set of principles, an American Green movement would have to build better coalitions, rather than simply present an ideological alternative. Anyway, our pragmatic traditions can't digest *a priori* abstract ideas—we always want to know, "Will it play in Peoria?" We are compulsive problem-solvers; even the left in its heyday had to adjust its principles to shifting situations. For ideologues like Capra and Spretnak all this is distressing, but it's the name of the American political game. The Greens, if they happen here, will attract disaffected leftists as well as environmentalists, peaceniks, a few trade unionists—maybe even a right-wing libertarian breakaway from the conservative camp. They will face the same task as any other American party—converting a pickup team into a contender.

15

IS DEMOCRACY POSSIBLE? THE DECLINE OF THE PUBLIC IN THE AMERICAN DEBATE

To dissenting and oppositional intellectuals the 1920s were a turning point. The "American Celebration," always an intrinsic feature of American nationalist ideology, seemed to reach a fever pitch with the presidential election of the deeply conservative and isolationist Warren Harding, the ascendancy of a new era of religious fundamentalism, the crushing of the Great Steel Strike in 1919, and the wave of subsequent lost strikes—in the midst of unparalleled prosperity—in textiles, the needle trades and metal fabricating industries, and the turn of the Democratic party from its promise of a New Freedom to an adjunct of the national consensus. Leading philosophers and critics such as Thorstein Veblen, John Dewey, and especially Walter Lippmann were convinced that republican democracy was in crisis. They spent much of the postwar

era trying to understand it and to find the strategic grounds for political reconstruction.

The consensus among most of these writers was that industrialism and urbanism had produced a palpable decline of the democratic "public." There was also agreement that the key to this deterioration of public life was to be found not in the surface evidence of a new conservatism, labor struggles, or the religious revival that, notoriously, challenged the legitimacy of natural science to explain human and cosmological evolution. Instead, these postwar developments were themselves symptoms of the increasing mediation of reality by newspapers, film, and radio. These new media provided only partial and often distorted information, and the public's capacity to make political decisions suffered accordingly. Knowledge of public events had become impossibly fragmented, everyday life had become increasingly privatized, and, perhaps most importantly, the whole society had become absorbed in an orgy of consumption. For these critics, the survival of democracy was itself at stake. For if one could not presuppose, even in theory, the existence of a public capable of grasping both large (national and international) and local public issues, then the institutions of democracy were fated to wither, regardless of the formal guarantees of participation provided by open primaries, general elections, and even membership in political parties.

Recall that for Jefferson, the possibility of a public of decision-makers hinged on the efficacy of public education that could provide to its people a broad cultural formation in which the individual, schooled in the tools of language, the intellectual and artistic traditions of civilization, and a thorough knowledge of contemporary public issues was literally *trained for citizenship*. For Dewey, the school became the moral equivalent of the education afforded aristocrats and upper-middle classes as a matter of right. For Jefferson and Dewey both, genuine democracy presupposed such citizenship training. By the early twentieth-century, however, Dewey seemingly had reason to be alarmed, and Lippmann to more than doubt, that an active democratic public was possible. Their despair can be traced to a long-standing assumption concerning the relation of high to "mass" entertainments—more globally to the degree that media dominates our intellectual as well as aesthetic lives.

In what follows, I will dispute their fundamental premise: the claim that the cultivation of aesthetic and intellectual "taste" is a necessary

concomitant, if not a prerequisite, of citizenship. I will argue that this profoundly undemocratic expectation has subverted the development of a genuine theory of the public sphere. For it assumes that, lacking education, the "people" are fated to be inherently incapable of governing themselves. At the same time, most theorists and critics in this mode recognize that mediated knowledge and popular culture are an inevitable consequence of what Benjamin calls the age of the mechanical reproducibility of art, and others have called "mass" society. Once one posits that industrialization, especially technological transformation, *entails* massification, fragmentation, and degradation, the logical outcome is that democracy is all but impossible, notwithstanding all protestations to the contrary.

It is now necessary to delve a little deeper into the precise nature of the connection between questions of political and social rule and those of culture. The theory of mass culture implies the theory of the massification of society and the transformation of the conception of the polis. We have lost, it suggests, a public sphere consisting in its ideal form of individuals who, because they are freed from the banalities of everyday life, can in consequence know the common interests and legislate in their behalf. And we have entered an age of mass passivity where citizenship consists merely in giving consent through the ritual of voting. The ultimate referent of mass society is the historical moment when the "masses" make the (still) contested demand for the full privileges of citizenship, despite the fact that they are obliged to work at mundane tasks, are typically untrained for the specific functions of governance, and are ensconced in the routines of everyday life. In this discourse, the term "masses" does not connote those on the lower rungs of the social and economic ladder (in Ortega's terms, the working class). More apposite is the distinction between those in all the classes of the third estate condemned to active participation only in the labor process and commerce, or in the vagaries of privatized existence (the family in its broadest connotation), on the one hand, and on the other the elite of intellectuals and modern aristocrats who are able to employ their leisure in the cultivation and dissemination of civilization, with all of the baggage associated with that term—aesthetics, ethics, and, of course, political and social knowledge, and the responsibility that is consequent upon it.

Plainly, the masses include the mass of the middle classes. Indeed, for de Tocqueville and Ortega on the right, as for Veblen on the left,

the urban middle class is invariably the bearer of cultural degeneration. For the high cultural intellectuals the banal existence of "mass man" disqualifies the "people" from making aesthetic and philosophical judgments. To the contrary, good taste must be protected from the masses of those engaged in commerce no less than the productive classes, lest civilization itself degenerate. According to these theorists, the "masses" are subject to a division of labor which limits their vision to the particular interests of their family and community. Moreover, as Walter Lippmann cogently argues, their ability to transcend the conditions of their own upbringing and immediate environment is virtually nonexistent. For him, privatized existence compounds the problems of systematically distorted communications offered by mass media and professional politicians.

What is at stake is whether a larger conception of democracy than that of representative, republican government—that is, a polity that can take control over economic and political life—is at all desirable, much less possible in a world increasingly dominated by standardization, fragmentation, and escapist pleasure, what Herbert Marcuse calls "repressive desublimation." In short, despite the pervasiveness of democratic ideology since the French Revolution, intellectuals left and right have questioned its consequences in terms that are remarkably consistent since de Tocqueville's lament.

Perhaps the most subtle and influential American treatise against the concept of mass democracy was Walter Lippmann's *Public Opinion* (1922). Lippmann had been a socialist, but discarded this allegiance in the wake of the Great War, when he discovered his own nationalism, but also the dangers of placing primary, much less exclusive reliance on the decision-making power of the democratic polis. Lippmann's crucial argument presupposes a social and, more specifically, an epistemological premise: that there is a profound chasm between "the world inside our heads" and reality. The world inside our heads is shaped by various stereotypes promulgated by habit and tradition, but also by newspapers, magazines, and the statements of politicians. The vast public forms its opinions according to these stereotypes which shape what we see:

"For the most part, we do not first see, and then define, we define first and then see. In the great blooming, buzzing confusion of the outer world

we pick out what our culture has already defined for us, and we tend to perceive that which we have picked out in the form *stereotyped for us* by our culture." (my emphasis SA)

This process is made all but inevitable by the fact that, individually, we occupy only a small part of the world—our family, our work, our friends are the context and the substance of what we call "experience." We may belong to civic groups, and labor and business organizations, or even be professionals, such as engineers, physicians, and attorneys. Yet according to Lippmann, none of us is exempt from perceiving the world as a series of stereotypes given to us by the culture. Thus, unlike most other critics of mass culture, who carefully distinguish between educated minorities and the masses, he is not concerned to reproduce a picture in which the mass public is fundamentally different from "trained observers." Unlike his master Plato, whose allegory of the cave places the philosopher in a qualitatively better position to see reality than the mass of people, Lippmann *universalizes* the problem of shadow knowledge to embrace all of humanity, insofar as they act as private individuals. Given the necessary distortions in perception, there are bound to be necessary distortions of judgment, mediated in the main by particular interests, by the fragmentation of everyday existence, and by the distortions of media representations. The "buzzing confusion of the outer world" is the mode of existence of humans. Although Lippmann is most interested in the problems of political democracy, specifically how the public may function as the *legitimating* base of any nonauthoritarian system of governance, his argument rests at its most profound level on what might be described as a *social epistemology,* in which "culture" is the crucial determinant of the ways of seeing social reality. His sources—the art critic Bernard Berenson and anthropologist A. Van Gennep—are much clearer about the Kantian premises of this argument. If there is no chance that the public can "see" beyond its own "self-contained community," or the distorted communications of the news media, or even "education and institutions" that can sharpen the differences between images and reality, "the common interests very largely elude public opinion entirely and can only be managed by a specialized class whose personal interests reach beyond the locality."[1] This is usually an irresponsible arrangement when the specialized class lacks the disinterest as well as the expert intelligence required to identify the public interest and act rationally to serve it. Yet in the absence

of a theory of social transformation that can account, if not for the immediate prospect, at least for the *possibility* of a democratic and competent public able to intervene in or control processes of governance, Lippmann is obliged to fall back on the hope to create a professionally competent public bureaucracy that is, at the same time, responsible to what he later was to term the "phantom" public.

The conclusion of Lippmann's discourse is both tortured and ironic. Clearly, he recognizes the danger of placing such extraordinary power in the hands of experts who, as his previous examples amply showed, were not typically more reliable than the broad public. But by providing stability, without which no intelligent and effective government can exist, the trained, expert bureaucracy may help unite "reason and politics." In the end, he argues, we must retain democratic institutions such as elections if only because the alternative, a self-contained oligarchy, is worse. Thus, the public must be consulted, and periodically must "intervene" to keep the technical bureaucracy honest, and to assert its own needs, but the creation of a genuine public sphere, as in the political theory that derived its conception of democracy from the Athenian example, is utterly out of the question. Finally, embarrassed by his own reference, Lippmann turns to Plato's words in Book V of *The Republic* as his epigraph: "Until philosophers are kings, or the kings and princes of this world have the spirit and power of philosophy, and political greatness and wisdom meet in one . . . cities will never cease from ill—no, nor the human race." For Lippmann, Socrates' decision to "retire in anger" in the face of the utopianism of his demand upon a state whose governance was propelled by the destructive effects of "culture," was no longer an acceptable alternative. Whatever their pitfalls, only the humanistic and technical intellectuals could provide hope that reason would control political life, and the prospect that culture— which, in this discourse, is the determining agent of social distortions— could be subordinated to intelligence. Only then could the "common interests" be revealed, and become the basis of public life.

Lippmann appropriates John Dewey's concept of *intelligence* as the standard against which the current confusion of public life could be measured, as well as the goal to which it must aspire. Yet Dewey himself, however much he admired the power of Lippmann's analysis of our contemporary malaise, was constrained to reject his conclusion that the time had come to abandon the ideology of popular democracy for a more realistic democratic elitism. To be sure, in his book-length

reply to Lippmann's assertion that the modern democratic state is in crisis, Dewey accepts Lippmann's judgment that the public has been severely weakened, if not destroyed, by the ascendancy of mass culture. The difference between the two positions consists of Dewey's stubborn faith that democracy can be reconstructed through an act of *will* that promotes the revival of community.

Dewey begins his crucial chapter, "The Eclipse of the Public," with the somber statement, "Optimism about democracy is today under a cloud."[2] To Carlyle's celebrated comment "Invent the printing press and democracy is inevitable," Dewey adds: "Invent the railway, the telegraph, mass manufacture and concentration of population in urban centres, and some form of democratic government is, humanely speaking, inevitable".[3] Yet for Dewey, the historical experience of industrial and urban democracies is no cause for celebration, and surely no cause for the self-congratulation that he saw in the America of the 1920s.

Democracy may be entailed by industrialism, urbanism, and technological change, but according to Dewey, its roots are agrarian: "American democratic polity was developed out of genuine community life, that is, association in the local and small centres where industry was mainly agricultural and where production was carried on mainly with hand tools."[4] Here he lays stress on "pioneer conditions" to account for the stability of early American democracy. These conditions "put a high premium upon personal work, skills, ingenuity, initiative and adaptability, and upon neighborly sociability." Therefore, public institutions such as schools developed under local conditions, and the appropriate form of governance of these institutions, given the ecological and economic basis of association, was direct participation among citizens, through the town meeting, in the decisions affecting these public goods.

"We have inherited . . . local town-meeting practices and ideas. But we live and act and have our being in a continental national state." Yet our political structures do not hold the national state together. According to Dewey, in modern industrial society "We are held together by non-political bonds, principally those of communications—railways, commerce, mails telegraph and telephone, newspapers. . . ."[5] (306). But while these instrumentalities create a fragile unity, they are not sufficient to maintain a genuine democratic polity: "It seemed almost self-evident to Plato—and to Rousseau later—that a genuine state could

hardly be larger than the number of persons capable of personal acquaintance with one another." (Ibid.)[6]

Here Dewey sounds the theme that animates much of American philosophy and art since the United States embarked, in the 1850s, on its century-long journey to world power. American democracy was born of the necessity arising from the conditions of its settlement. In order to negotiate their relationship with an obdurate nature that did not yield its fruits easily, the "pioneers" were obliged to share social and political power. The people who occupied this "virgin land" were fiercely individual, and cherished, above all other values, their freedom. But in the interest of survival, and then of prosperity, the settlers were obliged to constitute a political system based on the principle that all who engage in the labor of making of this wilderness that was America a civilized community shared equally in its governance. (Of course, they excluded Native Americans).

This system of direct, as opposed to representative, democracy flourished on a foundation of face-to-face interaction among white people who, whatever their differences, understood and therefore trusted each other within the limitations of any political relation. In the first half-century of the American republic, the root site of this remarkable public life was New England. Dewey gives the example of the school district:

> "they get a schoolhouse built, perhaps with their own labor, and hire a teacher by means of a committee, and the teacher is paid from the taxes. Custom determines the limited course of study, and tradition the methods of the teacher, modified by whatever personal insight and skill he may bring to bear." (Ibid.)[7]

What impresses is the informality of the process; the state is constituted through the face-to-face interactions of its members. One can extrapolate from this example the formation of a committee to build and maintain a local road, another to oversee the work of the tax collector, a third to develop a water and sanitation system, and so forth, and a community where final disposition of the recommendations of these subbodies are made by the town meeting. (Here, of course, the question of who gets to vote is undiscussed by Dewey. We know that the franchise in this democracy is reserved for male property owners.

While the evidence for women's protest against their exclusion is scant, we do know that the "crowd" of tenants and wage laborers who were typically denied the franchise frequently responded to decisions which affected them, but over which they had no control, with protests, often in the form of disrupting the town meeting.) This political idyll was short-lived. Dewey recounts that:

> "the temper and flavor of the pioneer evaporated" when "The wilderness is gradually subdued; a network of highways, then of railways unite the previously scattered communities. . . . Our modern state-unity is due to the consequences of technology employed as to facilitate the rapid and easy circulation of opinions and information, and so as to generate constant and intricate interaction far beyond the limits of face to face communities.[8]

Of course, the United States was a pioneer in the democratization of the political system, even as it forged a breathtakingly vast communications system that facilitated not only the spread of information but also of goods. Universal, white, male suffrage was enacted without the struggle that the English and other European workers conducted to win similar rights. With this technology-based communications revolution came a new *culture*. For thinkers of Dewey's generation, the ability of technology to maintain nation-unity was purchased at an enormous cost. "The public seems to be lost. . . . If a public exists, it is surely as uncertain about its own whereabouts as philosophers since Hume have been about the residence and make-up of the self. . . ."[9] If a free society *means* not only the right but the ability of its citizens to participate beyond voting in the decisions that affect their lives, then to the extent that mass communication and its culture have replaced the "face-to-face" community, American democracy is, indeed, in serious trouble. For democracy is the same as community life itself, where the idea of community entails participation among equals, at least for the purposes of public activity.

For Dewey, as much as for Lippmann and other postwar writers, political apathy and the absence of intelligent political discourse among those who participate in elections and other public forms on the basis of "habit and tradition," or self-interest, is a function of:

> The power of bread and circuses to divert attention from public matters. . . .

The members of an inchoate public have too many ways of enjoyment, as well as of work, to give much thought to organization into an effective public. Man is a consuming and sportive animal as well as a political one. What is significant is that access to means of amusement has been rendered easy and cheap beyond anything known in the past. And these amusements—radio, cheap reading matter and motor car with all they stand for have come to stay.[10]

Dewey is forced to admit that there are no certain paths to the formation of an articulate public. With the complexity and heterogeneity associated with industrialization and urbanism, the conditions for community life have been disrupted, perhaps forever. Moreover, while his framework of analysis is democratic rather than aristocratic, his invocation of a rural culture upon which to mount a critique of contemporary society leads to nostalgia rather than reconstruction, for he is hard put to find redeeming features in urban, industrial society, precisely because it engenders massification. Dewey describes contemporary American society as a mass society, constituted by the vast information networks whose volume and complexity overwhelm the individual, and all but drive (him) to retreat to the other "instinct"-induced activities, such as consumption and amusement. In current language, privatization is the consequence of massification. But if the implements of mass culture "are here to stay" and, since these judgments were rendered in the 1920s when consumer society was still in its infancy, and before television and VCRs became the main sources of information, it is hard to see how the public may be reconstituted, short of some unforeseen cataclysmic event that recreates the wilderness, in which small groups of survivors may finally form democratic communities.

Finally, Dewey rejects the inevitability of the coming of Mass Man, with its implication that only the rich and powerful and their intellectual retainers or, in its liberal technocratic version, experts, can be effective in solving social problems. However, since "human nature" is itself complex (we are pleasure-seekers as well as moral agents—the two for him are incompatible on the social level), we are compelled to recognize that democracy and freedom are not given by historical law. They are moral imperatives, the achievement of which depend on whether we have the will to employ our innate reason to suppress those

features of human character that, especially since the nineteenth-century scientific and technological revolution, have proven to be both powerful and amoral.

Like Veblen, whose roots were in the Scandinavian immigrants who transformed the plains and prairies of the American Midwest using their inherited artisanal skills and their communal ties, Dewey's native American heritage is deeply religious. More specifically, he has a faith that social problems can be solved only when the individual is both the end and the means of human activity. This aim can be attained through the development of what might be described as an *intentional* culture, the deepest source from which habit and tradition, the actual governors of public activity, are formed. Instead of submitting to habit, this culture would stress the unity of head and hand. That is, it would promote the application of intelligence—whose instrument is the scientific method—rather than its technological applications, to regulate our relations with nature and among ourselves.

Dewey tried to define a radical democratic vision of the future in which individuals, constituted as an independent and articulate public, could stem the tide of both totalitarianism and authoritarian democracy. In the early thirties he worked with Paul Douglas (later a US senator from Illinois), Reinhold Niebuhr, Norman Thomas, and others to form a third party as a practical vehicle to promote a new public life against the apathetic and narrowly self-interested political parties. This party failed when the progressive George Norris refused to run in 1932. Yet Dewey's commitment to social action never waned. He intervened throughout his life in practical political issues—trade unionism for teachers as well as industrial workers, schools (as well as education), and the defense of the rights of persecuted minorities, notably Leon Trotsky and his Soviet followers. Despite his fundamentally pessimistic analysis of modern culture, Dewey displayed an almost classic "optimism of the will," one that could only be grounded in ethical rather than logicoscientific theory. This ethical dimension was rooted in a faith for which the main local precedent was the New England town meeting, one signifier of a beloved community of individuals who, through dialogue and debate, were able to grasp common interests.

The mass society-mass culture debate begins with the French Revolution when, in the perception of representatives of the *ancien regime,* the "masses come to power."[11] For political and social theorists, even

those like Madison and Jefferson, who were key figures in the American Revolution, the necessary limits to the unthrottled power of the people were provided by the system of checks and balances which were designed to prevent representative bodies broadly linked to insurgent, dispossessed classes from capturing the state. The executive branch, but especially the Court, was to be the institutional expression of the best and the brightest of the new society; to which Jefferson added the provision of universal public education as the best guarantor of the creation of a responsible and active citizenry.

In this respect Dewey, although following this program, became an advocate of the link between citizenship and education *only* in consequence of the development of urban, industrial capitalism. For his historical reflection on *direct* democracy presupposed no conditions on citizenship. In a democracy, schools are to be the instrument of *Bildung* (self-formation) where the individual, regardless of social origin, may choose to imbibe the legacy of Western culture—not only literacy, but also history, government, literature, and most of all the ambiguous acquisition called "critical" thinking. The contract between a democratic state and its people was to be fulfilled primarily in terms of the educational system, at a time when distorted communication had become a normal means by which the underlying population received information.

In the past century, Dewey has become the veritable American philosopher of education, precisely for his insistence on education as the condition for informed citizenship and the fulfillment of the dream of social equality. This aim, rather than that of narrow occupation-oriented training, pervaded all of his proposals for school reform, even those that advised that children learned best through practices that were broadly "vocational" rather than rote. He accepted the judgment of his fellow intellectuals, that industrialism and urbanism tend ineluctably toward massification. Consequently, one may no longer (if we ever could) rely on the "free," private individual to constitute an effective polity without the mediation of the state to provide universal cultural formation. Eighteenth-century political philosophy posited the separation of the private from the public spheres as a necessary condition for the ability of individuals to make their collective voices heard in public affairs. Dewey, although retaining his ultimate reliance on individuality for preserving the common good, reluctantly advocated the development of the interventionist state to assure such an eventuality,

in the light of the wanton intervention of pernicious private interests in public affairs. Like many other liberals of his generation who held similar views, Dewey saw state intervention, though far removed from collectivist aims, as the last best hope for individual freedom. This, of course, distinguishes modern liberalism from state socialism, even as they both insist upon public ownership of public goods such as schools.

As Dewey correctly saw, state intervention in education can accomplish a great deal. However, what schools cannot do, indeed what is in the last analysis a worse-than-futile quest, is to "prepare" young people for responsible citizenship. This judgment derives not merely from my assessment that, from the child's standpoint, schooling is chiefly a ritual performance whose crucial requirement is to get by.[12] It also stems from the judgment that, as Lippmann observed, the program of linking a democratic polis to the "elevation" of the masses through cultural formation is fundamentally flawed.

It would be excessive to claim that Dewey relies exclusively on schooling to make democracy work to insure popular power. Yet in concert with intellectuals of the left as well as the right, his acceptance of the argument that the unintentional consequence of "progress" has been to crush the *capacity* of the individual to retain his or her sovereignty in the wake of the concentration of cultural as well as economic power in fewer hands, places his call for the revival of direct democracy in serious jeopardy. For if popular sovereignty is not unconditional, but must presuppose the successful transmission of Western culture through school (the most democratic institution of mass society), then we have arrived at a position in which the concept of democracy is significantly compromised.

In the light of the sordid history of the revolutionary movements of the twentieth-century, it is quite difficult to invoke without qualification one of their crucial precepts: that the masses of peasants and workers are capable of self-rule prior to the achievement of mass literacy, and certainly prior to their collective and individual acquisition of the gems of high culture. That self-rule would entail a radical reduction of the duration of compulsory wage labor, freeing women from the exclusive burdens of the home, and massive efforts to provide the tools by which scientific, technical, and political knowledge can be gained, goes without saying. But what is at issue in all appeals to the "people" is their deep suspicion, not without reason, of the educated classes, who appear as gatekeepers of a distant culture, and are often

the barriers to popular political and social participation. Since the French Revolution the concept of privilege has never been confined to economic property, but has typically included cultural property. Hence, together with the antagonism between classes based on the criterion of property ownership, there has also been a persistent historical gulf between intellectual and manual labor. For a century and a half, since the advent of mass public schooling, the democratic promise that education may be a leveller of class distinctions has been vitiated by devices such as IQ tests, that in every major country have produced a fairly rigid streaming or tracking system; and, of course, political philosophers and cultural critics have never ceased to impose sanctions on popular participation, but have instead insisted that politics and art are too important to be entrusted to the masses.

Despite the rhetoric of popular sovereignty, revolutionary leaderships—parties and military groups—often violated the assumption of the revolution, that it would be not only *for* the immense majority, but also *by* and *of* them. This gap between a rhetoric of popular democracy and an oligarchic political practice has its roots in both the American and French Revolutions. And, as we know, in Russia the Soviets were, as it turned out, more or less permanently disbanded in the wake of the exigencies of foreign invasion, civil war, and famine. The Chinese and Cuban revolutions periodically made attempts, with varying degrees of seriousness, to create forms of popular participation. In Cuba, neighborhood committees, factory councils, and other bodies have provided some democratic outlets for popular expression, but not unambiguously, because of their police function. And, notwithstanding its grave repressive distortions, the Cultural Revolution in China raised to the level of public discussion the question of the degree to which the revolution had been betrayed by its functionaries and intellectuals. Raised the question, but, as it turned out, in the service of a counterelite to that of the party technocrats.

It is only the revolutionary councils of the Paris Commune of 1871, the Soviets in 1905, and some of those formed in 1917 that afford a glimpse of what a developed, proletarian, public sphere might entail. These were, among other things, both forums for hammering out revolutionary policy *and* organs of administration—of the economy and of civil society. Different and opposing views of political parties, groups, and individuals were articulated without fear of reprisal because, however imperfectly, these institutions made the fundamental assumption

that their participants were speaking in good faith. These forums, usually of small units of workers, soldiers, sailors, and (perhaps the unknown aspect of the revolution of 1917 to 21) of anarchist-inspired peasants as well, approximated the conditions of face-to-face interaction from which Dewey derived his own democratic alternative. In these conditions, there was no presumption that citizenship crucially depended on literacy, or on any other high cultural formation.[13]

On the contrary. While the existence of peasants, workers, and artisans able to read and write was firmly established in all urban centers and in rural districts as well, the criteria for citizenship in a situation of popular participation are shared histories of oppression and shared modes of life, not high cultural formation or literacy. I want to suggest that these commonalities are one form of specification of what Dewey was to call *experience*. Theirs was the experience of exclusion by the higher orders, including intellectuals, from processes of public life. For the excluded, the prerequisite of education as a *condition* of participation in the public sphere was (and is) taken as a rationalization for privilege, however sincerely it may be held.

Since the intellectuals have, with some exceptions, traditionally associated themselves with power—either the political and economic kind or, in a different register, high culture—one might expect that there would be a countertendency to valorize the oral culture of the lower orders, an anti-intellectual populism that in context appears to represent the spirit of the insurgency. In fact, the rebellion of the Paris Commune and the rebellions it inspired in the twentieth-century are expressions of subaltern groups, a form of speech that requires no formal educational preconditions.

Of course this conception violates a major precept of ancient Greek democracy, which presupposed equals of homogeneous cultural formation. This has remained an ideal of even the most passionate democrats, such as Dewey. Nevertheless, Dewey regarded it as only one aspect of citizenship, and it is entirely inconceivable as anything but an ideology of exclusion in the contemporary world, marked by both heterogeneous class and cultural formation. It was precisely the requirement of literacy as a condition of voting that was resolutely opposed by the Black freedom movement in the twentieth-century, even as it fervently fought for expanded education opportunities for Blacks.

To be sure, democratic populism discovers its limits at the moment when rebellion transforms itself into administration. The historical re-

cord of the revolutions of the last two hundred years makes this crystal clear. For example, the Bolsheviks discovered that to *retain* state power, as opposed to seizing it, requires a huge army of soldiers, and an even larger army of bureaucrats and technically trained cadres. Consequently mass education becomes a priority of the new regime. Among Western capitalist states, despite the widely held view that a vast army of technically trained and literate workers was necessary for scientific-based industrial development, the imperative of mass, universal education was not a rational discovery of the employer class, but was the outcome of a determined, century-long struggle by workers' movements in alliance with social reformers. For these movements, literacy was not only a crucial form of cultural capital (there were those in the workers' movements who resisted this acquisition), but an important dimension of political and social emancipation. The employers and the reigning politicians of the liberal states were not easily persuaded that the advantages of schooling outweighed the risks of an educated working class, that might thereby discover its own capacity for self-rule.

Thus it is far from the case that schooling is historically rejected by movements for economic and social emancipation. For these movements, knowledge is, indeed, ineluctably linked to power. Even as they protested the monopolies of knowledge held by intellectuals and capitalist rulers, they understood its importance for their own aspirations, especially for full participation in the public sphere. As E. P. Thompson, George Rudé, and many others have shown, the written word, as much as oral tradition, was among the weapons of working-class emancipation. However, this is different from the proposition held by, say, Jürgen Habermas as much as Jefferson and Dewey, that the public sphere could be constituted only by those qualified by a certain cultural formation. Perhaps inadvertently, this utopian proposal is parallel to Jefferson's admonition that popular democracy presupposes popular education: the playing field can be levelled only on condition that each citizen possesses an equivalent cultural formation, that is, has access to the civilizing process once reserved for the aristocracy. For Jefferson, democracy presupposes universal *Bildung* (high cultural formation), just as for Habermas its realization hinges on a universal pragmatics universally internalized. In order to achieve this end, speakers must acquire communicative "competence," a euphemism for what has been described (by Basil Bernstein) as an elaborated code. In addition speakers agree to abide by rules. And, perhaps even more important, they share

a series of values upon which linguistic and moral interaction is not possible.

Now, it is not difficult to show that this prescription is both gendered and rooted in certain assumptions about class. Indeed, Habermas's early study, *Structural Transformation of the Public Sphere,* is precisely a critique of the failed project of citizenship under bourgeois stewardship. Published in 1962, when Habermas was still under the influence of Adorno, it was an exemplary work of critical theory, insofar as it offered both a historical and an immanent critique of the taken-for-granted features of liberal democratic culture. But in his later search to resolve the legitimation problems of late capitalist democracies, Habermas was constrained to abandon his penetrating insight that the concept of the "public sphere" was itself a central ideology of liberal democratic regimes. Instead, he substituted a positive theory, the theory of communicative action, that could account for its possibility. In order to accomplish this objective, on the assumption that conflict was built on the structural barriers to understanding, Habermas chose to limit himself to those problems that bear on the moral formation of individuals and groups, rather than the issues bearing on inequalities of economic and political power. By thus bracketing the "power" and "interest" from the public sphere, and specifying that "reason" is a presupposition of public communication, Habermas provides a moral justification for a conception of the public that is fundamentally exclusionary.

If democracy hinges on education—whether in the details of high art or the semantic and syntactical complexities of language—then Lippmann's suggestion that the idea of direct and persistent citizenship has been foreclosed is entirely reasonable. Moreover, the public sphere is always a *restricted* space—restricted, in Habermas's model, to people like himself, those who have undergone the rigorous training of the scientific and cultural intellectuals. Among the moral if not the practical elements of this formation is the separation of knowledge from interest, manifested in the ability of the intellect to transcend the materiality of the body, including emotion. For only those individuals who have *succeeded* in screening out the distorted information emanating from the electronic media, politicians, and the turmoil of everyday life are *qualified* to participate in social rule.

If all cultural formation is embodied and interested, however, then no such antidemocratic exclusions can ever be admissible. In which case both optimistic palaver about universal "truths" and pessimistic nar-

ratives about public decline may be dispensed with. What cannot be jettisoned is an urgent effort to reconstitute subaltern publics which will once again, in the wake of the most blatant power grab in this century, discover their own historicity.

NOTES

1. Walter Lippmann, *Public Opinion* (New York: Doubleday Anchor Books, 1954), p. 195.
2. John Dewey, *The Public and its Problems* in John Dewey, *Later Works* volume 2 (Carbondale: Southern Illinois University Press, 1984), p. 304.
3. Dewey, *Public and its Problems . .* , ibid.
4. Ibid.
5. Dewey, p. 306.
6. Ibid.
7. Ibid.
8. Ibid p. 306–307.
9. Ibid p. 308.
10. Dewey, *Public and its Problems,* p. 321.
11. Jose Ortega y Gasset, *The Revolt of the Masses* (New York: W. W. Norton), p. 11.
12. Peter McLaren, *Schooling as a Ritual Performance* (London: Routledge, 1990).
13. For an account from the perspective of the anarchist peasants see Voline, *The Unknown Revolution* (New York: Free Life Editions, 1975).

INDEX